VLADIMIR
TATLIN
AND THE RUSSIAN
AVANT-GARDE

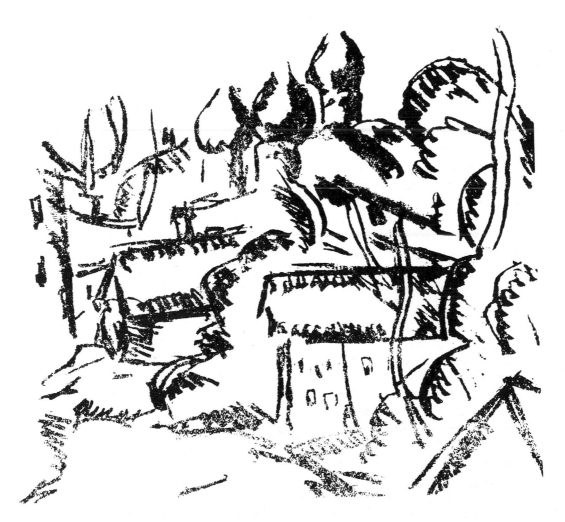

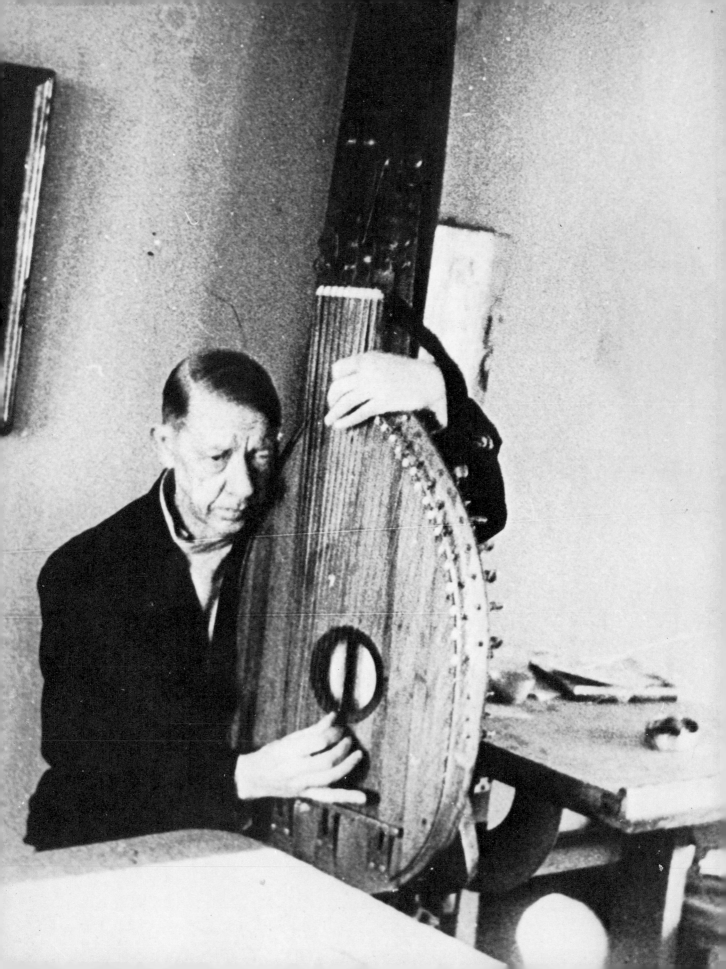

VLADIMIR
TATLIN
AND THE RUSSIAN
AVANT-GARDE

JOHN MILNER

YALE UNIVERSITY PRESS
NEW HAVEN AND LONDON
1983

Designed by Faith Brabenec Hart
Set in Monophoto Sabon and
printed in Great Britain by
Butler & Tanner Ltd, Frome, Somerset

Library of Congress Cataloging in Publication Data

Milner, John.
 Vladimir Tatlin and the Russian avant-garde.

 Includes bibliographical references and index.
 1. Tatlin, Vladimir Evgrafovich, 1885–1953.
2. Constructivism (art)—Soviet Union. I. Title.
N6999.T39M54 1983 709′.2′4 82-25923
ISBN 0-300-02771-0

(half-title page) Vladimir Tatlin: *Landscape with Church*, 1912–13. Lithograph, 16 × 18 cm. Collection Thomas P. Whitney, Connecticut.

(frontispiece) *Vladimir Tatlin playing the domra*, 1940s. Photograph: Collection Professor Norbert Lynton, Brighton.

*For the painter James William Milner,
my father and my initiator in art*

ACKNOWLEDGEMENTS

I AM INDEBTED to many people for assistance in the preparation of this book. Some provided specific help and others were inspirational. Significant in both areas were the painter Kirill Sokolov and his wife, the scholar Dr Avril Pyman. It was always a pleasure and an excitement to visit their house. Their help and generosity has been forthcoming whenever it was called upon. Dr John Golding and Professor Norbert Lynton in their enthusiasm and profound interest have also been an inspiration for a number of years. I have much appreciated their kindness and conviction. With regard to detailed work on the early stages of the text, I have benefited from the caustic and considerate criticisms of Dr Christopher Green. Further intellectual encouragement has been the work of Susan Compton who has rendered intelligible much that was obscure to me in Russian futurism. I have tried in the footnotes to acknowledge specific debts to her work, but in addition my gratitude is due to her as a generous person and an exacting scholar. My scholastic debts are numerous. Professor John E. Bowlt of the Institute of Modern Russian Culture at Blue Lagoon, Texas, has been the model of open-handed scholarship with his information and advice. Robin Milner-Gulland has spurred on my interest in Khlebnikov, as indeed has Anthony Parton from the point of view of his own research into the work of Larionov.

In the accumulation of visual material, Tatlin presents particular problems. Mr George Costakis, whose magnificent collection has itself become part of the history of Russian art, could not have done more to help me solve certain of those problems. Together with Mrs Angelica Zander Rudenstine of the Solomon R. Guggenheim Museum in New York, he has been unfailingly helpful. Angelica Rudenstine has been disarmingly efficient in response to every difficult and demanding letter that I have sent her. Her copious and precise catalogue of the George Costakis Collection is essential reading for every student of Russian art as it has been for me.

For assistance with photographic material I am grateful also to private collectors and art historians as well as archives and museums. I wish in particular to express my thanks to Robert L. Tobin of New York, Jay Cantor of Beverly Hills, Thomas P. Whitney of Washington, Herman Berninger of Zurich, David Elliott of Oxford, Jean Chauvelin of Paris, Felix Klee of Bern, Tatiana Loguine-Mouravieva of Paris, Oleg Prokofiev of London, Alexander Lavrentiev of Moscow, and to the collector of

Russian theatrical designs Nikita D. Lobanov-Rostovsky of London. It has been my acute pleasure to visit André-Boris Nakov in Paris and to receive his assistance with certain illustrations. I owe a debt to his tireless and illuminating discoveries.

Exhibitions have played a vital role in rendering accessible much Russian art that has long remained unseen and unconsidered. Annely Juda in London has been helpful and welcoming. In Cologne Antonina Gmurzynska has achieved much through her exhibitions and the scholarship of the catalogues which accompany them.

Museum staff who have supplied me efficiently with information and photographs include Antoinette Reze-Hure at the Musée Nationale d'Art Moderne in Paris, Thomas D. Grischkowsky and Ms Page Curry at the Museum of Modern Art in New York, Celia Ascher at the McCrory Corporation in New York, Stephanie Barron at the Los Angeles County Museum, William Cuffe at the Yale University Art Gallery, Anne K. Buckley at the Wadsworth Atheneum in Hartford, Connecticut, Pauli Snoeks at the Stedelijk van Abbe Museum in Eindhoven, Jean Mauroy at the Maison de la Culture de Nevers, Dr Eliane De Wilde at the Musées Royaux de Beaux-Arts de Belgique, Brussels. Dennis Farr of the Courtauld Institute Galleries, London, has also been helpful. I am most grateful to the directors of Soviet museums without whom many of the illustrations would not have been possible, to N. Sulyaeva, director of the Museum of the Great October Socialist Revolution in Leningrad, N. B. Volkova, director of the Central State Archive of Literature and Art in Moscow, and S. Ye. Strizhneva, director of the State Mayakovsky Museum, Moscow.

Specific photographic credits include the following: Herman Berninger, *Oeuvre catalog Jean Pougny (Iwan Puni)*, Tübingen (Verlag Wasmuth), 1962 (Plates 96–7,105); David Browne, Newcastle-upon-Tyne (Plates 243–4); Susan P. Compton, London (Plates 7, 8, 31, 42, 90, 108, 139); M. Coppens, Eindhoven (Plate 74); Jacqueline Hyde, Paris (Plate 71, Colour Plate I); Alexander Lavrentiev, Moscow (Plates 126–7, 214, 232); Robert E. Mates, New York (Plates 13, 72, 241); Joseph Szaszfai, New Haven (Plates 59, 85); Cliché des Musées Nationaux, Paris (Plate 131); La Réunion des Musées Nationaux de Belgique (Plate 162); Courtauld Institute of Art (Colour Plate IV). Occasionally it has been necessary to reproduce works from catalogues, in particular, the following which is indispensable to the study of Tatlin: Larissa Zhadova, *V. E. Tatlin*, Moscow (Sovetsky Khudozhnik), 1977 (Plates 21, 24, 38, 48–9). I am grateful to A.D.A.G.P., Paris, for permission to reproduce the works of R. Delaunay, N. Goncharova, W. Kandinsky and M. Larionov (Plates 2, 3, 5, 6, 25, 27, 40–1, 50, 60, 64, 66, 74–6, 82, 99, 100, 112, Colour Plate I; © A.D.A.G.P. Paris, 1983).

Finally my thanks to Lesley Milner, my wife, who has been tolerant, encouraging and, at the right times, fruitfully discouraging. To her I owe particular gratitude: without her this book would not exist.

viii

CONTENTS

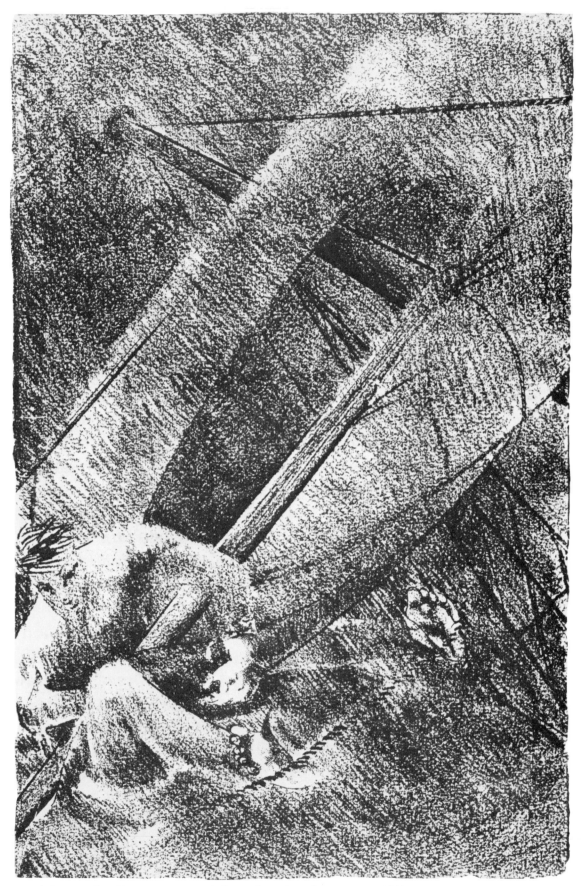

1. Vladimir Tatlin: Illustration to S. Sergel, *On the Sailing Ship*, Moscow, 1929.

INTRODUCTION

TATLIN's enthusiasms ranged from folk music, for which he made his own many-stringed instrument, the *bandura*; to sailing, which proved a formative experience of life-long importance; to poetry, for he counted numerous pioneering and inventive poets amongst his friends; to art, the nature of which he examined with ruthless curiosity until the end of his life. For Tatlin, art was a subject to be explored and examined, and if his originality and commitment were enormous there was nevertheless a part of Tatlin that viewed art from the outside, fascinated by it yet eager to comment as an observer upon its nature and role. This he did not through written argument but through his works. He was not an artist whose work exhibited stylistic cohesion; first and foremost he was an investigator of art. From this point of view his non-art activities, his involvement with aeronautical design for example, and his experience of working in the subtle and mobile organism of sailing ships cannot be separated from the activity of investigating art. For Tatlin, art was not separate from life but an integral part of a wide range of activities. If his works are problematic it is because they accept their context and refuse to become signs of a perfect and other-worldly existence. In the creative activity of Tatlin the real and the ideal are in constant interplay and utopian visions impinge upon the credible and the practical.

This breadth makes Tatlin's creations fascinating and his projects influential. It permitted him to move confidently between painting, three-dimensional construction and projects of architectural scale, to involve himself in designs for the stage, for films, for books and even for gliders. His works were of the utmost diversity. Tatlin the man is what united these diverse activities and it is towards a view of the man that this book is dedicated.

Tatlin, perhaps like William Morris, was a man who thrived upon contrasting activities and for whom no single path of investigation could be adequate to explore the implications of his creative thought. Conflicting activities held in precarious and shifting balance constantly provided new and unprecedented avenues of exploration. For Tatlin was an explorer and in his discoveries lies his achievement.

When the artists and designers of Western Europe began to learn of Russian constructivism in the early 1920s, the movement was assumed to be mechanistic and essentially urban in its outlook. The study of Tatlin and Rodchenko in particular reveals this as an error. They were concerned with the nature of creativity more than

1

engineering. For Tatlin, this had poetic and mystical implications as well as social and practical ones. His originality was undeniable and it had its roots as much in Russia as in cubism or the artistic innovations of the West. His responses to the West were balanced by convictions and by a context that was distinctly Russian.

Tatlin remains a mysterious figure of great originality and influence whose works continue to fascinate. The implications of his explorations are still felt and his diverse discoveries are still the subject of intense study and interest. This book attempts to make clearer the avenues and aims of his enquiries and by doing so to focus the image of a unique man.

1 CANVAS

As a youth Tatlin had left home to go to sea. At the age of forty-four those experiences were still clear to him and important. When asked to illustrate a book, *On the Sailing Ship* by S. Sergel, in 1929, he drew from experience (Plate 1). The ship is seen from the vertiginous viewpoint of the masthead, the sea and ship rolling below, everything visible in movement. One drawing shows a figure precariously balanced on ropes and wrestling high above the ship amongst the rigging with flapping filling canvas. The tilted composition of the drawing emphasizes the lurching and swaying of masts and canvas. The figure who might so easily have been Tatlin slips to a corner of the drawing as if about to lose his grip completely. It is a dynamic drawing in which the human figure grapples to reconcile buffeting air and weather with the wood, canvas and rope of the ship's construction. The figure is the crucial intermediary between the natural world and the complex construction that is the ship. The physical stress of controlling the ship and the physical risks involved are dramatically depicted, for the fury of the oncoming night storm at sea all but engulfs the struggling figure. The ship must be made to respond to changes in the movement of sea and air, elements beneath and above it, its flexible construction harnessing the power of nature and responding as fast as possible to its most extreme conditions. The ship was not to fight natural forces but to move with them in practical and effective harmony. Canvas was, for Tatlin, first of all the material of sails, responsive to a breath of wind, a practical and useful material, slapping wet with rain or filling brilliant against the sky in sunlit weather. Only subsequently did canvas become for Tatlin the material of fine art and then only one material amongst many alternatives. Canvas was no mere support for oil paint or tempera but a material to be manipulated in accordance with its own possibilities. Life beneath canvas sails taught Tatlin a sailor's way of handling materials, a complete language of the handling of materials distinct from that which he was soon to encounter amongst artists.[1]

When Tatlin ran away to sea he was still a boy. He grew familiar with the port of Odessa, with Black Sea towns and Crimean ports. He sailed to Bulgaria, and later in the Mediterranean to Greece, Italy, Morocco, Egypt, Syria and Turkey. The identity of sailor recurs throughout Tatlin's life and work, through wars and revolutions, through the most demanding and rewarding creative developments. 'I would set myself to sail on distant journeys to earn my keep. By this means I was able to see the

3

shipping and sea, numerous other countries, their people, and fish, and birds. I observed them passionately in those days and my observations led me to a variety of conceptions that I was only subsequently to realise.'[2]

A portrait of Tatlin (Plate 2) by his painter friend Mikhail Larionov shows him in about 1908 in sailor's striped shirt against a background of leafy wallpaper. It is painted with a freshness and rhythmic looseness of finish that testifies to Larionov's interests in Fauve and expressionist art. Tatlin appears as a morose young man. He is seen frontally and an otherwise symmetrical pose serves to emphasize the askance gaze of the eyes. The face, which Larionov modelled vigorously, has a firm but slender chin and the lips are full. The impression is of a melancholy and pensive sitter, the deflection of whose eyes reveals an independence of mind, a self-contained youth of abundant physical strength but caught by a strange stillness and introspection. Compared with Larionov's self-portrait (Plate 3), which explodes in eager vitality, the pensiveness of the young Tatlin is emphatic.

His sailing and his friendship with Larionov sum up the vital elements of Tatlin's early years and were to remain points of reference through a complex career. Sailing provided one order of direct experience that was to haunt Tatlin's imagination long after his active sailing ceased. In the paintings, ideas and energy of Larionov, Tatlin first encountered the vigorous contradictions that so characterized Russian art, increasingly aware of its national identity precisely when knowledge was growing of the most exciting of recent Western European developments in Munich, in Berlin and, above all, in Paris. Tatlin's involvement in art begins here at a complex moment, entering discreetly into movements already underway and soon to reach their height. The story of this involvement entails a discussion of the context within which Tatlin was to become a prominent figure, but initially his collaboration was tentative. It was always to remain distinctly independent.

In Larionov's self-portrait and his portrait of Tatlin this conflict is held in balance, poised and unresolved. Both paintings reveal in their handling an awareness of contemporary French and German painting. Indeed Larionov was alternately both to seek and to shun close links with Western art. His desire to evolve an independent Russian art was tempered by a desire to measure up to the achievements of painters in Paris, Berlin and Italy. He was knowledgeable enough to have such a choice before him, at once aware of the West with its European artistic traditions, and of the East, with its Asian and distinctly Russian art forms arising from distinctly Russian criteria and priorities. That search for a lost innocence which imbued so much Western European symbolist writing and painting with a wistful emotional potency, as active an element in Mallarmé's poem *L'Après-midi d'un faune* as it was in Gauguin's defection to the South Seas, found a resounding response in Russia extending beyond the Urals at the edge of Europe and far into Asia. Russia in its own traditions and values presented a dichotomy where the tasteful, cultivated and urban art of European capitals was in sharp conflict with a richly varied and indigenous tradition. That native tradition was increasingly brought under the scrutiny of intellectual and artistic circles in Moscow and St Petersburg. In the vital traditions of folk decoration, of woodblock prints (*lubki*) and, above all, of icon painting, the creative person seeking

4

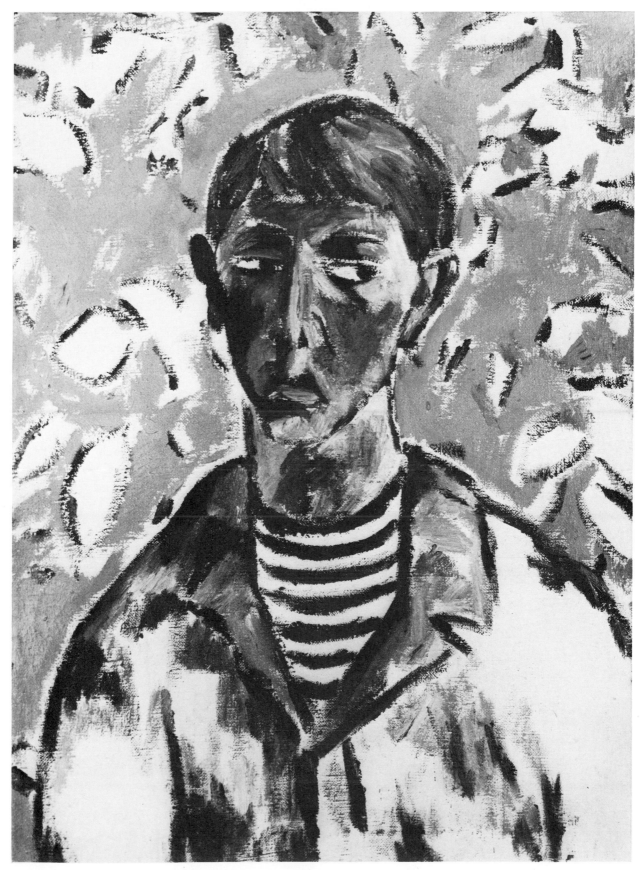

2. Mikhail Larionov: *Portrait of Vladimir Tatlin in a Seaman's Blouse*, 1908. Oil on canvas, 76.8 × 59.1 cm. Jay Cantor Collections, Beverly Hills, California.

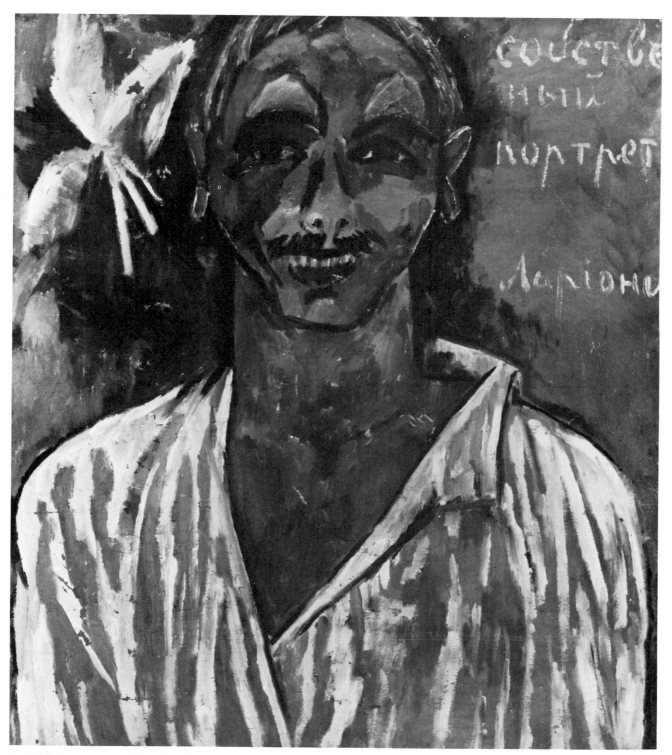

3. Mikhail Larionov: *Self-Portrait*, 1910. Oil on canvas, 104 × 89 cm, inscribed 'Self-portrait Larionov'. Private collection, Paris.

flight from stifling European conventions could find rich alternatives. Many Russian artists did this. Towards the end of the nineteenth century painters associated with the World of Art (Mir Iskusstva) circle, amongst them Surikov, Ryabushkin, Nesterov, Serov, Levitan, Malyavin, Vrubel, Golovin, Viktor Vasnetsov, and in due course Bakst and Kandinsky, sought to revitalize Western sophistication by injecting the physical vigour, the rich decorative force and the expressiveness of traditional elements of Russian life and culture. Larionov's early development took place against this background and it was into this that Tatlin was drawn at the time of his earliest involvement with an active and independent group of painters.

One other factor emphasizes, both for Larionov and for Tatlin, the divergent pull of Western Europe on the one hand, and of indigenous Russian art on the other, for both men were closely identified with the south of Russia, far from Moscow and further from that most Western of Russian cities, St Petersburg. They were further from the capital than were ever Cézanne and Van Gogh working in the Midi or Gauguin in Brittany. The Ukraine, the Crimea and Georgia were areas with distinct local traditions closer to Constantinople than to St Petersburg.

Mikhail Larionov was born at Tiraspol in Bessarabia where his family retained a house that was to cradle the development of a vital phase of Russian artistic and literary life. Tatlin was Ukrainian by upbringing and a regular visitor as a youth to the Larionov home. The South Russian flavour of much art and writing that was in due course to be influential in Moscow and in St Petersburg has scarcely been recognized. Kiev, Kharkov and Odessa, cities with a lively cultural life, looked south to the Crimea and the Black Sea and east towards the Caspian Sea in contrast to the westward focus of cities further north. Rural areas of the south were as close, in culture and in geography, to the East as to the West; Islamic Astrakhan, Samarkand and Tashkent were as near as Paris or Berlin. In the West the symbolist movement of the later 1880s and of the 1890s had confirmed a desire amongst many painters and writers to flee the modern urban city. In Russia this tendency was accelerated by an increasing awareness of Russia's own indigenous traditions and values, many aspects of which were foreign to Western concepts of creative activity. In Russia that malaise caused a cultural shift towards Russia's alternative identity as a vast agrarian and Asian country. For Tatlin, as for Larionov, and for many South Russians of their acquaintance, such a cultural shift was of vital importance, for it encouraged an assertion of independence from the Westernized cities of Russia and from the West as a whole.

Vladimir Evgrafovich Tatlin was born in Moscow in 1885—he was four years younger than Larionov—but his childhood was spent in Kharkov in the Ukraine. His mother, who died when he was two years old, had been a poet of some achievement. For Tatlin, who can scarcely have had any memory of her, she remained a respected figure in his imagination. Even as an old man he recalled her achievements with pleasure and pride: 'My mother was a poetess. She completed the Bestuzhevsky courses. Her poems were published in the leading journals of the time. Her work was closest to Nekrasov and Polonsky. The meeting of my father with my mother happened at Polonsky's funeral where my mother was reading her verses on the death of the poet.'[3] After the early death of his mother Tatlin grew up in the care of a

stepmother for whom he had little affection; his father, Yevgraf Nikiforovich Tatlin, had remarried soon after his mother's death. He was a railway engineer and travelled extensively in his work.[4]

Tatlin studied at the Kharkov Technical High School. His early familiarity with engineering was an influence of considerable bearing, for, although he never became an engineer and although his relations with his father were perhaps not entirely happy, periodically throughout his life he both commented upon the distinct roles of creative man and engineer, and also from time to time was to approach in his own practical work questions close to those of the professional engineer.

However, Vladimir Tatlin's initial bid for independence was not in the direction of engineering, but towards the sea. In 1902, at the age of eighteen, he left home for Odessa, the Black Sea port, where he found employment as a cadet on a sailing ship bound for Bulgaria, Turkey, Persia and out into the Mediterranean. The experiences of his early sea voyages can only have confirmed his awareness of the south of Russia, its neighbours on the Black Sea and its closeness to Asia Minor, to North Africa, to Islam.[5]

As Tatlin's first sea voyage was a substantial one, it might have made of him a sailor for life. Nevertheless, returning to Russia with a little money, Tatlin clearly had as a priority the determination to seek out the company of artists and to learn more about painting. He travelled to Moscow where he was introduced by two friends, the painters Levenets and Kharchenko, to various painting techniques. They prepared him for application to the Moscow College of Painting, Sculpture and Architecture, the most celebrated of Russian academies of art, yet the sort of painting that Tatlin had undertaken with Levenets and Kharchenko was not in a style or technique comparable with that found in the École des Beaux-Arts in Paris or in the academies of Munich, Berlin or Moscow. Tatlin's earliest paintings were probably icons and thoroughly traditional. He worked in an icon-painting studio near the Kremlin, delighting in the complex processes involved.[6] However, he did enrol, after the preparatory tuition of his friends, at the Moscow College, where Konstantin Korovin and Valentin Serov were amongst his tutors. Of all the tutors at the Moscow College at that time, it would have been difficult to find two more Westward-looking figures. Both were thoroughly familiar with Paris; Serov was an acquaintance of Degas and himself a painter who extended the techniques of *plein-aire* portraiture. Both were familiar with Impressionist painting and sought to develop and communicate its techniques within Russia. Tatlin's stay at the Moscow College at this time was short—he was to return later. The tutors he met there had regularly visited Paris and Berlin. Their outlook provided a dramatic contrast to that of one who had begun by painting icons. This dichotomy of methods and aims of painting was characteristic of Russia in Tatlin's formative years; no comparable contrast existed for young French, German or Italian artists.

For a while Tatlin returned south to enrol at the N. D. Seliverstova School of Art at Penza where he studied under the painter I. Goroshkin-Sorokopudov and an illustrator of folk stories, A. Afanasev. In the summer months he returned to the sea, a practice maintained spasmodically until 1915, yet he also found opportunities for

working as a painter.[7] In view of the conflicting demands of Westernized and indigenous cultures, it is significant that amongst his temporary employment he undertook copies of old Russian church frescoes. When short of money 'he would work as a stand-in wrestler. He was given a five rouble note for losing according to a strictly predetermined plan. Sometimes even ten.'[8] At other times 'he would earn his livelihood, bread, canvas and paints working as an extra at the opera theatre'.[9]

Tatlin remained at Penza from 1904 until 1910, during which time he re-established his association with Mikhail Larionov, and visited him at Tiraspol in 1907–8. The portrait of Tatlin in a sailor's striped shirt dates from this time. Larionov had studied at the Moscow College of Painting, Sculpture and Architecture, which he had entered in 1898. He did not receive his diploma until 1908 but was by this time a prolific painter. Serov in particular had influenced Larionov towards Impressionist painting by 1902. In February 1906 Larionov exhibited with Diaghilev's World of Art group in St Petersburg and with the Union of Russian Artists. The Russian rooms at the 1906 Salon d'Automne in Paris, which Leon Bakst decorated, included work by Larionov, and during that year he was able to see his work there when Diaghilev invited him to Paris together with Pavel Kuznetsov. They arrived in Paris at the time of the greatest activity of Fauve artists. The directness of handling and strength of colour displayed in paintings by Matisse, Derain and others came as a revelation that made the painterly dabs of colour of Larionov's Impressionist and pointilliste works seem timid. The impact of contemporary French painting was immediate. The Georgian painter Georgiy Yakulov and the Armenian Martiros Saryan established a style that all but merits the title of Asian Fauve. Their brushwork was left much in evidence and their paintings brightly coloured yet their themes were inextricably Russian and Asian. Saryan, with a brutal directness that transmitted the gestures of Matisse to Turkestan, evolved a unique, vital and brilliantly coloured means of depicting the bazaars, people and blazing light of Southern Central Asia.

Through Larionov, Tatlin's own leanings towards a distinctly Russian art were to be confirmed. Furthermore it was through Larionov that Tatlin was introduced to a tightly knit and vigorously active group of like-minded painters and poets. The mutual involvement of painters and poets was crucial to this circle, and Tatlin, whose mother after all had been a poet, was attracted as much by the poets as by the painters. A vital force within it was David Burlyuk, active as both painter and poet. Amongst the most influential members was the itinerant poet Viktor Khlebnikov, who later changed his Christian name to Velimir to make it appear more Russian, and whose writing, ideas and friendship were to prove crucial to the development of Tatlin's extraordinary art. During the next four years their influence was increasingly felt in the literary and artistic milieu of Moscow and St Petersburg.

When Tatlin became involved in this circle of artists it was through his friendship with Larionov and not strictly as a contributing member. It is, however, vital to an understanding of Tatlin's early introduction to art to place an adequate emphasis upon this aggressive development that so strangely and like a curious hybrid emerged fully fledged from Parisian example. Whilst adopting distinctly Russian imagery and techniques derived from popular painting, Larionov continued to respond to French

4. Vladimir Burlyuk: *Portrait of Khlebnikov*, 1913. Lithograph.

5. Mikhail Larionov: *The Poet Velimir Khlebnikov, c.* 1909. Oil on canvas, 133 × 104 cm. Private collection, Paris.

6. Mikhail Larionov: *Portrait of Vladimir Burlyuk, c.* 1909. Oil on canvas, 133 × 104 cm. Musée des Beaux-Arts, Lyon.

painting on display at the first and enormous Golden Fleece exhibition in Moscow in 1908; alongside his own and his colleagues' paintings, there were almost three hundred French paintings including Fauve works from the Salons des Indépendants of 1905 and 1906. No more intimate awareness of French painting could be expected; included were works by Sisley, Pissarro, Cézanne, Gauguin, Van Gogh, Matisse, Derain, Marquet, Van Dongen and Braque. Russian art at the turn of the century was undergoing a period of extension, growth and fruition; at the same time as its contacts with Paris and Munich were at their height, so too an unprecedentedly Russian art was evolving. This applies as much to the World of Art as to the Golden Fleece. Furthermore it was a phenomenon as evident within the work of the individual as within the broader artistic context.

David Burlyuk was born in Kharkov in 1882; he was one year younger than Larionov and three years older than Tatlin. As a Ukrainian subject he was as well placed as Larionov, Saryan, Yakulov and others to appreciate the turn towards the East. Although Tatlin had some involvement with Burlyuk, he was more attracted in his creative outlook to the chief poetic talent of Larionov's circle, with whom he was to evolve the most complex and intimate creative relationship—to Velimir Khlebnikov.

Born in 1885, and therefore a precise contemporary of Tatlin, Khlebnikov was from Astrakhan on the north-west coast of the Caspian Sea. The son of an ornithologist, Khlebnikov began at first to study birds. His first poem, 'Birds in a Cage', dates from his observations of their behaviour at Simbirsk in 1897, when he was only twelve. The

10

following year, as a student at Kazan Gymnasium, he studied the migration of birds. In 1905 he spent five months in the Ural Mountains engaged upon ornithological studies, and in 1911 certain of his observations were published. The themes of flight, migration and birdsong are recurrent in his poetry and potent sources for his imagination. But they comprise only one of a series of distinct and ostensibly unrelated studies each of which found expression within his extraordinary poems. In 1903, for example, Khlebnikov was enrolled as a student of mathematics at the University of Kazan. In 1907 during the Russo-Japanese War the Russian fleet was destroyed at Tsushima. Khlebnikov, impressed by the historical importance of the event, became preoccupied with historical calculations. The dates of wars and battles were crucial to these calculations which Khlebnikov optimistically hoped would reveal a mathematical basis, a precise rhythm influencing major historical events throughout the centuries.

These diverse studies were well begun by the time Khlebnikov was painted in his loose Russian shirt by Larionov (Plate 5) and by the time he grew closer to the orbit of Tatlin who was just beginning to investigate the practice of painting. Many of Khlebnikov's ideas were to find an echo in Tatlin's creations. Larionov, a friend of both, provided a vital link.

In his paintings of Khlebnikov and of David Burlyuk's brother Vladimir (Plate 6) Larionov has emphasized their rural appearance. They are portrayed almost as wild men, particularly Burlyuk with his loose open-necked shirt, bare chest and thick neck,

11

a densely compact physique suggestive of bear-like strength. By comparison, Khlebnikov is frail. The hair which falls loosely across his forehead, the rapt concentration of his gaze and the pursed lips draw the observer's attention to the book he is holding and by implication to the fact that he is a poet. But the rural appearance was not incidental; it was an integral element of his identity.

At the time of Khlebnikov's introduction to Larionov and other painters and painter-poets in the south, he was working upon the first of his poems to receive wide acclaim. This was 'Incantation by Laughter' published in 1910, but composed two years earlier.[10] The poem at once distinguishes particular characteristics of Khlebnikov's verse and it does so with a startling clarity. In the poem Khlebnikov weaves a complex pattern of variations upon the Russian word *smekh*, meaning laugh. By adding prefixes, suffixes, diminutive endings and by forcing the word's root to function in different parts of speech, Khlebnikov produced a poem every word of which derived from *smekh*. The Russian language makes wide use of prefixes and suffixes to convey shades of meaning, yet Khlebnikov's poem by its repetitive yet evolving sounds based upon a single root abandons the restraints of sense. 'Incantation by Laughter' is full of wit; but it is scarcely intelligible. Its repetitive transformations emphasize inexorably the sound of the root word so that this takes precedence over its meaning. The reader or listener no longer glides unwittingly from sound to meaning. This process of referring almost instantaneously from a word's structure to its meaning has been interrupted by Khlebnikov through insistent repetition and through the sequence of shifts in the role and implications imposed upon the root in use. Sound then supersedes sense and 'Incantation by Laughter' begins to sound like laughter, by virtue of its physical structure, its noise. In its shifting roles, the awareness of semantic structures in language is also made more evident than is the meaning they normally help to sustain. Certain words are newly coined by the poet who in effect has taken the root of a word and moulded as material the sounds of vowels and consonants that comprise it. The Russian text rattles with the noise of laughter. It goes beyond imitation, for the material of the word is so consistently the centre of attention: narrative action is scarcely permitted to disturb this intense concentration.

'Incantation by Laughter' was the first substantial poem published by Khlebnikov that illustrated his interest in the possibilities of a poetry based substantially upon the material qualities of words and their historical evolution. One can see Larionov's portrait of Khlebnikov as revealing an investigative mind charting new explorations in poetry. Beneath the lazy flow of his hair Khlebnikov was an inspired man. His poetry was to amaze by its extreme originality which combined a sense of both history and of sound: the poet became a manipulator of the *material* of words. It was to prove an influential step and to earn Khlebnikov the reputation of an explorer and discoverer amongst poets, artists, and even philologists.

During 1908 Khlebnikov was studying Sanskrit, Slavic studies and biology at the University of St Petersburg. He was also becoming closely involved with writers and painters there. The poet Vassily Kamensky began to publish Khlebnikov's verse in his journal *Vesna* (Spring), and he also introduced Khlebnikov to the painter Nikolai Kulbin, to the publisher, musician and painter Mikhail Matyushin and to his wife, the

12

poetess Elena Guro. By 1909 his circle of acquaintances included David Burlyuk and his brothers Vladimir and Nikolai in addition to Larionov. Khlebnikov's contacts with painters were proving as fruitful and as numerous as Tatlin's involvement with writers.

If South Russia had provided an indispensably Russian and rural cradle for the collaboration of sympathetically minded poets and painters, they nevertheless measured their achievements against Western developments. Within Russia this necessitated the display of vigorously primitivist works in the sophisticated and Westernized setting of St Petersburg. It necessitated in particular an approach to the writers and artists of the World of Art. Larionov had had close links with Diaghilev and the World of Art from 1905, and if folk themes adopted by Bakst, Benois and Bilibin depicted rural Russia by lavishly elegant means, this nevertheless prepared the way for the cruder enthusiasm of Larionov, providing access into respected publishing and exhibiting circles.

When Tatlin completed his studies at the Penza School of Art in 1910, he travelled to Moscow and again enrolled at the College of Painting, Sculpture and Architecture. Amongst his contemporaries were Larionov, Goncharova, Kuznetsov, David Burlyuk, Pyotr Konchalovsky, Aristarkh Lentulov, Robert Falk and the painter-poets Alexei Kruchenykh and Vladimir Mayakovsky. It was a complex and fruitful academy that went far to spread the influence and techniques of Impressionist painting within Russia; it was also extraordinarily effective in the development of diverse individual artistic talents, producing painters of vigour, renown and intelligent independence rather than mere exponents of a common preordained style of painting or sculpture. Tatlin again studied with Serov and Korovin, whose painterliness and lack of literary or dogmatic preoccupations ensured both their influence and their popularity with younger artists.

Tatlin remained at the Moscow College until 1911 by which time his career as a painter was well launched. He became particularly friendly with the painting student Alexander Vesnin, and they set up a studio together in Ostozhenko Street in Moscow. Together they gave private lessons in painting to maintain themselves. Vesnin, a little older than Tatlin, came from the Volga, and was to remain a life-long friend.

Tatlin's work at this time is little known and probably little survives. It appears, however, that drawing was of particular importance to him, for he included drawings executed in 1909 amongst works shown at an exhibition held three years later in Moscow. Two of them were still lifes and one a garden scene, but he also included a view of the south, as if to indicate the continuing importance of experiences and ideals there even when embroiled in the complex and tumultuous artistic developments of Moscow.[11]

Meanwhile Larionov had continued to explore primitive forms. During his military service he worked on a series of soldier paintings of exemplary awkwardness, many of which were inscribed with drawings and writing that emulated graffiti and emphasized the crudeness of his work. This theme was further developed at Tiraspol in the summer of 1910 where Larionov and David Burlyuk worked together on the evolution of a new group, the Knave of Diamonds (Bubnovyy Valet). Its first exhibition

followed in December 1910. Larionov's work increasingly challenged pictorial conventions: it referred less and less to conventions or to meanings beyond the painting itself. As with Khlebnikov, the observer is left with a new awareness of material values. During the next year Larionov began to pursue this investigation further. Whereas recent compositions still referred recognizably to soldiers, he now turned his hand to works that systematically reduced the evidence of an image or subject-matter and came to rely not upon references but upon visual events on the surface independent of elements of depiction. This development Larionov called *luchizm*, translated via French as 'rayonnism' or more directly as 'rayism' (*luch* means a beam or ray of light). Larionov's *Rayonnism* manifesto was not, however, published until 1913 and, in view of difficulties in dating his paintings, the dating of the ostensibly non-figurative rayonnist works may perhaps most reasonably be located towards the end of the period 1911–13, for during this period other contemporary Russian painters were moving decisively towards a less evident subject-matter. Kandinsky in particular had suppressed the legibility of his imagery to an unprecedented degree by 1911, forcing attention upon the handling and material qualities of his medium as the eye sought to interpret its lines, colours and rhythms.

Larionov, who with David and Vladimir Burlyuk had organized the Knave of Diamonds exhibition, had included Kazimir Malevich and Wassily Kandinsky amongst the participants. Kandinsky sent four *Improvisations*.[12] In addition the Russians Falk, Konchalovsky, Alexandra Exter, Ilya Mashkov and A. A. Morgunov were amongst the contributors, and French contributors included Le Fauconnier and Gleizes. But a distinct feature of the show was the inclusion of painters, some Russian, some German, from Kandinsky's circle in Munich, amongst them Alexei von Jawlensky (Yavlensky), Marianne von Werefkin (Verefkina), Kanoldt, Erblöh and Münter. Kandinsky, who was working on the text of *Concerning the Spiritual in Art* during 1910, was increasingly influential in Russia, and with his influence came contacts with Germany and with Western Europe.

<p style="text-align:center">*　　*　　*</p>

Such was the complex intermingling of aims, ideals and contacts of the immediate circle from which Tatlin began to emerge as an independent artist, having now completed his tuition at the Moscow College. Every kind of link was possible through Larionov and the Burlyuk brothers. They were organizers of large international exhibitions of contemporary Western art which, by setting it in the context of the work of practising Russian artists, made the maximum contrast with Russian achievements. Contacts with French and German art abounded, yet Larionov and his circle were evolving a kind of painting with great independence that comprised, increasingly, the conscious rejection of cultivated European values for a more Asian, southern and indigenous art.

It was in the south that Tatlin made his first substantial exhibition début at the Second International Art Exhibition held in Odessa. His exhibited works included two watercolours, two sketches and five titled works.[13] Of these *In the Port* may have had its origin in Tatlin's sailing experiences, whilst *In Turkestan* points to Tatlin's

exploration of Russian Asia east of the Caspian Sea. A contemporary watercolour depicting sailors in Odessa (Plate 7) reveals the same close links with the south and with the sea. Two figures are depicted, apparently arranging contracts of employment. Despite the complex spatial construction of the work the imagery remains immediately recognizable. In the background a noticeboard proclaims 'MAGAZ[IN] FLOTSK[IY]' (naval stores), and the figure to the left carries a bundle either of material or of contracts. Striations at his neck hint at a uniform or a sailor's shirt and the flat hat confirms this impression. What is unexpected about the watercolour is that, whilst Tatlin retains depiction as a crucial element of the work, the viewer is nevertheless confronted with emphatic evidence both of the materials employed by the painter and of the manner in which he has handled them. The liquidity of watercolour is evident, as is the brushwork: striations and scumbles build up a complex sequence of inter-penetrating planes, rendering background shops barely legible and the boards of the foreground floor tilted vertically, parallel to the picture plane. Tatlin places his figures against this floor and attempts no coherent perspective system to articulate illusionistic space within his work. His figures are utterly anonymous and comprise assemblages of loose, arc-shaped brushmarks. The work is consistent but awkward and difficult to read. The primitivism courted by Larionov, combining as it did the directness of Parisian Fauve handling with the gaucheness of graffiti and peasant simplifications, has had a telling effect upon Tatlin. The shallow picture space and tilted floor-plane may ultimately be traced back to Cézanne, but the scarcely resolved stylization of

7. Vladimir Tatlin: *Seller of Sailors' Contracts*, Odessa, 1910. Water-colour on paper. Whereabouts unknown.

8. Vladimir Tatlin: *Picking up Matches*, 1910. Indian ink on paper, 23.5 × 18 cm. Whereabouts unknown.

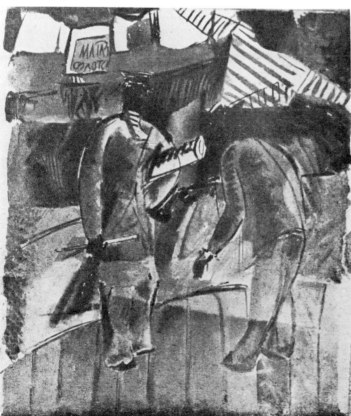

Tatlin's figures owes more to primitivism and the south. If Tatlin's other exhibits in Odessa in 1910 were comparable, their position would have reflected clearly the current balance felt by numerous Russian painters between Western and Eastern tendencies. Indeed an ink drawing of 1910 of a man picking up matches (Plate 8) indicates this balance tipping decisively towards the East.[14] In it an anonymous and faceless hatted figure in loose shirt and trousers stoops to pick up a box. The figure, built up from arcs loosely applied with a brush, and perhaps a pen in addition, has little solidity; his hands are schematically indicated and his feet reduced to stumps. The lack of any background further undermines any suggestion of recession into picture space, and the leaving-open of forms, permitting the white of the paper to enter the figure, renders it closer to a pictogram than an illusionistic drawing. The tendency to representation or depiction is held in check by an emphatic display of the means employed: it is impossible to forget the brushwork when seeking to interpret what is represented. Tatlin is close to the calligraphic traditions of Asia and the Arab countries with their attendant commitment to the performance of the drawing. The handling of material has increasingly come to the fore as a dominant element within the drawing, and what is depicted, despite its lively energy, is consequently less important (see also Plates 9, 10).

Amongst companion exhibitors at the Odessa exhibition of 1910 were names familiar from the Larionov circle. Larionov himself, Goncharova, Yakulov and David and Vladimir Burlyuk all had works on display, as had Kulbin, Falk and Alexandra Exter, who, born in Kiev, maintained strong Ukrainian links. She also had strong connections outside of Russia, in particular with Paris, and had travelled abroad regularly from 1908. In addition Munich painters were strongly represented at Odessa. Münter and Jawlensky were shown, and Kandinsky's display constituted a major revelation with fifty-four works ranging from 1906 up to his most recent *Compositions* and *Improvisations*, a sign of his fecundity and vigour as a painter which he pressed home with the inclusion of *Improvisations* in the Moscow Knave of Diamonds exhibition in December 1910.

It was during 1910 that Khlebnikov's 'Incantation by Laughter' was published in the volume *The Study of the Impressionists* edited by the painter Kulbin in St Petersburg. Khlebnikov's association with painter-writers was flourishing. Like them he was willing to make experiments where technique and material took precedence over meaning or description. Increasingly such an approach was used to undertake a mystical search for meaning based upon acute aesthetic sensitivity. Kandinsky's *Concerning the Spiritual in Art* was dealing with this question so redolent of the nervous aesthetes of the 1890s, for whom suggestion was all and for whom description represented the banal antithesis of evocation. Kandinsky was not alone in the tenor of his thoughts, as Kulbin makes clear in *The Study of the Impressionists*: '*Blue Light*: thought in words, in sounds, in pigments. Drawing is melody. *Red light*: mood. The sounds of pigments. The colours of words. The colours of sounds. Scales. Ornament. *Yellow light*: Sculpture. Free creativity. Illusion and form. The psychology of expression. The shared creativity of artist and viewer.'[15] The implied sentiments behind this list are not remote from certain of Kandinsky's principles. In 1908 Kandinsky's

16

synaesthesia had led him to entitle a painting *White Sound*. Khlebnikov was published in a context well aware of Kandinsky and of Larionov in 1910. The same could be said of Tatlin exhibiting in the Odessa Salon where Kandinsky and Larionov were vigorously represented. Kandinsky's *Crinolines* of 1909 was amongst the paintings shown in Odessa. Much as with the drawings, figures here are stylized and simplified. They may be recognized as figures yet the brushwork and colour that encompasses their forms appears increasingly to take upon itself an energy and vitality beyond and even contrary to that demanded by description of subject-matter: the brushwork retains the energy of its application. The spiritual quest evident in the *Improvisations* and *Compositions* of Kandinsky finds little apparent response in the matter-of-fact subjects of Tatlin's studies, yet it had begun to usurp the autonomy of the image.

By 1910 Khlebnikov and Tatlin shared a common context and many personal friends,[16] despite the widely different nature of their products and the distinct backgrounds from which they came. In terms of the new emphasis that each placed upon his material means, be they sounds or lines, both were closer to Larionov than to Kandinsky whose spirituality at this time seemed contrary to their comparatively practical attitudes.

In April 1910 Khlebnikov collaborated with the Burlyuk brothers, the poets Kamensky, Guro and others in the publication of an anthology of poems and images printed on wallpaper pages. The book became a seminal object for the movement that in due course became known as Russian futurism. Poets and painters were coming

9. Vladimir Tatlin: *Walking Figure with Small Subsidiary Study*, c. 1911. Ink on paper, 34.2 × 25.4 cm. Private collection, England.

10. Vladimir Tatlin: *Seated Nude*, c. 1911. Ink on paper, 34.2 × 25.4 cm. Private collection, England. Drawn on the reverse of Plate 9.

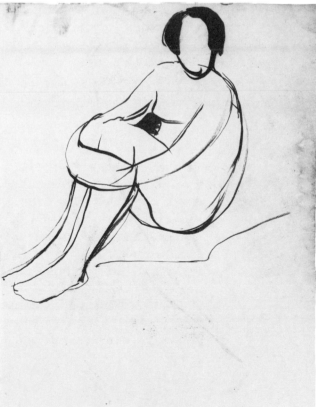

together, and if Tatlin and Khlebnikov did not cooperate at this juncture, it is clear that they had every opportunity to learn of each other's work and ideas through mutual acquaintances, especially through David Burlyuk, who was directly involved in literary as well as visual groupings and displays. The book, *A Trap for Judges*, was deliberately crude and unorthodox;[17] furthermore the use of patterned wallpaper for the pages distinguished it by an awkward and startling home-made appearance. Once again the materials employed were extraordinarily noticeable and important. This was as much an answer to the elegant and lavish publications of the World of Art, as was Larionov's soldier series to the professionalism and finish of Bakst or Serov amongst World of Art painters.

The book was prepared in Kamensky's St Petersburg apartment. David Burlyuk was a prime force in its emergence but the title was Khlebnikov's. David Burlyuk was as closely involved with painters through the Knave of Diamonds as with the poets of *A Trap for Judges* with whom he was collaborating simultaneously. Through the activities of these diverse groups Tatlin and Khlebnikov were steadily drawn closer together, whilst amongst painters Tatlin in 1911 was an intimate member of Larionov's circle with Goncharova and Malevich, whom he had met through Larionov.

The close-knit cooperation that all of this implies did not survive 1911, and the history of Russian art from 1911 until the war began in 1914 is shot through with factions and briefly independent groups. The first Knave of Diamonds exhibition led Larionov to the conviction that this group had become too closely identified with German art. Vladimir and David Burlyuk had contributed to the second Neue Künstlervereinigung exhibition in Munich in September 1910.[18] Kandinsky had reviewed the exhibition in the Russian periodical *Apollon*. The Burlyuks again showed in Munich with the first Blaue Reiter exhibition in 1911 along with Kandinsky, Auguste Macke, Franz Marc, Gabriele Münter, Arnold Schönberg, Robert Delaunay and others, whilst an advance announcement of the forthcoming *Blaue Reiter Almanach* proclaimed 'Symptoms of a new spiritual Renaissance'.[19] Larionov's response to this was steadily to encourage the emergence of a new group, the Donkey's Tail (Oslinyy Khvost), into which he was to draw Goncharova, Malevich and Tatlin but not David Burlyuk. Larionov increasingly saw his standpoint as opposed to that of Burlyuk.

Tatlin, who was now becoming a participant in group activities adhering to anti-Western criteria, was busy working from the life model, executing many drawings (Plates 9–10), and beginning to undertake large canvases. He was still sharing his studio with Alexander Vesnin but other painters came to work there. He had become friendly with the painter V. V. Lebedev and his wife, the sculptress Sarra D. Lebedeva, through the Bernstein School of Painting in St Petersburg in 1910, and from 1911 his studio attracted also Nadezhda Udaltsova, Lyubov Popova and Robert Falk.

It would, however, be a mistake to imagine that Larionov or Tatlin had severed all links with more Western or more consciously aestheticizing organizations. On 28 November 1911 the World of Art exhibition opened in Moscow and included Benois, Bakst and Dobuzhinsky alongside Mashkov, Falk, Vladimir and David Burlyuk, Yakulov, Larionov and Goncharova. Tatlin did not contribute but it is likely he paid

18

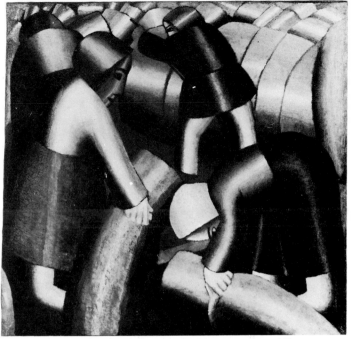

11. M. K. Čiurlionis: *Taurus*, *c.* 1908. Tempera. M. K. Čiurlionis State Art Museum, Lithuanian S.S.R. From the Zodiac cycle of paintings.

12. Kazimir Malevich: *Taking in the Harvest*, 1911. Oil on canvas, 72 × 74.5 cm. Stedelijk Museum, Amsterdam.

the exhibition a visit, as he was based in Moscow and as it showed his close colleagues. He would have seen there an enormous memorial retrospective exhibition devoted to the Lithuanian composer and mystical painter Mikolajaus Konstantinas Čiurlionis, numbers 313 to 470 in the catalogue (Plate 11). Through this exhibition the mystical tendencies evident in the work and ideas of Kandinsky and of Kulbin could not have been more forcefully consolidated or confirmed as an active element within contemporary Russian art. It was to have a long gestation in Tatlin's investigation of the creative process, but it was a formative influence of some richness that brought him close to the poet Khlebnikov and initiated a pathway in Tatlin's imagination that was scarcely exhausted at the end of his life.

Currently, however, Tatlin's painting was becoming increasingly identified with Larionov, Goncharova and Malevich. They had all shown at the Union of Youth (Soyuz Molodezhi) exhibition in 1911 in St Petersburg, as had Varvara Stepanova and Olga Rozanova. Tatlin exhibited a portrait, a series of drawings, a view of a kitchen garden and a life-study from a female model. In the subsequent Union of Youth exhibition which opened in St Petersburg on 17 December 1911 (until 23 January 1912)[20] all four again showed works, as did the Burlyuk brothers, Matyushin, Ivan Puni (Jean Pougny) and Rozanova. Clearly the differences of opinion concerning the collaboration of the Burlyuks and Larionov within the Knave of Diamonds did not prevent their work being seen in proximity at the exhibitions of the Union of Youth. Both remained considerable forces in practical and theoretical terms. At this exhibition Tatlin made his first substantial début in St Petersburg. The peasant themes of Larionov and Goncharova found an echo in Malevich's contributions, the *Harvest* (Plate 12), the *Peasant Funeral*, the *Mower in the Field*, the *Carpenter*, but in Tatlin's exhibits the atmosphere of the sea replaces that of the fields.

19

Kazimir Malevich had developed rapidly from the heavily stylized paintings that were as much post-Impressionist as primitive and that indicated an unexpected debt to Gauguin's example in quitting Western Europe. By 1911 his painting was more sophisticated and up to date by comparison with Parisian styles. By 1911 the impact of cubism was clearly at work. A comparison of his *Woman with Buckets and a Child* (Plate 13) of 1910–11 and *Taking in the Harvest* of 1911 reveals the immediate arrival of Léger's conical and tubular motifs in Russia. Malevich at this stage employs tubular forms to provide a dense, shallow picture space. He also constructs his figures from these elements still with one eye upon flattened images from peasant art and is not yet concerned with the multiple viewpoint of French cubist painters, evident, for example, in Léger's painting *Les Fumeurs* of 1911 (Plate 14).

Tatlin's *Fishmonger* (Plate 15) exhibited at the Union of Youth at once reveals a different position. The density of taut shining cylindrical forms in Malevich's painting gives way to a dynamic swing and counterbalance in Tatlin's, where the handling of paint remains more calligraphic and where the picture space and imagery are built up from planes defined by intersecting curves. Colours are kept distinct and the handling is never prosaic or lifeless as in Malevich's dense painting. There are similarities, however, for Tatlin flattens his picture space—but more dramatically and more dynamically than Malevich. Both take any hint of a horizon line off the top of the

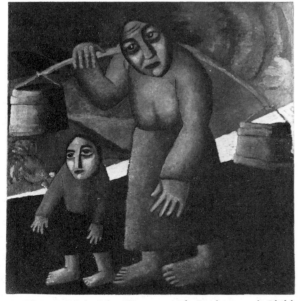

13. Kazimir Malevich: *Woman with Buckets and Child*, 1910–11. Oil on canvas, 73 × 73 cm. Stedelijk Museum, Amsterdam.

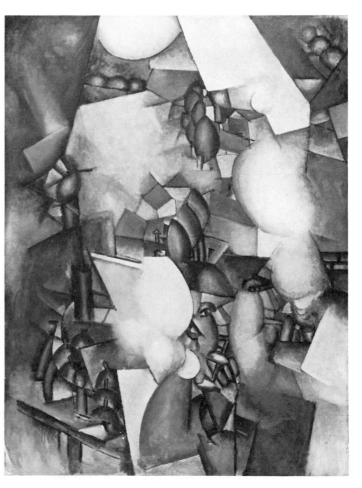

14. Fernand Léger: *Smokers*, 1911–12. Oil on canvas, 129.5 × 96.5 cm. Solomon R. Guggenheim Museum, New York.

15. Vladimir Tatlin: *Fishmonger*, 1911. Gum paints on board, 76 × 98 cm. Tretyakov Gallery, Moscow.

painting and tip up the foreground space, as first Degas, Cézanne and then cubists had done in France; yet folk and icon traditions in Russia had also employed this device. Compared with the curving and counterbalanced thrusts of Tatlin's painting, that of Malevich is stirred by slow and awkward rhythms, more appropriate perhaps to the earth than to the sea.

The fishmonger provides an emphatic foreground. Behind him rises the upper surface of his bench with a large headless fish upon it. To the left two figures with a basket have come to purchase fish. They are on a much smaller scale and are loosely brushed in with a calligraphic technique reminiscent of the drawing of the bending figure executed in 1910. The scale of the figures at the left indicates their distance from the fishmonger, although little coherent perspective is suggested. Tatlin's loose brush-work recalls them to the picture surface, suspending them ambiguously in space.

Tatlin displays none of the heavy modelling evident in the paintings by Malevich. Slight indications of shadows clarify for example the near edge of the fishmonger's bench, but for the most part the calligraphically applied sweeping surface rhythm established by the build-up of arcs in Tatlin's painting, overwhelms such indications of depth and recession, asserting instead the dynamic two-dimensional structure of the picture surface. In this respect the small figures at left, the fish and the larger figure at right all cross the canvas cheek by jowl. The separation of colours, their relative

lack of modulation or adjustment, and Tatlin's determination to retain hints of the bare canvas between areas of colour, all of these point to the intense concentration of the painter upon the surface of his painting and a turning away from illusions of depth and recession. Whereas Malevich had vigorously and almost tangibly modelled a shallow, restricted space, Tatlin is, at one step, closer to the flat picture surface. This development has both Western and Russian roots.

Amongst contemporary French painters only Léger had evolved so clear a separation of colours by 1911, although the interlocking of background and foreground space was a central feature of cubist painting. Malevich was clearly impressed by Léger in 1911 and it is possible that Tatlin shared something of his enthusiasm whilst developing Léger's techniques to different ends. Tatlin's painting is flatter by far than Léger's for whom a robust and, by suggestion, tactile picture space was part of an evolving concern with maximum density of surface up to his *Contrast of Forms* series of 1913. Whilst Tatlin may have chosen to separate and contrast the colours of his pigments, the rhythmic flatness of his picture space cannot owe much to Léger, or indeed to Malevich.[21] Goncharova had experimented, in paintings on peasant themes, with flat frieze compositions reminiscent of embroideries but not with a complex rhythm like that of Tatlin's *Fishmonger*.

Tatlin's composition is a swirling assemblage of arcs, freed from the rigidity of the rectangular canvas by a clearly suggested oval format formed by arcs across three corners. Further curving rhythms spiral within this, bowing towards the centre and only settling to any semblance of firmness as they comprise the large figure at right. With the exception of the bench-end, Tatlin has confined himself to a single linear motif, one which retains much of the energy of its calligraphic execution; from it he has constructed his composition. In this Tatlin is more aware of the process of making the object that is his painting, than of looking at and observing the particularities of the world about him. This emphasis upon the painting as a made object may be traced in the tubular and anonymous figures of Malevich's contemporary paintings, and in the rayonnist works of Goncharova and Larionov. It was a uniting feature of the Donkey's Tail painters.

More immediately accessible in Russia than the cubism of Léger were the major works by Picasso owned by the brilliant and adventurous collector Shchukin. Large earth-coloured canvases of 1908, of enormous strength, they portrayed anonymous nudes constructed from heavily modelled curving elements. Shchukin's choice of works was itself distinctly Russian.[22] The greys and browns, the strength of physique were redolent of the earth and of peasants, despite the anonymity of Picasso's figures. They chimed in perfectly with the outlook of primitivist painters and yet were Parisian in origin. The mask-line stylization of the heads in Picasso's painting is reflected and adapted by Malevich. The woman in his *Woman with Buckets and a Child* bears a head crudely comparable to that at the right of Picasso's *Three Women* (Plate 16). The head in each is an irregular almond shape, as are the eye-sockets. Malevich adds pupils and distinguishes the eyebrow ridge from the eyelid, yet retains Picasso's anonymity of figure and his extension of the forehead plane along the nose.

In his *Fishmonger* Tatlin is engaged in a similar reduction of individual traits to a

16. Pablo Picasso: *Three Women*, 1908. Oil on canvas, 200 × 178 cm. Hermitage Museum, Leningrad.

17. Vladimir Tatlin: *Fishmonger*, 1911. Drawing (possibly lithograph), inscribed 'Fishmonger, Tatlin'. Whereabouts unknown.

18. Vladimir Tatlin: *Fisherman*, 1911. Drawing (charcoal?). Whereabouts unknown.

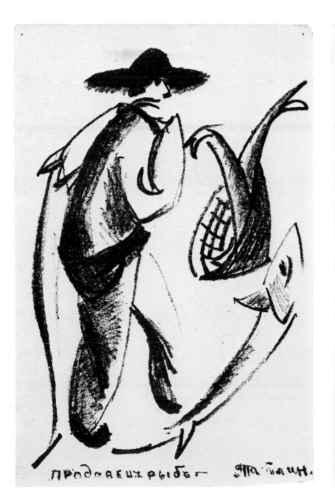

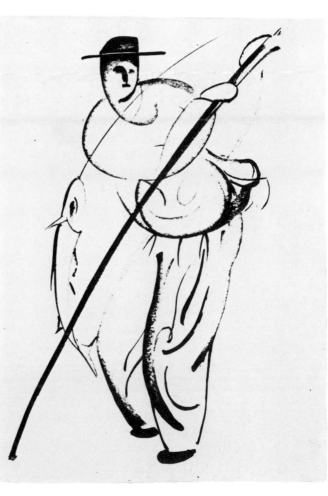

systematic indication of structure, for he too constructs the head within an oval-almond format, reduces eyes and mouth to lozenge curves and leads the ridge of eyebrow directly along the line of nose (Plate 17). The almost sculptural solidity of Picasso's painting is not attempted, yet his technique of evolving figures from a rhythmic repetition of curving elements is. Furthermore, the suggested oval format of Tatlin's *Fishmonger* hints again at cubist inspiration.

Were Tatlin a Western European painter such considerations might suffice. Russian considerations, however, formed a conscious part of his outlook at this time. His allegiance with Larionov, Goncharova and Malevich was undertaken to pursue this aim. As the flatness of his picture space and its extraordinarily rhythmic organization are the features least readily echoed in Western comparisons, it is perhaps in this consideration that he was closest to more Eastern sources.

Amongst Tatlin's earliest painting experiences had been involvement with church art, both in painting icons and in copying frescoes and wall paintings. Whereas in the West cubism derived much of its direction and force from a rejection of an indigenous and long-standing tradition of depicting space according to systems of perspective first evolved during the Renaissance, in Russia no such indigenous system existed. Renaissance traditions appeared as a later manifestation of Western and Westernized taste. They had astonishingly little effect upon icon painting whose traditions were scrupulously maintained and preserved. Pictorial structures, ultimately Byzantine in origin, were preserved in Russia for hundreds of years after their disappearance in Italy. The Orthodox Church had not undergone the transformations that comprised the Renaissance in Italy and thence in Northern and Western Europe. As a consequence, the saints and figures of Russian icon painting made none of the approachable and credibly human appearances that grew familiar in the West. For Tatlin, as for Malevich and Goncharova, the icon provided a living and Russian alternative to Western traditions. Their search for a Russian identity could find in the icon spatial systems that were not imported. Furthermore, many icons were pictorially superb, their painters' control complete and their emphasis upon materials crucial. Tatlin had painted icons, and if he eagerly learnt of Western developments it was not in ignorance of spatial devices already at odds with Western Renaissance traditions.

Andrei Rublev's *Holy Trinity* (Plate 19), depicting the Archangels Gabriel, Raphael and Michael, provides a celebrated and superb example. The formal stylizations were rigidly controlled. Gold leaf creates a timeless and placeless context for the supernatural event, yet it also prevents the painting from functioning as a window upon a scene. No suggestion is made of an illusion by which the viewer might look through the surface to the events depicted, for these occur emphatically on the surface. Contrast with the gold leaf stresses the distinct qualities of the paints employed, and areas of colour comprised of different pigments are kept distinct and separate one from another. Silhouette is used in place of atmospheric recession, and rhyming shapes across the painting produce a composition of exquisite balance and tenderness: the symmetry of the flanking figures is disturbed only by the cross-rhyme of the heads, where the central and right archangels bow to the left in an echo that is without a jarring element anywhere in it.

24

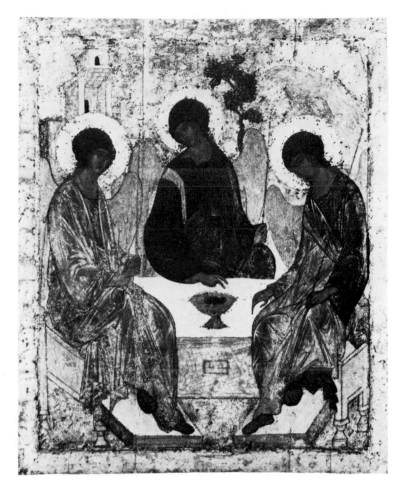

19. Andrei Rublev:
Holy Trinity, c. 1420.
Icon painted on panel,
142 × 114 cm.
Tretyakov Gallery,
Moscow.

To turn from this to Tatlin's *Fishmonger* is to enter again, and brutally, the world of daily experience, for this theme is as mundane as it was familiar to Tatlin; yet reflected here is a remarkable separation of colours, a linear and flat compositional structure, a distinct system at work and a mask-like anonymity that resembles icon painting. Tatlin's bench-top rises no more vertically than that attended by Rublev's angels. The fishmonger's head is more loosely painted but not more flat or stylized than that of Rublev's angel. Even its tilt, its lucid gaze, the clarity of its silhouette, especially of neck and chin, the diminutive mouth and continued plane from forehead onto nose all enhance the comparison with devices and techniques of painting icons and not canvases. The icon, despite increasing Russian scholarship, was little known in the West; it comprised a distinct Russian element of great beauty and resolution. Not less important for the practical Tatlin amidst anti-Western colleagues was that icons eluded the academy's preoccupation with illusion and even, connoisseurship aside, with the need for an educated and cultured awareness of art. An icon was clearly an object to be used, transported, carried in processions and installed. Its traditions recognized and maintained a visual system that emphasized rather than

25

denied the surface of the object. For Tatlin, becoming aware of the breakdown in the West of the credibility of illusionistic picture space, the icon painters provided an experienced and proven source of enquiry. The importance of cubism and the achievements of icon painting did not, in this sense, comprise a contradiction for Tatlin. They could be reconciled in a new form of painting that was systematic, and that revealed its materials and comprised a frank recognition of the painting as an object. There were even occasional calligraphic elements in icon painting that perhaps supported the inclusion of this element too within Tatlin's work.

At the Union of Youth in December 1912 and January 1913 in St Petersburg, Tatlin also exhibited two landscapes, not a theme adaptable to the icon's stylization. A further *Fisherman* (see Plate 18), a *Sailor* and other sea-inspired pictures testified to the continued importance of his experiences as a sailor. The *Fishmonger*, however, reveals the degree to which Tatlin's painting had become primarily a structure, rhythmically organized, into which the features of familiar experience were insinuated. Circular curves subdivide the canvas and come to contain imagery only after their rhythmic and proportional relationship is established. This development was contemporary and comparable with that of Juan Gris in Paris. In Russia the compositional curves of Malevich's paintings were strong pictorial elements, but never applied so systematically as they were by Tatlin. So intense a concentration upon pictorial rhythms was echoed in Russia by Larionov's progression away from depiction towards non-representational paintings in his rayonnist or *luchist* style where arrow-darts of colour, each implying swift recession towards a perspectival vanishing point, were contradicted in their flight by other rays, fleeing equally swiftly in opposing directions, providing a densely crystalline but also dynamic picture space. They lacked the flatness of Tatlin's paintings but did require the rhythmic subdivision of picture space by means of a sequence of focal points. Larionov's rayonnist works eventually dispensed altogether with imagery and references outside of the painting, but for Tatlin references remained essential. On the other hand, Larionov was personally close to Tatlin in 1911 and he was a prolific painter. He held a one-day exhibition of no fewer than 124 works in Moscow on 21 December 1911.

During the same month the Burlyuk brothers in their family home at Chernyanka, near Kherson on the Black Sea coast, were planning the final stages of the first Knave of Diamonds exhibition to go ahead since the defection of Larionov and his colleagues. The poet Benedikt Livshits who was staying with them recalls that Alexandra Exter brought photographs as evidence of recent cubist work by Picasso. 'This is good,' proclaimed Vladimir Burlyuk, 'Larionov and Goncharova have had it.' The Burlyuks' sense of competition with their erstwhile colleagues was acute and their commitment to a kind of cubism was explicit. When the exhibition opened on 25 January 1912 in Moscow, the extent of their commitment was obvious. David Burlyuk stressed in particular the multiplicity of viewpoints that cubism in Paris appeared to embrace, exhibiting *Principle of Flowing Colouring in Painting from Three Points of View* (Cat. No. 14), *Free Colouring* (16) and *Depiction from Several Viewpoints* (21). Vladimir's exhibits included *Geotropism* (9) and *Heliotropism* (11). Other Russian exhibitors included Exter, not surprisingly in view of her assistance to the Burlyuk brothers, Falk

26

and Kulbin. From Germany, Kandinsky was represented and, like the Burlyuks, provided a link between Russia and Germany. Kandinsky brought recent major canvases[23] to the exhibition as well as paintings by Macke, Marc and Münter. Die Brücke painters extended the German section, reflecting the breadth of Der Sturm gallery in Berlin. Kirchner exhibited, as did Heckel and Pechstein. From France came the Fauves, Friesz, Camoin, Matisse, Van Dongen and Derain. In addition, to crown the Burlyuks' latest discoveries, came Gleizes, Le Fauconnier (who showed a study for *L'Abondance*) and a vital trio for contemporary Russian artists—Picasso, Léger[24] and Delaunay. As far as Tatlin was concerned, no more interesting line-up of artists could have been brought to his door. It is barely conceivable that his allegiance to Larionov's group prevented him from attending the exhibition. In Kandinsky's work Tatlin could see a vigorous exploration of calligraphic marks and a fascinated study of icons that paralleled his own enthusiasms, yet the dynamic energy of Kandinsky's paintings was devoted to the depiction of apocalyptic events, a spiritual preoccupation not evident in Tatlin's painting. They appeared instinctive in their evolution, closer to Čiurlionis and perhaps even to Kulbin than to the new paintings by Tatlin. Delaunay, Léger and Picasso helped to bring Tatlin up to date in terms of Parisian cubist picture structure.

In addition to Burlyuk's 1912 Knave of Diamonds exhibition, the group arranged two debates. The first was held on 12 February at the Polytechnic Museum. Burlyuk pressed home his apparent familiarity with cubism by lecturing on it and stressing the unimportance of subject-matter. Uproar ensued when Goncharova, formerly a Knave of Diamonds supporter, publicly announced the formation of the rival group, the Donkey's Tail. A second discussion followed on 25 February from which the Larionov circle were absent. At it David Burlyuk deprecated Italian futurism, having only recently become aware of it through his flourishing international contacts. In March 1912 David and Vladimir Burlyuk exhibited at Der Sturm in Berlin, where Delaunay and Kandinsky were represented, as indeed was Goncharova.

Any lingering doubts Tatlin may have had concerning the intriguing developments of contemporary Western art received the sharpest possible challenge in March 1912, when the Donkey's Tail group replied to Burlyuk with an exhibition in Moscow. Burlyuk had stressed his Westernized and sophisticated international links. In response, the Donkey's Tail was emphatically Russian, rural and folk-based. It also provided the first opportunity for Tatlin to show a large number of works. Malevich exhibited twenty-three peasant paintings, Larionov fifty works (many soldier paintings), Goncharova fifty works on rural themes and Tatlin fifty works. These four painters provided the substantial core of the Eastern view. The cultural dichotomy of Russian art could not have been more acutely presented to the Moscow public than it was by these two large exhibitions held within a month of each other. Whereas Burlyuk had sought links with Berlin, Munich and Paris, Goncharova proclaimed her allegiance to 'Chinese, Byzantine and Futurist styles'. In keeping with Larionov's aims, the Donkey's Tail exhibition showed primitivist paintings by Shevchenko, Chagall and Le-Dantyu.

Tatlin's paintings, despite their flavour of working life at sea, must have seemed sophisticated. The *Fishmonger*, for example, was shown, but so too were studies from

as early as 1909. He was careful to include his Asian *Turkestan*, however. Yet his most recent works were perhaps most completely at variance with the primitivist paintings of Larionov, Goncharova and Malevich. These were Tatlin's designs for *The Play about the Tsar Maximilian and his Arrogant Son Adolf*,[25] staged by the Moscow Art and Literary Circle and directed in 1911 by M. N. Bonch-Tomashevsky. Tatlin's designs are characteristically full of vitality: their lavishness, however, recalls more closely the love of folk-tales characteristic of the World of Art and evident in the work of Bilibin, Bakst or Nikolai Rerikh (Nicholas Roerich) than the brutal primitivism of Larionov's circle. Yet Larionov had, after all, been closely linked with the World of Art, and in any case Tatlin's designs carry further the structural innovations of his paintings.

A number of artists associated with the Knave of Diamonds and the Donkey's Tail contributed to Diaghilev's World of Art, the theatrical bias of which flourished as never before as the work of Bakst, Benois and Rerikh found an echo amongst younger men. The sumptuousness of Bakst found a brilliant and strange reflection in the lavishness of his pupil Chagall. Goncharova and Larionov were later to become dynamic contributors to Diaghilev's émigré Ballets Russes. In 1911 these theatrical tendencies were beginning to reach their height.

Whilst Tatlin did not design for the ballet, his sets and costumes for *Tsar Maximilian* have all the stylized and incisive vigour associated with Diaghilev's circle. These early stage designs occurred at a crucial moment of Tatlin's development but have been largely ignored. As his study of icons had revealed, easel paintings arose from West European conventions and traditions. In Russia, especially for the Donkey's Tail group, the association of painter and easel painting was called into doubt. For many, easel painting became but one of a variety of alternative activities and approaches. This difference of priorities is important, for the theatre in particular was central to many Russian artists' development and did not comprise a flight into peripheral activities or a turn from art to design. The theatre in Russia relied upon and recognized its artists to a degree unparalleled in the West. Without so intimate an involvement Diaghilev could not so utterly have astonished Paris with the Ballets Russes.

In Tatlin's theatrical designs for *Tsar Maximilian* this vigour is much in evidence. No theatre-goer watching a performance before Tatlin's stylized and rhythmic sets would take for granted the role of the artist-designer. The decisive rhythmic qualities in particular stressed the action of a scene, its distinct character or mood, yet were clearly artificial and in evidence as painted and designed works in themselves. No more abrupt and theatrical shift of mood could be manifest than that which appears from a comparison of Tatlin's grim, menacing arches in the set for a *Hall in the Castle* (Plate 20) with the explosive and childishly naughty effervescence of the florid set for the throne room where the Tsar sits upon a circular seat (Plate 21), its gothic back flanked by guards holding halberds. This is set upon a low mound and is approached by a flight of steps, and the whole is seen through an arch in what appears to be a tent decorated with enormous tulip-like flowers and leaves. Further figures of men stand beside the tent at either side (see also Plates 22–3). Most extraordinary of all, at each

28

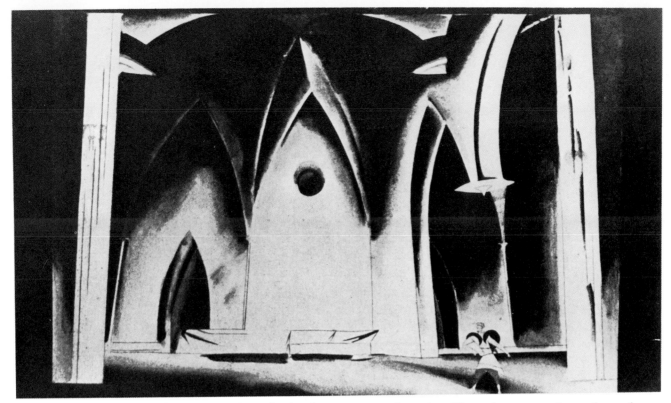

20. Vladimir Tatlin: *Hall in the Castle*, set design for the play *Tsar Maximilian*, 1911. Watercolour, gum paints and gouache on card, 80 × 93 cm. Tretyakov Gallery, Moscow.

21. Vladimir Tatlin: Set design for *Tsar Maximilian*, 1911. Watercolour and pencil on paper, 50 × 68 cm. State Theatre Museum, Leningrad.

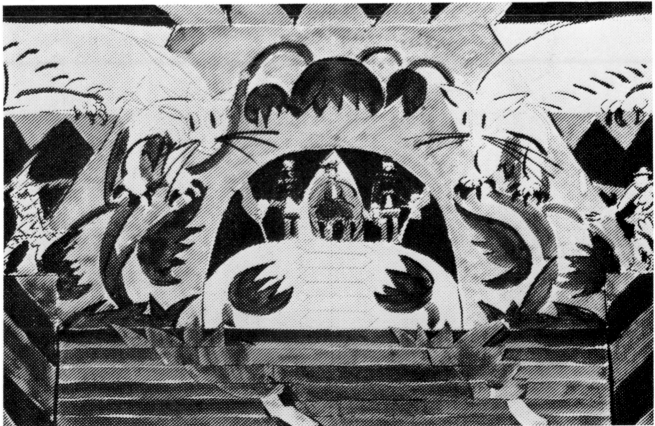

side leaping towards the opening, are two rats (or perhaps cats), indicated by a few lines that stress their long whiskers and fiercely hooked claws. The overtly Russian folklore flavour characteristic of designs by Bilibin and Rerikh has lost its precise and decorative polish, echoing still the stylizations of Art Nouveau and close in their way to early Kandinsky. Tatlin's vitality is revealed in looser strokes at once more painterly and verging on disarray. Linear rhythm and pattern remain strong but loosen within the symmetry of this panel to a hectic rhythm more akin to Stravinsky than Rachmaninov, with a flavour of the savage and the primitive.

Tatlin's study for the villainous character Venerin Zadirschik (Plate 24) is an equally vibrant and alarming design—a flower-man radiant with menacing tufts of plant upon his back, enormous epaulettes, and mole-claw hands. In both designs a strong degree of symmetry renders the image explosive in its structure and its energy. It seems to burst upon the viewer. The flourishing boots with giant spurs are resolutely back-to-back across the surface of the page. Whilst coat-tails, hands and the heart upon his tunic stress both the flatness of the page and the symmetry of the image, only

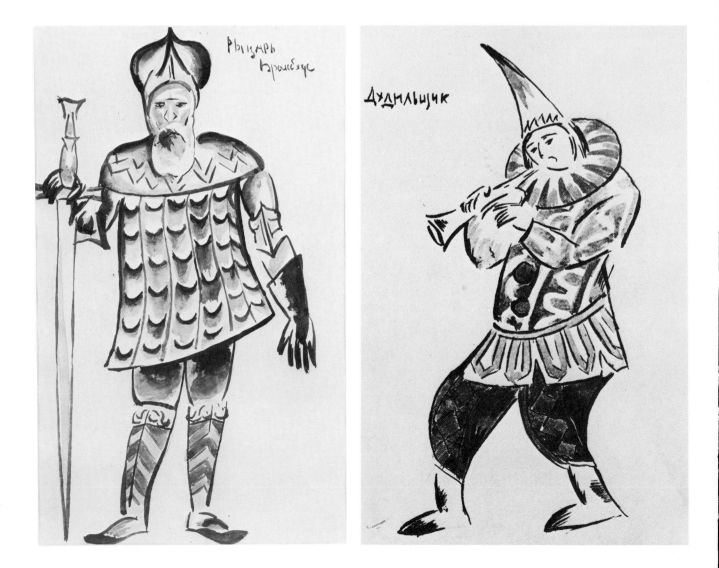

the leering and large-eyed face detracts decisively from this, gaining thereby the focus of attention. The symmetry in each of these designs points to their artificiality of construction and militates against a casual suspension of disbelief in which the theatrical design presents no more than the credible props of daily life or an exotic setting. Tatlin in both has so livened his page and so energetically decorated his figure and set design that awareness is drawn directly to bear upon their intrinsic qualities. Symmetry implies an approach to geometrical form and this is thoroughly employed by Tatlin. The throne-room set (Plate 21) is suggestive of folded forms and, for all the irregularity of its foreground plants, it is largely symmetrical around the centre-vertical. In addition triangular hills appear to pass as regular as saw-teeth behind the central pavilion or tent. The costume study is based upon circular arcs, one of which forms the curve of the costume's shoulders. The boots underline this geometrical construction, and not solely by the exaggerated swelling of their calves: on the right is a boot worthy of Popova ten years later, for circles and curves are all that comprise it. For all the apparent freshness and directness of these designs, a premeditated,

22. Vladimir Tatlin: Design for *Tsar Maximilian*, 1911. Watercolour and ink on paper, 32 × 19.5 cm. Galerie Jean Chauvelin, Paris.

23. Vladimir Tatlin: *Trumpeter*, costume design for *Tsar Maximilian*, 1911. Watercolour and ink on paper, 32 × 19.5 cm, signed lower right. Collection Mr and Mrs N. D. Lobanov-Rostovsky, London.

24. Vladimir Tatlin: *Venerin Zadirshchik*, costume design for *Tsar Maximilian*, 1911. Watercolour and pencil on paper, 24 × 17 cm. State Theatre Museum, Leningrad.

geometrical structure is at work, evident in both the larger compositional features and in smaller details. Whilst his handling remained direct and even calligraphic (as in the face of Venerin Zadirschik), Tatlin was nevertheless continuing an exploration of underlying geometric structure. These works are not as spontaneous as they first appear to be.

The *Hall in the Castle* (Plate 20) is outwardly less regular, yet it has a theatrical sense of atmosphere and the potential of action to an acute degree. To relegate such a work to the level of a subsidiary and supportive role in a theatrical production is to ignore the integral nature of the artist's involvement in the production and its impact upon an audience; furthermore, it assumes that theatrical work is subsidiary or secondary in importance to painting easel pictures with a less precise function or purpose. But this distinction did not apply to Russian artists. In Russia, at the height of a complex and fecund period in art, theatrical design never ceased to attract the creative man or woman, from Serov and Bakst to Tatlin and from the 1890s through the 1920s.

The *Hall in the Castle* dwarfs its inhabitant actor with a series of enormous pointed arches. The costumed figure reveals at once a geometrical foundation, for Tatlin has constructed this little man from arching curves of circles. The vaulting in the castle echoes further the lines of his legs, like an echo of his presence. A few straight lines flank the set, but Tatlin works primarily with circles to build a stark imposing rhythm, to construct a set that is a depiction of a hollow gothic castle hall, but also a pictorial structure whose control relies upon the internal rhythms and echoing relations of the parts. If such echoes and rhyming shapes recall French cubism, as does the inconsistent light source, Tatlin has clearly kept his distance from cubist contemporaries both in Russia and abroad. Developing here, and equally evident in the *Fishmonger* painting, is a method of construction dependent upon geometrical forms and the rhythms evolved from them; in relation to this, description and depiction are of secondary importance. For all the life and enjoyment these works evoke, and perhaps because of it, construction takes precedence over observation. By 1911, amidst a tumult of conflicting developments within Russian art and a growing knowledge of events further west and east, Tatlin had evolved a method of constructing his works that was original, confidently handled, and of immense rhythmic control. In time this was to flourish into a method for investigating creative activity itself.

2 THE PAINTER

IN 1911 Vladimir Tatlin was on the brink of his independent career as an artist. He remained close to Larionov, and their collaboration had become a creative one. The Knave of Diamonds had endeavoured to represent the latest in Western developments; this was exemplified by the eagerness of David Burlyuk to exhibit in Russia recent art from Paris, Munich and Berlin. By contrast, the Donkey's Tail focussed its attentions further east and south. The Russian cultural identity, part European and part Asian, was illuminated by this contrast. Initially Tatlin was drawn to those who rejected Western developments, into the circle of Larionov, Goncharova, Malevich, Shevchenko, Chagall and others. Whilst their work remained Western in many respects, it chose none the less to seek its vitalitiy from Russia, its own distinct cultural traditions and priorities, and to re-examine its own *raison d'être* in the light of that contrast. This element of aloofness from the West, which endured a deluge of new tendencies and developments from France, Germany and Italy, permitted artists in Russia to examine with a degree of independence the nature of that creative force, its purpose and its products. For Tatlin this was of crucial importance. At the very moment of his emergence as an independent artist, he was acutely aware of the duality of Russian art, aware of Europe and of Asia, aware of the urban centres of art and those remote Kirghiz plains unforgettably evoked by Kuznetsov, aware of both sophisticated and erudite developments in art, yet involved in addition with the icon, with a revival of folk art and with wilful primitivism. From such an axial position Tatlin could examine cultural questions with breadth: his investigation was thorough and systematic. It is a sign of his achievement that he followed the implications of his study to their ultimate conclusions. Larionov had helped him to begin. His guide henceforth and increasingly was the poet Velimir Khlebnikov, whose own evolution combined publishing in the capital and Moscow with Asian meanderings close to his origins in Astrakhan. The nature of Khlebnikov's poetry was intimately concerned with Russian history as well as the rhythms and sounds of its Slavic language. No single figure could more thoroughly have woven Tatlin's creative work into an awareness of that aspect of Russia not part of Europe.

Tatlin and Larionov were soon to drift apart. Both were soon to be involved in a frank appraisal of art in Western Europe and both were to travel to Paris to develop their art further: the pendulum swung from East to West and back with regularity in

the two years before the First World War. Both Russian art itself and the Russian awareness of Western art were evolving rapidly.

At the height of his rayonnist phase Larionov again painted Tatlin (Colour Plate I). As in his earlier portrait of Tatlin the figure is half-length and seen frontally. The same stern gaze with its suggestion of morose distrust stares from the canvas, recognizably the same man despite the gulf which separates Larionov's earlier style from the crystalline cross-hatching evident here. The painter Nikolai Kulbin in 1910 had written of art as the philosopher's stone of the alchemists. He too was fascinated by crystalline form: 'In the crystal lies the very greatest symmetry, the utmost regularity of position. The salt crystal, a cube, is but one example of the great harmony. In it all edges, surfaces and angles are equal; all of its relations are exact.' He goes on to assert, 'We are cells in the body of the living Earth; we fulfil its wish but we do not all hear its voice. It is difficult, very difficult to read spontaneously the hieroglyphics of life or the structure of the crystal, of the flower or beautiful living animal.'[1]

The crystal which so preoccupied Kulbin in 1910 as an example of natural harmony is reflected in the rays and diagonals of contemporary paintings by Larionov and Goncharova. In Larionov's portrait of Tatlin the image emerges through a densely criss-crossing and crystalline structure. Lettering and numbers applied to the picture surface indicate at once an awareness of French cubism but echo too the hieroglyphics of life intuitively sought and referred to by Kulbin. When Larionov had written upon the surface of his soldier paintings, that scrawl was calligraphic by comparison with this lettering, which emulates without dissemblance the stencilled letters used by Braque and then Picasso from 1911. The lettering on this painting is significant. If the figures *28* refer to Tatlin's age, the painting would date from 1913. This is supported by comparison with drawings made by Larionov on themes associated with his *Seasons* paintings and with Khlebnikov's poem 'The Shaman and Venus' published in 1913 in *A Trap for Judges, No. 2*. The lettering 'BALDA' can refer to the word for a large hammer, but it is associated in a drawing by Larionov on the Shaman and Venus theme, where the letters occur in a sequence which may be unravelled by reference to the date on the drawing, which is also written out of sequence. Khlebnikov's poem is devoted to Buryat Mongol shamanism and in the Buryat Mongol language *balda* is associated with a shaman or priest. Larionov has perhaps identified Tatlin with the shaman of Khlebnikov's poem. Such exotic references are a frequent feature of Khlebnikov's poetry and it would not be extraordinary for Larionov to use them.[2] The lack of analytical modelling continues to distinguish the rayonnism of Larionov from imported cubism, however, although his subject's apparent 'condensation' from a larger and less distinctly visible surrounding form recalls attempts by Picasso to reconcile individual portraiture with the more generalized analysis of form integral to cubism. In Picasso's *Portrait of Vollard* the image of the sitter appears faceted as if glimpsed through a crystal, retaining in the larger proportions the placing of an academic portrait, yet shattered in details. It was a Russian collector, Shchukin, who bought Picasso's *Portrait of Vollard*: increasingly it was works seen in private collections that had an impact upon younger painters.

Tatlin's decision to forsake Larionov's group for a brief enrolment in Burlyuk's

25. Natalya Goncharova: Cover for A. Kruchenykh and V. Khlebnikov, *Worldbackwards*, Moscow, 1912. Collage 18.6 × 15 cm. British Library, London.

Knave of Diamonds in 1913 was a sign of his increasing independence. It is also an indication of Tatlin's awareness of paintings by French and German painters. Tatlin's links with the Burlyuk group grew simultaneously with those of Velimir Khlebnikov who began to collaborate with David Burlyuk, the poet Alexei Kruchenykh and the painter-poet Vladimir Mayakovsky in the Hylaea literary group in 1912. It was through such interlinked and fluctuating liaisons that Tatlin became the first illustrator of Khlebnikov's poetry (Plate 26), when *Worldbackwards*[3] was published in 1912 (Plate 25). In this volume, Larionov, Goncharova and Tatlin came together with the poets Kruchenykh and Khlebnikov. It is here that the significant collaboration of Tatlin with both painters and poets is made explicit and concrete. The volume also establishes a latest possible date for his introduction to Khlebnikov and his poetry.

Already in 1910 the publication *The Studio of the Impressionists*, edited by Nikolai Kulbin, and *A Trap for Judges* had prefigured the combination of literary and visual activities characteristic of the small publications associated with David Burlyuk,

Kamensky, Kruchenykh and Khlebnikov over the next few years. *A Trap for Judges* was printed on wallpaper and was aggressively visual. With *Worldbackwards*, handwritten text fused organically with accompanying drawings, especially in parts by Goncharova and Larionov.

Streetnoises, an illustration by Larionov for *Worldbackwards*, incorporates lettering reminiscent of stencilling, here associated with the image of horse and cart perhaps as a tradesign or slogan. Larionov's inclusion of musical staves, notes and key signatures predates its inclusion into cubist works by Picasso or Braque. In this lithograph the subject recalls that of Italian futurist painting. Rayonnism was partly compatible with the Italian futurist theory of lines of force and the interpenetration of images, but David Burlyuk at the second Knave of Diamonds debate at the Moscow Polytechnic Museum on 25 February 1912[4] had deprecated the work of the Italian futurists. Nevertheless, 1912 was the high point of the production of Italian futurist manifestos, an activity already underway for three years, and Italian futurist paintings were causing a stir in Paris. Many Russian artists, Exter for example, were regular visitors to Paris and it would have been extraordinary if Italian futurist ideas had not filtered to Moscow at the moment of their most active dissemination. The 1909–10 Russian Izdebsky Salon had included four works by Giacomo Balla. In June 1912 the second issue of the periodical issued by the Union of Youth translated Boccioni's *Technical Manifesto of Futurist Painting* of 11 April 1911. Larionov's depiction of *Streetnoises* may be a direct response to Boccioni's text.

Tatlin was drawn closer to the Union of Youth during 1912. In collaborating with Larionov and Goncharova at the time of *Worldbackwards* it is likely that Tatlin was familiar with their response to Italian futurism, for both the Larionov circle and the Union of Youth were well aware of Boccioni's ideas, as was Mayakovsky. Tatlin was a member of both circles. At the moment of gaining independence as a painter Tatlin was confronted with acutely diverse tendencies in art. If his interests remained thoroughly Russian in one direction, and his friendship with Khlebnikov consolidated this, nevertheless Tatlin was thoroughly up to date with recent developments in France and Italy.[5]

Tatlin's illustration to *Worldbackwards* (Plate 26) was closest in technique to Larionov's linear designs in the same book, in particular that on leaf 32 where Larionov depicted figures apparently slinking away from a battle (Plate 27). No horizon is indicated but the landscape and overhead projectiles are constructed from intersecting arcs that do not form closed planes. Tatlin's drawing, with its more explicit figures, has no clear horizon or floor line, but suggests a high viewpoint and schematically depicts an Arab doorway and perhaps a roof line at top left. One figure in Turkish dress falls beheaded; the other raises his sabre perhaps in victory, perhaps to strike again. Tatlin's drawing is rich in atmospheric suggestion: the Muslim arch, reduced to a minimum, the loose trousers, and the fez that each combatant wears set the scene precisely. The strict linearity of the drawing makes its impact dynamic. This belies its apparent slightness in which it resembles Larionov's drawing for leaf 32. More significant for Tatlin are the calligraphic elements from which his forms are built. They rarely add up to closed or solid forms and by their looseness convey much

26. Vladimir Tatlin: Illustration to a poem by Khlebnikov, from *Worldbackwards*, 1912, leaf 39. Lithograph, 18.6 × 15 cm, signed 'Tatlin V. E. 912g'. British Library, London.

27. Mikhail Larionov: Illustration from *Worldbackwards*, 1912, leaf 32. Lithograph, 18.6 × 15 cm. British Library, London.

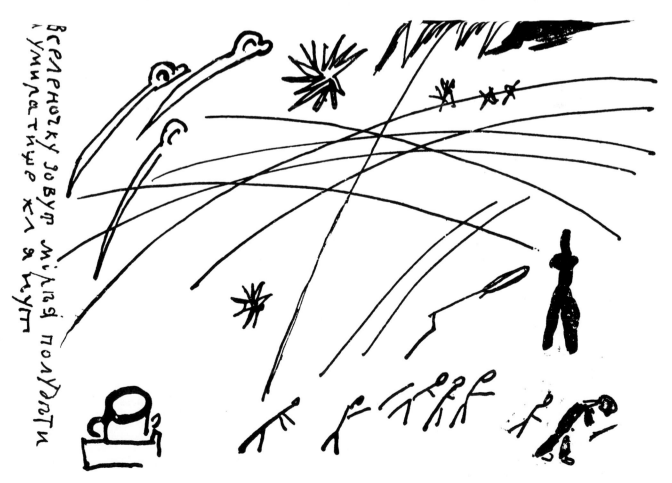

of the action. Elision is essential to this drawing. The Arab doorway suggests an entire palace by twelve or so lines. The attacking figure is furiously energetic without any substance or solidity. The severed head shows no lower edge. Tatlin's drawing appears slight but is radically edited to maximize dramatic and calligraphic effect. Only at the top right does Tatlin permit a denser congregation of lines, staccato diagonal dashes which shimmer with the furious movement of the sword. They mark the one point of rapid movement in the drawing, and explain the drama by doing so. Whether such dynamism derived from the crystalline intersections of Larionov, or more directly from the lines of force described by Boccioni, may be impossible to determine, for Tatlin has used the device so simply and effectively that, whilst his commitment to depicting movement cannot be doubted, it is impossible to detect explicit stylistic borrowings. This originality was a sign of Tatlin's strength. It never deserted him, for each undertaking was a new exploration. As long as Tatlin so ruthlessly stripped away all that was superfluous, there was no room for stylistic experiment or indulgence: every element had a place, a function and a purpose. Tatlin's investigations were committed to clarity and not to the adoption or promotion of a style.

Tatlin's first major display had illustrated this indeflectable vitality in the Donkey's Tail exhibition of March 1912. The influx of Italian futurist ideas can only have spurred on his investigation. The *Fishmonger* with its underlying structure of curving rhythms was amongst his exhibits; the *Sailor* (Plate 28), possibly a self-portrait, was also there. It permits a comparison with the standpoint of the Italian futurists and with the cubist borrowings that flavoured Larionov's portrait of Tatlin. It is at once clear that Tatlin's originality rejects overt borrowings. Tatlin, acutely aware of pictorial construction, locks his image into place relating it firmly to the canvas edges and the picture surface. The rhythmic curves relate directly to the edges of the painting and by their intersections build the image. This construction permits of little recession and Tatlin has emphasized this flatness in his handling of colour and in his flanking of the central head by figures made to appear more distant by scale only, but whose brushwork and position on the contrary recall them to the surface and defy all attempts to read them as distant figures in an illusionistic space. Tatlin's extraordinarily flat imagery makes the *Fishmonger* seem full of perspective. Compared with this *Sailor*, Larionov's portrait of Tatlin seems full of depth and flickering light, sculpturally firm in its modelling of chin, nose and eyes. Tatlin in his *Sailor* relinquished atmospheric effects for a tightly flattened surface, devoid of perspective, more calligraphic than modelled and almost wholly lacking in consistent chiaroscuro (see also Plate 29). Nevertheless, this is a vital painting. The severe means employed by Tatlin in removing superfluous detail have left an image of great clarity and strength in which alertness informs every mark. That energy, which ran so loosely through the fighting Turks of the *Worldbackwards* illustration, is now focussed upon a head of iconic rigidity. By contrast with the strength of Tatlin's *Sailor*, Larionov's portrait of Tatlin is vague and unresolved beyond the area of the face, whilst Tatlin's painting is nowhere vague and unresolved: his painting is thorough and complete, its rhythms continue decisively to the very corners without lessening of control or attention. Only in the icon was there a precedent for so emphatic a control of linear rhythms across

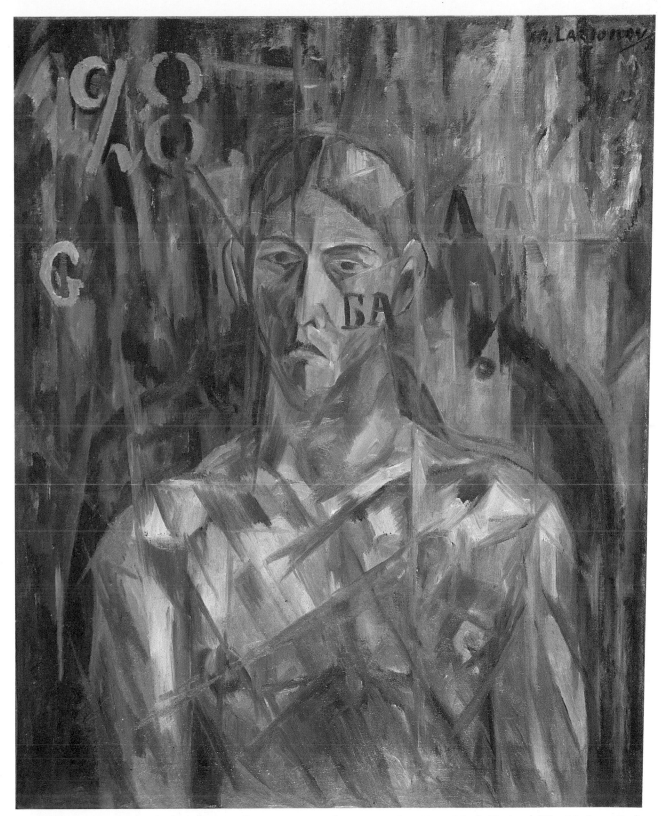

I. Mikhail Larionov: *Portrait of Vladimir Tatlin, c.* 1911–12. Oil on canvas, 90 × 72 cm. Musée National d'Art Moderne, Paris (Gift of Michel Seuphor).

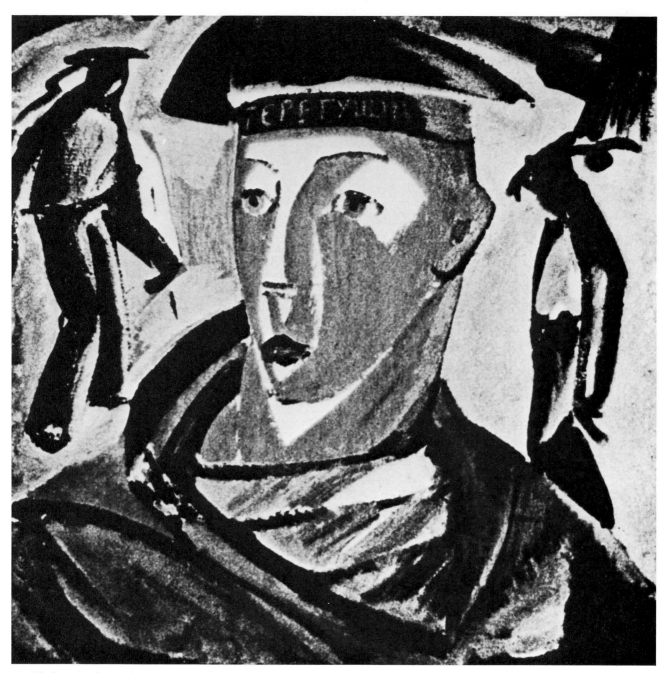

28. Vladimir Tatlin: *Sailor*, 1911–12. Oil on canvas, 71.5 × 71.5 cm. Russian Museum, Leningrad.

the picture surface. Although his theme related to daily life and thus echoed Larionov's soldiers or the peasant themes of Goncharova and Malevich, Tatlin was not easily reconciled to the primitivism of the Donkey's Tail group. But Tatlin did share their desire for a distinctly Russian inspiration. Tatlin found in Byzantine traditions a sophisticated means of pictorial construction that emphasized both the materials employed and the means by which they were manipulated. Tatlin continued to look

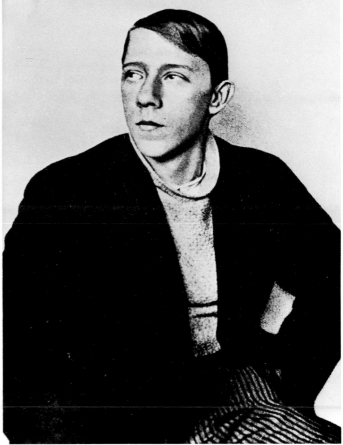

29. Vladimir Tatlin: *Sailor*, 1912. Lithograph, 14.5 × 9.5 cm, signed in the stone 'TATLIN'. Collection Thomas P. Whitney, Connecticut. Published as a postcard by A. Kruchenykh.

30. Vladimir Tatlin, *c.* 1912–13. State Mayakovsky Museum, Moscow. [Photograph Novosti Press Agency (APN), London.]

as much to the East as to the West, as much to the icon as to Picasso. The small flanking figures against a flat ground, the geometrical structure and even the square format of the painting recall icon painting, a tendency confirmed by the strict distinction of colours. Here Tatlin keeps blue and yellow distinct, unmixed and separate: the icon painter practised such separation through the necessity of preparing each colour from separate pigments. Tatlin continues this practice despite the possibility of easily mixing his pigments. As a result the edge or boundary of a colour is emphasized and made to carry an expressive rhythm. There could be no fading to a convenient and foggy background. In this firmly structured painting the highlights on the face and larger marks reflect the underlying rhythm of arcs and curves around the eyes, rhythms that circle out to the corners of the painting. It has been suggested that the portrait is of Tatlin himself. A photograph of Tatlin (Plate 30) in precisely this pose tends to confirm this, although the iconic remoteness of the figure in the painting and Tatlin's newly evolved geometrical construction would both tend to play down any likeness.

Tatlin's exploration of the icon brought Tatlin to conclusions curiously compatible with aspects of Parisian cubism. A flattened picture surface, an elaborate pictorial structure to which imagery was subsidiary, and the separation of colours, all con-

41

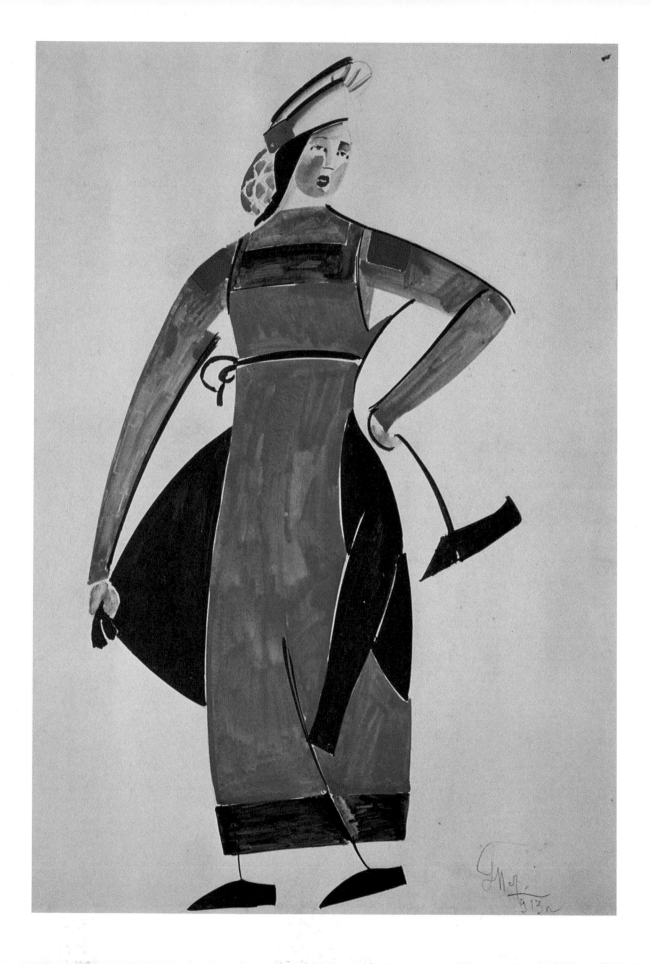

31. Vladimir Tatlin·
Flowers, 1912. Oil on
canvas, 93 × 48 cm.
Tretyakov Gallery, Moscow.

cerned the cubists as much as Tatlin. Yet Tatlin brings other strengths: all illusionistic recession gone, no need arises for the enigmatic and contradictory chiaroscuro of cubism. The impact of the icon was driven home in 1913 when an enormous exhibition of icons was held in Moscow in celebration of the Romanov dynasty.

'From 1912,' wrote Tatlin, 'the members of my profession found it necessary to improve their eyes.'[6] A new pictorial and visual discipline was at work but its evolution was not independent of poetry. On 20 November 1912 at a Union of Youth meeting Vladimir Mayakovsky, both painter and poet as was Burlyuk, discussed analogous ways of constructing the artwork in visual and verbal media.[7]

During 1912 Tatlin began to move away from Larionov's immediate entourage and to develop independently. His friendship with Larionov and Goncharova became less important for his art (Plate 31). Contact with Malevich continued despite an increasing sense of competition between them. The Union of Youth was a less personal organization than had been Larionov's circle or indeed the Knave of Diamonds. Furthermore its activities were wide-ranging and included a periodical publication as well as exhibitions. On 17 December 1912 Tatlin helped stage a theatrical production for the

43

II. Vladimir Tatlin: *Peasant Girl*, costume design for the opera *Ivan Susanin* by Glinka, 1913. Watercolour on paper, 46 × 29 cm, signed in pencil lower right. Collection Mr and Mrs N. D. Lovanov-Rostovsky, London

Union of Youth.[8] On 3 January 1913 he was accepted as a member of the Union of Youth together with V. D. Bubnova and A. A. Morgunov.

Tatlin's move was made in an atmosphere of feverish activity amongst painters and poets known to him, most of whom were also associated with the Union of Youth. Early in 1913 and coincidental with Tatlin's joining the Union of Youth, a manifesto appeared printed on wrapping paper, bound in a sacking cover and bearing the title *A Slap in the Face of Public Taste*.[9] It was unillustrated, but in common with earlier publications by Burlyuk and Kruchenykh showed a dual concern for both painting and writing, a concern to discover a common basis for both modes of creative activity. Aggressively modern, it called for Pushkin, Dostoevsky and Tolstoy to be 'thrown overboard from the steamer of Modernity'. The poets' right to invent new words was defended, and the 'new nascent beauty' announced 'of the self-sufficient Word'.[10] The manifesto was signed by Mayakovsky, David Burlyuk, Khlebnikov and Kruchenykh. Eight poems by Khlebnikov were included and a poem by Kruchenykh in which wrong stresses were indicated, there were no capital letters and the sequence of the events was interrupted so as to occur in the format third part, first part, second part. Amongst the book's concluding essays David Burlyuk's two articles discussed the significance of cubism and *faktura*. He recognized the importance of Cézanne but continued by describing cubist painting in terms unfamiliar in Paris but important in Russia. According to Burlyuk, writing at the end of 1912, cubism had augmented the visual language of line and colour by two new elements: *surface* and *texture*. He used the words *sdvig* (shift) and *faktura* (handling), the first implying passage across the painting, and the second indicating those signs showing how the material of the paint has been manipulated. The Impressionists had given brushwork a structural role within the build-up of their picture surface. Burlyuk discussed this phenomenon in Monet's waterlily paintings and its integral role in Cézanne's compositions. From this moment forward the concept of *faktura* was central to much of Russian art theory and practice. *Faktura* showed the process of working the material, revealing the nature of that material, making it a structural element within the created object, be it painting, sculpture, poem, film or whatever. *Faktura* was not pattern and was not synonymous with texture: it was the handling of material left evident. Cézanne exemplified this process of building up a painting. Picasso and Braque appeared to extend his discoveries.

An increased awareness of material factors lay behind these developments amongst both painters and poets. The concept of *faktura* and its attendant awareness of materials evolved in visual and in verbal activities simultaneously, for words too have a material existence as well as a meaning to which they refer. This was as much a cornerstone of Khlebnikov's poetry as it was of Tatlin's work. Khlebnikov manipulated words' structure and sound in new ways, seeking to work upon the roots of words. His essay 'A Sample of New Word-Making in the Language'[11] concluded this manifesto volume. The stress upon verbal material was firm, and Khlebnikov's poems revealed the process in action. Their reliance upon strict control of sound makes them close to impossible to translate. In 'Turnaround', published in 1913, for example, each line is a palindrome that can be read from left to right or right to left. The first line,

44

meaning 'Horses, trampling, a monk', is spelt *Koni, topot, inok*. Structure and sound take precedence over description and meaning.[12]

A Slap in the Face of Public Taste presented another facet of Khlebnikov's poetry and a concept of importance for Tatlin. Khlebnikov's training had encompassed the most diverse activities from bird-watching in Astrakhan, a linguistic study of Sanskrit and of Slavic languages to modern mathematical theory in addition to literary theory. For Khlebnikov the study of words was the basis of his poetry; this in turn was inseparable from a sense of human history. Khlebnikov suspected that in language lay hidden great secrets concerning human evolution and identity. For Khlebnikov the study of poetry moved hand in hand with etymology and with history. In *A Slap in the Face of Public Taste* this curious synthesis begins to emerge in print. Khlebnikov was convinced that history had mathematical laws and that rhythmic waves passed through the vast mass of human activity. The first of his studies of dates was published in this book of manifestos, showing how multiples of years separated in time the fall of empires. 'Some-one 1917' was the last line of his list; in four years his prophesy was fulfilled.

The mutual friendship of Tatlin, Khlebnikov and Larionov may throw retrospective light upon Larionov's portrait of Tatlin (Colour Plate I)[13] in which the figure *28* occupies the top left corner of the canvas: for Khlebnikov, *28* was a number signifying personal destiny in his analysis of dates, just as 365 years was the length of a historic wave or hyper-year, a rhythm, according to Khlebnikov, that influenced events of the widest human significance. The letters and figures in Larionov's painting should be seen with poetic and temporal theories in mind, for they were of growing importance to Tatlin, to Khlebnikov and to many who studied their example. Larionov's shifting, crystalline planes suggested movement in time as well as movement in space.

Tatlin's painting the *Sailor* (Plate 28)[14] makes evident use of *faktura*, revealing in this painting all the brushwork so that his viewer is aware of his handling. By 1911 Tatlin had evolved a new method of putting his painting together. Its taut rhythms are minutely controlled by circular arcs derived from the overall square of the canvas. This, for Tatlin, has become the *material* of his art, and his composition does not emerge solely as a result of aesthetic decisions; geometrical relations construct his image across the canvas. A compass placed at the top right corner, drawing a circular curve from top left to bottom right passes along the front edge of the sailor's tunic. Precisely the same curve is employed throughout the painting from centres beyond its edge to provide every other arc of importance in the work. A single curve repeated and related in scale to the overall canvas whose edge is its radius, supplies the unit element for the whole painting, leaving it dynamic, rhythmic and utterly flat.

Tatlin allowed no more than token indications of illusionistic space. His painting was built up from a repeated element, and a geometric one at that; Tatlin was no longer composing but constructing. With aesthetic decisions held in check, a new and vigorously rhythmic system was evolved.

That such a system is compatible with cubism can be illustrated with relation to works by Picasso held in Russian collections by 1912 and by a consideration of Tatlin's studies, both drawings and paintings, from the life model. Two drawing

45

books preserved from Tatlin's Moscow studio at 37 Ostozhenko reveal precisely this approach. Certain of the drawings are closely observed studies from the life, whilst others are more loosely drawn, and certain are clearly constructed by means similar to those used for the *Sailor*. The sketchbooks contain drawings from 1909 to 1914. They reveal the shifts and developments of Tatlin's evolution of a new pictorial structure and his simultaneous response to cubist ideas.

Closely observed drawings perhaps of 1911–13 (Plates 32–7) show figures in many life-room poses, occasionally employing a rhythmic *contraposto*. Cross-hatching is applied to throw figures into relief and to suggest a consistent light source. Despite simplifications of the figure, Tatlin is concerned to reveal the structure of the figure through observation, pose and chiaroscuro.

One figure drawing (Plate 35) reveals a continuing and astute perception of structure but is more summary and superbly rhythmic. No identity is given to the model, but the weight and stance are faithfully depicted. The head and arms are reduced to a few lines. Heavier drawing stresses the legs and back of the torso. This is a perceptive

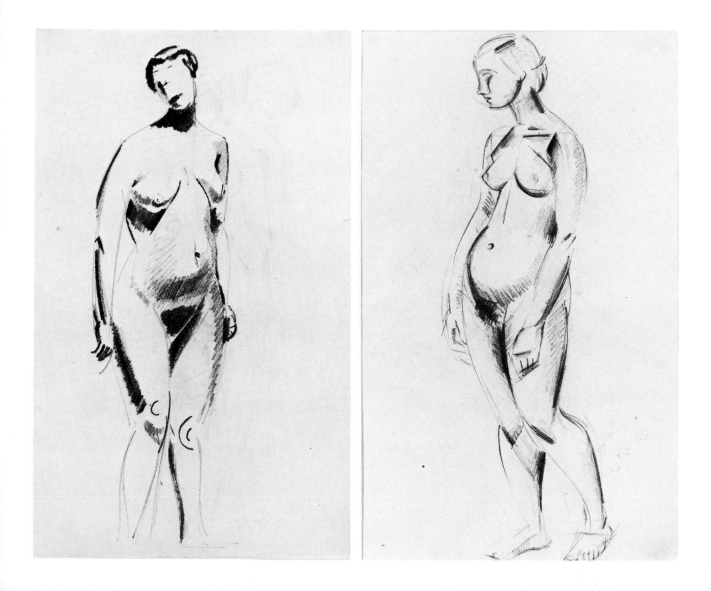

drawing in which the artist is acutely aware not only of looking at the model and recording impressions, but also of the process of making the drawing as a special kind of object. All extraneous detail is excluded. Tatlin, with a faultless sense of proportion, uses circular curves to draw parts of the figure. The line of the figure's right arm is the arc of a circle precise enough to have been drawn by compasses centred off the left edge of the page. The right hand is a semi-circle and the adjacent forearm is the arc of a larger circle. Finally a far longer arc descends from the left shoulder to left foot. Although this has been adjusted and modified, its rhythmic and structural purpose is clear. That Tatlin can so convincingly have manipulated the figure by these means is an impressive testament to the thoroughness of his life drawing and his familiarity with such ostensibly intractable means of working. The small geometric figure who inhabited the gothic hall of Tatlin's design for *Tsar Maximilian* of 1911 (Plate 20) was an early sign of a complex system evolving.

Such a process, particularly when applied to life drawing, is synthetic. It brings together the conflicting demands of perception of the model and construction of the

32. Vladimir Tatlin: *Nude, c.* 1911–13. Pencil on paper, 42.8 × 25.8 cm. Collection George Costakis, Athens. [Illustration © George Costakis 1981.]

33. Vladimir Tatlin: *Standing Nude*, 1912–14. Pencil on paper, 33 × 22 cm. Collection Thomas P. Whitney, Connecticut.

34. Vladimir Tatlin: *Nude, c.* 1913. Pencil on paper, 22 × 17.2 cm. Collection George Costakis, Athens. [Illustration © George Costakis 1981.]

drawing. Tatlin establishes various points of balance between an academic naturalism guided by perception, and a severe sense of geometry that dominates his arrangement of marks upon the page. Drawings from the sketchbooks (Plates 36–7) reveal the nature of this synthesis. In one drawing (Plate 36) the model is seen from the front, with one elbow raised whilst her other arm crosses diagonally in front of her. Shading is used to clarify the modelling, especially at the complex point beneath the arm and by the model's waist. Elsewhere such shading is less consistent and that on the neck recalls the inconsistent chiaroscuro of Picasso's analytical cubist paintings. On the raised arm chiaroscuro is minimal, with only one edge of the arm depicted. The emphatic lines along the breasts and thighs, in function more rhythmic than descriptive, become the elemental marks from which Tatlin constructs his figure.

These drawings reveal the conflict of observation and construction. It was a living consideration within contemporary cubist painting too, and, even though Tatlin's imagery is here completely legible, it is reasonable to suppose that Tatlin might turn to cubist painting to discover how Picasso, Braque and their contemporaries had resolved these problems. If in Tatlin's drawing the shading of the neck recalls Picasso,

35. Vladimir Tatlin: *Standing Nude seen from behind*, c. 1912. Pencil on paper, 43 × 26 cm. Central State Archive of Literature and Art, Moscow. Sheet 25 (obverse) of an album of drawings.

36. Vladimir Tatlin: *Standing Female Nude*, c. 1912. Pencil on paper, 43 × 26 cm. Central State Archive of Literature and Art, Moscow. Sheet 62 of an album of drawings.

37. Vladimir Tatlin: *Seated Female Nude*, c. 1912. Charcoal on paper, 43 × 26 cm. Central State Archive of Literature and Art, Moscow. Sheet 74 of an album of drawings.

a comparable painting further indicates a response to early cubist painting and suggests how the conflict between depiction and construction was resolved.

Tatlin's *Reclining Nude* of 1912–13 (Plate 38) is close in its modelling to the drawing (Plate 36) discussed from the sketchbooks. Vigorous lighting gives roundness to the limbs and describes the neck. The model has no facial features and, as a result of this, the painter can be less concerned with the minutiae of observation and perception. Furthermore the source of light is not consistent: both the upper ridge of her hip and of her nearer arm are in shadow, yet her lower thigh is shaded underneath. Her hands and feet, as much as her head, are reduced to a few curves and are severely stylized. The planes that comprise her lock her rhythmically into the swooping curves of the florid background material and the folds of material upon which she lies. The material is lavishly decorative, recalling both the World of Art and Matisse, who had been in Moscow in November 1911 on Shchukin's invitation. The particular stylization of foot and leg seems further to recall Matisse's simplifications in the major decorations executed for Shchukin. Yet the repeated curve of the foreground cloth has precedents in cubism as does the firmly modelled yet inconsistent lighting. Russian collections

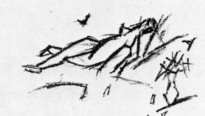

38. Vladimir Tatlin: *Reclining Nude, c.* 1913. Oil on canvas, 106 × 142 cm. Central State Archive of Literature and Art, Moscow.

39. Mikhail Larionov: *Reclining Nude*, from A. Kruchenykh, *Old Time Love*, Moscow, 1912, p. 1. Lithograph, 14.5 × 9.7 cm. British Library, London.

40. Vassily Kamensky: Ferro-concrete poem 'Shchukin', from V. and D. Burlyuk, *Tango with Cows*, Moscow, 1914. 19.7 × 19.7 cm. Circling around 'Shchukin Palace' are references to his collection of paintings by Cézanne, Monet, Picasso, Gauguin, Van Gogh, Pissarro, Le Fauconnier, Denis, Derain, Meunier and Matisse.

showed Matisse and Picasso to superb effect (Plate 40). An intermingling of impressions is not surprising. For Tatlin such an impetus was, characteristically, more than stylistic influence, for it functioned to provoke and assist his own exploration of pictorial structure.

Tatlin has achieved a vigorous modelling of the limbs whilst suppressing any suggestion of a deeply receding picture space. The figure leans almost against the edge of the painting, her toe all but touching its furthest corner. The florid curtain is so full of vitality that its pattern pushes forward and does not hold its place behind the figure. This *Reclining Nude* is less rigorous or complete than the *Sailor*, yet it reveals an exploration of new techniques, to give a dense, shallow picture space with a maximum of rhythmic coherence. Such considerations stress the constructing of the painting and relegate to subsidiary importance elements of observation and depiction. In the *Reclining Nude* the curtains hang in arcs that comprise almost precisely the arcs of a circle whose radius is the height of his canvas. Here too Tatlin permits a material feature of his canvas to determine the rhythms employed across it.

During 1913 Russian awareness of cubist and Italian futurist aims and achievements became acute, finding a response amongst almost all of Tatlin's immediate colleagues. The rayonnism of Larionov and of Goncharova came to reflect aspects of cubism, as Larionov's portrait of Tatlin revealed. In that work the figure was static, whilst in many rayonnist works vibrant movement is depicted more in keeping with the percolation of Italian futurist principles into Russia during 1912 and 1913. Larionov's dating is difficult to establish, but the small books of verse published by Kruchenykh and Khlebnikov illustrated by Larionov, Goncharova and Tatlin in 1912 indicated a similarity between, for example, Larionov's *Streetnoises* and a work like Boccioni's *Noises of the Street*, as suggested earlier. On the other hand, Larionov already in 1912 had begun to turn to the depiction, sometimes primitive and sometimes rayonnist, of classicizing or academic pictorial themes, handling them with robust and enthusiastic disrespect. In *Old Time Love*,[15] a thin volume published in October 1912 in which Larionov illustrated hand-written poems by Alexei Kruchenykh, page one (Plate 39) depicts a reclining nude who gazes upon a vase of flowers whilst butterflies hover in the air. The stylization of this figure is a mixture of primitive simplification and rayonnist faceting. Her pose is traditional and, less specific than life drawing, she is a Venus, an Olympia or an odalisque, creatures not far removed from that classicizing element so evident in recent works by Matisse.[16] The pose is closely comparable to that of the nude depicted by Tatlin and is likely to be contemporary with it. There too it is possible that Matisse provided a degree of inspiration, yet Tatlin's figure is more specifically a life painting than is Larionov's small figure. This close comparison reveals how far Tatlin remained from the radical readjustment of the figure seen in the drawings and paintings of Larionov. Tatlin's pictorial structure was not dynamic in the explosive manner used by Larionov where lines radiated into empty space out from the image, but exhibited a rhythmic order determined as much by the canvas edge and its proportions as by the image it contained. The explosive force of Larionov's rayonnism was closer in spirit to the lines of force described in Italian futurist manifestos, whilst Tatlin's rigidly controlled canvases remained indebted to the

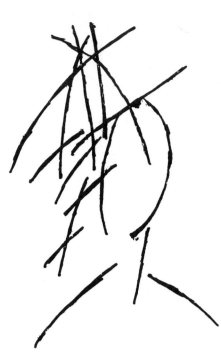

41. Mikhail Larionov: *Lady with a Hat*, from A. Kruchenykh, *Pomade*, Moscow, 1913. Lithograph, 14.9 × 10.5 cm. British Library, London.

42. Vladimir Tatlin: *Forest*, set design for the opera *Ivan Susanin* by Glinka, 1913–14. Gum paints on card, 54 × 95 cm. Tretyakov Gallery, Moscow.

disciplines of icon painting with its emphasis upon a clearly subdivided picture surface.

The dichotomy between rayonnist and primitivist tendencies in Larionov's work was not resolved in 1913. The book *Pomade* (Pomada), published in January 1913, bore on its cover a primitive putto descending on rudimentary wings to deliver a wreath, whilst in *Lady with a Hat* (Plate 41), in the same booklet, Larionov removes his image to the limits of legibility, employing only a criss-crossing of openwork strokes, much looser than Tatlin's yet pointing none the less to a similarity of technique.

Despite their involvement with other groups of painters, Larionov and Tatlin both exhibited at the World of Art exhibition in 1913. Larionov contributed rayonnist works and Tatlin showed costume and set designs as well as maquettes for the opera by M. I. Glinka *Ivan Susanin* or the *Life of the Tsar*, a production for which Tatlin hoped his designs would be accepted but which was never realized. The importance attached by Tatlin to this project is emphasized by the large number of studies executed. He exhibited a further selection at the World of Art exhibition of 1914, approaching the project with the utmost thoroughness and involvement. The theatre was a fruitful area of activity throughout his life. It is significant that when he was most involved with the analysis of pictorial structure, he was nevertheless committed to stage design. A number of Tatlin's designs were completed as paintings and have outlived their connexion with Glinka or the theatre. The *Forest* (Plate 42) is amongst these. It is as deeply atmospheric as the *Hall in the Castle* design for *Tsar Maximilian*. The gloom of densely overlapping trees is unbroken even by leaves. Great columns of trees rise and arch impenetrably thick to the very top of the painting or proscenium arch, dwarfing the cloaked figure who stands with his staff isolated in the direction-less maze that confronts him. Such a wealth of atmosphere indicates the potency of Tatlin's imagination and it must not be discounted in considering his more austere

52

and material-oriented investigations. Tatlin was deeply involved with poets and with their imagery. He had in addition a musical predilection evident in many of the photographs of him which portray him with his *bandura*, the Ukrainian folk instrument resembling a large mandolin. His imagination was lyrical as well as methodical. The atmospheric resonance of the *Forest* is not at odds with geometrical construction, for compasses and ruler are much in use even where the practicalities of constructing stage sets must be considered. The mood is as lugubrious as any symbolist design twenty years earlier for a production of *Pelléas and Mélissande* could have made it. By using the discoveries of his own most recent paintings, by revealing his material and his handling of it, its *faktura*, by constructing from linear elements, employing almost exclusively intersecting arcs and straight lines, Tatlin has evoked a magical and exotic scene that is thoroughly theatrical and painterly. Only the funereal rhythm of the towering trees masks the vitality necessary to achieve this. A set design for *Ivan Susanin*, formerly in the Costakis Collection, now in the Tretyakov Gallery, makes this at once apparent. As florid and full-blown as a Bakst or Benois, with that decorative vigour characteristic of the World of Art, which Diaghilev dominated and to which Tatlin contributed in 1913 and 1914, the warm decorations are here held in place by a rigid but rhythmic series of divisions rising through the set. The exact geometrical centre is cut by a vertical straight line to either side of which arcs suggest barrel vaults and archways sumptuously decorated with floral designs. In this respect the design is rich in illusionistic space, yet its articulation of the flat picture surface is rigorously maintained. The *Forest* set was comparably divided through the centre, and in both, the borderline between theatre design and painting was scarcely recognized, provoking an analogy between pictorial space and the restricted actual space of the stage. The models constructed by Tatlin for this project must have further explored their common ground.

53

Tatlin's set is full of a distinctly Russian flavour and vitality. Only later do sets and costumes by Goncharova or Larionov attain this vigour where severity and generosity are brilliantly combined. The example of Matisse was perhaps still felt; Mattisse's paintings in Russia reflected Russian taste in the weight and fullness of their decorative qualities, easing their assimilation into Russian cultural development, whose past left halls decorated with devices of comparable lavishness.

In its real space the stage could offer actual movement whilst in painting this remained suggested. Theatrical designs, however complete in themselves, promised movement and development on stage (see Plate 43). Tatlin's figures enter left with geometric precision, dressed in rich scarlet, white and black. In their designs geometry prevails. Just as in the *Forest* Tatlin devised his sets for practicality as well as atmosphere. Florid decorations were to fill the top half of the stage leaving severe blank walls below against whose angularity the small richly coloured figures would clearly be seen whenever they moved on stage.

Costume designs, however geometric, lose nothing of their ethnic flavour, and Tatlin's designs for this project are part of that search for a distinctly Russian art (Plates 43–9, Colour Plate II). The primitivism pioneered by Larionov has, surprisingly, given way to decoration of the kind that characterized the use of traditional and folk motifs by Golovin, Benois, Bakst and Rerikh, painter-theatrical designers of the World of Art, and prime contributors to the first wave of Ballets Russes success in Paris in Stravinsky's *Firebird* (1910, choreography Fokine, décor Golovin and Bakst),

43–7. Vladimir Tatlin: Costume designs for the opera *Ivan Susanin* by Glinka. Whereabouts unknown.

43. *Group of Soldiers*, 1913. Watercolour and ink on paper, signed and dated lower right.

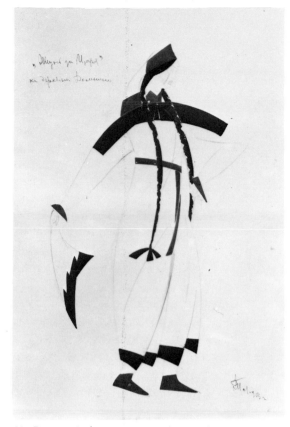

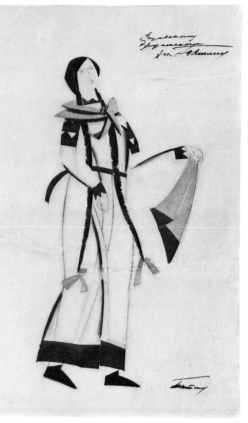

44. *Peasant Girl*, 1913. Watercolour and ink on paper, signed and dated lower right, inscribed 'Life of the Tsar' top left.

46. *Man with a Sword*, 1913. Watercolour and ink on paper, signed and dated lower left, inscribed 'Life of the Tsar' upper right.

45. *Peasant Girl*, 1913–14. Watercolour and ink on paper, signed lower right and dedicated, perhaps as a gift, upper right with the date 3 February 1929.

47. *Peasant Girl*, 1913. Watercolour and ink on paper, signed and dated lower left, inscribed 'Life of the Tsar' upper right.

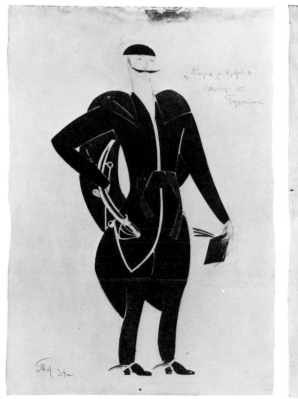

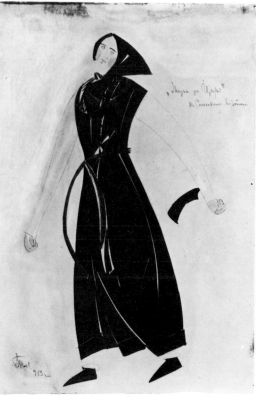

Petrushka (1911, choreography Fokine, décor Bakst) and, in May 1913, the *Rite of Spring* choreographed by Vaclav Nijinsky with décor and costumes by Nikolai Rerikh.

In view of Tatlin's increased involvement in theatrical design and his links with the World of Art, the national and folk art flavour of his designs must be seen against contemporary developments in the Ballets Russes. By 1913 Russian art had gained enormously in confidence and had begun to venture west. Tatlin was to follow this trend. Diaghilev's Ballets Russes ensured that these journeys west were no mere pilgrimage. By 1913 Russian artists were increasingly in evidence in Paris, in the midst of theatrical and musical life, and at the heart of developments in painting and sculpture, cubism especially. Tatlin's visit west was in homage, but not to a totally foreign citadel of culture. The vision of Russian art growing there owed much to Sergei Diaghilev, but its spirit was, in 1913, already alive in Tatlin's theatrical designs in Russia. By the following year Goncharova and Larionov were both at work in Paris on the Ballets Russes' *Le Coq d'or* (Plate 50). Tatlin's designs for *Ivan Susanin* were shown once more at the World of Art exhibition in St Petersburg that year. They were no less vital than those with which Larionov and Goncharova ushered in a new phase of Ballets Russes success. They reveal that Tatlin's links could scarcely have been closer.

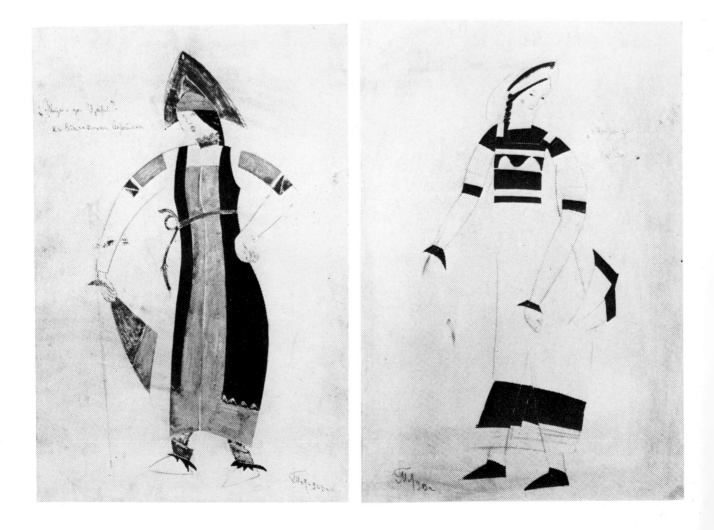

More than the designs of Larionov or Goncharova in 1913, Tatlin relied upon geometrical foundations now evident in most of his work, a structural geometry devised to articulate utterly flat and two-dimensional picture space. His costume designs are no exception. Costumes for Russian girls are largely composed with ruler and compasses (Plates 48–9). The arms reveal this most obviously, for the curves of the shoulders are built on circular arcs. Their figures are constructed from geometrical pieces and resolutely adhere to the flattest pictorial space. His drawings are no less decorative for this, and no less explicit as designs from which a costume maker might need to work.

In these works the balance between observation and construction is tipped heavily towards the latter. His figure drawings trace this shift from observation to pictorial structure. It marked a new awareness of the painting's flat surface, and the particular demands of its rhythmic organization over and above the less ordered world of visual observation.

Tatlin had joined the Union of Youth at the start of 1913. When the third issue of its journal appeared in March 1913 he could recognize in an article by the painter Olga Rozanova criteria applicable to his paintings. The essay was entitled 'The Bases of the New Creativity and Why it is not Understood':

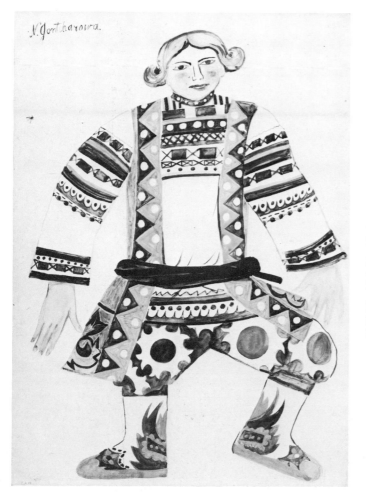

48. Vladimir Tatlin: *Girl in a Red Sarafan Dress*, costume design for *Ivan Susanin*, 1913–14. Watercolour and pencil on paper, 46.8 × 32.3 cm. Leningrad State Theatre Museum.

49. Vladimir Tatlin: *Russian Girl*, costume design for *Ivan Susanin*, 1913–14. Watercolour and pencil on paper, 46.8 × 32 cm. Leningrad State Theatre Museum.

50. Natalya Goncharova: *Russian Peasant with Embroidered Clothes*, costume design for the ballet *Le Coq d'or* by Rimsky-Korsakov, 1914. Watercolour and gouache on paper, 38 × 27 cm. Victoria and Albert Museum, London. Performed by the Ballets Russes directed by Diaghilev at the Théâtre de L'Odéon, Paris.

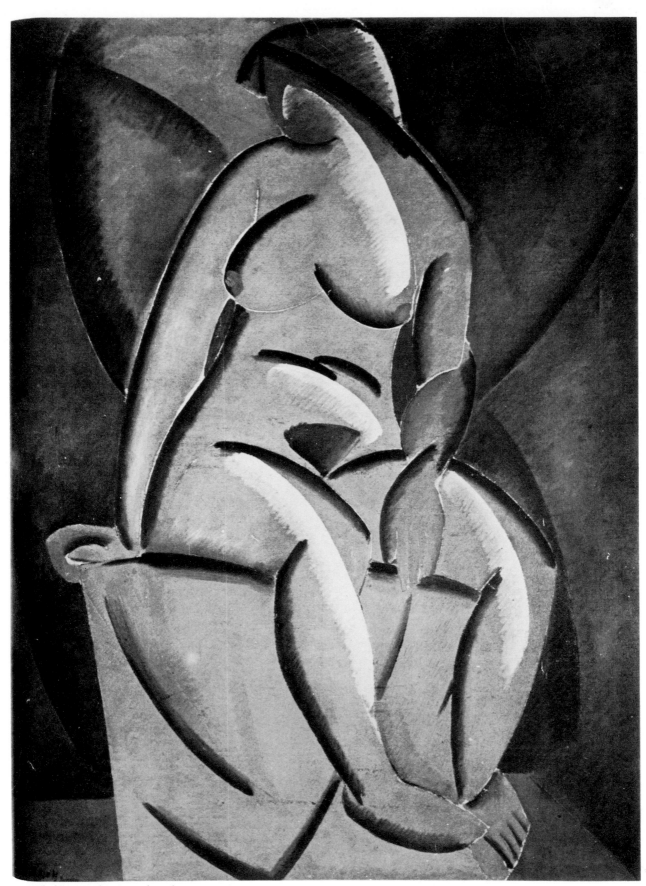

51. Vladimir Tatlin: *Seated Nude*, 1913. Oil on canvas, 143 × 108 cm. Tretyakov Gallery, Moscow.

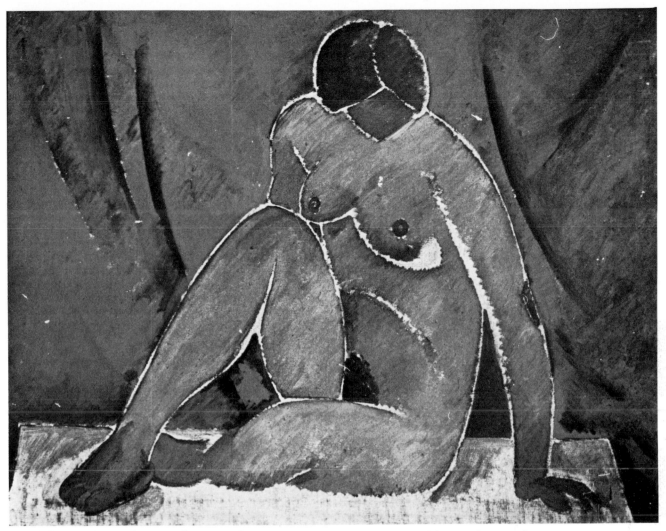

52. Vladimir Tatlin: *Reclining Nude*, 1913. Oil on canvas, 104.5 × 130.5 cm. Russian Museum, Leningrad.

The artist only fully consciously creates the painting when he does not copy nature, when he subordinates initial impressions of it to those informed by the whole psychology of modern creative thinking: what the artist sees, plus what he knows, plus what he understands and so on. The result of this awareness in the execution of a canvas is that through working constructively the artist brings into play the most important single consideration of all—the internal demands of the painting.[17]

The distinction between observing the visual world and constructing visual objects had become a recurrent dichotomy in Tatlin's painting and drawing by 1912. Works of the next year confirmed this but showed Tatlin increasingly concerned with the creation of the painting according to its own characteristics and demands. Rhythm and proportion, an underlying geometry, the materials employed and *faktura*, the handling of these materials, were integral to this process. As Tatlin grew less concerned with observation and the recording of visual impressions, his art became an investigation, in visual terms, of the process of creativity. More in fact than Rozanova,

59

Tatlin was able to concentrate consciously upon material questions without becoming less creative. When Tatlin left Russia in 1913 for Berlin and Paris, his painting was already of impressive maturity and originality. It exemplified to an unprecedented degree what Rozanova put into words. For Tatlin the internal demands of the artwork were of paramount importance.

The large *Seated Nude* (Plate 51) of 1913 reveals his achievement at the time of his departure, and a further horizontal work (Plate 52) echoes its linear completeness. In earth-pigment equivalents of primary colours, Tatlin's seated female model embodies a completely controlled sequence of curvilinear rhythms. Her anonymity and the stylization of her face, hands and feet confirm that here construction takes precedence over observation, and that it is the demands of the painting which prevail above the particular characteristics of the model. Behind the figure, suggestions of arcs follow the same circular curve and do not comprise an explicit image. The figure too is dominated by curves. Colours, kept separate, reduce suggestions of illusion and *trompe l'œil*. Similarly light and shade, though consistent (light falls from top left), are devoid of intermediary tones so that any sense of relief or of rounded forms is counteracted by a starkness that breaks up the solidity of the figure. The legs in particular appear opened up to the space around them, no longer closed forms. Rhythmically the model extends beyond her silhouette, her curves echoing as far as the corners of the painting. The handling is rough and dry with only minimal mixing of one area of painting into another, employing in preference a cross-hatching technique readily visible along the arc to the left of the model's seat. By this means and by its texture the material of the paint is emphasized and its power to evoke illusions suppressed.

Tatlin's closeness to the Union of Youth before leaving Russia lies in this firm articulation of the picture surface and his rhythmic control to which every detail is subordinated. Tatlin is elemental and strong; in his paintings there is nothing superfluous. Control is exerted to the edges of the canvas, to the least parts of the image and in every rhythmic suggestion.

52a. Vladimir Tatlin: *Tavern Scene*, 1912–13. Lithograph, 16 × 18.5 cm. Collection Thomas P. Whitney, Connecticut.

52b. Vladimir Tatlin: *Café Scene*, 1912–13. Lithograph, 17.5 × 19 cm. Collection Thomas P. Whitney, Connecticut.

3 THE IMPACT OF THE WEST

Tatlin's position before leaving Russia in 1913 was that of a sophisticated painter well aware of aspects both of cubism and of Italian futurism, but this awareness had grown alongside a more powerful and immediate framework of theory and practice evolved entirely within Russia. There was in particular no equivalent in the West of the extraordinary poetry of Velimir Khlebnikov. Whilst Apollinaire and Marinetti were writing shaped poems with varied typography, paralleled in Russia by Zdanevich and Kamensky (Plate 53), the poetry of Khlebnikov was quite unique, involving an unprecedented synthesis of etymology, history, mathematics and the study of migrating birds.

Simultaneous with the Western influences of cubism and Italian futurism, Tatlin's immediate circle was developing a compatible theoretical framework that was nevertheless distinctly Russian and the result of thorough cooperation between painters and poets. The Union of Youth and the Russian futurist anthologies that flourished in the period 1912–14 indicate the fruitfulness of this cooperation. Whilst cubist elements are occasionally evident in these books, their originality and independent daring must not be underrated, for nothing like them existed in the West. Malevich, Tatlin, Rozanova, Larionov and many others worked closely with the poets Kruchenykh, Khlebnikov, Kamensky and Guro.[1] Painter-poets, in particular David Burlyuk and Vladimir Mayakovsky, were central figures in these activities.

For Tatlin the visual artist embarking upon a journey to the West, the visual achievements and innovations of cubism were of the utmost interest. His determination to seek out Picasso makes this clear. But it is essential to recognize in addition the diversity of his interests, the closeness of his association with poets as well as painters, and the extent to which his own work was in line with cultural theories current within the Union of Youth and poetic circles familiar to Tatlin at the time of his departure. Certain of these criteria could be and were applied to cubism. Khlebnikov was a central and generative force in the emergence of these criteria. They emerged as broad cultural developments being evolved by painters and poets together. What their slim and surprising volumes exemplified was spelled out as theory in the periodical *Union of Youth*.

By April 1913 *The Service Book of the Three*[2] had been published containing three illustrations by Tatlin. It confirmed his association with the poets and made him

Mayakovsky's first illustrator. It also emphasized his rapprochement with the Burlyuk circle and included a portrait drawing by Tatlin of Vladimir Burlyuk (Plate 54). Tatlin's calligraphic brevity resembles Mayakovsky's drawing technique at this date (Plate 55). Tatlin reduces his drawing to the barest minimum, stripped of all superfluous detail. A single line describes the back of Vladimir's head, the crown of his head and his forehead, just as a single line indicates lower lip, chin and neck. Such economy of means recalls caricature, yet Tatlin stops short of this, leaving an impression of succinctness and not exaggeration.

The other two illustrations by Tatlin for *The Service Book of the Three* share the dominant diagonal motif. In the depiction of a fish on a plate (Plate 56) spatial ambiguity abounds. Whether the fish or the small box at lower right is on the table is impossible to determine. Cross-hatched shading interrupts rather than strengthens any hint of coherent chiaroscuro and gives a flickering vitality to the page. The construction of the third drawing (Plate 58) is closer to Tatlin's compositions built up from unit elements. A housepainter, long brush and bucket slung over his shoulder, halts on a road that recedes rapidly behind him. Chiaroscuro is more consistent yet the drawing appears to rely upon the particular theme of the cone-shaped curve employed for boots, bucket and overcoat. These bear the only indications of firm modelling by chiaroscuro, all other lines remaining flat along the page. The line indicating the edge of the road at left is broken and clearly drawn in after the foreground figure. Together with the total lack of shading or descriptive detail, this anchors it to the page surface despite the hint of perspective suggested by its curve.

62

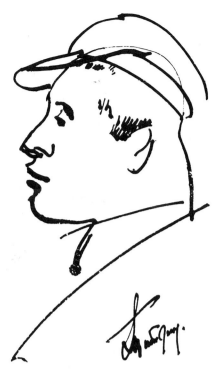

53. (facing page) Vassily Kamensky: Ferro-concrete poem: 'The Sun' (Lubok), *c.* 1913. Linocut, 22.9 × 34.9 cm. Collection Thomas P. Whitney, Connecticut.

54. Vladimir Tatlin: *Vladimir Burlyuk*, from D. and V. Burlyuk, et al. *The Service Book of the Three*, Moscow, 1913. Lithograph, 21 × 17.6 cm, signed lower right.

55. Vladimir Mayakovsky: *Velimir Khlebnikov*, from *The Service Book of the Three*, 1913. Lithograph, 21 × 17.6 cm.

The conical forms and outdoor setting recall those of Malevich's *Woman with Water Pails* (Plate 57) painted the previous year. Tatlin's drawing has none of the weight or density of picture space that characterized Malevich's painting, although the dynamics of its picture surface are comparable, particularly if allowance is made for Tatlin's much flatter picture space and calligraphic application. In one sense Tatlin is more concerned with *faktura* than Malevich, for whom the need to depict conical surfaces illusionistically demands a mechanical and deadening application of the paint.

Poetic concepts were being adopted by painters and vice versa. What was emerging in 1913 was particular to neither mode of activity: it was a theory of creativity on more general bases and far-reaching in its implications. When *Pomade* was published in January 1913 with poems by Kruchenykh and illustrations by Larionov, words, which according to the poet were meaningless, were employed solely for their sound. The first poem ends as follows:

> dyr bul shchyl
> ubeschchur
> skum
> vy so bu
> r l ez

Such a poem, as it did not rely upon meaning, could only rely instead upon its sounds and rhythms. The material qualities of Kruchenykh's words took precedence over the indication of meanings. Later in 1913 this use of words or fragments of words was

63

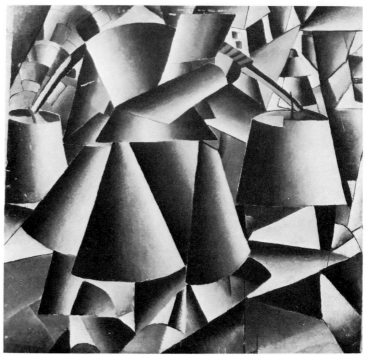

56. Vladimir Tatlin: Illustration to Mayakovsky's poem 'Signboards', from *The Service Book of the Three*, 1913. Lithograph, 21 × 17.6 cm, signed lower left.

57. Kazimir Malevich: *Woman with Water Pails: Dynamic Arrangement*, 1912. Oil on canvas, 80.3 × 80.3 cm. Museum of Modern Art, New York.

nominated 'the word as such' (slovo kak takovoe). By October 1913 Kruchenykh and Khlebnikov had published a book of this title in which *dyr bul shchyl* was repeated, and to which Malevich, Rozanova and Kulbin contributed.[3] Such activities acquired the descriptive label 'beyond meaning', contracted in Russian to *zaum* where *um* implies significance and meaning, and *za* indicates beyond. The material qualities of the word came to the fore in *zaum* poetry by Khlebnikov and Kruchenykh in particular. Such innovations were well underway before Tatlin's departure for Berlin and Paris, and so too were the theoretical speculations that arose from them concerning the manipulation of verbal material, its control and its function. By the time of his departure Tatlin was aware of an investigation into material construction, undertaken in both verbal and visual spheres, construction that brought into question the validity of conventional meanings beyond the material to hand. Khlebnikov brought to *zaum* works historical and etymological implications by invoking words' evolution and etymology. Sound and structure were of paramount importance. As poets evolved a means of discussing these new developments, a critical framework emerged which painters adopted for their parallel investigations of material and depiction. By autumn 1913 Malevich had adopted the label '*zaum* realism' (zaumnyy realizm) to refer to such paintings as *Woman with Water Pails*. Tatlin's acute awareness of material and rhythmic qualities in paintings and theatre designs must be seen against this background, for he was a pioneer in this respect before his visit west. It was increasingly possible to describe his work in terms employed by the poets.

A Trap for Judges, No. 2,[4] published in February 1913 between wallpaper covers,

58. Vladimir Tatlin: Illustration from *The Service Book of the Three*, 1913. Lithograph, 21 × 17.6 cm, signed lower right.

brought together most of the pioneers. Although Tatlin was not amongst them, David Burlyuk, Nikolai Burlyuk, Mayakovsky, Livshits, Kruchenykh, Goncharova, Larionov and Khlebnikov all were. 'We have set syntax loose,' proclaimed its manifesto. 'We have begun to attach meaning to words according to their graphic and phonic characteristcs ... We think of vowels in terms of space and time.'[5] *Zaum* was perhaps the most important concept formulated before Tatlin's intimate contact with Parisian cubism. It was distinctly Russian: Khlebnikov's etymological research made this inevitable. It made explicit the priority of material factors in creative activity, including their extension through time. Khlebnikov invoked here his historical-mathematical studies, but it was important for other poets and for painters. *Zaum*, whether poetic or pictorial, implied a construction in material terms that was not a timeless abstraction. The studies of time and of material were seen as inseparable and led both poets and painters to examine recent thinking concerning the nature of time, whether the physics of Einstein or the mystical fourth dimension of Pyotr Uspensky.

In March 1913 the Union of Youth journal published a text by M. V. Matyushin discussing Uspensky's *Tertium Organum*, a book in which a detailed description is attempted of four-dimensional space uniting Uspensky's impression of recent mathematical theories with a theosophical view of history.[6] Bearing in mind Khlebnikov's interest in a mathematical structure of history, it is clear that the Union of Youth considered the nature of time a serious study. Within this group Tatlin, approaching theories of material construction, would also encounter theories of time. This was central to his later development and was to link him closely with Khlebnikov.

On 24 March 1913 the Target (Mishen) exhibition opened in Moscow, largely comprising artists of the Donkey's Tail group with whom Tatlin had so recently exhibited. The exhibition continued until 7 April 1913 and featured rayonnist and other works by Larionov, Goncharova and Malevich, though Tatlin did not exhibit. The dynamism inherent in rayonnist painting was compatible with that of Italian futurist painting, and Malevich with his *Knifegrinder: Principle of Scintillation* (Plate 59), No. 95 in the Target exhibition, made the link explicit, even to the repetition of limbs to indicate movement in the manner employed by Severini, Balla and other Italian futurists. In so far as movement demands temporal extension, Malevich here already reflects a concern with time that would become a focus of his attention by the end of 1913. Larionov's primitivism also survived vigorously into 1913. His sequence the *Seasons* (Plate 60) unites diverse tendencies evident in the small books of that year. Verbal and visual modes are integrated on the flat canvas surface. Larionov's primitive handling is employed to coarse effect deliberately disrespectful to the pictorial precursors of his subjects and poses. These large paintings were hung in four-square format to indicate the cycle of the seasons (Plate 61). The sense of planetary movement implied in this was allied to a rural primitivism that locked Larionov's theme into an agrarian rather than a mechanistic context. Here at least no hint of modern machinery is evident. Larionov's imagery and handling owed more to the south of Russia than to Italian futurism, to that more Asian and rural enthusiasm held in common with the Buryluks and with Khlebnikov.[7] Elsewhere in the exhibition the southern flavour was consolidated in the works of poet-painters. Zdanevich showed the *Star of the*

66

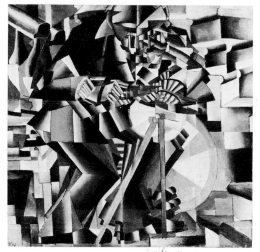

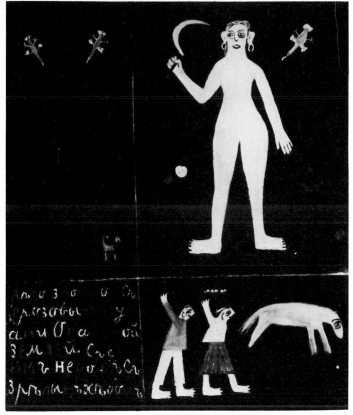

59. Kazimir Malevich: *The Knifegrinder: Principle of Scintillation*, 1912. Oil on canvas, 80 × 80 cm. Yale University Art Gallery, New Haven, Connecticut (Gift of Société Anonyme).

60. Mikhail Larionov: *Summer*, 1912. Oil on canvas, 138 × 117 cm, inscribed 'Burning hot summer with storm clouds, sun-scorched earth, with blue sky, with ripe corn'. Private collection, Paris.

61. (below) Larionov at left, Goncharova and others at the exhibition Donkey's Tail and Target, frontispiece of *Donkey's Tail and Target*, Moscow, 1913. British Library, London. Larionov's *Seasons* paintings are visible in the background.

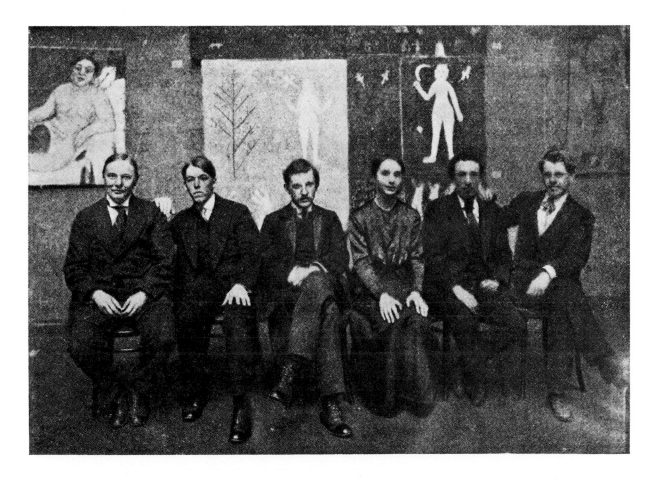

Caucasian Cabaret (Cat. No. 56) and Le-Dantyu *From Caucasia, Georgian Dance,* and *Sazandar*. S. M. Romanovich exhibited a *Caucasian Hairdresser's Sign* (106). Even Malevich described his *Peasants in a Field* (97) as exemplifying the 'new Russian style'. The primitivism of Larionov's circle was emphatic at the Target exhibition. Four works by the untaught Georgian sign-painter Niko Pirosmanishvili were included (a portrait of Zdanevich amongst them) with works by other sign-painters and a large group of children's paintings from the collections of A. V. Shevchenko and I. D. Vinogradov.

In not exhibiting at Target, Tatlin distanced himself further from Larionov. Having been attracted to cubism early in 1913, Tatlin had found the Union of Youth more sympathetic, and by the time cubism was debated at the Knave of Diamonds meetings in February 1913, Larionov's group had dissociated themselves. In March 1913 Tatlin joined the Knave of Diamonds exhibition, showing *Composition with Nude, Self-Portrait*, a *Composition with Fishermen* of 1912 and flower studies, one of which was

62. Vladimir Tatlin: *Analytical figure drawing, c.* 1913–14. Charcoal on paper, 43 × 26 cm. Central State Archive of Literature and Art, Moscow. Leaf 79 from an album of drawings.

63. Vladimir Tatlin: *Standing Nude*. Pencil on paper. Galerie Jean Chauvelin, Paris.

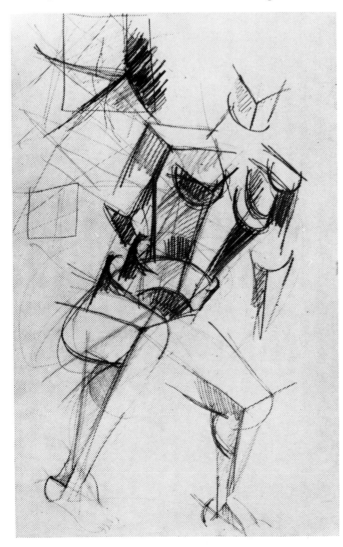

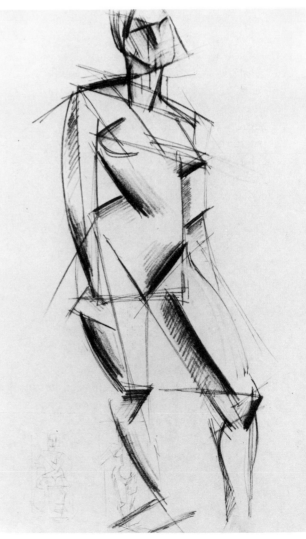

64. Mikhail Larionov: *Woman behind a Table*, from *Worldbackwards*, 1912. Lithograph, 18.4 × 13 cm.

65. Olga Rozanova: Illustration from the periodical *Union of Youth*, No. 3, 1913. Lithograph, 24 × 24 cm. British Library, London.

owned by Alexander Vesnin, his early companion in Moscow with whom he shared the studio on Ostozhenko Street.

Alongside his own paintings at the Knave of Diamonds, Tatlin could see paintings by David and Vladimir Burlyuk and Alexandra Exter. The Burlyuks had strong contacts with Munich and Exter with Paris, which she visited annually (she showed a Seine view at this exhibition). She had brought cubism in photographic form to show to the Burlyuk brothers. Through her Tatlin could gain advice and introductions for his visit to Paris. He wanted especially to visit Picasso, having been deeply impressed by his paintings in the Shchukin collection. A gouache by Picasso hung in the Knave of Diamonds exhibition. There were also works in the exhibition by Le Fauconnier and by Braque, who exhibited *Violin* of 1909 and *Harmonium*.

By comparing an ostensibly cubist figure drawing (Plate 62) by Tatlin with drawings from Larionov and Rozanova it is possible to assess Tatlin's response to cubism in Russian terms. Those by Rozanova and Larionov were published before Tatlin's departure. Tatlin's drawing reveals a systematic attempt to reduce his figure to combined cubic and cylindrical forms so that the projecting corner of a cube gives forward thrust to head, knees and breast where it is modified by the curve of a tilted cylinder. This renders the image dynamic and apparently translucent by depicting distinct aspects of the body's structure simultaneously. The pelvis and waist appear as hollow, interslotting cylinders, devices closest to the analytical cubism of Picasso and Braque during 1909–10. Tatlin's reduction of the figure to geometrical elements is no more extreme. Larionov, however, already in 1912, in *Woman behind a Table* (Plate 64), had approached such devices in terms of his own explosive rayonnism. His model's head is facetted into the edges of cubes and her breast presents a distinctly cube-like corner. His dynamic lines, for all the firmness of this figure, spread into

69

space and lock the figure into its surrounding space. Tatlin seems more concerned with analysing the separate figure. On the other hand, Rozanova's designs (Plate 65) reveal cube-edges but without attempting to analyse volumes systematically as Tatlin has done.

When Tatlin set off from Russia in 1913 it was with a group of Ukranian musicians invited to Berlin to play at a Russian exhibition of folk art and to sing Ukranian folk ballads before Kaiser Wilhelm, who complimented Tatlin on his performance on the *bandura*.[8] But his journey was motivated by a hunger to learn of Western developments and of cubism in particular, though he travelled as an independent painter whose development already embraced severely geometrical composition in paintings in which the rigorous acceptance of the canvas's flat surface was unprecedented. He was a brilliantly original stage designer on the fringe of Diaghilev's circle whose designs were foreign to Bakst's generation with features not yet attempted by Larionov or Goncharova. Lastly, he was intimate with poets, the fecund, innovative orbit of Kruchenykh and Khlebnikov, whose aims were independent of cubism yet equally radical. Tatlin in the spring of 1913 was on the brink of new developments. His experience of art in Berlin and in Paris was to prove of ineradicable importance; he travelled with a receptive mind, but his achievements were already considerable.

<center>* * *</center>

Picasso recalled Tatlin playing the accordion in his studio in Paris. Determined to visit Picasso, once there Tatlin made every effort to stay as a pupil or assistant, even offering to sweep his floors and stretch his canvases. 'They communicated by gestures, smiles and drawings, and, according to Tatlin, understood each other perfectly.' As a gift, Picasso gave Tatlin tubes of paint which Tatlin admired in the sparse studio that contained little else apart from Picasso's iron bed covered in an army blanket. Tatlin carefully preserved the gift of pigments. He had come to Paris from Berlin where he returned in the autumn of 1913.[9] Both cities were in a state of cultural ferment. Cubism flourished in exhibitions in both cities and Tatlin was much impressed by it. But as he did not speak French or German he was dependent upon Russian artists. His colleagues in Russia had boasted strong Parisian contacts. Some of his closest friends had been to Paris and in 1913 were still there. Larionov, Goncharova and Kuznetsov had visited Paris on Diaghilev's request in 1906. Larionov and Goncharova would return there to work for Diaghilev in 1915. Altman and Morgunov had both visited Paris. Morgunov, who had just joined the Union of Youth along with Tatlin, had exhibited Parisian paintings at the 1911 Knave of Diamonds exhibition and would contribute another painting of Paris to the next Union of Youth exhibition at the end of 1913. Similarly, Tatlin's colleague Grishchenko had shown Parisian paintings in 1912 at the Knave of Diamonds.

At the height of cubism Paris was undergoing a lively influx of Russian talents. Diaghilev's Ballets Russes had prepared the way for this since 1908 and had begun a new spectacular phase in 1913, in which the cruder vitality of peasant themes superseded the suggestive atmospherics of earlier more overtly symbolist works. On

70

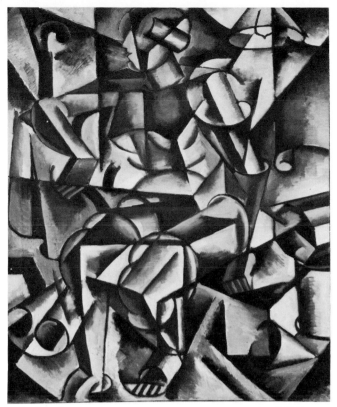

66. Mikhail Larionov: *Vladimir Tatlin*, 1912. Pen and ink, 15 × 12 cm. Collection Mr and Mrs N. D. Lobanov-Rostovsky, London.

67. Lyubov Popova: *Seated Nude*, *c*. 1913. Oil on canvas, 106 × 87 cm. Collection Ludwig, Cologne.

29 May Diaghilev's Ballets Russes at the Théâtre des Champs Elysées unleashed Stravinsky's *Rite of Spring*. Choreography was by Vaclav Nijinsky with costumes and sets by Nikolai Rerikh, whose work Tatlin would have known through the World of Art exhibition society in St Petersburg. The performers provoked a *succès de scandale* by their ferocity and originality. The vigorous Russian importation electrified Paris. With Diaghilev's Ballets Russes a cultural pendulum reversed its swing: instead of Parisian innovations holding sway in Russia, Russian culture by 1913 was tumultuously manifest in Paris.

To investigate Tatlin's experience of Parisian cubism it is sensible to assume that in a month or more he not only visited Picasso but was an eager and informed seeker who learnt as much as possible about contemporary developments. The activity of Russian artists in Paris provided Tatlin with an introduction to the latest Parisian cubism, developments in which they were deeply involved and to which they were substantial contributors. They provide a framework relevant to Tatlin's experience in Paris, and the platform from which he viewed what he came to see, even though the precise details of his encounters remain obscure.

Tatlin's studio in Moscow had become a meeting place where artists studied and worked together. Known as the Tower, it had attracted diverse talents by 1912 without comprising a formal group. Alexander Vesnin was there, but so was Alexei Grishchenko, Viktor Bart, Kirill Zdanevich and the women painters Lyubov Popova and Nadezhda Udaltsova, both of whom were so excited by cubism that they left Russia in 1912 to study painting under Albert Gleizes and Jean Metzinger at the atelier

71

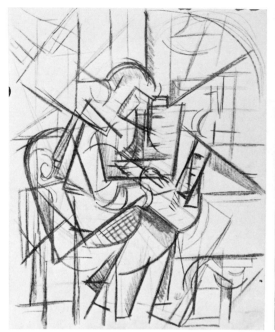

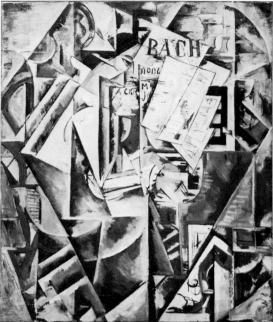

68. Nadezhda Udaltsova: *Drawing for 'At the Piano'*, 1914. 22.2 × 35.5 cm. Galerie Gmurzynska, Cologne.

69. Nadezhda Udaltsova: *At the Piano*, 1914. Oil on canvas, 107 × 89 cm. Yale University Art Gallery, New Haven, Connecticut (Gift of Société Anonyme).

70. Alexander Archipenko: *Médrano I*, 1912. Painted wood, glass, sheet metal, metal wire, found objects, height 96.5 cm. Destroyed.

71. Alexander Archipenko: *Seated Nude*, 1911. Bronze, 60 × 32 × 34 cm. Musée National d'Art Moderne, Paris.

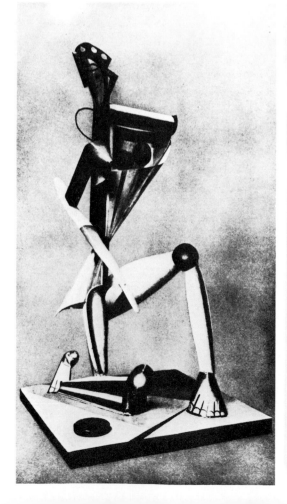

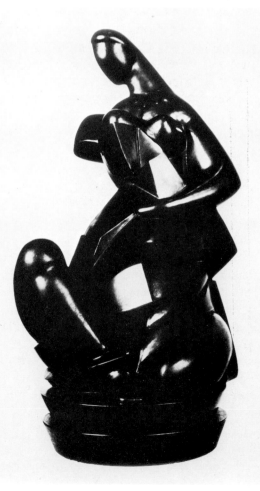

La Palette in Paris where Le Fauconnier and Dunoyer de Segonzac also taught. Their transfer from Tatlin's circle in Moscow to the heart of cubism could not have been more direct. When Tatlin followed them to Paris the next year he could not have had a more convenient entrée into the Parisian cubist studios.

Just how closely his work approached that of Popova in his interpretation of cubism is revealed by comparing Tatlin's cubist figure drawing (Plate 62) with a nude by Popova for 1913 (Plate 67). Tatlin and Popova both indicate the breasts by the projecting corner of a cube but intersect this with a curve that simultaneously suggests the roundness of the breast. The knees of Popova's figure similarly comprise the corner of a cube, intersected by circular planes to describe the round cross-section of the limbs; Tatlin's drawing employs comparable devices. The pelvic girdle of Tatlin's figure suggests the penetration of a translucent, hollow space, just as the cone-shaped elements of the upper arm in Popova's figure appear to slot one through another. Udaltsova's conversion to cubism was comparable, as *At the Piano* (Plates 68–9) of 1914 reveals. Popova and Udaltsova were friendly with Tatlin before his direct experience of cubism in Paris, and continued to work closely with him after their return to Moscow.

A further focus of talents was provided by the studios of La Ruche, the circular, former exhibition building at 2 rue Dantzig in Montparnasse. The studios, let to artists and writers of many nationalities, reflected in microcosm the thoroughly international flavour of contemporary Parisian culture. Léger had a studio there. The sculptor Laurens, the painter Modigliani and the Italian painter-critic Ardengo Soffici were there. In addition there was a strong Russian contingent. David Shterenberg and Anatoli Lunacharsky visited La Ruche. Marc Chagall had moved there in the winter of 1911–12 and the Ukrainian Alexander Archipenko was also in residence. Later inhabitants included Zadkine, Lipchitz, Soutine and the poet Blaise Cendrars.

Archipenko, who like Exter was from Kiev, belonged to a slightly earlier transfer to Paris. Exter had begun regular visits to Paris in 1908 and Archipenko had moved there the same year. From 1910 Archipenko exhibited at the Salon des Indépendants and at the Salon d'Automne and his cubist works progressed from carved sculptures to assembled 'sculpto-paintings'. The first major example, *Médrano I* (Plate 70), was rejected by the 1912 Salon d'Automne. The same year he opened a private academy in Paris. When Tatlin arrived in Paris Archipenko was at a transition point but was thoroughly established amongst cubist sculptors and within La Ruche. East Europeans were especially drawn to cubist sculpture: the Hungarian Csaky, and the Lithuanian Lipchitz as well as Baranoff-Rossiné, Zadkine and Archipenko, whose studio was renowned as a meeting place for artists and in particular those of Eastern Europe. The two distinct phases of Archipenko's work in the period 1911–13 both bear closest comparison with Tatlin's evolution in 1913.

Archipenko's *Seated Nude* of 1911 (Plate 71) indicates the degree to which Tatlin and Archipenko shared comparable concerns before Tatlin became intimate with cubism. The rhythmic coherence of Tatlin's *Seated Nude* of 1913 (Plate 51) for all its flatness finds a kindred coherence, though less severely edited, in Archipenko's sculpture. The model in both cases is seated and holds a drapery to her. Archipenko's figure

73

has one knee raised and appears to be seated on the ground, whereas Tatlin's rests upon a seat. Both figures are alike in the taut curvilinear rhythms with which their forms are articulated. Each rises from an unnaturalistically broad, firm base to an arching neck leading to an anonymous head, which is simplified to a ridge marking the line of the nose and the axis of the face. Within the dynamic silhouette which this provides, cusp-like curved forms comprise a rhythmic and stylized rendering of the body. In both, the breasts are clearly defined and slightly pointed recalling the blank smoothness of the head which hangs out over them. The total rhythmic effect is of a stable and essentially conical form filled with smaller vital movements. In both works, feet, hands and head are simplified so that the figure retains its anonymity, a generalized image of a figure. The extreme reduction of the face in each case emphasizes the extent to which the figure is a basis for an analytical exercise involving the whole body.

By 1913 Archipenko was working on very high relief sculptures combining diverse materials. In *Médrano I*, now lost, wood, glass, metal wire, found objects, paint and sheet metal were assembled to form a figure kneeling on one knee with an arm raised and head turned. The sculpture was free-standing and, of necessity, made radical simplifications to the elements of the body (in terms of both limbs and materials). A chest cavity of bent sheet metal provided rigidity and volume without solidity and by a twist provided a pelvis. The materials were sometimes left visible and sometimes partly modified by paint as, for example, in the indication of the toes. It is likely that Archipenko was working on *Médrano II* (Plate 72) at the time of Tatlin's visit. Certainly other assembled and polychrome works were underway in his studio in preparation for the one-man exhibition arranged for that autumn at the gallery of Der Sturm in Berlin. *Médrano II* repeated the double-cone torso and mixing of media, but now connected to an *L*-shaped base providing support beneath and behind the assembled figure. This additional rigidity brought Archipenko closer to relief sculpture with its attendant ambiguities between painting and sculpture. Contemporary still-life reliefs explored this further. Only the Russian Baranoff-Rossiné had approached such complex mixing of materials. In 1913 he too was at work on assembled figure sculpture, and the materials he incorporated were at least as intractable as those of Archipenko: *Symphony No. 1* of 1913 (Plate 73), for example, incorporated broken egg-shells.

To compare assembled works by Archipenko and Baranoff-Rossiné in 1912–13 is to recognize in Archipenko's work a more coherent handling of diverse materials, yet even his appear makeshift except within the framework of a rigid ground or base. In other words, Archipenko's reliefs gained from residual suggestions of pictorial composition a coherence denied to the more precarious free-standing works.

From the point of view of Russian contributors to cubism in Paris Archipenko comprised an innovator whose sculptures and paintings extended the means of cubism. Archipenko was not an outsider but an integral part of the diversity of cubism in 1912–13; he was a member of the Section d'Or group, friendly with French artists, and a perfect go-between for Tatlin. He was a close neighbour of Robert Delaunay and his Russian wife Sonia (Terk) Delaunay. Together with Osip Zadkine, Archi-

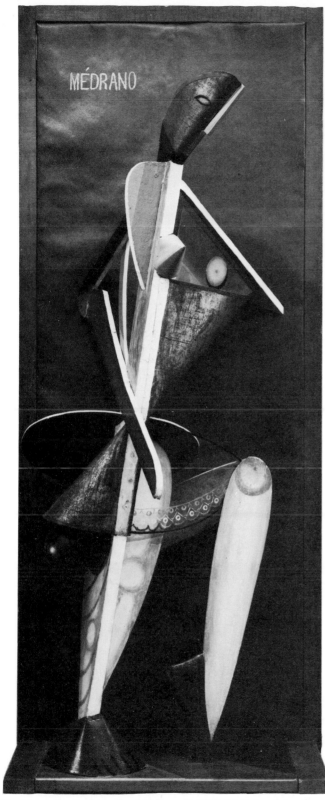

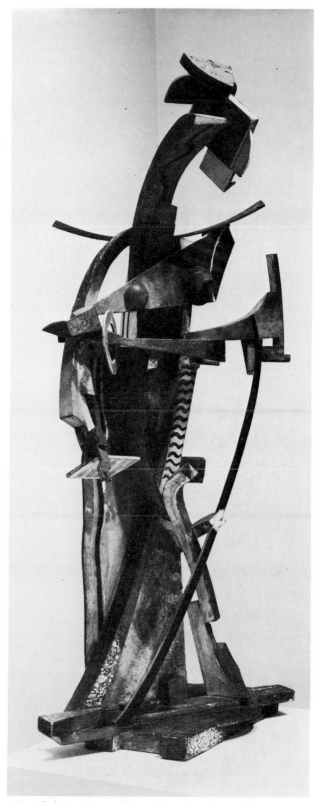

72. Alexander Archipenko: *Médrano II*, 1914–15. Painted tin, glass, wood, oilcloth, 127 × 51.7 × 43.2 cm. Solomon R. Guggenheim Museum, New York.

73. Vladimir Baranoff-Rossiné: *Symphony No. 1*, 1913. Painted wood, card and crushed egg-shells, 160.5 × 72.5 × 63.5 cm. Museum of Modern Art, New York (Katia Granoff Fund).

penko introduced a strongly Russian contribution to cubist sculpture in Paris. Lyubov Popova, from La Palette, and the sculptress Vera Mukhina had visited the studios of Archipenko and Zadkine in 1912. Tatlin cannot have been unaware of this. Chagall's earliest Parisian paintings reflected Delaunay's images of the Great Wheel and the Eiffel Tower. There is no reason to assume that Tatlin avoided such contacts.

Robert Delaunay's claim to be a formative influence upon Tatlin's mature work has been ignored, although recurrent themes of his paintings are reflected in Tatlin's later work. His love of modernity led him to themes scarcely attempted by the Italian futurists. Delaunay more than any other contemporary cubist celebrated the Zeppelin, the flights of Blériot, the mechanical marvel of the Great Wheel and the upward thrusting surge of Eiffel's tower leaping high above the city's roofs and domes (Plate 74). In January 1912 Robert Delaunay had sent three works to the Knave of Diamonds exhibition in Moscow with Gleizes, Le Fauconnier, Léger and Picasso. In Paris in February and March 1912 his kaleidoscopic and rainbow-coloured *Tower* paintings were shown at the Galeries Barbazanges, and again that spring at Der Sturm in Berlin, an exhibition to which Vladimir and David Burlyuk, Goncharova and also Kandinsky contributed. When he showed *La Ville de Paris* at the 1912 Salon des Indépendants in Paris, Russians were well represented there by Baranoff-Rossiné, Chagall, Kandinsky, Konchalovsky and Mashkov. By the time of Tatlin's visit Delaunay's reputation and the Russian presence were both substantial facts.

A second theme of Robert Delaunay's 1912–13 paintings associated light and colour effects with planetary and stellar movement (Plate 75). His disks swirled with colour devoid of any subject except an underlying sense of the moving earth, sun and moon. This was to become a fertile thematic source for Tatlin. Delaunay was discussing these ideas with Russian artists in 1913, among them, the Georgian painter Georgiy Yakulov, a friend of Tatlin's, who related these themes to Asian art. Yakulov visited Robert and Sonia Delaunay at Louveciennes, where he discussed diverse colour theories and read to them his essay *The Blue Sun* which outlined his study of the changing nature of light and its influence upon culture. Subsequently Yakulov was to deliver this lecture at the Stray Dog cabaret in St Petersburg. Yakulov saw in Delaunay an artist who 'sought to resolve the problems of the movement of light, of colour, of rhythm and of cadence'.[10] Delaunay's *Window* paintings (Plate 76) illustrate this. That Le-Dantyu's *Portrait of M. Fabbri* (Plate 77), with its comparable facetting, should be illustrated in the publication *Donkey's Tail and Target* in 1913 suggests that Delaunay's influence penetrated into that group also. Delaunay was at the height of his career and his reputation in Russia was growing. During 1913 he was well represented in exhibitions in Berlin and Paris. For a Russian painter interested in cubism and travelling to those cities a study of Delaunay's work was all but obligatory. Yakulov was one such artist; it is likely that Tatlin was another.

Picasso was the generative focus of cubism. Tatlin visited his studio for lengthy periods on several occasions. Here was a counterpoint to the work of La Ruche, where Tatlin could examine Picasso's recent, constructed still lifes and collages in which the pictorial frame and format were abandoned for an assemblage of objects in high relief with sections cut and interslotted together (Plate 78).

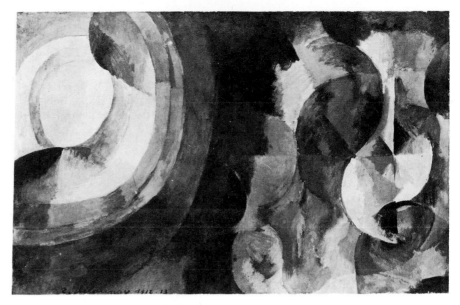

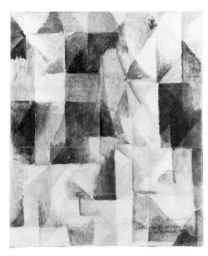

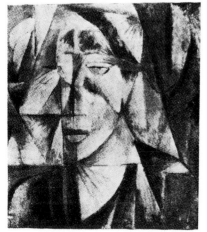

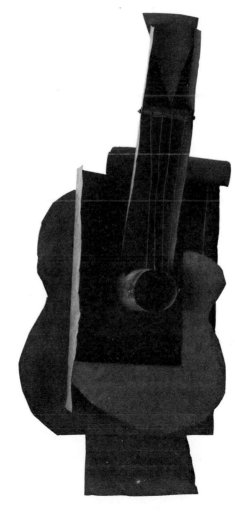

74. (above left) Robert Delaunay: *The Cardiff Team (Third State)*, 1912-13. Oil on canvas, 196.5 × 130 cm. Stedelijk Van Abbemuseum, Eindhoven.

75. (above) Robert Delaunay: *Circular Forms, Sun and Moon*, 1913. Oil on canvas, 65 × 100 cm. Stedelijk Museum, Amsterdam.

76. (far left) Robert Delaunay: *Windows Open Simultaneously, First Part, Third Motif*, 1912. Oil on canvas, 45.7 × 37.5 cm, later inscribed 'Les Fenêtres 1912 à Alex. Tairoff amicalement ce souvenir de Paris 1923'. Tate Gallery, London.

77. (bottom left) Mikhail Le-Dantyu: *Portrait of M. Fabbri*, 1913. Illustrated in *Donkey's Tail and Target*, 1913. British Library, London.

78. (left) Pablo Picasso: *Guitar*, 1912. Sheet metal and wire, 78 × 35 × 19.5 cm. Museum of Modern Art, New York.

In order to examine Tatlin's response it is essential to examine closely the development of his work after returning to Russia. During the next six years he continued to digest what he had encountered in Paris; he was concerned with handling or *faktura* more than with stylistic considerations and this led to his virtual abandonment of painting. What he had discovered was so radical that its implications were assessed a little at a time over years of experiment. The technical qualities of Tatlin's subsequent reliefs reveal the growth of ideas encountered in Paris and Berlin when transplanted into the special atmosphere of Russian cultural theories, themselves of great originality. Tatlin's knowledge, for all that it was gained in the West, was fruitful in tackling distinctly Russian creative problems.

Although Tatlin saw constructed still lifes in Picasso's studio, other scuptors too were constructing, amongst them Archipenko, Baranoff-Rossiné and French cubist sculptors, such as Henri Laurens. Later in 1913 Popova was again in Russia working closely with Tatlin, Udaltsova and Alexander Vesnin. The links were numerous and thorough. To describe such bridges between French and Russian artists leaves out of consideration the vital role of pre–First World War Paris as a cosmopolitan and international focus for artistic activity. Russians were no more the only foreign artists in Paris than was French art the only art to be seen there. The Italian futurists had recently been drawn to Paris and exhibited there. In June 1913 Umberto Boccioni

79. Umberto Boccioni: *Fusion of Head + Window*, 1912. Plaster, wood, various materials. Destroyed 1916.

80. Blaise Cendrars and Sonia Delaunay: *La Prose du Transsibérien et de la Petite Jehanne de France* (published as a scroll), Paris, 1913. Pochoir, 200 × 35.5 cm. Tate Gallery, London.

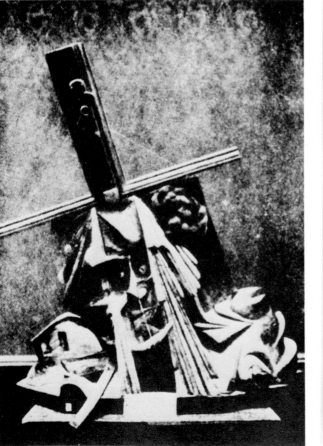

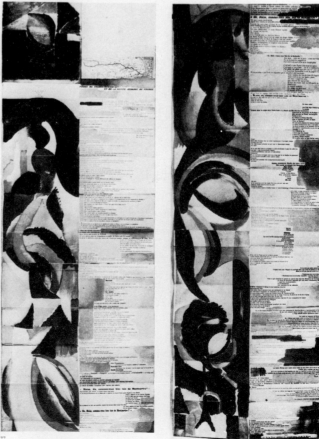

exhibited sculptures in Paris and, in view of the pleas made by him in his manifesto of futurist sculpture for a sculpture of movement constructed from diverse materials, he may have been a seminal influence upon the evolution of constructed sculpture in Paris.[11] Alexander Exter had met Boccioni in Paris in 1912 through Archipenko, and in 1913 Vera Mukhina and Popova visited his sculpture exhibition. In all probability Tatlin did too. In view of his closeness to Popova it is clear that Tatlin's constructions made upon returning to Russia should be compared as closely with those exhibited by Boccioni (Plate 79) as with those of Archipenko, Laurens or Picasso. In any case, *Apollon* magazine carried an unillustrated article on Boccioni's sculpture in the autumn. Clearly the impression that Picasso made upon Tatlin must not be under-estimated, but that this occurred amongst a wide variety of impressions can scarcely be doubted.

Parisian cubists had begun to show their work outside France. Delaunay, Léger, Picasso, Le Fauconnier and others had shown in Russia. In Germany, complex links with Parisian art were established. During 1913 both Delaunay and Archipenko had one-man exhibitions at Herwarth Walden's gallery Der Sturm in Berlin. Delaunay's exhibition in February 1913 again included his *Tower* paintings, whilst Archipenko showed fifty-seven works there in September.

Berlin is en route to Moscow or Leningrad from Paris, and Yakulov for one stopped off at Berlin on his return journey from visiting Paris and the Delaunays. He had a particular reason to do so, for Berlin witnessed, again at Der Sturm, the enormous and thoroughly cosmopolitan First German Autumn Salon (Erste Deutsche Herbst-salon) open from 20 September to 1 December 1913. Yakulov was amongst the Russians represented, together with Larionov, Goncharova, Kandinsky, Jawlensky and Kulbin. Robert Delaunay was substantially represented with compositions on solar and lunar themes as well as paintings featuring the Eiffel Tower, *Soleil tour aeroplane simultané* and *Seine tour roue ballon roue ballon arc-en-ceil simultané*. Sonia Delaunay exhibited the fruit of her collaboration with Blaise Cendrars: *La Prose du Transsibérien et de la Petite Jehanne de France* (Plate 80), the complex visual and verbal synthesis reminiscent of the collaboration of poets and painters in Russia, which itself dealt with a Franco-Russian theme. It was known in Russia later in 1913 where Delaunay's 'simultanéisme' was discussed at the Stray Dog cabaret.[12] There is no reason to suppose that Tatlin remained ignorant of the Delaunays' achievements.[13]

Ultimately the response of Tatlin to his experience of art in Paris and Berlin must be sensed by reference to his own work after the visit. The fact that he began to construct sculpture upon his return to Russia attracts attention to Laurens, Archi-penko and Boccioni as well as to the reliefs and the drawings for constructions executed by Picasso. It is necessary to concede that responses of differing kinds may be evident in Tatlin's work. To seek a stylistic response may be less fruitful than to recognize thematic links or techniques in the manipulation of materials or to expect certain immediate enthusiasms to give way to more considered responses that may have crystallized over several years. Art in Paris and Berlin was too rich and complex to receive a simple response particularly from so original a person as Tatlin. His visit occurred when his painting seemed resolved, uniting contrasting factors in works of

strength, clarity and firm rhythm. He travelled west as a mature painter. He returned the constructor of reliefs. This profound shift indicates the radical importance of his visit.

<center>* * *</center>

In the winter of 1913–14 an experimental cubist group incorporating Popova, Udaltsova, Alexander Vesnin, Vera Pestel, Alexei Grishchenko and Ternovets gathered again around Tatlin in his Tower studio. The year 1913 also saw the publication of Alexei Shevchenko's book *The Principles of Cubism and Other Contemporary Tendencies in Painting*.[14] The Knave of Diamonds group published a collection of essays by V. Aksenov on contemporary Russian painting followed by an essay from Le Fauconnier and an excerpt from Apollinaire's *Les Peintres cubistes* discussing the work of Léger.[15] Cubism and mysticism had been linked by Matyushin in March 1913. Furthermore Matyushin had published in Russian translation Gleizes and Metzinger's *Du cubisme* that year;[16] he had also discussed Uspensky's *Tertium Organum*.

It is possible to compare Tatlin's relief the *Bottle* of 1913 with earlier works by Picasso, Laurens[17] and Archipenko which Tatlin may have seen in Paris or Berlin, yet it is of importance also to remember the context of Tatlin's return to the circle of his

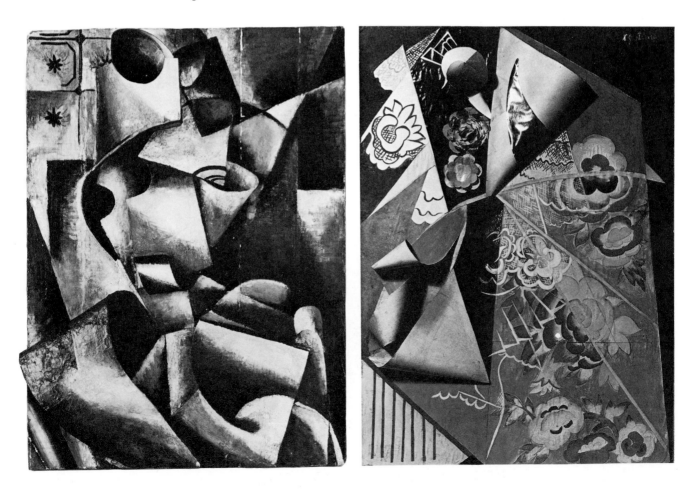

studio in Moscow, where once again Russian values began to assert themselves. Tatlin's response to cubism and futurism was not entirely separable from that of his Russian contemporaries. Popova worked several times on relief paintings (Plate 81), as Larionov and Goncharova (Plate 82) did later. Moulded or bent shapes emerged from the painted picture surface resulting in a suddenly increased sense of material relations. By comparison Tatlin's pioneering *Bottle* relief (Plate 83) appears gravely harmonic and decisively resolved. In place of the hectic and fussy energy of reliefs by Popova and Goncharova, Tatlin provides a severely edited construction, a reductive quality already evident in the nudes which preceded his visit to Paris. Nothing in this relief is superfluous, vague or ill-considered. Enthusiastic energy has given way to the extreme calm of a work devoid of extraneous detail. Tatlin has employed found and ready-

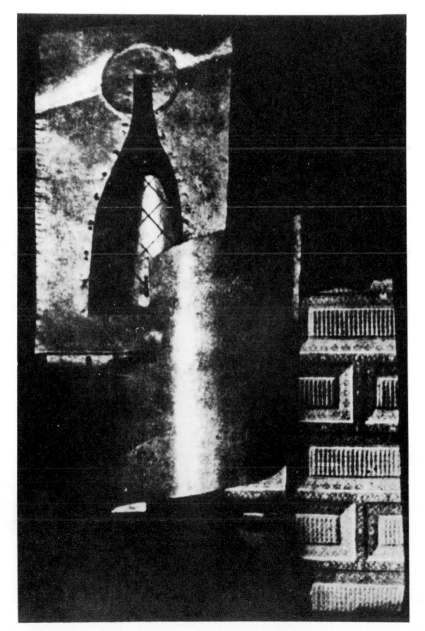

81. Lyubov Popova: *Relief*, 1915. Mixed media. Collection Ludwig, Cologne.

82. Natalya Goncharova: *Espagnole*, 1916. Mixed media on paper, 77 × 53 cm. Collection Robert L. Tobin, New York.

83. Vladimir Tatlin: *The Bottle*, c. 1913. Tinfoil, wallpaper, etc. Whereabouts unknown.

81

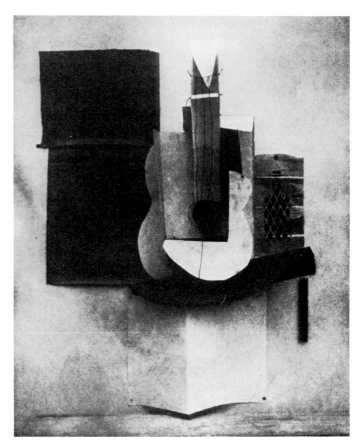

84. Pablo Picasso: *Still Life with Guitar and Bottle*, 1912. Mixed media construction. Destroyed. Illustrated in *Sorées de Paris*, No. 18, 15 November 1913. The guitar motif is closely related to Picasso's *Guitar* (Plate 78).

made elements, pieces of metal, wood and wallpaper, and has assembled them so that no extra feature intrudes and every incidental detail is concisely incorporated into his construction. Picasso and Archipenko had both used found elements, manipulating their rhythms and changing their identities. Picasso made visual puns in this way, so that a handle could stand for the neck of a bottle. Tatlin does not do this, but his *Bottle* relief makes reference to the bottle's profile, its transparency, the roundness of its neck and the cylindrical curve of its body. This adept singling out of particular features was thoroughly cubist but distinguished by Tatlin's severe economy of means.

Tatlin had relinquished the illusion of space that can exist within a painting. By working in relief he abandoned also the coherent uniformity of material, and was obliged to find coherence in differing materials, the pieces of wood, metal and paper employed in his relief. Subject-matter, the bottle in this case, helped to unite these elements, and this remains a pictorial feature of the relief. But conflicting material qualities had to be resolved also in terms of the manipulation that they permitted (bending or puncturing, for example), and in terms of their physical proportions. Painterly adjustments of colour and tone were no longer possible. This succinctness, evident in recent paintings and theatrical designs by Tatlin, provided the means to reconcile elements made of differing materials. *Faktura*, which had formerly meant

the handling of paint for Tatlin, was now in evidence as the handling of other materials in a way that recognized their individual qualities and resolved their oppositions. The points where one material meets another in the reliefs are the points where these oppositions must be resolved in material terms. Tatlin's few nails or slotted metal contrast starkly with the confusion or vagueness of Archipenko, Baranoff-Rossiné, Popova or Goncharova in this respect. Appropriate connections become necessary where diverse materials meet. The points of connection need to be clearly revealed, for it is here that the contrasts and relations of Tatlin's materials originate. At these points of emphasis the qualities of materials are revealed through Tatlin's handling of them, through his *faktura*. The broad expanse of an element is a rhythmic extension of the qualities revealed. The aspects of the *Bottle* relief which lend it coherence despite the variety of its parts are its imagery, suggesting a still life of a bottle before a wall, the explicit nature of Tatlin's handling of materials, and his decisive control over rhythm and proportion. The first of these, a suggestion of still life, is thoroughly cubist recalling reliefs and collages by Picasso; particular motifs, especially the grid across the bottle and the wallpaper, support this comparison (Plate 84). In the rhythmic control of his construction, Tatlin finds fewer comparisons, although Juan Gris[18] applied comparable severity and control in this respect. In the manipulation of materials, or *faktura*, Tatlin is breaking new ground, despite the inspiring experiments of Picasso and Boccioni in 1912–13, for Tatlin is analytical where they were accumulative: Tatlin's construction arises from his materials, whilst theirs gave depiction priority. For Tatlin, construction evolves from material and its handling: material and *faktura* lead to construction. Tatlin has seized upon cubism, showing an immediate and enthusiastic response to new works seen in Paris or Berlin, but has employed its innovations to ends that are his own. In the next two years the imagery, essential to almost all Parisian cubism, was systematically relinquished by Tatlin. Cubism did not overwhelm Tatlin. Whilst its importance could not be denied, for Tatlin its action was catalytic.[19]

Tatlin's erstwhile colleagues, now in the Donkey's Tail group, in particular Larionov, Goncharova and Malevich, were all prolific theorists and practitioners late in 1913. Goncharova and Larionov, whilst evolving rayonnism, also began to respond to Italian futurist and French cubist devices. They collaborated on numerous small books including *Hermits*, *Half Alive* and *Pomade*[20] in the first part of the year and also on theoretical texts. *Rayonnism* emerged early in 1913, followed by Eganbury's *Natalya Goncharova, Mikhail Larionov* and the publication of the text *Donkey's Tail and Target*.[21] This intertwining of primitivism, rayonnism, Western cubism and futurism reached a high point in the work of Larionov and Goncharova whilst A. Shevchenko, painter and theorist of cubism and primitivism, published a small book called *Neo-Primitivism*.

For Tatlin, Malevich provided the most important visual example of this new synthesis of the primitive and the sophisticated, although Picasso had heralded such primitivism in works of 1908. Flirtation with both cubist and Italian futurist devices had led Malevich to contrast techniques within a single work. The *Portrait of M. V. Matyushin the Composer*, for example, presents recognizable clues to his subject in

the central section depicting forehead, hair and parting, as in a cubist painting, and a collaged strip of squares resembling piano keys, a reference of a different kind that undermines the illusionistic picture space. Finally, the many smaller planes which intersect do not permit interpretation as subject-matter. They form a dense agglomeration isolated; at times they suggest a background, but elsewhere, at left, they encroach upon the imagery to mask it in the manner of a curtain or screen. Similar devices were characteristic of recent collages and paintings by Picasso, Braque and Gris. Malevich used them to draw attention to the conventions of painting, so that subject-matter became a secondary consideration. Despite their cubist traits these paintings also approached concepts of space and time elucidated by Malevich's sitter Matyushin, concerning the fourth dimension and the poetic innovations of Khlebnikov and Kruchenykh. For Malevich, to suppress recognizable imagery comprised an answer to the poets with whom he collaborated, who wished to suppress meaning in their use of words and emphasize their material qualities. This brings Malevich closer to Tatlin than the outward appearance of his works might suggest. They had both contributed to the Donkey's Tail group and both were now asserting their independence. In addition they both responded to the works, ideas and friendship of Velimir Khlebnikov, although Malevich's collaboration with the poet Kruchenykh must not be underestimated.

The Three,[22] a book illustrated by Malevich in 1913, brought together the poets Khlebnikov, Kruchenykh and Elena Guro (Matyushin's wife): it united new spatial concepts with the new study of words. *The Three* was published by Matyushin. He declared in the unsigned introduction: 'The days are not far when the conquered phantoms of three-dimensional space, of illusory drop-shaped time, and of cowardly causality ... will reveal before everyone what they have always been in reality—the annoying bars of a cage in which the human spirit is imprisoned.'[23]

Kruchenykh envisaged in *New Ways of the Word*[24] an intuitive grasp of knowledge, by-passing the intervening filter of the senses, involving in the created work the abandonment of meaning for the direct manipulation of material qualities: 'Whereas artists of the past went through the idea to the word, futurists go through the word to direct knowledge. In addition to the existing sensation, notion and concept, the fourth unit, "highest intuition" is being formed.'[25]

Malevich's increasingly irrational juxtaposition of images (culminating with his *Englishman in Moscow*, 1914) must be seen in this context. *The Word as Such*[26] was published by Kruchenykh and Khlebnikov in autumn 1913 with Malevich's *Reaper* pasted onto its cover. Space, time and language provided the nexus of topics that occupied Khlebnikov in his extraordinary poems and researches. Kruchenykh and other poets responded readily to his ideas, and so did painters, Malevich amongst them. *Arithmetic* by Malevich (Plate 85), published in *The Three* in 1913, exemplifies the influence of the poets, especially Khlebnikov whose work was becoming increasingly radical in its curious blending of mathematical, historical and linguistic traits. Rozanova, the wife of Kruchenykh, was another collaborator in that field. It was to this context, a distinctly Russian one by virtue of its linguistic aspect, that Tatlin returned in the autumn of 1913.

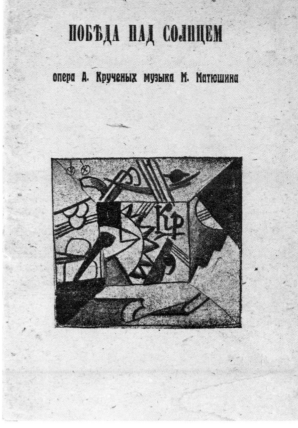

85. Kazimir Malevich: *Arithmetic*, from A. Kruchenykh, *Let's Grumble*, St Petersburg, 1913. Lithograph, 17.5 × 11.8 cm, inscribed 'arithmetic K. Malevich'.

86. Kazimir Malevich: Cover illustration to A. Kruchenykh and M. Matyushin, *The Futurist Opera: Victory Over the Sun*, designs by Malevich, St Petersburg, 1913. Letterpress, 24 × 17 cm. British Library, London.

On returning to Russia Tatlin submitted designs for *The Life of the Tsar* to the World of Art winter exhibition. Whilst Tatlin was aligning himself with the World of Art so too was Khlebnikov. The World of Art, no longer dominated by the *fin-de-siècle* luxury of Bakst and his contemporaries, was looking for younger talents. Larionov and Goncharova joined Diaghilev the following year, prime contributors to the barbaric energy of the Ballets Russes' newest productions. Tatlin's designs prefigured theirs. He was by no means behind the times exhibiting theatrical studies at the World of Art. On the contrary, theatrical design remained important for Tatlin at the critical moment when his early achievements and methods were being re-examined and reassessed in the light of new discoveries.

At the Union of Youth exhibition in St Petersburg the same winter, 23 November 1913 to 23 January 1914, the collaboration of poets and painters was clear. It featured a posthumous exhibition of work by Elena Guro. Olga Rozanova showed a portrait of her husband, *Portrait of the Poet A. E. Kruchenykh*, whilst Malevich divided his exhibits between 'autofuturist realism' and '*zaum* realism'. Tatlin contributed an oil and three other works. The oil indicated by its title *Compositional Analysis* the continuing structural nature of his studies.[27] This was to be the last Union of Youth

85

exhibition, although the organization itself survived into 1914.[28] In December 1913 it was through the Union of Youth that two brief but influential productions occurred. These were Mayakovsky's first play, entitled *Vladimir Mayakovsky: A Tragedy*,[29] and the opera *Victory over the Sun* (Plate 86) written by Kruchenykh, set to music by Matyushin and designed by Malevich. The 'Three' were again together in collaboration: Khlebnikov, who provided the prologue, was an ever-present influence in those cosmic and mathematical themes dear also to Matyushin and evident in the planets and symbols of Malevich's cover illustration for the score of the opera.

The year 1913 had been a full and formative one for Tatlin during which his art was forcefully wrenched into a new course. As the *Bottle* relief showed, the experience of Paris and Berlin had opened up entirely new avenues of enquiry. But Tatlin was still a distinctly Russian artist. Upon returning to the orbit of Khlebnikov, he re-examined his earlier beliefs about structure in creative activity. Before his journey he had been involved in discussions of the extent to which Russian art should be independent of the West. Late in 1913, as Tatlin sought to assess his recent experiences, this dichotomy of allegiance or identity was acutely in evidence. If the *Bottle* seems to respond at once to Paris and Picasso, subsequent works appear to do so less. In Russia there were investigations of an extraordinary kind under way, no less original than the Parisian cubists' analysis of means and techniques.[30] In Russia, in line with the theories and poems of Khlebnikov, poets, painters and musicians were drawn together. From physics, linguistics and history, they sought an art with the broadest application, with no equivalent in the West. Their investigative approach to creative activity was committed to exploration and discovery. There is no reason to suppose that Tatlin was not excited as much by these developments as by those in Paris. His work was to suggest, on the contrary, that the analytical element of cubism encouraged his independent researches as close to Khlebnikov as to Picasso. Cubism provided an impetus not a pervasive concept or theory. When Tatlin turned to the poems of Khlebnikov he encountered a concept of material, a sense of an Asian and rural past, and a fecund originality.

4 MATERIAL VALUES

AMONGST the last activities of the Union of Youth before its dissolution in 1914, was to invite to Russia the poet-leader of the Italian futurists, their prime activist and proselytizer, F. T. Marinetti. His arrival in St Petersburg polarized the affiliations of Russian painters and poets. Kulbin and Malevich were attracted by Marinetti, but Khlebnikov was dismayed. According to Matyushin, he was so angry with Kulbin for acting as host that he almost attacked him at a reception in Marinetti's honour. Khlebnikov withdrew and did not cause a brawl but his feelings testify to the strength of loyalties and allegiances within Russian futurism. Marinetti's visit followed upon an increasing exposure of Italian futurist ideas and works. Manifestos had been published in Russian, Russian artists in Paris had met Boccioni and Severini, and they had visited Boccioni's exhibition of sculpture there in 1913. Malevich, most evidently in his *Knifegrinder* painting, had employed the Italian futurist techniques of depicting movement. Rozanova adopted an urbanism in her paintings compatible with that of the Italians, whilst Popova in a basically cubist *Italian Still Life* of 1914 (Plate 87) made reference to the flag of Italy (top right of the painting), *Lacerba* (the letters *LAC*, left of centre at the bottom of the painting), the mouthpiece of Italian futurism, and even, perhaps in reference to Marinetti's militarism, the phrase 'des canons'.

The Russians were neither ill-informed about Italian futurism nor necessarily antagonistic, but the appearance of Marinetti in Russia implied an identification of Italian and Russian futurist aims, with recognition of Marinetti as the pioneer and even the leader of an international futurism.[1] This brought into the open the heated question of how far Russian innovations should remain independent of Western European developments. The noisy urbanism of Marinetti found no sympathetic echo in Khlebnikov's awareness of rural Asian roots. His sense of history, of the place of man in the universe, even his linguistic studies, could not be reconciled to Marinetti's dream of the dynamic and mechanized City of the Future. Not for Khlebnikov was the imitation of roaring steam engines. Not for Marinetti were solitary wanderings in Astrakhan or the study of birds' migration.

Marinetti brought to a head the split within the Union of Youth. Marinetti's word for futurists, *futuristi*, implied dynamic thrust and enthusiasm for machinery. Russians close to Khlebnikov used the Slavic word *budetlyane*, meaning those who will be,

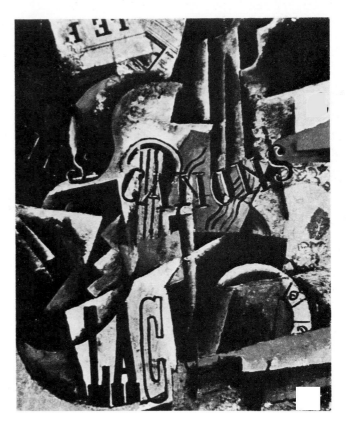

87. Lyubov Popova: *Italian Still Life*, 1914. Oil on canvas, wax, paper collage, 62 × 49 cm. Tretyakov Gallery, Moscow.

88. Larionov and Goncharova (seated front right) with a group of Russian Futurist artists and writers, several with painted faces. [Photograph Mme Tatiana Loguine-Mouravieva, Paris.]

dwellers of future time. The Italian word had active connotations; the Russian word, derived from the future tense of the verb 'to be', carried a sense of the passive mode, of existence extending, not of action applied.

Even before Marinetti's arrival, Larionov suggested rotten eggs as a welcome. But Malevich and Shershenevich defended him. The collaboration of the 'Three' (in fact, four: the poets Kruchenykh and Khlebnikov, the theorist-publisher-musician Matyushin and the artist Malevich) which had reached fruition in the recent performances of *Victory over the Sun* was under stress in the early months of 1914. It is unlikely that the sympathy and rapport felt by Malevich for the writings and ideas of Khlebnikov, could endure so vigorous a wrench – at least as far as collaboration in future projects might be concerned. The conversion of Vadim Shershenevich extended to his publication of collected Italian futurist manifestos in translation during 1914, amongst them Boccioni's *Manifesto of Futurist Sculpture*, Russolo's *Art of Noises* and Marinetti's manifesto *Variety Theatre*.[2]

When the Knave of Diamonds exhibition opened early in 1914 in Moscow, the allegiance between Malevich and Matyushin clearly remained in evidence, for Malevich exhibited his *Portrait of M. V. Matyushin the Composer, Author of the Futurist Opera Victory over the Sun*. Exter showed cityscapes, including *Study of the City's Motion in Planes*. Popova, Udaltsova and others of Tatlin's immediate circle exhibited works of a cubist flavour.

In 1914 Malevich seemed to be an agile interpreter of developments in Italy and Paris, although he made no personal visit to Paris. A cubist townscape drawing by

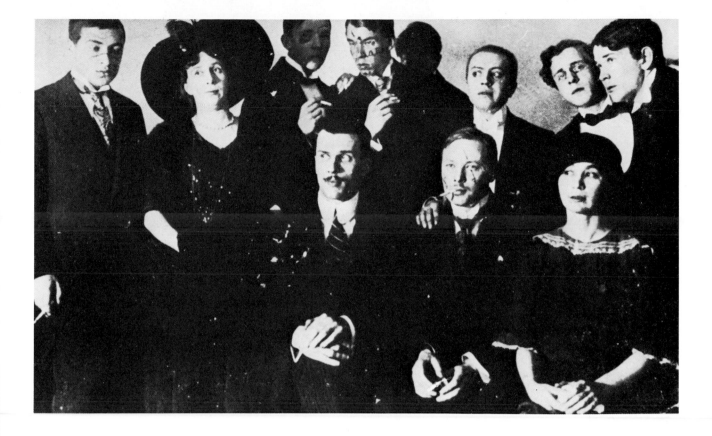

Tatlin bears an inscription in Malevich's hand: 'Drawing by Tatlin. He took lessons in cubism from me. K.M.'[3] The artists gathered around Tatlin at his studio were investigating cubism. But by the spring of 1914 Tatlin decisively asserted his independence and originality in more reliefs assembled from diverse materials. Whether or not Tatlin had in fact considered himself a pupil of Malevich, he was now embarked upon complete independence. His respect for Malevich led to fierce competition and not collaboration.[4] The factions induced by the visit of Marinetti must have emphasized this rift, for Tatlin's interest in Khlebnikov clashed awkwardly with Malevich's support for Marinetti.

Marinetti's visit occurred when numerous Russian futurists were away from the capital. The increasingly public and bizarre manifestations of Russian futurism led Larionov, Zdanevich, Mayakovsky and David Burlyuk to parade painted, made-up and outrageously dressed for public walks and performances in Moscow (Plate 88). There followed a long tour through Russia. When Marinetti arrived this tour was in mid-progress. December 1913 saw Mayakovsky, David Burlyuk and the poet-pilot Vassily Kamensky leaving for the south, visiting, lecturing and performing in a long line of cities, finishing at Baku on the Caspian Sea on 29 March 1914.[5] They performed every few days. A southern bias was established with performances in the Ukraine, the Crimea, Georgia and Azerbaijan. Kamensky recalled the meeting at Kharkov which he opened berating the audience and discussing 'the word as such'. Burlyuk followed with an illustrated lecture on *faktura* in post-Impressionist painting, futurism and cubism. Mayakovsky attacked current views of art and art critics. Then came

readings of their poetry by Kamensky, Burlyuk and Mayakovsky. The evening concluded with a long informal debate. At Odessa, according to Kamensky, they were showered with flowers, candy, fruits, several boxes of herring, and one stinking pike. Their performances in propagating Russian futurism made committed converts and fierce antagonists throughout large tracts of the south. Marinetti was fortunate to have them so far from his own mission in the north. Kamensky, Burlyuk and Mayakovsky on their tour emphasized the common ground in both verbal and visual activities in poetry and painting. This was not simply the basis for an analogy: an investigation of their common structure was underway, a theory of creative work beyond the confines of a particular medium which was to provide a basis for discussion and experiment throughout the next decade. *Faktura* was much discussed both within poetry and within painting. The recognition of the qualities of materials employed was of cardinal importance, whether that material be words or paint, sounds or pigments. The first was crucial in the poetry of Khlebnikov; the second grew step by step more essential to the constructions of Tatlin. Until Khlebnikov's death in 1922, their work grew closer and more specifically connected in themes and aims.

Burlyuk and Mayakovsky on tour spoke from experience as both painters and poets. Kamensky, their fellow performer, produced shaped poems, as did Zdanevich and others. At Exhibition No. 4: Futurists, Rayonnists, Primitives, organized by Larionov in March 1914, Kamensky exhibited 'ferro-concrete poems' including *A Fall from an Aeroplane* in which a heavy weight marked with a face, hung by a wire in front of a metal sheet, above fragments of aeroplane and suggestions of blood. A thunderous noise was produced by rattling the weight against the metal sheet.[6] This was an extraordinary work for a poet, indicative of the search for common ground, for an analysis of creative work, and the means of its construction. To consider Tatlin's early reliefs purely in connection with cubism is to oversimplify the cultural context within which he was working. That a poet should produce such a construction makes clear that to consider Tatlin's reliefs against the background of innovations in poetry is not absurd. *Faktura* provided the link. In 1914 the theoretician V. Markov (Waldemars Matvejs) published a booklet on *faktura*.[7] Tatlin's reliefs of 1914–15 were hybrid and sophisticated works moving away from French cubist or Italian futurist borrowings towards a far-reaching exploration of material qualities, of *faktura*, and of the construction that arises from their interplay. This exploration was beyond style or personal expression. It continued the austere assembling of works already evident in the painted compositions of 1912 and 1913. Tatlin was becoming a pioneer, for to work beyond style or self-expression was a radical new development, a broad investigation of the nature of creative activity. Dealing directly with materials, no longer recording emotions or dreams, he became a constructor and an investigator. The art object continued to exist as the culmination of a process of investigation. *Faktura* and construction both implied a process: they were not stylistic or expressive devices. Just as Khlebnikov considered that every verbal construction was a process and not an object, so Tatlin's reliefs resulted from a process at work, material and *faktura* leading to construction.[8] Under the influence of these Russian ideas, Tatlin's work became less and less cubist: the impact of Picasso and of Paris was transformed.

90

On 10 May 1914 Vladimir Tatlin opened his studio at 37 Ostozhenko in Moscow for five days to exhibit his recent reliefs. Tatlin's latest works displayed his newly independent position and firm commitment to construction. The First Exhibition of Painterly Reliefs⁹ retained a nominal reference to painting. The reliefs themselves Tatlin called 'synthetic-static compositions', for they united conflicting material qualities, each a synthesis of conflicting demands. 'The materials incorporated into these works,' wrote Tatlin, 'are wood, metal, glass, stucco, card, iron etc. The surfaces of these materials have been worked upon with putty, fumes, powder and other processes.'¹⁰ The wealth of colour characteristic of painting and rich in possibilities of illusion has given way to a varied handling of materials. *Faktura*, no longer limited to the artist's brushwork, has been extended to the exploratory manipulation of materials to hand, for it is through the study of materials that the construction of each relief is discovered and the synthesis of conflicting qualities resolved.

Much of cubist and futurist art had remained committed to recognizable subject-matter. The Italian futurists had turned to urban mechanistic and vigorously muscular themes in their attempt to encapsulate that dynamic thrust which for them appeared to characterize the twentieth century: in the process of their investigation they had adopted new means of depicting their subjects. The cubists were less unanimous in their approach to their subject-matter. Delaunay was attracted by modern themes, the Eiffel Tower, mechanical flight and sportsmen. With Duchamp and Léger, Delaunay revealed an interest in movement which the fragmenting effect of cubist devices was well suited to depict. On the other hand Picasso, Braque and Gris often restricted their subjects to the mundane and static objects of still lifes. By contemplating the depiction of these objects they were able to examine their methods. Depiction and its processes became, in effect, their subject-matter, whilst the guitar, the glass or the bottle comprised little more than a pretext for their investigation.

Tatlin's relief *Collation of Materials* (Plates 89–90) which includes a reference to a glass and perhaps a suggestion of table surface, shares something of the iconography of Picasso's still lifes. Tatlin's imagery is not clearly legible throughout the relief, although the transparent and curving top element recalls a glass with great directness. Beyond this only hints are proffered through the contrast of surfaces and shapes suggestive of a cylindrical container or a flat supporting surface. Subject-matter is merely intimated; it does not play as central a role in this relief as it had in the *Bottle* (Plate 83), whose analytical traits referred as often to the subject-matter as to the materials employed.

The wit that activated cubist assemblages by Picasso is lacking in Tatlin's relief, for subject-matter as such, and related questions of depiction and representation, are side-stepped. Tatlin's handling of imagery is overshadowed by an emphasis upon the handling of materials. Picasso, using diverse materials in his reliefs, had been obliged to make them work together: he necessarily investigated construction in such reliefs, although their diversity was dictated more by their associations than a sense of materials. The sculptors Archipenko and Laurens made overt use of material qualities but with an eye to the ambiguities of representation. Tatlin goes further: the handling of materials dominates the manipulation of imagery, their inherent qualities are

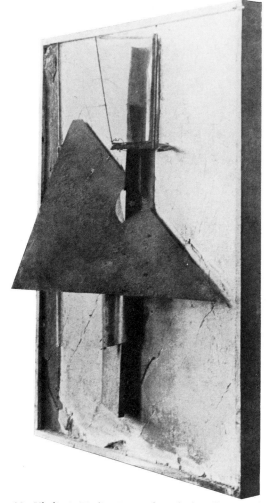

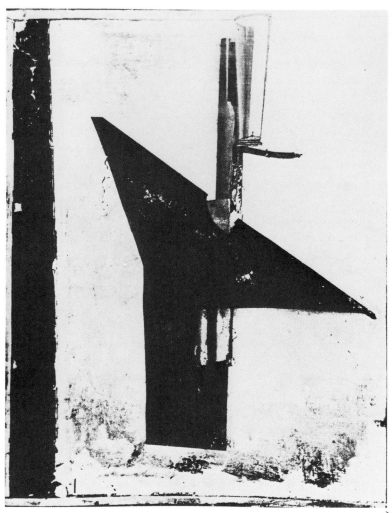

89. Vladimir Tatlin: *Painterly Relief. Collation of Materials*, 1914. Iron, plaster, glass, asphalt. Whereabouts unknown. Three-quarter view.

90. Vladimir Tatlin: *Painterly Relief. Collation of Materials*, 1914. Iron, plaster, glass, asphalt. Whereabouts unknown.

emphasized and contrasted. They are united not by an image but by resolving the conflict of their material qualities, their size, flexibility and so on.

In using a plaster ground and wooden rectangular frame Tatlin has retained a hint of the format of a painting, yet illusionistic space has now been abandoned. Aesthetic predilection, self-expression and even stylistic considerations have been jettisoned. Handling and materials produce construction; and the task of the creative person is to wrest coherence from material conflicts and contrasts.

The rectangular plaster ground bears a tonal and probably colouristic modification at left. The ground itself underlies the whole relief, providing support at all points. Yet Tatlin clusters the parts around an almost vertical axis. All of the remaining elements connect with this axis, which fulfils a structural and unifying role. Glass, asphalt, metal, all attach differently. At points of juncture the contrast of diverse material qualities is resolved. Between such points the spreading surface of a material reveals other features (malleability and shine, for example) that emphasize each element's individual characteristics.

92

Tatlin treated his materials to a whole sequence of processes: handling has come to include the exploration of materials. His forms project before the picture plane, extending beyond illusionistic manipulation of paint into the manipulation of many materials. Through this manipulation (*faktura*) differing material qualities are revealed.

Essential to these reliefs as such considerations are, Tatlin's use of a spinal axis is a spatial device that arises from an attempt not simply to explore individual elements, but to combine them. Construction arises from the coming together of the parts and cannot be attributed to any one element. Scale and shape determine the assemblage as much as flexibility or rigidity do. Where the strong diagonal cuts the vertical axis a focal point is established, providing a nexus of materials. Such a focal point suggests the origin or zero of a graph, although here it is differing materials that diverge from this point. With characteristic meticulousness Tatlin has emphasized this nexus by cutting a niche from his triangular piece to reveal what lies below, part of the construction which would otherwise have remained obscure.

This relief, which is lost, has been variously dated.[11] Its vertical curve of metal, a cylindrical form with its bottom edge cut diagonally, recalls the *Bottle* relief, as does the remaining hint of still life subject-matter. What is new here is the balance of depictive and material considerations. In the 'Glass' relief, *faktura* dominates the representation of a still life, whilst in the *Bottle* every feature supported the motifs of bottle and wallpaper.

The spatial complexity of the 'Glass' relief is partly revealed by the existence of photographs from two viewpoints. Tatlin uses planar surfaces to divide space, avoiding cumbersome closed volumes, even though he appears to have used found elements, preferring not to shape his pieces. Material is a given factor in the sense that geometers might accept an axiom.

If cubist techniques are at work in this relief, Tatlin's Russian context has to be considered too, for here in 1914 was a meeting point of East and West. It cannot be assumed that Western innovations were more or less important than Russian practices. Painterly considerations persist in this relief; after all, Tatlin was experienced as a painter. An image against a background within a rectangular frame is a painter's format. When it is recalled that Tatlin had worked with icons, whose mounts might often be metal or wood in high relief, the transition from a flat painted surface to relief is less surprising than it would be for a Western European painter.

The poets Khlebnikov and Kruchenykh had only recently emphasized *faktura* of the word. Khlebnikov had begun to explore the word's physical properties, its sound, its roots and its evolution through time and use. The structure of language in terms of both etymology and syntax fascinated these poets whose ideas and aims found immediate echoes in the works of closely associated artists. Malevich and Tatlin were amongst those who responded most vigorously to these developments. For Malevich in 1914 the conflict of imagery, made possible by cubist techniques, was accompanied by conflicting means of representation within a single work. The *Private of the First Division* (Plate 91), for example, combined collage with several kind of representation fragmented and brought together on a single canvas.

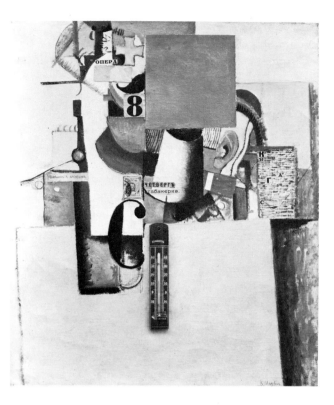

91. Kazimir Malevich: *Private of the First Division*, 1914. Oil on canvas, with collage of postage stamp, thermometer, etc., 53.6 × 44.8 cm. Museum of Modern Art, New York.

Tatlin, whose concept of *faktura* was more far-reaching, had begun to undermine the special status of painting. The way was open to the exploration of other materials than oil paint, tempera or canvas. Indeed the abandonment of picture space demanded a move into other materials, for oil paint and canvas were charged with connotations now irrelevant.

If for the poets the *faktura* of words included an awareness of their evolution through history, of their fashioning through use, for Tatlin the handling of his materials similarly had its evolution through time in many human activities. His experience at sea relied upon a highly articulate handling of wood, rope, canvas, metal and tar. This tradition of using and combining materials was beyond the sphere of art in any academic sense, yet so was his work with reliefs and so was the study that Khlebnikov made of language.

Both poets and painters were explorers of a language. The interest excited amongst phoneticians, such as Lev Yakubinsky, and linguistic scholars, such as Roman Yakobson, by Khlebnikov's poetry is one sign of this. Tatlin did more than study materials in isolation or in simple combinations, he studied their time-honoured and unpretentious practical traditions as a living language of materials. Khlebnikov explored language as material, Tatlin explored materials as language. From this point forward no distinction could be made between one creative activity and another that did not recognize their common identity as material constructions. For this reason oil paint and canvas were a hindrance to Tatlin, merely one relation of materials amongst

94

many. In addition, as the use of materials evolved through time, the constructor using such materials, be he poet or painter, inherited a language with its own structure and history. This was the proper subject of his investigation; it had little use for self-expression or illusion. Creative work became investigation, each object constructed became an exploration.

This aspect of Tatlin's development is increasingly evident, leading to economical constructions of originality and clarity. His approach is not that of an engineer imposing a mechanical function upon materials that he has allocated and combined to suit his purpose. Tatlin has no such purpose. The function of his works is of a different order altogether: it is exploratory. In his attitude to paint he is closer to the sign-painter than to the academician. In his attitude to materials he is more at home with the boat-building sailor than with the ostensibly cultured carver in marble.

Two related reliefs by Tatlin, dated 1913 and 1914, owned respectively by Ivan Puni and Alexandra Exter, appear to confirm these tendencies. They share certain features with the *Bottle* and 'Glass' reliefs although in neither of these does recognizable imagery persist. Through these works Tatlin influenced Puni's and Exter's development towards construction in the face of Malevich's more painterly innovations. Tatlin's importance was increasingly recognized by painter friends who acquired his works (Alexander Vesnin and Nadezhda Udaltsova also owned works).

It was useful in relation to the *Bottle* and the 'Glass' to assess the relative importance of image and material. The element of depiction was decreasing. In the relief on a wooden board, featuring a piece of easel and a box, owned by Puni (Plate 92), the section of easel is not depicted but incorporated directly. Whilst recognition of the shape engenders associations, no illusionism or representation is involved. The section of easel is a selected ready-made object and the same may perhaps be assumed about the box, the piece of decorated material (linoleum?) attached to the board, and the central light-toned elements. The control so clearly manifest in this spartan relief depends above all upon proportions and shapes, spatial qualities, yet substantial in their way. The relief is essentially two-dimensional, for all of its major planes are parallel to the background board, across whose surface the five pieces are rhythmically distributed.

Comparison with the 'Glass' relief (Plate 89) shows that this relief too has more than one axis and a focal point. The central elements define it by their shared vertical edges and their horizontal top edges. These are in turn parallel to the sides of the base board. The left edge has its vertical extended and emphasized by the letter-like inscription that is suggestive of a cryptic key to the relief. This motif is marked upon a surface printed with a pattern of small ellipses. Whilst its vertical sides reflect those mentioned above, and its bottom edge is parallel to that cutting the focal point, part of its upper edge follows a line formed by the pattern. A drawn line in the 'key' echoes this as do the angle of the large element, emphasized by its own painted lines, and the angle of the box. The position of the large element is similarly precisely fixed.

Tatlin in concentrating upon scale and proportion has resolved diverse elements harmoniously across the surface of his board. No element is left unaccounted for; no element escapes the rhythmic coherence of the arrangement. This comprises one kind

95

of material construction. That the elements are wood or linoleum or paper matters less than in the 'Glass' or the *Bottle*. Given elements are reconciled to a harmonious coexistence through the discovery of an underlying rhythmic and linear structure.

The relief that Exter owned (Plate 93) is more complex in its projection into space of assembled elements. That it is related to the relief Puni owned is suggested by their publication side by side in 1915, and confirmed by the inclusion into this relief of more of the card, paper[12] or linoleum used in the relief owned by Puni.

In this relief Tatlin moves more decisively off the two-dimensional surface of the base. That Exter owned it suggests that the relief was not a temporary arrangement pinned against a wall. The oval decorative designs indicate that the scale is close to that of the relief Puni owned. Numerous other characteristics make the two comparable, in particular the reliance upon a vertical axis and underlying rhythmic structure based upon proportion.

Tatlin worked forwards from the plane of his relief's base, applying first those flat elements which could be resolved by a study of their shapes and proportions across the two-dimensional surface. By this study five diverse elements were brought together in a rhythmically controlled arrangement determined by the proportions of the base and the dominance of a vertical axis through the relief. This two-dimensional

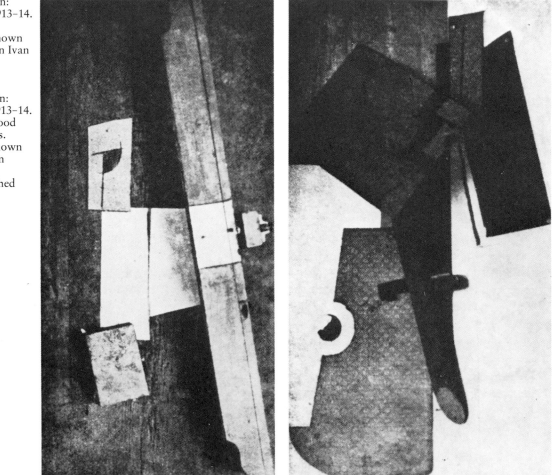

92. Vladimir Tatlin: *Painterly Relief*, 1913–14. Collage on wood. Whereabouts unknown (formerly collection Ivan Puni). Photograph published 1915.

93. Vladimir Tatlin: *Painterly Relief*, 1913–14. Construction of wood and other materials. Whereabouts unknown (formerly collection Alexandra Exter). Photograph published 1915.

arangement reflects that evident in the relief owned by Puni, but here a step is taken into the third dimension, away from the base and the surfaces parallel to it.

A found object, comprising a cylindrical wooden pole with a device mounted on it transversely and at right angles, is inserted diagonally across the main axis of the relief. At its lower end this pole has been cut at an angle making an elliptical surface. The pole therefore has a longest edge and a shortest edge; the longest lies along the base of the relief so that the elliptical surface rises at an acute angle from the base. The lower point falls on a horizontal given by the irregular piece and over the vertical axis of the relief. The upper end of the pole remains hidden beneath a final planar element. If the pole is symmetrical, then the hidden elliptical end may support and define the angle of the last element, which also touches the base's edge at left.

Both reliefs have features in common. They incorporate pieces of identical material (the decorated elements), and include an important secondary axis, diagonal to the central vertical axis. The strongly three-dimensional object in each case is reserved for this diagonal. The axial angle is almost the same in each relief with an ostensibly symmetrical found object lying along it. Each of these comprises the most complex object in the relief and has associations of practicality. The relief owned by Exter incorporates surfaces not parallel to the base or ground of the relief and is the more adventurous of the two.

Tatlin referred to both of these works as 'painterly reliefs': they appear to incorporate marks suggestive of the clues familiar in cubist paintings and collages. These provide no hint of representational intent. On the contrary, they sum up the dominant rhythmic traits of a structure evolved from the pieces to hand.

To compare these works with cubist reliefs is to acknowledge the importance for Tatlin of reliefs by Picasso in which found objects were incorporated. The oval-patterned material recalls cubist collage and the wallpaper of Tatlin's own *Bottle* relief. Having conceded this, however, it is clear that Tatlin has avoided representation. A few ambiguities perhaps remain, but nothing unequivocal. As cubist works, they are as abstruse as anything by Picasso or Duchamp. As with Duchamp the cubist technique of incorporating elements directly into the work has had a profound effect, leading to the abandonment of representational function. As with Duchamp, so with Tatlin, it was the found object that was most useful, particularly when it was evidently a manufactured object. Tatlin's elements in these reliefs were fragments of daily life. Duchamp and Tatlin evolved an activity of discreet intervention in the world of objects. Whilst Duchamp isolated and displayed his objects within a culturally sensitive context, Tatlin incorporated them into reliefs employing their unmodified shapes and proportions, devising a construction with minimal reference to aesthetics or taste, and a minimal alteration to his chosen elements.

Seen as Russian works these reliefs comprise a further step towards a recognition of the *material* of the creative person's work. Rhythm and completeness are as vital here as for the poets. As they recognized the material characteristics of words and language, so it became clear that more substantial materials, such as wood or metal, also demanded a usage and a language to organize them into mutual coherence, a language of the handling of materials.

As poets abandoned a precious poetic language, marble and bronze were rejected in the visual sphere. This is not to say that the language of Khlebnikov or Tatlin was as readily assimilable as that of the street, but it is to acknowledge structures related to a common fund of experience. This takes Tatlin, and Khlebnikov, beyond the bounds of stylistic innovation into a vastly broader field. Khlebnikov's example was vital to Tatlin, but his own innate detachment provided the right temperament for the exploration that he was just beginning on the eve of war in 1914.

Group allegiances no longer had the same significance for his investigation of a visual and material language. Material led to construction through its handling. That handling, *faktura*, became a central issue, for that is where the language lay, with its usages and structures that evolved and grew through the centuries.

The pamphlet published by Tatlin in 1915 declared, after listing the exhibitions to which he had contributed, that Tatlin 'neither belongs nor has belonged to Tatlinism, rayonnism, futurism nor to the Wanderers, nor to any such groups'.[13] And by 1914 the close friendship that once existed between Malevich and Tatlin had developed into competition. Their creative paths diverged, yet each exerted a far-reaching influence upon other Russian painters.

Tatlin strikes a new balance between material and imagery, between construction and representation. What was central to the wit and vitality of cubist collage is here redundant to the point of atrophy. The underlying geometrical structure of Tatlin's reliefs enabling him to organize the heterogeneous elements recalls the cubism of Juan Gris, for whom such an underlying structure was characteristic.

Malevich in 1914 also employed ready-made objects. *Private of the First Division* (Plate 91) incorporates printed lettering, a stamp and a thermometer with its wooden support. Whilst Malevich's painting contrasts many techniques of representation, the geometrical areas recall Tatlin's applied elements in the relief owned by Exter (Plate 93). Furthermore, the painting is constructed around a strong vertical axis near the centre of the painting, from the left vertical edge of the rectangle near the top running down the left edge of the thermometer mount. The large rectangle, against which the thermometer hangs, establishes almost vertical and horizontal axes in a manner also evident in the underlying geometry of Tatlin's reliefs. Despite their rejection of representation, it is likely that these two reliefs, particularly that owned by Exter, reveal the continuing importance of cubism as it was assessed in Russia during the winter and spring of 1913–14. Tatlin's colleagues were eager students of cubism and so, in 1914, was Malevich. By May 1914 representation meant less to Tatlin than did the new exploration of materials, but cubism made this new study possible: Tatlin's investigation of the language of materials progressed from a cubist beginning. His constructions concisely and economically brought together both East and West, though little remained here of the urban themes of Italian futurists, or the concern for representation that characterized most cubist painting or sculpture. Historical events were soon to confirm, through cultural and political isolation, a drift away from the West. With the coming of war in autumn 1914, foreign travel became impossible. In the storm to come, the example of Khlebnikov became a guiding light.

5 CULTURAL ISOLATION AND FERMENT

THE coming of war in 1914 intensified activity in the Russian art world. Paris and Berlin ceased to function as international cultural centres. The rising tide of national awareness was increased within the arts by the return from abroad of many creative talents. In Russia this new concentration acted as a lens intensifying artistic innovation. Yet it also installed an isolation that remained unbroken for eight years.

The dialogue established by Exter, Popova, Udaltsova, Tatlin, Yakulov and many others between the cultural innovations of Paris and those of St Petersburg and Moscow ceased. This cultural isolation necessarily favoured the development of indigenous tendencies. Malevich and Tatlin grew more influential and antagonistic. A crucial year for both men, 1915 saw the emergence of open competition between them.

One foreign influence of importance newly felt amongst the writers and painters of Khlebnikov's and Mayakovsky's circle was that of the British vorticist group. In February 1915 a celebration was held at the Stray Dog cabaret in Petrograd to mark the launching of a new periodical, the *Archer* (Strelets), whose contributors included a familiar alignment: David and Vladimir Burlyuk, Kamensky, Khlebnikov, Kruchenykh, Livshits, Mayakovsky, the musician Lourie, Rozanova, Kulbin and M. Sinyakova. The periodical discussed the English group in Zinaida Vengerova's article 'The English Futurists'[1] made up of an interview with Ezra Pound, a discussion of the vorticist publication *Blast* and illustrations of work by Wyndham Lewis. Lewis's *Portrait of an Englishwoman* (Plate 94) of 1914 differed radically from cubist or Italian futurist works in its pictorial construction, which is wholly rectilinear and leaves the impression of depicting a three-dimensional structure. Lewis reduces the head to an almost illegible simplification. Whilst the eyes may be located aside the line of the nose, the painting's lower half defies interpretation in figurative terms.

Nothing similar had penetrated Russia from Paris or Italy; its inclusion in the *Archer* is a testament to the interest it aroused. The Stray Dog cabaret, which had earlier seen *La Prose du Transsibérien* of Sonia Delaunay and Blaise Cendrars, now discussed vorticism, virtually the final Western innovation to make such an impact for almost a decade. To reduce a figure to geometrical planes was characteristically

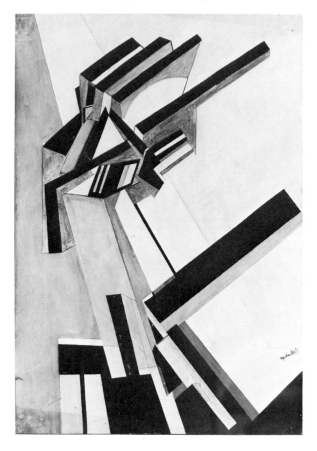

96. Tatlin (centre) with Boguslavskaya (left), Exter, Puni and Rozanova, 1915. Illustration to review of exhibition Tramway V, published in the Petrograd journal *Voice of Russia*, March 1915. Collection Herman Berninger, Zurich.

94. (top left) Wyndham Lewis: *Portrait of an English-woman*, 1914. Pencil, ink and watercolour, 56 × 38 cm. Wadsworth Atheneum, Hartford, Connecticut (The Ella Sumner and Mary Catlin Sumner Collection).

95. (top right) Cover of *Took—The Futurists' Drum*, ed. V. Mayakovsky, et al., Petrograd, 1915. Letterpress on grey woodchip paper, 34.7 × 24.5 cm. British Library, London.

97. (right) Newspaper review of Tramway V exhibition, March 1915. Collection Herman Berninger, Zurich. Tatlin's *Painterly Relief* is illustrated alongside Puni's *Card Players* relief and Exter's painting *Florence*.

vorticist. Lewis was prime amongst them, but such techniques were well developed too by Bomberg. Only later did Russian painters attempt such radical simplifications. This occurred during 1915, and it is reasonable to suppose that the impact of vorticism was not an unrelated phenomenon. The geometrical structure, the leaning axis, the move away from depiction were all themes of interest to Tatlin, in whose painterly reliefs of 1914 imagery is suppressed and geometrical structure given precedence.

When the Russian publication *Took—The Futurists' Drum* (Plate 95) appeared in December 1915,[2] it had the scale of a mere pamphlet compared with the substantial bulk of the vorticists' *Blast*, but the heavy lettering of its cover echoes the emphatic capitals of *Blast*. Furthermore the sentiments expressed in it by Mayakovsky are those of vorticists in London, proclaiming the death of destructive futurism which he saw overshadowed by the war.[3] He pointed to the architect as the agent of positive creative endeavour: 'We consider the first part of our programme, the destruction, finished. So do not be surprised if, instead of a jester's rattle, you see the blue-print of the architect in our hand.'[4]

Amongst the Russians whom the war forced back from Paris, were Ivan Puni and his wife Ksenia Boguslavskaya (Plate 96). The owner of a painterly relief by Tatlin, Puni responded to his example, making reliefs which nevertheless referred equally to Malevich's innovations of 1915. Puni and Boguslavskaya provided the financial support for the two crucial Petrograd exhibitions of 1915, Tramway V,[5] which opened on 3 March, and 0.10, December 1915 to January 1916. In the meantime, in April 1915, Moscow witnessed the major exhibition The Year 1915. Tatlin contributed to all three. Tramway V, subtitled the First Futurist Exhibition of Paintings, attempted a comprehensive survey of contemporary trends: the term 'futurist' was still flexible enough to embrace Malevich and Tatlin. By the end of the year the inclusion of both men within a single term or a single exhibition was barely possible. Reflecting the tone of Mayakovsky's assertion in *Took—The Futurists' Drum*, 0.10 was called the Last Futurist Exhibition of Paintings. To Mayakovsky it seemed that war would destroy the past and give creative man a new role, no longer an observer critical of society's values, but a committed integrated force within its evolution at a time of change. The Last Futurist Exhibition implied the expectation of change: a final summing up of achievements before the new constructive era.

At Tramway V, the first of the three exhibitions, Tatlin and Malevich established the furthest points of innovation against which the works of Exter, Klyun, Morgunov, Popova, Puni, Rozanova and Udaltsova could be assessed. Exter showed still lifes (Cat. Nos. 85–92) but also *Florence* (79–80) (Plate 97), *Paris Boulevard, Evening* (81), *Synthetic Portrayal of a City* (82–3) and *City* (84). Popova exhibited *A Smoker* (44), *Woman with Guitar* (45), *Violin* (46) and *Figure + Horse + Space*, the syntax of its title from Boccioni or Severini. Rozanova showed two portraits (60–1), a street scene (62) and *In the City* (63). Udaltsova's comparable themes included *Female Model with Guitar* (73), *Violin, 1914* (77) and *Still Life* (78) which she described as 'surface compositions', a description applicable to Tatlin's reliefs of 1914–15. As Tatlin had acquired a still life from Nadezhda Udaltsova by the end of 1915, it is important not

to underestimate his admiration for her work. He was less explicit in titles, referring simply to painterly reliefs, five dating from 1914 (64–9) and one from 1915 (70).[6] Tatlin's contribution to an exhibition still distinctly cubist in flavour is indicative of his own closeness to that movement. If he was breaking new ground in 1915, he had not left cubism far behind.

Puni and Klyun were closer to Malevich, who showed a survey of his painting from *Argentine Polka*, 1911 (Cat. No. 14), to the *Portrait of Matyushin*, 1913 (20), and his recent *Englishman in Moscow* (18) (Plate 98). Here the lettering is cubist but the assemblage of images and abrupt transitions of scale are provocatively illogical. The painting is inscribed 'Partial Eclipse', which describes the overlapping of images, and 'The Horse-Race Society'. Four images overlap at the centre of the painting (figure, fish, candle, sword). Crossing axial lines determine their positions much as they provided a structure for Tatlin's diverse elements. The candle's right edge establishes a slightly tilted vertical axis continuing down between the lettering to the bottom edge of the canvas. At right angles to this a tilted horizontal axis extends from the sword handle through the top of the C-shaped letter, the lower tip of the ladder and the zig-zag of three fixed bayonets.

Tramway V summed up the vigorous Russian response to cubism and, to a lesser degree, Italian futurism. Its sheer diversity made an impressive display; it was a highpoint not a beginning, its diversity balanced by a common cohesion which could not long be maintained. The divergence and competition of Malevich and Tatlin were to render this impossible.

The Year 1915, the exhibition which followed in Moscow in April, was a less intensely focussed assessment of trends showing widely differing painters. Larionov and Goncharova exhibited, the former showing a relief with a fan. David Burlyuk, Vladimir Burlyuk, Mayakovsky and Marc Chagall were represented, as were Falk, Konchalovsky, Lentulov, Mashkov and Saryan. Tatlin could be studied in a far wider context beyond the suggestion of a group identity. His colleague Grishchenko exhibited, and Miturich showed his portrait of the composer Arthur Lourie. Yakulov too showed a portrait. The unique position of Tatlin was clear when the exhibition opened on 5 April 1915 and not least to critics unsympathetic to the way that 'Tatlin nailed an enamel bucket onto his picture' or that 'Tatlin's picture is made up of a white tin plate, a piece of drainpipe, half a cylinder of glass and little more'.[7]

An important contributor to The Year 1915 was Wassily Kandinsky.[8] Tatlin's abandonment of representation can only have been encouraged by Kandinsky's attempts to suppress ready access to his imagery. Kandinsky made the painted surface an arena within which the material of his paint and the varied character of his handling were of paramount importance. But the hectic vigour of Kandinsky is the opposite of Tatlin's reserve. Tatlin could compare his own innovations with the undeniable daring of Kandinsky. *Composition VII*, amongst Kandinsky's exhibits, was the fruit of intense study into the mechanics of *faktura* and the organization of the picture surface (Plate 100). Kandinsky's drawings for *Composition VII* (Plate 99) emphasize the centre of the painting around which the other elements orbit, however loosely they appear to be painted. The illusion of recession behind the picture plane

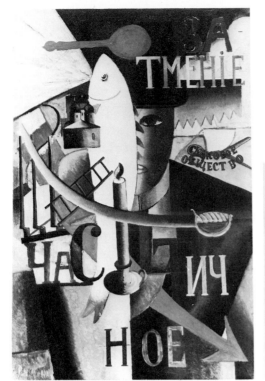

98. Kazimir Malevich: *Englishman in Moscow*, 1914. Oil on canvas, 88 × 57 cm. Stedelijk Museum, Amsterdam.

100. (bottom) Vassily Kandinsky: *Study for Composition VII*, 1913. Oil on canvas, 78 × 99.5 cm. Städtische Galerie im Lenbachhaus, Munich.

99. Vassily Kandinsky: *Schematic Drawing for Composition VII*, 1913. Pen and ink, 21 × 33.1 cm. Städtische Galerie im Lenbachhaus, Munich.

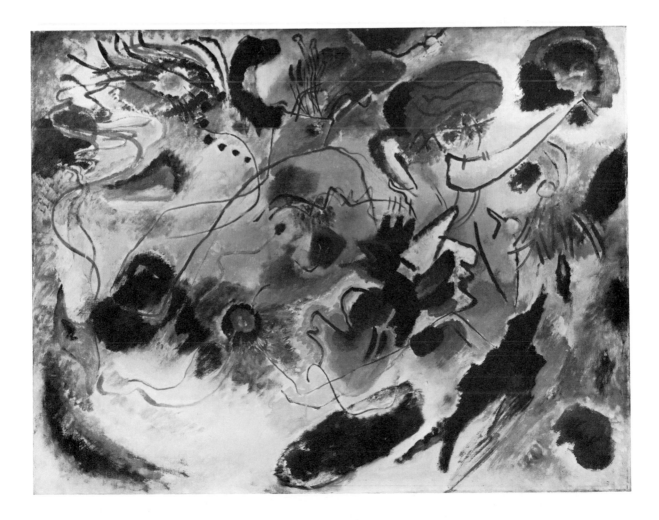

is achieved by an underlying structure explicit in drawings. Arcs which swing above and below the central focus establish an elliptical plane along the circumference of which clusters of lines and colours are precisely located. Because the ellipse suggests a circular plane seen from an acute angle, it hollows out a limited picture space full of movement, carrying the eye along its edge, returning continually around its arcs up to the picture plane and around into its limited recession. The loose calligraphic clusters of marks providing localized focuses within the painting are suspended from an underlying rhythmic structure.

Although Kandinsky was committed to an illusion of picture space, there was much here of interest to Tatlin in terms of surface organization, where both painter and relief-constructor faced comparable problems. *Composition VII* has a geometrical substructure, and frankly accepts the importance of *faktura*. Furthermore Kandinsky with his *Klänge* woodcuts of 1913 had asserted the common ground of visual and verbal creativity.

The Year 1915 presented a wide-ranging survey of contemporary activities. It enabled Tatlin to exhibit his reliefs in Moscow outside the futurist context. The Petrograd exhibition Tramway V early in the year showed Tatlin within a tighter group whose respect for cubism and Italian futurism provided a precarious cohesion. The intense experimentation that arose from this courting by Russian artists of Western cultural developments reached fruition in a period of sudden isolation that

101. Poster for 0.10, the Last Futurist Exhibition of Paintings, December 1915. Galerie Jean Chauvelin, Paris.

102. Cover of catalogue *0.10. The Last Futurist Exhibition of Paintings*, Petrograd, 1915. Collection George Costakis, Athens. [Illustration © George Costakis 1981.]

reunited dispersed Russian artists. The consequent ferment of activity made the cohesion of Tramway V impossible to maintain beyond the end of 1915, for the activities of Malevich and Tatlin in particular became openly antagonistic. By December 1915 distinctly Russian concerns became dominant. The suprematism of Malevich and the corner reliefs of Tatlin were developments of enormous originality, distinctly Russian in character and so incompatible that Tatlin and Malevich came to blows.

In December 1915, 0.10, the Last Futurist Exhibition of Paintings, opened at the Dobychina Gallery on Petrograd's Champs de Mars (Plates 101–2). Now Tatlin and Malevich emerged as the heads of opposing factions, radical innovators who published pamphlets to accompany their exhibits. Tatlin, dismayed at what he considered the amateurism of new works by Malevich, refused to exhibit his own reliefs alongside them. A last minute débâcle was avoided only by Alexandra Exter's suggestion that Tatlin with Popova and Udaltsova should exhibit in a separate section of the exhibition from Malevich and his sympathizers. Tatlin emphasized this withdrawal by a notice at the entrance of his section proclaiming 'Exhibition of Professional Painters'. The tenuous cohesion of earlier 1915 had evaporated by December. In spite of these difficulties the exhibition opened and continued into the new year. The divergence at its core provided the poles of a radical new assessment of visual creativity in Russia.

0.10 was the public début for the kind of painting called 'suprematism' by Malevich (Plate 103) and described in his accompanying pamphlet *From Cubism and Futurism*

103. Malevich's suprematist section at the exhibition 0.10, Petrograd, 1915, showing the *Black Square* hung across the corner of the room like an icon. [Photograph Galerie Jean Chauvelin, Paris.]

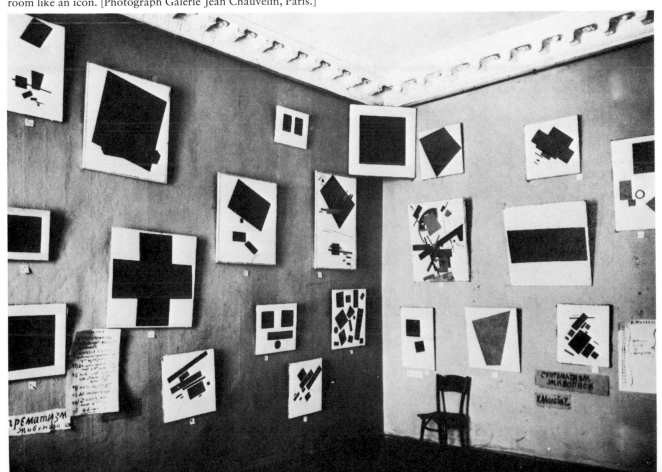

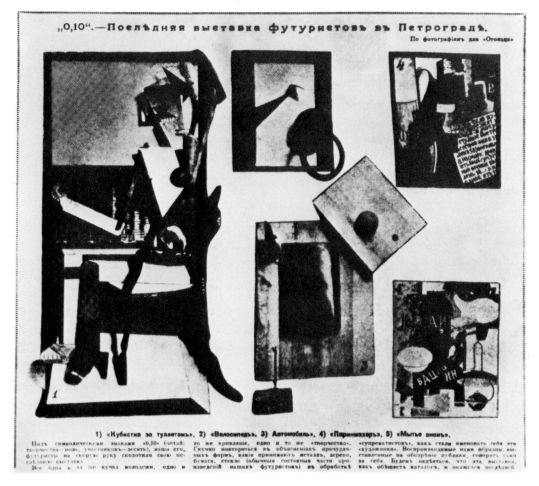

104. A page from the periodical *Ogonek*, 3 January 1916, illustrating reliefs and paintings at the exhibition 0.10. Left is Klyun's *Cubist Woman at her Toilet*, centre two reliefs by Rozanova *Bicyclist* (top) and *Automobile* (bottom), right two paintings by Puni *Barbershop* (top) and *Window Dressing* (bottom). [Photograph Angelica Rudenstine.]

to Suprematism: The New Realism in Painting.[9] Although his paintings were geometrical, his text asserted a sympathy with the mechanistic urbanism of the Italian futurists: 'The new life of iron and the machine, the roar of automobiles, the glitter of electric lights, the whirring of propellers, have awoken the soul, which was stifling in the catacombs of ancient reason and has emerged on roads woven between earth and sky.'[10] Having examined representation and imagery in the cubist and irrational phases of his work, Malevich was in a position to choose to employ them or not: suprematism ensued. The *Black Square*, hung high across a corner at 0.10, stepped beyond representation and beyond imagery, permitting no reading of subject or illusion of space, a negative gesture, undermining cultural conventions that survived even the rigours of cubism intact. Form, no longer linked to depiction, could now be complete in itself: 'I have transformed myself *into the zero of form*, dragged myself from *the rubbish-filled pool of academic art*.'[11] Yet the *Black Square* began a new

language of forms without imagery. Even here, however, one convention survived, even in the radical *Black Square*: that of painting a form against a background. Malevich accepted it vigorously. In a sense even the black square is an image, sharing the frontality and decisiveness of an icon whose suspension across a corner Malevich imitated at 0.10.[12] In complex suprematist painting each geometrical shape in relation to another suggests forms flying in white space. Malevich's commitment to an illusion of movement emphasizes this, transforming austere paintings by a vitality and energy comparable to that of Kandinsky's contemporary compositions: 'Forms move and are born, and we make newer and newer discoveries.'[13] In addition he continued to give titles to paintings although he commented at 0.10: 'I wish to indicate that real forms were looked upon as heaps of formless pictorial masses from which was created the painting which has nothing in common with nature.'[14]

Malevich announced the formation of a suprematist group with Ivan Puni, M. Menkov, Ivan Klyun, Ksenia Boguslavskaya and Olga Rozanova. The group's contribution to 0.10 was characterized by extraordinary titles, some of which appear to indicate lost sculptural works of originality and importance. Klyun exhibited a sequence of seven *Basic Principles of Sculpture* (Cat. Nos. 25–31), a *Flying Sculpture* (32), and *Cubist Woman at her Toilet* (24) (Plate 104). Ivan Puni exhibited *Painterly Sculptures* (110–20). In Tatlin's section the two women, Lyubov Popova and Nadezhda Udaltsova, both showed still lifes, amongst them the *Bottle and Wineglass* by Udaltsova which Tatlin owned.[15] Tatlin provided a counterpoint to Malevich, although Malevich showed thirty-six paintings and Tatlin exhibited only twelve reliefs. Nor were Tatlin's the only three-dimensional works.

105. Olga Rozanova (left), Ksenia Boguslavskaya and Kazimir Malevich at the exhibition 0.10, Petrograd, 1915. [Photograph Herman Berninger, Zurich.]

Tatlin's pamphlet was factual and not in the least theoretical or explanatory.[16] After the briefest biographical note and list of exhibitions of easel paintings, the pamphlet stresses his independence. His studio exhibition, First Exhibition of Painterly Reliefs, is mentioned and the reliefs owned by Puni and Exter reproduced. The pamphlet concludes curtly: 'In 1915 in Tatlin's studio *Corner Counter-Reliefs* were constructed which were exhibited at the subsequent season at an exhibition assembled in Moscow and at the Last Futurist Exhibition [i.e. 0.10] in Petrograd.' The pamphlet illustrated two corner counter-reliefs and dated them 1914–15. The pamphlet itself, dated 17 December 1915, was disseminated at 0.10 and is visible pinned to the wall in one view of Tatlin's part of the exhibition (Plate 106). The publisher of the pamphlet was the *New Journal for Everyone* in whose offices Tatlin found a sympathetic supporter, the critic Sergei Isakov.[17] In the twelfth issue of the journal in 1915 Isakov discussed the reliefs in an article.[18] Nos. 132–44 in the exhibition were by Tatlin and photographs survive of three of them in situ, their numbers reasonably legible (Plates 106–7). One of these, not illustrated in the pamphlet (Plate 107 right), was a dynamically rhythmic relief against a flat background but with no rectangular support, Tatlin having abandoned the residual pictorial surface across which the reliefs owned by Puni and Exter were arranged. Relinquishing this background led to a completeness independent of picture surface. Curved edges and surfaces are combined with agility, with no part superfluous or unconsidered, a relief in which diverse elements are rhythmically united. The curves of shiny metal sheet provided a more subtle yet emphatic rhythmic device than any encountered in earlier reliefs. Tatlin was to use this device several times.

No. 133 at the exhibition (Plate 106) was a corner counter-relief dated 1914–15 in Tatlin's booklet. Whilst not abandoning a painting-like adherence to the wall surface, this relief has nevertheless moved decisively into three-dimensional space, supporting a conglomeration of elements on three wires across a corner space, with an additional vertical wire attaching the foremost projecting element to a point above the relief. No hint of a picture plane remains as the sheets of metal curving through space divide it vigorously in a variety of directions. Tatlin has here an equivalent of picture space, where the painter's illusionistic intersection of planes, as in cubism for example, gives way to a construction in which diverse elements are actually slotted together in a real but bounded space. Tatlin's corner relief is an equivalent to painting and is not free-standing sculpture. Its painterly nature is made clear in a comparison of this relief with Kandinsky's *Composition VII* (see Plates 99–100) which Tatlin could study at the Moscow exhibition, The Year 1915. Where Kandinsky has lines supporting clusters of brushwork, Tatlin has wires across a corner hollowing out an equivalent space (Plate 108). Kandinsky uses planes of coloured pigments, whilst Tatlin's are of bent and curving metal. Where Kandinsky's central focus is a key point in the pictorial cohesion of the work, Tatlin's central focus, like the origin of a three-dimension graph, is the point through which his planes are slotted one through another. Tatlin's relief is still *painterly*, suggesting a gliding, floating space (Plate 109) more easily described through the illusionism of a painted canvas. His relief tips forward to emphasize its suggestion of flight. It also tips to the right and the line of the wires

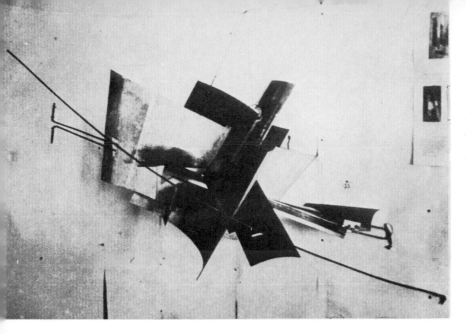

106. Vladimir Tatlin: *Corner Counter-Relief*, 1914–15. Iron, aluminium, paint. Whereabouts unknown. [Photograph A. B. Nakov, Paris.] On display at the exhibition 0.10, Petrograd, 1915, Cat. No. 133. Tatlin's pamphlet is visible at right pinned to the wall.

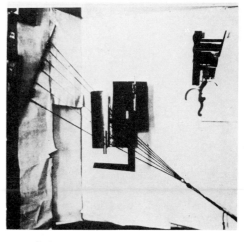

107. Vladimir Tatlin: *Corner Counter-Relief and another relief*, 1914–15. Wood, iron, metal cable, etc. [Photograph A. B. Nakov, Paris.] On display at the exhibition 0.10, Petrograd, 1915, Cat. No. 132.

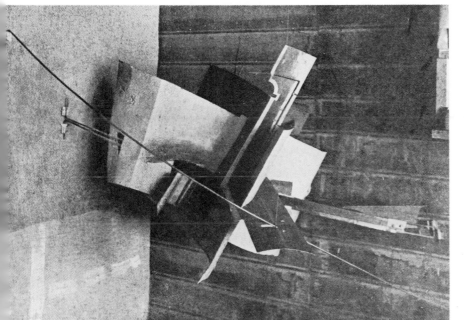

108. Vladimir Tatlin: *Corner Counter-Relief*, 1914–15. Iron, aluminium, paint. Whereabouts unknown. Photograph published in 1921.

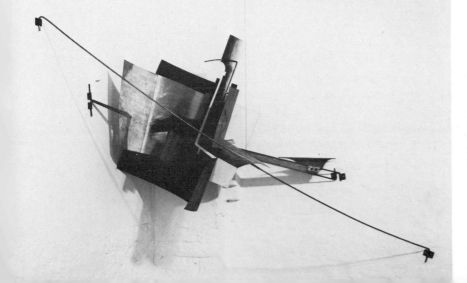

109. Reconstruction of Tatlin's *Corner Counter-Relief*, 1914–15, made by Martyn Chalk, Hull, 1979. Iron, aluminium, zinc, paint, 78.2 × 152.4 × 76.2 cm. Annely Juda Fine Art, London.

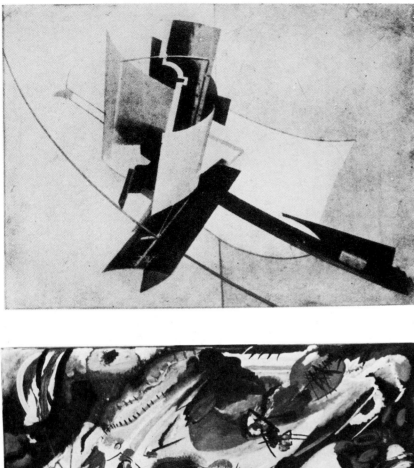

110. Vladimir Tatlin: *Corner Counter-Relief*, 1914–15. Iron, aluminium, paint. Whereabouts unknown. Illustrated in Tatlin's brochure published to accompany his exhibits at 0.10.

111. Vladimir Tatlin: *Drawing*. Ink and wash on paper, 53 × 41 cm. Galerie Jean Chauvelin, Paris.

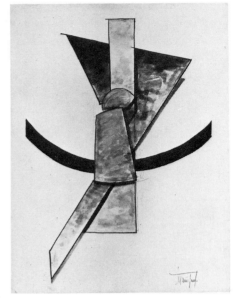

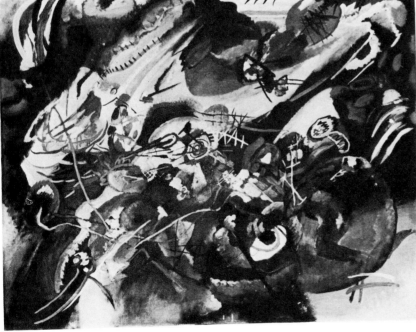

112. Vassily Kandinsky: *Sketch 1 for Composition VII*, 1913. Oil on canvas, 78 × 100 cm. Collection Felix Klee, Bern.

113. Vladimir Tatlin: *Drawing*. Coloured crayon. Galerie Jean Chauvelin, Paris.

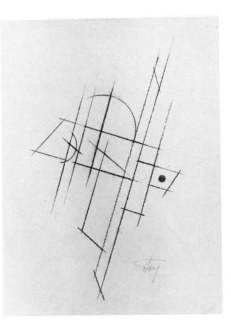

recalls the tilt of Kandinsky's lines (Plates 110–13). The contemporaneity which lends credibility to this comparison is supported by painterly marks on the relief itself. Upper left of the centre a broad sweep of brushmark or of rubbing smears the large light sheet of metal above its cut-away hole; secondly the forward projecting element that links the vertical wire bears a device of crossing lines comparable to a recurrent motif in Kandinsky's *Composition VII*; it is visible at the lower right of studies for the painting. And Kandinsky's lines fulfil a comparable function to Tatlin's wires, penetrating the planes and providing them with dynamic support.[19]

Features linking this corner relief to earlier painterly reliefs include the use of found elements, rigorously organized, despite their irregularity, around a focal point at the heart of the construction from which three axial planes emerge at right-angles each defined by one of the relief's main elements. As the joining of parts reflects their distinct material qualities, connexions are kept simple and explicit.

Connexions with the walls, unpretentious as they are, leave nothing obscured and show no superfluity. The central cluster of sheets of metal is rigid in itself, so that the support provided by wires passing through it is revealed as a separate function. Points of contact are differently resolved on each occasion and for each contrast of materials. Along the tallest central feature runs a metal rod bent back at an acute angle. To connect these two pieces Tatlin has folded a small clip from the sheet metal back over the rod, providing a link that reveals the flexibility of one against the rigidity of the other. The large curved element approaching a half-cylinder provides rigidity in one direction; a large pale element passes through it and the two are pierced by the shallow-curved feature that projects forward from the relief. A rigid structure results. The motif of crossing lines on the foremost surface recalls motifs applied in other works, whilst the corrugated metal, lower left of centre, echoes that of the curvilinear relief hung nearby at 0.10.

Tatlin took pains to show his reliefs against a white paper background which in the photograph of No. 132 at 0.10 was at two points ripped by the relief (Plate 107). Already by 1914, Tatlin's reliefs had become fully three-dimensional, yet here the white paper enhanced the comparison with suprematist picture space.

Tatlin's investigation of specific pieces of material largely side-stepped aesthetic predilection and self-expression, as it relinquished too the traditional materials of sculpture, marble, bronze or stone: construction replaced composition. Each project became a distinct, unique undertaking, the resolution of conflicting material qualities which produced construction. For Tatlin, the investigator, each work had its own solution, demanding that originality which makes a survey of Tatlin's creative career so impressive in its sheer diversity.

Whilst at work on reliefs to be shown at 0.10, Tatlin took up other projects. His neighbour and friend, the painter Alexander Vesnin, enlisted his help on baroque decorative paintings for the house of O. V. Sirotkin at Nizhny-Novgorod. More significant were Tatlin's designs for *The Flying Dutchman* by Wagner.[20] The production was never staged but Tatlin's experience as stage designer and sailor made his knowledge of sails, knots and rigging vitally useful. His life as a sailor had a direct bearing during 1915–18 upon his creative work. If Tatlin was impressed by Kandin-

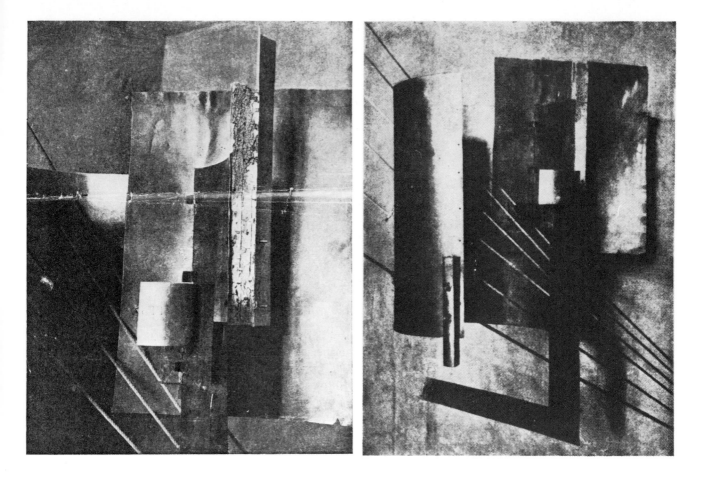

sky's *Composition VII* or a related work, he could also find there both sailing motifs and a love of music. Tatlin was a musical man, albeit within a folk tradition. Once material construction was begun, no ultimate distinction was possible between one kind of creative activity and another.

Construction demanded the abandonment of a special role for bronze and marble, and called into question the academic handling of those materials. Other traditions of handling materials thrived, comprising a history other than art history. The handling of materials could be studied as a language with its own usages and specialities. Wood, stone, metal or glass were all in common use and had, in terms of *faktura*, common means or usages more responsive to material than aesthetic demands. Khlebnikov explored language as material; Tatlin worked with more tangible materials, yet both explored *faktura*, which at its broadest implied the history of the handling of the material world, a study of man's activity as material within a material world. That *faktura* had a historical dimension was as clear to Tatlin as it was to Khlebnikov. Tatlin's experience as a sailor familiarized him with a handling of canvas utterly at odds with that taught at the Moscow College. Beneath enormous sails and intricate rigging, Tatlin inherited procedures in which the handling of materials was precise, practical and articulate. The creak of wood against the sea or the flapping of a sail in the air were conflicts of materials: the ship's structure and survival relied upon articulate handling of those materials to resolve and take advantage of their opposition.

112

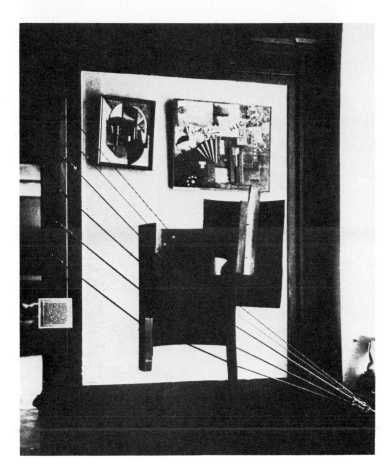

114. Vladimir Tatlin: *Corner Counter-Relief*, 1914–15. Detail of the central section. Russian Museum, Leningrad. Illustrated in Tatlin's pamphlet published to accompany the 0.10 exhibition. Pamphlet in the collection of George Costakis, Athens. [Illustration © George Costakis 1981.]

115. Vladimir Tatlin: *Corner Counter-Relief*, 1914–15. Detail of the central section. Russian Museum, Leningrad. Illustrated in Tatlin's pamphlet published to accompany the 0.10 exhibition.

116. Vladimir Tatlin: *Corner Counter-Relief*, 1914–15. Exhibited at the Russian Museum, Leningrad, 1927.

No. 132 at 0.10 was a corner counter-relief by Tatlin involving ropes and knots quoting the mariner's handling of materials (Plate 107). The linear supports are no more disguised than the rigging on a sailing ship or the strings that cross the wooden surface of such a musical instrument as the many-stringed *banduras* that Tatlin made. This relief comprised a complex assemblage suspended upon six transverse wires rising diagonally from a single support, lower right, to six points of support, upper left. They penetrate the central section by passing between its vertical planes and through a sequence of holes in the largest curving sheet of metal. The spacing of these holes determines the height of the planar elements. Tatlin's pamphlet reproduced two photographs of the central part of the relief (Plates 114–15) which is also seen in full in the photograph taken at 0.10 (Plate 107). A further photograph of the work, exhibited in the Russian Museum in 1927 (Plate 116), shows it modified or repaired, with new pieces of wood replacing the wormeaten pieces originally employed, and without part of one of the supporting cables.[21]

A clear vertical axis runs along the right edge of the largest rectangular sheet which is curved into a part cylinder giving rigidity in one direction. A found element, an inverted *F* in shape, penetrates this curved plane but follows too the vertical axis. A second rectangular plane slots onto the first and it too is penetrated by the *F*-shape, providing the basic interslotting rigid core without the single focal point of the other corner relief. Smaller pieces are attached to this: a small curve of metal attached

113

117. Vladimir Tatlin: *Drawing for a Corner Counter-Relief*, c. 1915. Pencil on paper, 15.7 × 23.5 cm. Collection George Costakis, Athens. [Illustration © George Costakis 1981.]

vertically to the upper wormeaten piece of wood. Four kinds of connection are employed: threading through holes, interslotting sheets of metal, folded back clips of metal, and bolts connecting wood to metal.

Tatlin's use of damaged wood in this relief complements his selection of irregular or dented metal sheet. His handling of these elements and the construction evolved from them relies upon minimal modification of his material. He does not work, as an engineer might, by disposing materials to a predetermined position and function. On the contrary, he evolves his construction from materials to hand. Damaged wood and discarded metal sheeting reveal qualities of their material, and from this arises the construction. He is discovering a coherent structure and not imposing, according to predetermined plans, an arrangement of materials: the construction is discovered (Plates 117–18).

Found elements of two kinds are employed by Tatlin: these comprise fragments, or occasionally the whole, of useful objects which retain connotations of their former use, and fragments of material already cut or shaped but not completely identifiable with specific made objects. This permits Tatlin, without resorting to representation, to retain the associations of certain objects or fragments, recalling not their image but their use and familiar contexts in the world of objects. The reliefs owned by Puni and Exter (Plates 92–3) both function in this way, whilst the corner counter-relief No. 132 at 0.10 in its means of support provoked comparable marine associations (Plate 120). A possibly damaged relief formerly in the collection of George Costakis (now in the Tretyakov Gallery, Moscow) incorporates bent metal, wood and leather upon a drawing-board base. Near the centre of the board the reverse side of an embossed metal sheet recalls icon mounts. This relief incorporates materials with a rich variety of textures rigorously organized across an underlying geometrical structure. Its disposition of parts parallel to the board resembles the painterly reliefs of 1914. However, if elements are lost, a vigorously three-dimensional construction may have been lost too.

The drawing-board base itself has connotations of the studio, a shift from the

114

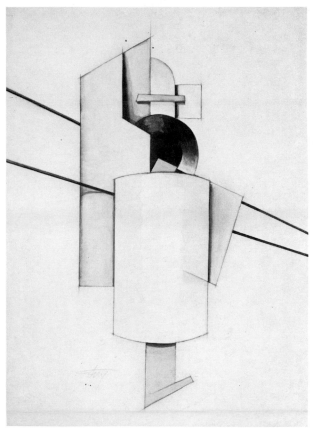

118. Vladimir Tatlin: *Drawing for Corner Counter-Relief*, *c*.1915. Charcoal on paper, 23.3 × 15.7 cm. Collection George Costakis, Athens. [Illustration © George Costakis 1981.]

119. Vladimir Tatlin: *Study for a Counter-Relief*, 1914–15. Gouache and charcoal, 49.4 × 34.2 cm. Museum of Modern Art, New York (Gift of Lauder Foundation).

120. Reconstruction of Tatlin's *Corner Counter-Relief*, 1914–15, made by Martyn Chalk, Hull, 1980–1. Iron, wood, steel wire, cord, pulleys, 225 × 232 × 82 cm. Annely Juda Fine Art, London.

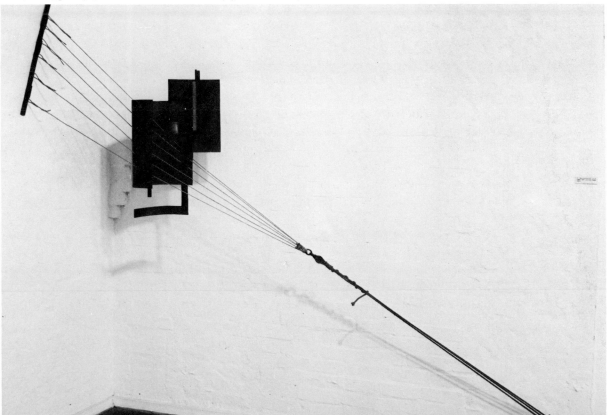

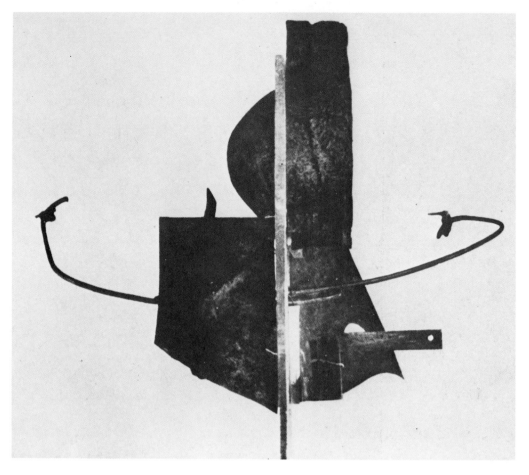

121. Vladimir Tatlin:
Centre-Relief, c. 1915. Iron
with assembled elements
including a palette and
set square. Whereabouts
unknown.

122. Vladimir Tatlin:
*Centre-Relief with Cyrillic
Letters DRU, c.* 1916.
Mixed media.
Whereabouts unknown.
Photograph published in
Vytvarne Umeni, No. 8–9,
Prague, 1967.

123. Vladimir Tatlin:
*Drawing for a Counter-
Relief, c.* 1915–16.
Charcoal on paper, 31.8 ×
24.1 cm. Collection
McCrory Corporation,
New York.

academic concern with depiction, to the tools of the studio. By shifting the context
within which the object is encountered, Tatlin draws attention to the uses associated
with the objects incorporated into his reliefs. The activities of the painter may have
merited special attention in this respect. A relief known only in one photograph
includes a set square and a palette (Plate 121), finely finished man-made objects within
a construction of bent and weathered metal. The firm central axis is preserved in this
relief although peripheral attachments are also made. Not apparently a corner relief,
this could have been attached to a flat vertical wall. A photograph (Plate 122) survives
of a further 'centre relief' supported by a wire in this fashion, similarly featuring a
vertical plane perpendicular to the wall. Both reliefs rely upon axial planes at right-
angles which organize irregular elements by reference to an underlying geometry. The
wriggle of corrugated metal that emerges at an angle at the base of the relief that is
wall-mounted recalls directly the use of such metal in at least two pieces shown at
0.10, where it too may have been shown, for its method of support is basically that of
a corner 'counter-relief' adapted to the flat wall. Tatlin reserved the term 'relief' for
constructions that could be hung against a flat wall, and 0.10 included such works.
Counter-relief by contrast demanded space behind the construction as well as in front
(Plate 123). Reliance upon a flat surface hinted again at a painting, as did construction
from a plaster base, closer perhaps to the relief objects made by Picasso in 1913. As

116

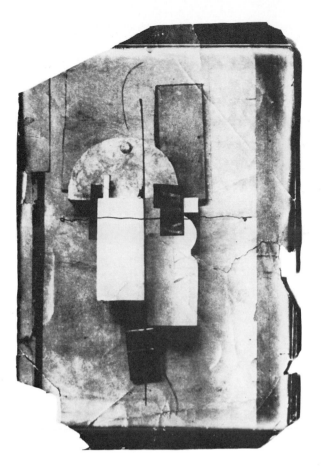

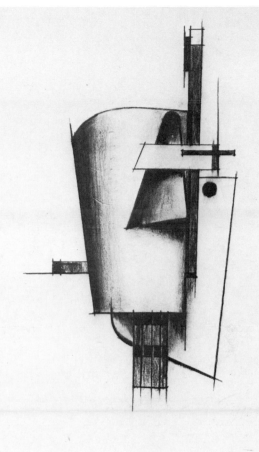

the lettering in the Cyrillic form of *DRU* indicates, cubist devices were not far from Tatlin's mind. His colleagues were just beginning to emerge from cubism. Tatlin did much to lead the way, yet he still held Picasso in high respect and continued to reflect upon his innovations. It is essential, however, to recognize that distinctly Russian developments involved Tatlin directly, exerting upon him influences that arose from cultural researches without precedent or equivalent in Western Europe: Khlebnikov complemented but also in part supplanted Picasso. Furthermore, as historical events progressively impinged upon creative work in all fields, so the theory of history developed by Khlebnikov alongside poetic, linguistic and ornithological studies, began to influence his contemporaries.

One response to the war was to organize fund-raising charitable exhibitions. L. I. Zheverzheyev lent to the Dobychina Gallery in Petrograd a selection of theatrical designs from his enormous collection, including designs by Tatlin for *Tsar Maximilian* and by Malevich for *Victory over the Sun*, in addition to eighteenth and nineteenth-century works.[22] An auction of art works, arranged by the Society for the Encouragement of the Arts, raised more than 5000 roubles to assist the victims of war and included works by Natan Altman, an exhibitor at 0.10, and Lev Bruni, the painter friend of Tatlin from Petrograd, who with the artists Pyotr Miturich and Tyrsa was increasingly recognized as a draughtsman of promise.[23]

117

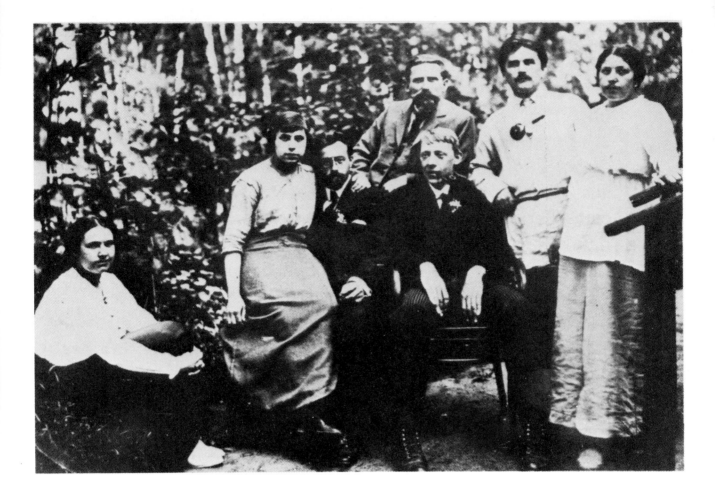

Khlebnikov's response to the war reflected the trend of his thought since the sinking of the Russian fleet at Tsushima in the Russo-Japanese War. Khlebnikov had then determined to discover mathematical laws governing human history. The nature of time preoccupied him, and current theories of a fourth dimension encouraged this. Matyushin had discussed these theories, and Malevich at 0.10 had reflected this interest in suprematist paintings. The title of No. 40, for example, was *Pictorial Realism of a Footballer—Colour Masses in the Fourth Dimension.*[24] The popular writings of Pyotr Uspensky gave these theories an historical interpretation and Matyushin had even discussed cubism in this context. 'Objects,' wrote Malevich in his pamphlet to launch suprematism, 'embody a mass of moments in time. Their forms are various, and consequently their depictions are various.'[25]

Khlebnikov, who studied the evolution of word-roots as a material manipulated by man, considered that human history had a structure, a rhythm and shape susceptible to study and even prediction. He considered that all material had a temporal dimension, no less precise than the three dimensions of space. The evolution of human history was no exception and by the spring of 1914 Khlebnikov had begun to plan a government not of space but of time, led by designated 'Presidents of the Globe'. Khlebnikov, adopting the title 'Velimir I, King of Time', in 1915 founded a society to

118

124. Group photograph taken at Nemchinovka, *c.* 1915. Tatlin is seated (with pipe); behind him stand Ivan Klyun (left) and Kazimir Malevich (right). [Photograph A. B. Nakov, Paris.]

125. Vladimir Mayakovsky: *Portrait of Khlebnikov*, 1915. Ink on paper. State Mayakovsky Museum, Moscow.

promote the awareness of history's hidden structure, the Society of 317, which by 1918 included Malevich, Pasternak, several pilots, an Ethiopian and a Chinaman.[26] The 317 of the Society's title derived from Khlebnikov's theory that 317 years comprised an historical wave, determining the rhythm of great events. The numbers 365 and 28 were vital, said Khlebnikov, to national and individual fates respectively.

Khlebnikov sought the hidden rhythms of history through a mathematical study of dates: 413 years, according to Khlebnikov, divided the beginnings of ages, and 951 years marked great campaigns repulsed. With Europe in turmoil in 1915, Khlebnikov predicted the end of a state in 1917. The accuracy of this prediction was to add authority to his assertions. Matyushin published in 1914 Khlebnikov's *Battles 1915–1917: A New Teaching about War*, which included this prediction. Theories of time and history were inextricable in his writings from those concerning birdflight or the structure of language. These utterly diverse elements found a fruitful cohesion in the poetry which became Tatlin's favourite reading.[27] Khlebnikov visited 0.10, as well he might, for both of its opposing key figures, Malevich and Tatlin, were indebted to the extraordinary tenor of his thoughts. For his friend Tatlin, Khlebnikov wrote a panegyric of his work to serve as a complementary guide to the reliefs and counter-reliefs.

119

Tatlin

Tatlin, initiate of whirling blades
And austere singer of the screw-propeller,
One of the order of sun-catchers,
With a mighty hand has bent
The iron horse-shoe
To knot the spidery veil of rigging.
Dumb and blind, the pincers
Look into the heart of secrets
Which he has demonstrated.
Just as unsung and possessed of deep knowledge
Are the tin objects which he has worked with a brush.

Tatlin, taynovidets lopastey
I vinta pevets surovyy,
Iz otryada solntselovov.
Pautinnyy dol snastey
On zheleznoyu podkovoy
Rukoy mertvoy zavyazal.
V taynovidene shchiptsy
Smotryat, shto on pokazal,
Onemevshie sleptsy.
Tak neslykhanny i veshchi,
Zhestyanye kistyu veshchi.

Velimir Khlebnikov, 1916[28]

Khlebnikov's 'spidery veil of rigging' recognizably refers to exhibit No. 132 at 0.10. Tatlin owned the manuscript of the poem which he preserved religiously.

During 1916 their association flourished. Khlebnikov produced three major publications during the early part of the year. In April Matyushin published Khlebnikov's latest mathematical and historical work, *Time is the Measure of the World*,[29] and in the same year a prose text, *Ka*, was published in which the central figure flits from century to century 'as comfortable in the centuries as in a rocking chair'.[30] Intersplicing of imagery occurs recalling the interslotting planes of cubist painting:

The dull breakers, sparkling at their crests, shone through him. A seagull, flying past behind the grey spectre, was visible through his shoulders, but less vivid in hue. Having flown past, the gull reclaimed its bright, black-white plumage. Ka was bisected by a girl in a green swimming suit covered with silver spots. He shuddered and reclaimed his former silhouette.

His preoccupation with time, history and mathematics was growing. An untitled fragment of 1916 proclaims:

We took $\sqrt{(-1)}$ and used him for a table. Our Go-dive-plane was built from glass, thought and iron—it flew, it ran and it dived. Wheels, surfaces, propellers. What

120

was visible was very successfully and rapidly printed onto the window of the Dive-plane-runner by lightwriting. We were studying what we could learn from photographs. Here are the guides' faces. Here is a flock of swallows. And seagulls, tree-stumps, water, fishes. Underwater, beneath the sea, we listened to the laughter of the enemy on the other side of the world. I was writing out a text in a far-off city, slowly drawing out the words. I grew thoughtful. A century of war was passing before me.[31]

The Society of 317 published in 1916 Khlebnikov's prophetic scroll *The Trumpet of the Martians* proclaiming time as the fourth dimension. The opening section, signed by Khlebnikov, Maria Sinyakova, Bozhidar, Grigoriy Petnikov and Nikolai Aseyev, proclaimed that man in the past had erected the sail of government only in the dimensions of space: 'Clad only in the cloak of victory, we begin construction of a young union with a sail around the axis of time, anticipating from the earliest, that our measure is greater than Cheops, and our task brave, enormous and rigorous.'[32] Khlebnikov's imagery is full of ships: he thought of his poems as sails erected in the flow of time. Part one of the manifesto ends 'Groan, black sails of time!' Common to the consciousness of both Khlebnikov and Tatlin were the sea and those black sails of time, the movement of history and the rhythm of its waves. 'May the Milky Way split,' declared the manifesto, 'into a Milky Way of inventors and a Milky Way of those who acquire. This is the word of a new Holy War.'[33]

Tatlin, at the height of this activity, was collaborating with Khlebnikov on an evening performance staged at Tsarytsyn, where D. Petrovsky read Khlebnikov's 'Iron Wings', which referred to Tatlin's reliefs and the brushwork upon them. Tatlin was involved personally and directly with the presentation of Khlebnikov's work on this occasion and not for the last time.

Mohammedan themes in Khlebnikov's writing, whether of Holy War or Paradise, recall his origins in Astrakhan. His sense of personal identity owed as much to Central Southern Asia as to Europe. Tatlin had sailed the Black Sea, but Khlebnikov's origins were more Eastern, from the shores of the Caspian Sea, the coastline of which is shared with Persia. Khlebnikov periodically wandered in Asia, impossible to contact. In spring 1916 he set out for Astrakhan but was drafted into the Tsarist Army. He did not adjust well and was soon discharged: 'I am a Dervish,' wrote Khlebnikov to the painter Kulbin, 'a yogi, a Martian, anything but a private in a reserve regiment.'[34]

Khlebnikov's imagery of sails and ships echoed Tatlin's experience, and its importance for his reliefs may be considerable. Tatlin was again at work on a nautical theme combining his knowledge of construction and seamanship in a project of 1915–16 for which he created a wooden ship to be used in a mystical film, *Spectral Charms* (Navi chary), based on Fyodor Sologub's novel and directed by Vsevolod Meyerhold. It featured an enormous wooden mast with all the appropriate fittings of riggings and crow's nest.[35] Filming began in summer 1917 only to be overtaken by revolution. The war prevented Tatlin from sailing, but did nothing to drive the sea or ships from his mind.

When Tatlin showed reliefs in Moscow he did so in an exhibition organized by

Клюнъ И. В.
Сокольники, 4-й Полевой, 10.
14. Граммофонъ.
15. Озонаторъ.
16. Арисмометръ.
17. Футуристическій пейзажъ.
18. Голова пильщика.
19. Пробѣгающій пейзажъ.
20. Автопортретъ.

Малевичъ Казимиръ
3-й Яжской пер., д. 5, кв. 3.
21. Корова и скрипка.
22. Шахматистъ.
23. Англичанинъ въ Москвѣ.
24. Авіаторъ.
25. Кубистическое построеніе
26. Дачникъ.
27. Военный портной 1914 г.
28. Дама
29. Шахъ и матъ
30. Лакей съ самоваромъ (Собраніе А. М. Константиновна).

Моргуновъ Алексѣй Алексѣевичъ.
31.
32.
33.
34.
35.
36.
37.
38.
39.

Пестель Вѣра Ефремовна
Москва, Грибоѣдовскій 4, кв. 3 (Плющиха),
40. Чайная (1915 г.).
41. Бидоны (1915 г.).
42. Игроки въ карты (1915 г.).

43. Мертвая натура (1916 г.).
44. Дама съ самоваромъ (1915 г.).
45. Сундукъ и чайникъ (монохромный рельефъ 1916 г.).
46. Художникъ Татлинъ и бандура (1916 г.).

Попова Любовь Сергѣевна
Новинскій бульваръ, 117.
47. Дама съ гитарой (1915 г.).
48. Скрипка (1914 г.).
49. Портретъ (1915 г.).
50. Рисунокъ къ портрету (1915 г.).
51. Путешественница (1915 г.).
52. Бутылка и стаканъ (1915 г.).
53. Ваза и фрукты (1915 г.).
54. Кувшинъ на столѣ (пластическая живопись 1915 г.).
55. Игра въ карты (живопись пластическое равновѣсіе 1915 г.).

Родченко Александръ Михаиловичъ
Каретно-Садовая, д. 4, кв. 1.
56. Двѣ фигуры.
57. Рисунокъ къ картинѣ „Двѣ фигуры".
58. Танцовщица.
59.
60.
61.
62. графика.
63.
64.
65. Натюръ мортъ (обои).

Татлинъ Владиміръ Евграфовичъ
Москва (Плющ.), Грибоѣд. 4, кв. 3, т. 1-88-42.
66.
67. угловые контръ-рельефы 1914—1915 г.
68.
69.
70. рельефы 1913—1914 г.
71.
72. рельефъ 1915 г.

127. Page from the catalogue of the exhibition The Store, 1916. Alexander Rodchenko Archive, Moscow. Tatlin's reliefs are listed, Cat. Nos. 66-72, but in addition Vera Pestel exhibited a painting of Tatlin with a *bandura* (Cat. No. 46).

himself, The Store (Magazin), held in an empty shop at 17 Petrovka Street in March 1916. Despite their real antagonism over suprematism, Tatlin invited Malevich to participate. Malevich tactfully, or through Tatlin's persuasion, showed irrational ('alogist') and cubist works, amongst them the *Englishman in Moscow* (Plate 98), the *Aviator* and the *Cow and Violin*. Suprematism nevertheless exerted an increasing influence upon painters close to Malevich and even upon those close to Tatlin. As Popova, Exter, Udaltsova and Klyun emerged from cubism, a modified suprematism attracted them all. The Store represented no more than a temporary setback for the movement.

Tatlin exhibited seven constructions—four reliefs of 1913-14 (Cat. Nos. 68–71), two corner counter-reliefs (66–7) and a relief from 1915 (72) substantially repeating his section at 0.10 (Plate 127). The monthly *Apollon* reported 'corner counter-reliefs with intersecting surfaces of aluminium, thin sheet metal, iron, wood and card-board'.[36] The shop on Petrovka Street had two rooms. In the first hung Tatlin's reliefs alongside the works of Popova (*Playing Cards (Pictorial Plastic Balance)*—55), Exter, Udaltsova (who again exhibited the *Bottle and Wineglass* (78) owned by Tatlin), Klyun, Malevich and Bruni. Sofya Dymshits-Tolstaya and Morgunov also exhibited; Wassilieff, Pestel and Ostetskov were in the second room, together with Rodchenko, who was making his exhibition début on Tatlin's suggestion.

Having been impressed by the futurist tour when it reached Kazan, Alexander Rodchenko had travelled to Moscow to study, progressing rapidly via cubism to paintings constructed with ruler and compasses, often texturing his pigment to indicate *faktura*. He became a central figure in the exploration of construction. The Store introduced him directly to the conflict of Tatlin and Malevich, on the personal level and in his painting. Rodchenko, like Exter, Popova, Vesnin and others, found in this conflict a fruitful dichotomy. Tatlin already knew Rodchenko's wife, Varvara

Stepanova. He met Rodchenko on a visit to Vesnin. Later Tatlin, organizing The Store, visited Rodchenko to inspect his work, and invited him to contribute. Costs were shared amongst the exhibitors and Rodchenko was employed to sell tickets.

Rodchenko witnessed the continuing antagonism of Malevich and Tatlin at the opening of The Store: 'Do you know,' Rodchenko recalled Malevich commenting, 'that everything they have done has already been seen and already been made? All of that is out of date. Now we must make new things, something nearer ourselves, something more Russian. That's what I am doing myself: and you already intuitively are doing the same, it's in the air.'[37]

Though cubism persisted at The Store, new attitudes had begun to supercede it. Rodchenko admired Malevich's paintings, as 'they were fresh and original with no resemblance to Picasso'. Of contributors to The Store, the women, Popova, Wassilieff, Exter and Udaltsova, had all studied in Paris and been affected by cubism, as had Tatlin and his friend Lev Bruni. The impact of Paris had by 1916 found an answer that was overtly Russian. Suprematist paintings by Malevich and constructions by Tatlin comprised indigenous developments of forceful originality, and the basis for much that was to follow. Lev Bruni, a draughtsman of restraint and beauty, began to make constructions. At The Store, according to Rodchenko, 'Bruni showed a broken-up barrel of cement and a pane of glass which had been pierced by a bullet. Both works were bound to arouse the indignation of the public.' This element of provocation owed much to the Russian futurists' noisy rejection of conventions. In *Took—The Futurists' Drum* (Plate 95) at the close of 1915, Mayakovsky had made three demands to: '(1) Smash the ice-cream mould of every kind of rule for making ice of inspiration, (2) Break the old language that is powerless to keep up with the speed of life, (3) Throw out the old greats from the steamer of modernity.'[38] Bruni's exhibits embodied his iconoclasm. At the exhibition The Year 1915, according to the painter Lentulov, 'Mayakovsky exhibited a top-hat that he had cut in two and nailed two gloves next to it'; whilst 'Kamensky asked the jury persuasively to let him exhibit a live mouse in a mousetrap.'[39] Bruni's exhibits owed a debt both to Tatlin's constructions and to the outrageous precedent of the poets' exhibiting tactics.

Writing in his monthly 'Letter from Moscow' in the Petrograd periodical *Apollon*, the critic Tugendhold, who visited The Store, referred to a three-dimensional relief by Lev Bruni (see Plate 128) and a 'glass relief' painted both sides by S. Tolstaya (*sic*). Regretting what he saw as an attempt to keep up to date, Tugendhold was particularly sad for Tatlin, Udaltsova, Exter and Rodchenko, whom he considered 'especially talented'. In an exasperated conclusion he declared that 'the exhibition The Store does indeed provoke the impression of a shop—an old second-hand junk shop!'[40]

Ivan Puni had exhibited 'painterly sculptures' at 0.10, and Ivan Klyun had also shown sculptures there. Now, at The Store, Tatlin was not alone in exhibiting three-dimensional pieces, for Bruni and Dymshits-Tolstaya were contributing too. Tatlin's reliefs were increasingly influential, and Rodchenko considered Tatlin his 'Master'.[41] *Apollon* magazine was to condemn this influence by 1917, pointing scathingly in an editorial to 'counter-reliefs like model aeroplanes' and proclaiming with confidence: 'You can be sure that the modern poets and artists are not those writing in some future

124

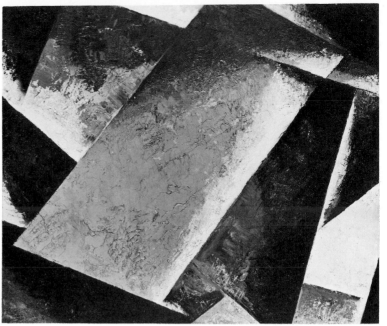

128. Lev Bruni: *Construction, c.* 1917. Aluminium, wood, rubber, etc. Whereabouts unknown.

129. Lyubov Popova: *Pictorial Architectonic*, 1918. Oil on canvas, 45 × 53 cm. Collection Thyssen-Bornemisza, Lugano, Switzerland.

language; they are far away from the researches of Mr Tatlin.'[42] The editor of *Apollon* took for granted the interrelation of verbal and visual elements in the works of which he disapproved. Significantly, Tatlin invited Khlebnikov to visit the exhibition in Moscow.

Tatlin exerted an ever widening influence, manifest from 1916 as a tendency towards construction. His achievement was beyond painting, and perhaps beyond art altogether. Yet his followers responded first to the visual appearance of his works more than to the process and method that they embodied. Construction was not confined to painting, and considerations of style no longer applied. His work, in consequence, showed no stylistic coherence for its development. Tatlin's investigation took him beyond style, along a path where creative activity itself was redefined.

Rodchenko was amongst the first to follow Tatlin's study of material and *faktura* in constructions. Rodchenko tried to move beyond taste, style and personal expression. Through contact with Tatlin, he began to study construction on the two-dimensional surfaces of paintings. Rodchenko was also impressed by Malevich, yet much of the motivation for his search began with Tatlin's conclusion that *faktura* and material produce construction. It remained a central tenet of Rodchenko's work over many years. His research into construction continued alongside that of Tatlin. Their means and their temperaments differed, but from 1916 the study of construction began to spread, generating a critique of creative activity that was rigorous, austere and rewarding. Tatlin appeared to be a pioneer explorer whose findings were eagerly awaited. The Columbus of new lands of poetry was Mayakovsky's description of Khlebnikov. Tatlin likewise explored new lands of creativity.

If The Store exhibition provided a temporary victory for Tatlin over suprematism, in November 1916 it emerged with a vengeance at the Knave of Diamonds exhibition in

125

Moscow. *Apollon* reviewed the exhibition, paying special attention to suprematism, and announced that 'the representatives of the newest tendencies evidently intend to collaborate on a monthly journal, *Supremus*, which will commence in Moscow in December or January, and will be dedicated to painting, decorative art, music and literature. The chief organizers and participants are Malevich, Rozanova, Puni, Exter, Klyun and Minkov.'[43] Klyun exhibited paintings and sculpture under the heading 'Non-objective creativity. Suprematism'. Malevich showed suprematist works, and Exter contributed designs for *Famira Kifared*, a play staged by the director Alexander Tairov at his recently opened Kamerny Theatre in Moscow. Her designs displayed a simplicity of form reminiscent of sets by Appia and Craig. The Knave of Diamonds featured many non-suprematists including Natan Altman who showed his high relief *Head of a Young Jew*. David and Vladimir Burlyuk exhibited, as did Chagall, Falk, Kuprin and Udaltsova. Popova exhibited a sequence of 'pictorial architectonics' under the group title *Shakhi Zinda*, after the name of the Moslem monuments of Samarkand.

The floating picture space of Malevich's most complex suprematist paintings of 1916 is reflected directly in paintings by Klyun, Exter and Popova, yet in each case, where Malevich overlaps forms and implies that space flows freely between them, Klyun, Exter and Popova (Plate 129) modify this to lock forms one against another paying attention to their structure, slotting geometrical elements through each other, as if depicting a construction made from planes interlinked as Tatlin might use. These works respond vigorously to both Tatlin and Malevich, in an attempt to form a synthesis between their divergent innovations.

Apollon magazine late in 1916 noted the emergence of a suprematist group at the recent Knave of Diamonds exhibition, but also announced new books from the Tsentrifuga (Centrifuge) publishing house, Moscow. Exter designed the publisher's logo. Their authors included Aseyev, a member of Khlebnikov's Society of 317, and the critic-theorist Aksenov.[44]

Khlebnikov had recently admitted H. G. Wells and Marinetti to his parliament of Presidents of the Globe.[45] In addition, Khlebnikov's extensive study of linguistic history and new words in poetry encouraged cooperation between linguists and poets. The Society for the Study of Poetic Language (Opoyaz) was established in 1916 by Mayakovsky's friends Osip and Lilya Brik together with Viktor Shklovsky, meeting weekly to discuss structure in language and art.[46]

Perched upon a carnival float beneath the banner 'The Presidents of the Globe', Khlebnikov, self-styled King of Time, progressed along Nevsky Prospekt in the heart of Petrograd early in 1917 proclaiming himself, the embodiment of an extraordinary vision that linked literature and the visual arts to an unprecedented concept of time and space, and predicting the collapse of an empire that very year. As the year unfolded, the prediction was fulfilled. Khlebnikov found himself in the midst of historical events that were to transform the nature and purpose of cultural activity. In that transformation his contemporaries increasingly sought guidance in the poet's speculations concerning creativity and the nature of time.

6 CONSTRUCTION AND PAINTING

WHEN the industrialist Filippov began, early in 1917, to arrange for the decoration of the Red Cock café at 5 Kuznetsky Bridge in Moscow, soon to be transformed into the Café Pittoresque, he called in Vladimir Tatlin as adviser.[1] If the decorations were not directly from Tatlin's hand, he nevertheless remained a powerful influence over the adoption of relief elements at the café. The Georgian painter Georgiy Yakulov (Plate 130) was the overall organizer of the mural decorations and three-dimensional constructions. Yakulov had just returned wounded from the front, but in 1913 had travelled to Paris and to Berlin. His designs for the Café Pittoresque were executed to reflect the light filtering through the roof windows (Plate 131). He also devised complex constructions suspended from lamps. The mixing of reflected and direct light provided a prismatic and kinetic effect within the vault of the once stark hall, whose art nouveau fittings provided many points of attachment for devices by Yakulov, Rodchenko (Plate 132) and others. Such preoccupation with light linked Yakulov with Delaunay, for both of whom it carried cosmic connotations. Delaunay also provided a theme for the writer Ivan Aksenov, who in 1915 had joined the Centrifuge group and who planned a book about Delaunay; in 1916 he published poems inspired by Delaunay's paintings of the Eiffel Tower.[2] Those cosmic connotations in turn were of interest to Khlebnikov, whose mathematical view of history was inevitably bound up with the movement of sun, moon and stars measuring time, space and human evolution. Khlebnikov was determined to gather to the Café Pittoresque all the Presidents of the Globe in his government of time. The café became a busy meeting place of great vitality for creative people during 1917–19.

The design by Yakulov for the stage area at the Café Pittoresque suggests the dynamic clutter of the interior. It reveals a vitality characteristic of Yakulov and soon to become evident in theatrical design. Amongst his assistants working at the café were Goloshchapov, who executed hanging metallic mobiles, Osmerkin who painted the glass after Yakulov's designs, and Varomilsky who made a chandelier from suspended tin-plate cones. In addition, Rodchenko executed designs for lamps, and Bruni, Dymshits-Tolstaya, Udaltsova and Tatlin were involved, as were Boguslavskaya, Golova, Shaposhnikov and Rybnikov, according to a letter written by Yakulov to Lunacharsky on 19 August 1918.[3] The café opened on 30 January 1918. Not all of the decorations were constructed and some were figurative (Plate 133). The constructed

figure visible in a photograph of a corner of the Café Pittoresque is comparable with later theatrical designs by Yakulov and was probably designed by him. The figure painted on the wall is probably by Yakulov too. The constructed figure shows the continuing influence of the assemblage techniques of Archipenko and Baranoff-Rossiné at work; the painted figure is much closer to contemporary pictorial experiments by Rodchenko.

Construction, within a decorative and theatrical atmosphere, dominated this Moscow meeting place in 1917. The corner disks, interslotted, recall both the constructions of Tatlin and the disks of Delaunay. They are probably after designs by Yakulov or a close assistant, but they do reveal two potent and pervasive influences operative during the decoration of the café, involving numerous painters and sculptors in an extension of their studios into three dimensions.

Interslotting circular disks can comprise a stereometric sphere. Naum Gabo, a Russian recently returned from Western Europe, was constructing figures by comparable stereometric structures at this time (Plate 134), but for Gabo pose and counterpoise remained as vital. This kind of construction was the antithesis of Tatlin's, for Gabo worked by cutting and welding, by imposing his concept upon the material employed and by forcing it to fulfil particular predetermined roles.

Rodchenko's lamps for the Café Pittoresque (Plate 132) were close to Tatlin's constructions. Curving metal sheets, slotted one through another, reflect and disperse the light from a concealed source. Their light-reflecting qualities owe more to Yakulov's overall plan, however, than to Tatlin's method of construction. In addition, the looseness of the corner-mounted disks or the figurative content of much that was displayed at the Café Pittoresque could scarcely be reconciled to Tatlin's austere

130. Vladimir Mayakovsky: *Portrait of Georgiy Yakulov*, 1916. Charcoal. Whereabouts unknown (formerly collection Osip Brik).

131. (facing page top) Georgiy Yakulov: *Design for decorations at the Café Pittoresque*, 1917. Pencil on paper, 26.5 × 20.5 cm, signed, inscribed 'for the Café Pittoresque'. Musée National d'Art Moderne, Paris.

132. Alexander Rodchenko: *Lamp design for Café Pittoresque*, 1917. Pencil on paper, 26.5 × 20.5 cm, signed, inscribed 'for the Café Pittoresque'. Whereabouts unknown.

133. A Corner of the Café Pittoresque, 1917.

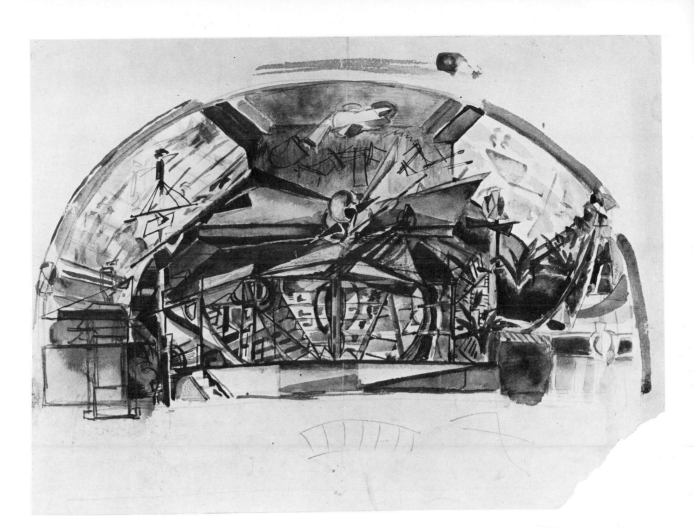

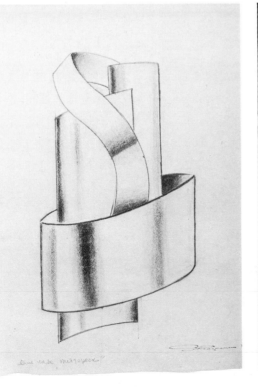

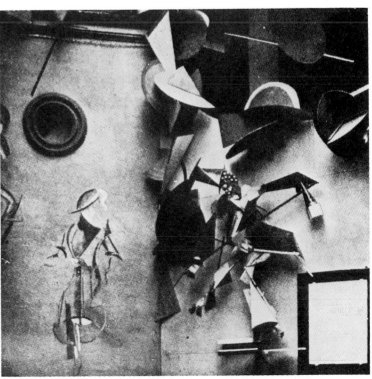

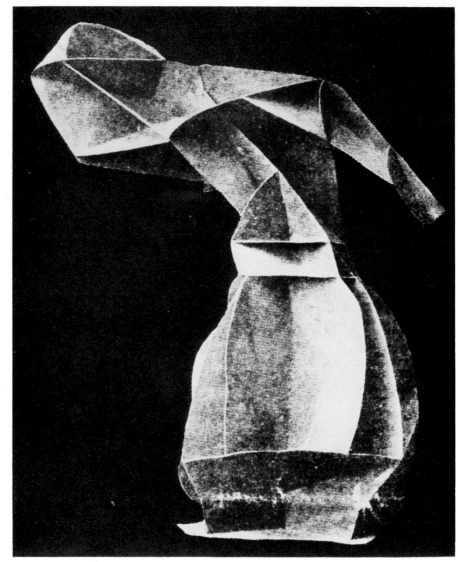

134. Naum Gabo: *Torso*, 1917. Sheet metal treated with sand. Whereabouts unknown.

135. Alexander Rodchenko: *Composition 56(76)*, 1917. Oil on canvas, 88.5 × 70.5 cm, inscribed on reverse: 'A modification of the plane through its execution in terms of *faktura*'. Tretyakov Gallery, Moscow.

136. Vladimir Tatlin: *Board No. 1*, 1917. Tempera and gilt on board, 105 × 57 cm. Tretyakov Gallery, Moscow.

methods. This was a decorative scheme first and foremost: 'My project was intended,' wrote Yakulov to Lunacharsky, 'to make, in decorative terms, a sort of popular street fair, like the Quartier fairs of Paris.' An assistant described the scene: 'There were all manner of fantastic figures in card, plywood and paper: lyre-shapes, angles, circles, funnels and constructions with spirals. Within the interior of this mass were disposed lamps. All this was irridescent with light: it all moved and vibrated. It seemed that the entire decoration was in movement.'[4]

Rodchenko, Popova and others in their studios continued to explore pictorial construction as a middle way between Malevich and Tatlin, by intersecting planes across the two-dimensional picture surface, by stressing the materiality of both paint or ground by varied texture of application, by contradictory illusions within picture space, and by leaving canvas or wood visible. *Composition 56(76)* by Rodchenko in the Tretyakov Gallery, Moscow (Plate 135), is subtitled, on the reverse, 'a modification

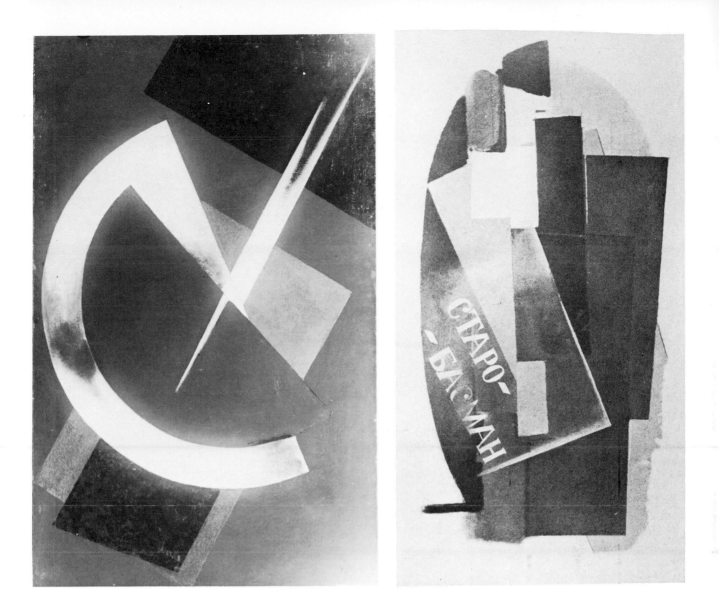

of the plane through its execution in terms of *faktura*'. In painting too *faktura* and material produced construction.

Certain of these painterly questions were approached by Tatlin in 1917 in *Board No. 1* (Plate 136). The painting is distinctly cubist in flavour and boldly inscribed with the capital letters 'STARO BASMAN', a reference to Tatlin's own address in Staro-Basmannaya Street in Moscow, the studio described by Rodchenko at the time of his earliest contact with Tatlin: 'Vladimir Evgrafovich Tatlin lived on Staro-Basmannaya Street on the eighth or ninth floor, in a flat belonging to the railway administration. He had made a studio in the loft which he heated himself. The studio was very strange: it was made with great sheets of plywood which served as partitions. There he lived all alone. Appropriately for a former sailor, everything was clean and in its place.'[5] Apart from this autobiographical detail with its cubist flavour, *Board No. 1* is comparable with attempts by Tatlin's contemporaries to define construction in terms

of painting. Tatlin, who began his creative career as a painter, had continued to refer to painting in his reliefs. 'Painterly relief' was a title he continued to employ. A related consideration is the degree to which an element of depiction survived in his reliefs and counter-reliefs.

When painters responded to Tatlin's work, Rodchenko and Popova amongst them, the result was a study of construction applied to the activity of painting. In so far as Tatlin had defined creative activity in material terms, this led to a broadening of the choice of materials even for painters, although it did not exclude paint, canvas or board. The main difficulty in using these particular materials was their association with traditional techniques of painting. To reapproach the traditional materials of painting was a difficult process and dangerous from the point of view of keeping the new study of construction clear. Tatlin used several kinds of paint, as did Rodchenko in 1917—lacquers, varnishes and metal paints. The language of handling paint that attracted Tatlin was as close to the sign-painter as to the academician. Contrasting paints and pigments one against another emphasized their material differences and militated against traditions of representation and depiction.

Tatlin's title for the painting *Board No. 1* was firmly factual, describing materials and rejecting any hint of representation. The oval painted section is interrupted at the right and along its lower edge, so that it may not be read as an illusion of a space through which to look. The viewer is continually reminded of the surface by devices which Tatlin shares with Popova and Rodchenko. Yet the planes which cross the surface appear to interslot. An element of illusionism does remain here, again as in works by Rodchenko and Popova, which is counterbalanced by reminders of the picture surface.

The painted planes are of two kinds, those reflecting the vertical axis left of centre, and those responding to an emphatic diagonal established by the lettering and adjacent edges. The two-axis construction is characteristic of Tatlin throughout his reliefs although here it is planes of paint that are assembled. At bottom right is the ragged edge of a plane that ascends through the painting diagonally intersecting vertical elements. This angle is repeated in the transparent plane inscribed 'STARO BASMAN'. A further transparent plane overlaps features parallel to the vertical axis. This interslotting of planes is equivalent to the interslotting of metal sheets in the reliefs. 'STARO BASMAN', the lettering which emulates a street-sign, refers to the factual evidence of Tatlin's address. The intersecting diagonal planes move through the main structure with a taut coherence not equalled by Rodchenko or Popova. *Board No. 1* was a substantial contribution to the study of construction in painting.

Tatlin's use of lettering in this painting and in at least one relief indicates the continuing importance of cubism. Cubism had provided the means of controlling the recognizable image amongst other factors in painting and had led the way to the steady suppression of pictorial imagery.

Tatlin's relief inscribed with the letters *DRU* (Plate 122) is made up of planes comparable to those painted on *Board No. 1*. With no ultimate distinction possible between construction in high relief, and the surface-construction of painting, Tatlin was able to move from one context to the other, making maximum use of his

132

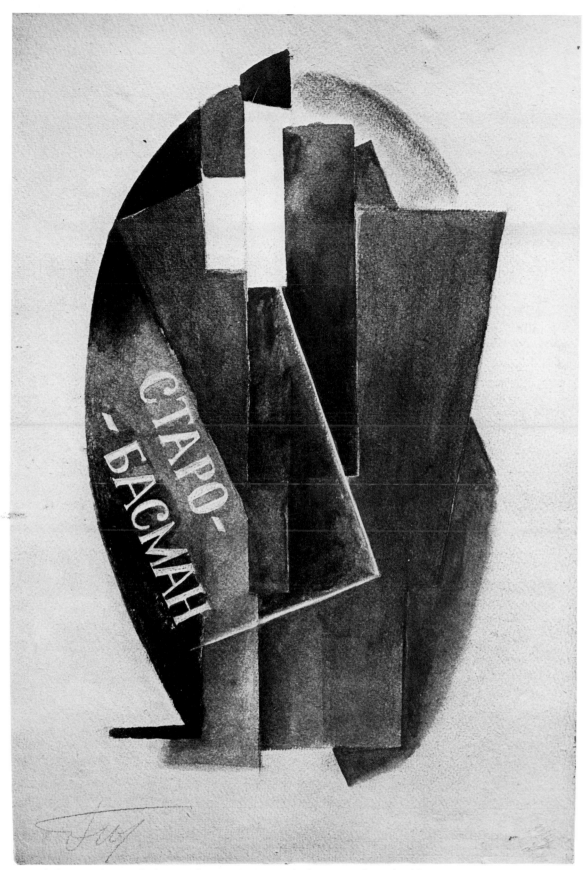

137. Vladimir Tatlin: *Study for Board No. 1*, 1917. Watercolour, gouache and gold paint on paper, 43.9 × 29.6 cm, signed, inscribed 'STARO-BASMAN'. Museum of Modern Art, New York (Gift of Lauder Foundation).

experience with reliefs to fend off traditions learnt at the Moscow College which might divert his study of the materials of painting into more conventional depiction. In their different ways Rodchenko, Exter, Vesnin and Popova all learnt from Tatlin's conclusions.

The poet Khlebnikov, who associated with many painters, employed effects in writings that are comparable to Tatlin's intersecting planes. His prose-tale *Ka*, published in 1916 but written a year earlier, provides luminous examples of simultaneous and intersecting images: 'She ran her hand over the strings: they emitted the rumble of a flock of swans just landed on a lake.'[6]

In this tale by Khlebnikov, Ka, the central figure, is a traveller in time, unhindered in his progress backwards and forwards through the centuries, an initiate of those secret mathematical laws which Khlebnikov sought to discern in the rhythms of history:

> Ka posed an elephant tusk in the air and on the upper surface he fastened years to serve as pegs for a stringed instrument. They were the following years: 411, 709, 1237, 1453, 1871. Below, on the lower slab of the tusk, he fastened these years: 1491, 1193, 665, 449, 31. The strings, ringing faintly, united the upper and lower points of the elephant tusk ... Ka observed that every string consisted of six parts, each of which held 317 years, for a total of 1902. Furthermore, while the upper pegs signified the east overrunning the west, the pegs at the lower ends of the strings signified movement from west to east.[7]

It was at a time of close cooperation with Khlebnikov that Tatlin began to make use of lettering and fragments of words. This may represent a response as much to Khlebnikov as to cubism. When Tatlin inscribed a painting (Colour Plate III) on an irregular board with the words 'Month' and 'May', he may have had in mind Khlebnikov's theories of time. Like *Board No. 1*, this painting is constructed around two principal axes with an intersecting transparent plane. The words are positioned one on each axis. The wood of the board is left visible revealing the material structure of the painting and thereby minimising illusionistic picture space. Furthermore, the non-rectangular shape of the piece of wood makes it impossible to look into the painting, as through a window: instead, the painting remains stubbornly unillusionistic, an object constructed from a chosen piece of wood to which words and thin surfaces of paint have been applied.

The link between Tatlin's constructions and Khlebnikov's ideas became increasingly explicit. The critic Nikolai Punin, writing retrospectively, referred to Tatlin producing 'a bas-relief of Khlebnikov's *Trumpet of the Martians*.[8] This was the title of the manifesto published in February 1916,[9] so that Punin probably refers to a relief executed later than those published in Tatlin's brochure. The large relief of 1917 in the Tretyakov Gallery, Moscow (Plates 138–41), made of iron and zinc on palisander and deal is contemporary with Khlebnikov's organization of the Presidents of the Globe, and may be the relief mentioned by Punin. This heavy object, impressive in its austerity, is constructed from two kinds of material, grey galvanized metal elements assembled on a dull wooden board, itself apparently a found object not specially made

134

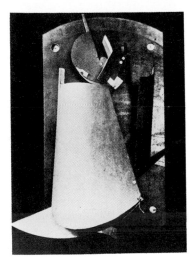

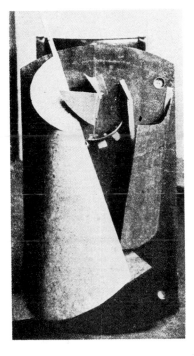

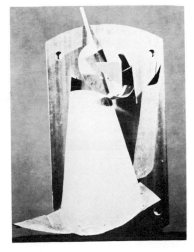

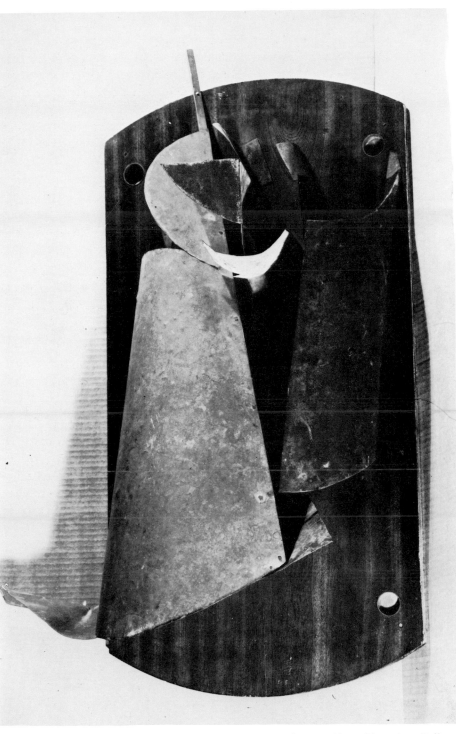

141. Vladimir Tatlin: *Relief*, 1917. Galvanized iron on wood, 100 × 64 cm. Tretyakov Gallery, Moscow. Present state.

138. (top left) Vladimir Tatlin: *Relief*, 1917. Galvanized iron on wood, 100 × 64 cm. Tretyakov Gallery, Moscow. Photograph published in 1921. The small elements top centre of this relief are seen to have changed position in later photographs (Plates 139, 141), and one feature, extending from the base-board lower right, disappears.

139. (middle left) Vladimir Tatlin: *Relief*, 1917. Galvanized iron on wood, 100 × 64 cms. Tretyakov Gallery, Moscow. Photograph published in 1930.

140. (left) Vladimir Tatlin: *Relief*, 1917. Galvanized iron on wood (palisander, deal), 100 × 64 cm. Tretyakov Gallery, Moscow.

for the relief. A photograph published in 1921 (Plate 138) reveals substantial discrepancies from the present condition of the relief (Plates 140–1).

A dual axis is defined by the converging edges of a large cone-like surface. A cylindrically curved section at the right continues the line of the left edge of this. Semicircular flat planes are attached above and below and a cluster of smaller pieces articulates the space near the top. The rod penetrating the work provides a rigid right edge for the large 'cone'; it also projects forward off the board at its lowest point, meeting, as it does so, a cut and folded semicircular sheet of metal held up from the board by an edge bent forward beneath its main surface. A rod rising from the surface along a diagonal was a motif employed in the relief of 1913–14 owned by Exter, where it lifted a flat plane off the surface. Here it is the complex conical surface that it levers from the board. The pieces are not slotted together but are fixed to the board, the curved top and bottom of which undermine the hint of a picture plane that persisted in the reliefs on rectangular bases. The complex conical curve replaces the recurrent cylindrical curve of earlier reliefs, permitting a construction to emerge off the flat plane of the board without being parallel to the board's edges. Conical curves had featured in works where Malevich used cubist motifs. He now began, as did Popova and Rodchenko, to introduce curved planes into his recent paintings. Tatlin, however, in this relief again moves beyond painting to an area of construction where influences upon him were necessarily extra-pictorial.

Khlebnikov, in his poem to Tatlin, had written of propellors; his manifesto had called for the hatching-out of the winged flying machine from the plump caterpillar of the goods train. The poet Kamensky was a pilot and one of his reliefs had dealt with the death of a pilot. Malevich too used such imagery, as indeed did Delaunay. It is not beyond possibility that something of this was evident in Tatlin's reliefs, yet he had abandoned all depiction in his reliefs and any such reference could emerge only on the level of a language of construction. Early flying machines comprised the forging of a brilliant new language of just such a kind and it is unlikely that Tatlin, with his related nautical knowledge at hand, should have chosen to ignore such developments.

On 2 November 1917 Tatlin and Khlebnikov planned to stage three works by the poet.[10] Although Tatlin produced designs it is not clear if the performance took place. *Death's Error* was one of the three works. Designs survive by Tatlin's friend and follower Lev Bruni, who associated a towering conical curve with the character Madame Death (Plate 142) in Khlebnikov's text. If Bruni associated the conical curve with Khlebnikov's writing in 1917, it is possible that Tatlin made a similar association when working on designs for the same dramatic poem (Plate 143). Bruni, usually a figurative painter and draughtsman, executed a number of reliefs under Tatlin's influence, and in 1917 they were neighbours as well as friends.[11]

Khlebnikov had published theories of history before the war. In 1914 *Battles 1915–1917: A New Teaching about War* spelled out his conclusions in detailed examples. The trauma of war lent immediacy to his theories, in particular his prediction that an empire would collapse in 1917. The First World War had made little impact upon the work of Tatlin, Rodchenko, Popova and others. Their experiments had posed a radical challenge to cultural conventions yet their direct involvement with political

142. Lev Bruni: *Madam Death*, costume study for Khlebnikov's dramatic poem *Death's Error*, 1917. Inscribed 'Madam Death 17. L. Bruni'. Russian Museum, Leningrad.

143. Manuscript sheet signed by Khlebnikov, Tatlin and Arthur Lourie, 2 November 1917, concerning the performance of Khlebnikov's *Death's Error*, *Madam Lenin* and *13 in the Air*, designed by Tatlin, music by Lourie. Whereabouts unknown.

events had been minimal. The war itself had scarcely changed this: their innovations remained poised upon the brink of the broadest application, yet found no outlet. Isolation caused by the war had concentrated and focussed Russian cultural questions separately and distinctly from those further west. Whatever the impact of his Parisian experiences, Tatlin was now firmly embedded in a Russian cultural context where Khlebnikov was a pervasive influence. As 1917 progressed Khlebnikov's predictions were apparently fulfilled. The February and October Revolutions saw the fall of the ancient Romanov dynasty and led ultimately to the communist government of the Bolsheviks under Lenin, an historical event of enormous impact. Its cultural implications were to involve Tatlin directly. His investigation into construction took on a new dimension. Khlebnikov remained his guide as Tatlin extended the study of materials into a broader historical and socially committed concept of construction. The social upheaval of the Revolution demanded a cultural response. In the early years of Soviet government Tatlin's concept of construction proved a fruitful source of new cultural attitudes. Activities often iconoclastic before the Revolution, now became committed and constructive. Tatlin's work, and its assimilation by those who followed his explorations, contributed to the evolution of a new cultural framework. Construction, with its inherent rejection of the sanctity of marble or bronze, implied an attitude that now took on a profound cultural resonance. Construction suggested an approach applicable to all creative work. On the broadest level it became a contributor to the construction of the new society envisaged by communism. Construction was no longer the building of an object but of a new way of life.

Already in 1914 Mayakovsky had declared that the enormity of war rendered painting a futile activity: 'Art', he proclaimed, 'is dead, because it found itself in the backwater of life; it was soft and could not defend itself.'[12] Tatlin's abrogation of self-expression, of decoration, of illusion, of style and of taste, equipped him to survive and contribute to the establishment of a new and communal culture. His explorations preceded the events that gave them historical significance; his pioneering investigations were increasingly respected in the early post-revolutionary years. Through Khlebnikov he had, in addition, a concept of time that embraced man's historical evolution. With Khlebnikov's concept for guidance he was able to elucidate the social implications of construction.

7 REVOLUTION

THE tumultuous political events of 1917 brought profound cultural change in their wake. Waves of strikes and demonstrations rose to a height during 10–12 February[1] and were followed in a few weeks by the establishment of the Petrograd Soviet of Workers' Deputies and the demise of the ancient Romanov dynasty in the person of Tsar Nicholas II.

The beginnings of revolution had an immediate impact upon the visual arts. In order to protect valuable objects the provisional government under Prince G. E. Lvov established a Commissariat for the Protection of Art Treasures. In Petrograd Mayakovsky was appointed to the Provisional Committee for the Union of Art Workers together with the critic Nikolai Punin and the poet Alexander Blok. On 12 March, again in revolutionary Petrograd, a group of artists and writers established the Freedom of Art Association.[2] Its members included Natan Altman, Ilya Zdanevich, S. K. Isakov, who had written about Tatlin's reliefs in 1915, Vladimir Mayakovsky, Vsevolod Meyerhold, Nikolai Punin and Sergei Prokofiev. A meeting was arranged for nine days later, 21 March, at the Troitsky Theatre, organized by Punin at Meyerhold's instigation. Punin, formerly a writer on art for *Apollon* magazine, was outspoken amongst those demonstrating their independence of World of Art ideals by their commitment to ideologies of the left.

When a comparable meeting took place at the Hermitage Theatre in Moscow, Russian futurists attended and Kamensky was the opening speaker. This First Republican Evening of Art was not exclusively futurist: Ilya Mashkov, for example, was there, as was Pavel Kuznetsov, but also present were Tatlin, Malevich, Yakulov, the theatre director Alexander Tairov, the poets Gnedov and Aseyev, and the painter-poets Mayakovsky and David Burlyuk. Tatlin and Chagall were elected on 12 April to revive the Union of Youth, an undertaking subsequently abandoned. The Knave of Diamonds too was submerged by events.

Political institutions decayed rapidly amidst demonstrations and fighting in Petrograd in July. Prince Lvov's provisional government was replaced on 6 August by the second provisional government under A. F. Kerensky. On 13 September the Petrograd Soviet went over to the Bolsheviks. In October Lenin called for the replacement of Kerensky. On 24 and 25 October[3] armed uprising in Petrograd precipitated a second revolution within a single year, the October Revolution that established Soviet power

138

144. Anatoly V. Lunacharsky, *c.* 1918. [Photograph BBC Hulton Picture Library, London.]

in Petrograd under the leadership of Lenin. Soviet control of Moscow and other cities followed rapidly.

In the early days of the October Revolution Mayakovsky met Lenin. A committee was formed to organize the cooperation with the Soviet government of writers, artists and theatre directors. Its members included Mayakovsky and Meyerhold. Their direct access to the government was through the Commissar of Enlightenment, A. V. Lunacharsky, a travelled, cultured man well aware of the diversity of contemporary Russian culture. 'The futurists,' wrote Lunacharsky, 'were the first to come to the assistance of the Revolution. Amongst the intellectuals they most felt a kinship with it and were most sympathetic to it.'[4] 'We the leftist artists,' declared Rodchenko in 1917, 'are the first to come to work with the Bolsheviks. And no one has the right to take this from us ... We have pulled by the hair the painters from the World of Art.'[5]

Initially a broadly based Association of Art Activists was formed. Lunacharsky appealed to it in the early days of Soviet power to create 'new, free, popular forms of artistic life'. Mayakovsky, Kamensky and David Burlyuk responded with *Decree No. 1 on the Democratization of Art*, sub-headed *The Hoarding of Literature and the Painting of Streets*: 'From this day forward, with the abolition of Tsardom, the *domicile* of art in the closets and sheds of human genius—palaces, galleries, salons, libraries, theatres—is abrogated.' They proposed to abandon easel painting for the painting of the streets and 'the ever-galloping herd of railway carriages' and took as their slogan 'All art to all of the people'.[6]

Painting was less adaptable than poetry and theatre. Tairov's Kamerny Theatre in Moscow continued throughout war and revolution. On 9 October Tairov's production of *Salomé* by Oscar Wilde opened with extraordinary sets and costumes by Exter. Her designs were shown at the final Knave of Diamonds exhibition,[7] arranged by Malevich after the Revolution and devoted to the full emergence of a suprematist

group. The last Knave of Diamonds exhibition was the final gesture of a long-standing, fruitful organization overtaken by unprecedented events. For a few months the World of Art and *Apollon* continued by force of momentum. At the end of 1917 *Apollon*, discussing the reorganization of cultural life, noted Nikolai Punin's appointment to the Russian Museum in Petrograd and that of Abram Efros to the Tretyakov Gallery in Moscow.[8] In December 1917 the World of Art even mounted a large exhibition in Moscow comprising almost four hundred works, to which Konchalovsky, Kuznetsov, Kustodiev, Lentulov, Mashkov, Sudeikin, Falk, Lissitzky and Yakulov were all contributors.

In the midst of political and cultural upheaval, theatrical and exhibition activity struggled on. Cafés provided vital centres for events and discussions. Under Kamensky, the cultural programme of the Poets' Café flourished throughout the winter of 1917–18. By 1918 Nikolai Punin was formulating a new critique:

> The general basis of all leftist groups of painters has been so-called 'painterly materialism', a more or less single-minded concept of painting as a self-contained and constructive system of forms and marks. So broad a category can be applied to a large historical period and is particularly relevant to that from Cézanne until today. It includes all the participants of leftist groups to whom it appears to provide a common artistic and cultural basis.[9]

Punin recognized Tatlin and Malevich as leaders within this development, and singled out the work of Pyotr Miturich.

New exhibition-organizing bodies arose to replace the Union of Youth and Knave of Diamonds. In Moscow, the Union of Professional Artists and Painters was established on Novinsky Boulevard. Members included Tatlin, Malevich, Rozanova, Yakulov and Grishchenko. A broadly inclusive body, it incorporated subsections, one of which, the Leftist Federation of the Professional Union of Artists of Moscow, had Rodchenko as its secretary during 1917–18. Their president was Tatlin who, on 21 November 1917, was elected by the Union in Moscow to be their delegate at the Art Section of the Soviet of Workers' Deputies. Mayakovsky had joined the Union on 10 June 1917, and Bruni was also a member.[10]

The immediate response of the Union to the demands of the Revolution was to compile an enormous survey of contemporary painting.[11] Seven hundred and forty-one works by 180 painters were assembled for exhibition in Moscow from 26 May to 12 July 1918. Amongst the contributors were Menkov, Klyun and Pestel, as well as Grishchenko, Drevin, Vesnin, Popova, Rodchenko, Rozanova and Udaltsova. Neither Tatlin nor Malevich appears to have exhibited; neither did Lev Bruni nor Pyotr Miturich. Furthermore, the World of Art painters were largely absent. But so broad a survey provided an informative background for new plans. When the Union proved too large and heterogeneous to function with coherence, Lunacharsky established a new department for the plastic arts with the painter David Shterenberg as president in Petrograd and Tatlin as president in Moscow.[12] Their activities incorporated all aspects of visual arts from exhibitions to art education. Under Lunacharsky's

department, known by the acronym IZO,[13] the Petrograd and Moscow Free State Studios were established. Amongst the tutors in Petrograd was Altman and amongst those in Moscow was Kandinsky. Lunacharsky also established a Department for Museums and the Conservation of Antiquities. Brik's colleague, the writer Viktor Shklovsky, worked for the conservational department in 1918: after arriving in Petrograd from the war, Shklovsky 'joined a commission whose name I do not remember. It was supposed to be responsible for the protection of antiquities and it was located in the Winter Palace. That was where Lunacharsky received people.'[14]

The new teaching establishments, the Free State Studios in Petrograd and Moscow, played an important role as centres for the growth of new cultural values. The degree to which their courses and aims were defined in terms familiar to Tatlin, Malevich, Rodchenko and others is an indication of the recognition that the government, through Lunacharsky, was willing to afford them. In May 1918 David Shterenberg argued that the political and economic structures introduced by the Revolution had a classless and untraditional culture implicit in them. 'Proletarian art', wrote Shterenberg, 'will be classless art, and opposed to all that has gone in the past.'[15]

The new Free State Studios were oriented towards material considerations incorporating a study of the eye's capacity to perceive colour and tone, scale, three-dimensional space, distance and movement. The Petrograd Free Studios pioneered new courses emphasizing material considerations and construction, both pictorial and three-dimensional. Tatlin's example, by 1918, exerted considerable influence. The aim of the Petrograd course was 'the development of the eye, and the study of materials and elements illustrating the pictorial-plastic method of art tuition'.[16]

The tutor was to work alongside his pupils.[17] After the establishment of the Petrograd Free Studios, art schools were planned on broadly comparable principles in Moscow, Pskov, Tver, Vitebsk, Ryazan, Kazan, Penza, Voronezh and Saratov, and IZO had a pedagogic section for the study of the teaching of the new aims and techniques.[18]

When Lunacharsky formed IZO, change followed in all areas of creative activity. Tatlin, as overseer of Moscow's art activities, was in a position of influence with regard to exhibitions, publications and art education. In close contact with Lunacharsky, he was in touch with the nerve centre of government. When the government evolved cultural policies, Shterenberg in Petrograd and Tatlin in Moscow were in a position to learn of them at first hand and to shape their realization. The study of construction had taken on a social dimension, assisting in the evolution of a cultural framework that increasingly preferred communal and material investigation to self-expression.

In April 1918 Nikolai Punin declared: 'Art does not ornament, does not agitate, does not delight, does not relieve depression and does not serve as a means of enrichment—art augments human experience, deepens and broadens knowledge of the world, of man and of their mutual relationships.'[19] The role of art, as much as its products, was constantly under discussion. Works executed before the Revolution were subjected to fresh scrutiny according to new criteria, and works executed after the Revolution had necessarily to take cognizance of those criteria. Punin was one

amongst many critics who sought to define them and apply them to contemporary creative activity. His position was necessarily anti-traditional: 'Beauty—that idol of all European aesthetics—has repeatedly shown itself to be a calamity for all revolutionary artistic creativity and it will remain so until it is overthrown for ever.'[20]

Punin abandoned the aesthetic viewpoint of his early *Apollon* articles to stress the changed context of the artist and his new-found social and proletarian orientation. 'To the Proletariat, in reality, all European, class-oriented, individualist and now dead art is unnecessary and foreign. He rejects it, and in this rejection reveals the astonishing, complete and refreshing consistency of the proletariat.'[21]

Tatlin's investigation of the processes of construction led to objects beyond personal taste and self-expression. Construction as an investigation was applicable to many fields, from language to architecture, a pragmatic examination of the material world and of how its materials could be organized and assembled. To explore its social implications was to define a new and underlying role for creative abilities: social organization was seen as integral to material construction. A new cultural structure was emerging that sought to respond to unprecedented political conditions.

'It is necessary to understand,' wrote Osip Brik, 'that art is not in ideas, not in words, but in actions, in deeds.'[22] The process of construction increasingly suggested a culture with its emphasis upon communal and material factors in which the individual object was but a detail and reflection of the whole, an example of a pervasive process. How far Tatlin, Rodchenko and others were in step with this broader cultural development was constantly reassessed. It gave rise to critic-interpreters whose purpose was to examine this relationship. Nikolai Punin was one such voice who championed Tatlin with a pamphlet devoted to his work in 1920 and a book in 1921. Through Punin's writing it is possible to inspect the relationship of the creative practitioner to the changing framework within which he operates. As Tatlin's post was high within IZO it may be assumed that criteria reflected in the writing of Punin were familiar to Tatlin, whose immediate task was the realignment of his discoveries in relation to a communally oriented society.

Tatlin, who had organized The Store exhibition, now found organizational work increasing with wide responsibilities and opportunities before him. In addition to teaching in Petrograd and Moscow during 1918 there was work with government bodies: he was a founder member of a department for the preservation of monuments of art and the normalization of museum matters, as well as head of IZO Narkompros in Moscow, a post he held until May 1920. His organizational work was increasingly evident to both public and government. In December 1918, for example, when Narkompros convened a conference of members of the Moscow and Petrograd Cinema Committees, Tatlin was amongst the delegates with Lunacharsky, N. K. Krupskaya, Meyerhold and Shterenberg. The conference recommended the transfer of all cinema affairs to Narkompros.[23]

When Lenin's plan for monumental propaganda to commemorate heroes and theorists of the Revolution in the public spaces of Russian cities was advanced, Tatlin, as head of the Moscow branch of Lunacharsky's cultural ministry, was the director of arrangements for Moscow. He submitted a plan that was confirmed on 17 June 1918.

The following day he began to organize a campaign of fifty monuments in Moscow. On 10 July 1918 Tatlin wrote with Lunacharsky a text submitted to Lenin concerning monumental propaganda, and later published under the title *Events and Instructions*. Many of the projects initiated involved colleagues with whom Tatlin had shared his studio in pre-war days. In one project Tatlin headed a team of artists and military advisers in a celebration planned for Moscow on 7 November in which coordinated illumination by searchlights across the city, fireworks and signal flares were planned, centring on Red Square, signifying the decay of the old order and the establishment of the new. On 5 November 1918 *Izvestia* reported that it would be 'a firework display greater than any seen in Moscow or in Western Europe'.[24] His assistants included Dymshits-Tolstaya, Kuznetsov and B. V. Shaposhnikov. Tatlin now worked with people and propaganda, responding to political and historical events.

Lunacharsky had made it clear within the first year of his activities that he intended a radical remodelling of cultural life. His support of leftist writers and painters led to criticism from unsympathetic quarters. If Lunacharsky supported Mayakovsky and others, he was not indiscriminate and he did not ignore other groups. In April 1918 he firmly criticized the futurists' self-advertisement.[25] In October he urged the acquisition of works from many movements for display in Russian and Western European museums.[26] Rodchenko became the director of a Museums Bureau during 1918[27] and a founder member of the Museum of Artistic Culture, established in 1919.

In 1918 the first issues of the weekly *Art of the Commune*[28] were published by Lunacharsky's department. The periodical sought to link the latest leftist works with the Revolution. The first issue appeared on 7 December 1918. Two days earlier the committee for the visual arts, chaired by Punin, discussed how the issue had been prepared within a week and 10,000 copies printed.[29] Mayakovsky, Punin and Brik were editors. Malevich contributed[30] and Mayakovsky's 'Order to the Army of Art', with its celebrated couplet 'The streets are our brushes, The squares are our palettes ...', was published in the first issue.[31] Brik was a particularly outspoken critic of traditional values. Viktor Shklovsky, who declared himself 'on the right wing' of futurist opinion, recalled how Brik 'worked in the Commissariat of Art. IZO, the section of Visual Arts, had its office on St Isaac's Square in the beautiful Myatlev House ... Here were David Shterenberg and the flat-faced Natan Altman.'[32]

Anti-art tirades from Russian futurists flourished in the pages of *Art of the Commune*. 'It's time for bullets to pepper museums,' wrote Mayakovsky in his poem 'It's Too Early to Rejoice' in issue No. 2 on 15 December 1918.[33] By the end of the month Lunacharsky pointed out the limits of government support for the leftists. Lunacharsky's letter, 'A Spoonful of Medicine' published in issue No. 4, warned futurists against assuming that they represented a state-sponsored, official group:[34] 'Two tendencies of the young periodical in whose columns I am printing this letter therefore give rise to certain fears: the destructive tendency in relation to the past and the tendency to speak in the name of authority when speaking on behalf of a particular artistic school.'[35]

The social extension of construction was fraught with difficulties. Rodchenko moved steadily closer to the committed iconoclasm of Mayakovsky and Brik. On 29

December 1918 Osip Brik declared in *Art of the Commune*, No. 4: 'The answer is clear. The proletarianization of all labour, including artistic labour, is a cultural necessity ... And no amount of tears shed for supposedly vanished creative freedom will help.'[36]

The problems inherent in the establishment of such a culture were numerous and difficult, involving the question of whether culture should be classless or proletarian, and whether proletarian culture could be evolved by intellectuals and creative practitioners already active or should arise indigenously from proletarian sources. Complex arguments arose from these difficulties. That non-objective painting, for example, was popularly unintelligible was a telling criticism of works intended to have a social significance reaching beyond aesthetic speculation.

'We assume', proclaimed an unsympathetic article of 1918, 'that proletarian culture is made by workers themselves, not by the intelligentsia, who by chance, or even deliberately, have come round to the ideas of the proletariat.'[37] Natan Altman's 1918 suprematist street decorations (Plates 145–6) sum up the difficulty, for more than the

145. Natan Altman: Decorations at the base of the Alexander Column, Petrograd, 1918 (here visited by children and a band). [Photograph Arts Council of Great Britain.]

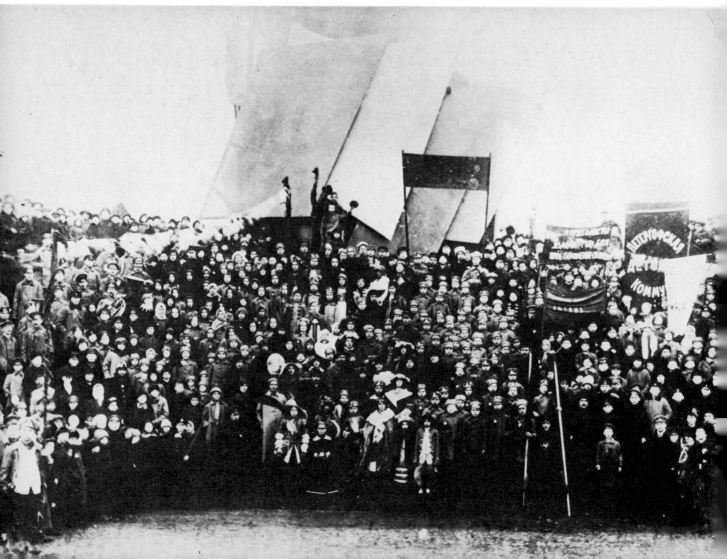

slogan 'Workers of the World Unite' was needed to make his work effective on the social dimension. In this lies a crucial problem for non-objective art and for the process of construction within the arena of art. This point provided a fulcrum for critical decisions during the next years.

Petrograd and Moscow in European Russia were not the only centres for such investigation. In the distant east in 1918 a group formed around the writer Nikolai Aseyev, sent to Vladivostok on military orders the previous year,[38] the theorist Nikolai Chuzhak and the writers Neznamov and Sergei Tretyakov. David Burlyuk, who had fled Moscow with his family in April 1918, joined the Vladivostok group until 1920 when the White Army again controlled Siberian territories. Burlyuk fled further to Japan and eventually to New York.[39] In the group's periodical *Creativity* Chuzhak in particular debated the reconciliation of intellectual endeavour and proletarian art.[40]

At Narkompros Tatlin contributed to a bureau for the establishment of links with international art organizations and publishers. It was proposed to establish a journal, *The International of Art*, with editorial assistance, advice and contributions from

146. Natan Altman: Decorations at the Alexander Column, Petrograd, 1918. The Winter Palace is visible in the background.

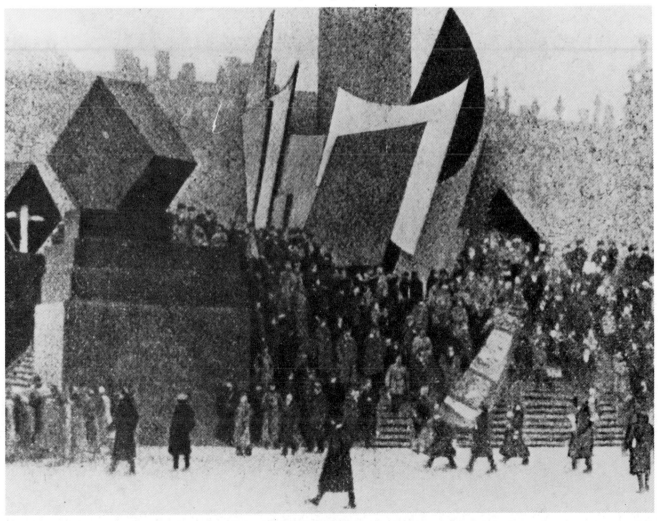

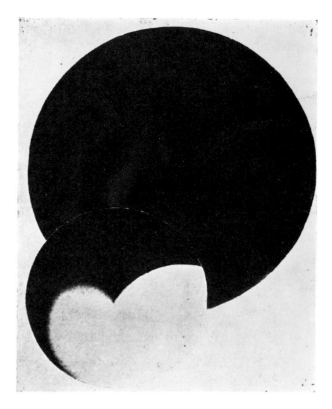

147. Alexander Rodchenko: *Non-Objective Painting*, 1918. Oil on canvas, 76 × 56 cm, signed on reverse vertically in green. Tretyakov Gallery, Moscow.

Kuznetsov, Morgunov, Punin, Lunacharsky, Tatlin and Khlebnikov. Tatlin prepared a text for the journal, which is partly preserved in the Central State Archive of Art and Literature in Moscow.[41]

Rodchenko too involved himself in organizational responsibilities. The non-objective paintings which he executed during the period of these commitments were unremitting in their attack upon pictorial conventions (Plate 147). Conceived as material constructions across a flat surface with contrasting *faktura* and pigments, they relied upon geometrical shapes whose position and scale were determined by the edges of the painting and arcs extended from it with compasses. When Malevich painted all-white paintings in 1918, Rodchenko replied with black works in which considerations of material were paramount. Rodchenko's elements were diagrammatic and geometrical. His paintings avoided personal expression and style, but were distinct in construction from Tatlin's works. In Rodchenko's work geometrical forms and mathematicians' instruments were employed expressly to reduce personal qualities.

Rodchenko, in 1918, was a most adventurous non-objective painter. Although impressed by Tatlin's example, he was not investigating pictorial space or materials in a manner that demanded relief constructions. In this he contrasts not only with Tatlin but with Bruni, Popova, Puni, Kamensky and others. By 1918 Rodchenko's painting had evolved a detachment comparable to that of Tatlin's although operating

146

in a different field. Paint and lines were no longer made to depict, they were themselves observed and investigated. The manipulation of imagery led to composition; the investigation of elements of pictorial structure, as Rodchenko had examined the plane and the line, led to construction.[42] Construction was not particular to one form of creative activity, and did not relate to conventional artistic categories. Construction was applicable to many fields, which were no longer ultimately distinct one from another.

Two closely related drawings by Rodchenko dating from 1918 show the impact upon him of the new groupings of creative people with newly defined aims. A drawing by Rodchenko inscribed 'Zhivskulptarkh' refers to an organization to which Rodchenko contributed, set up to investigate the relation between painting (ZHIVopis), sculpture (SKULPTura) and architecture (ARKHitektura).[43] For Rodchenko and Tatlin, construction in different forms replaced these distinctions. Yet Rodchenko until 1918 had been concerned almost exclusively with pictorial considerations, excepting the recent lamp designs for the Café Pittoresque (Plate 132). Furthermore, Zhivskulptarkh encouraged communal projects. Such communal work tended to embody a monumental tendency, being communal in aims as well as evolution. Tatlin, directly involved in monumental propaganda projects, began to turn his attention to communal creativity.

'Art', proclaimed Nikolai Punin, in an article dated 1918 but published the following year, 'as a condensor of creative energies freed from systematic and organized work can, in fact, be no more than a class product.'[44] Osip Brik in 1919 echoed Punin's convictions: 'The artist creates; but in the Commune everyone creates.' This implied an identification of art and work. According to Osip Brik artists necessary to the Commune 'carry out in full, defined and publicly useful deeds; they undertake actual work that demands their special abilities and special skills'.[45]

Nevertheless, exhibitions early in 1919 continued to emphasize painting and to be broad in scope. At the Fifth State Exhibition opening at the end of 1918 at the Moscow Museum of Fine Arts the fifty-three contributors included Kandinsky as well as Rodchenko. There was no jury and the exhibition was organized by IZO.[46] Neither Tatlin nor Malevich was represented. Tatlin, however, was not inactive, and he continued to acquire new posts: on 1 January 1919 he was appointed head of painting at the Free Studios in Moscow.[47]

Art of the Commune, which survived for only a few issues in 1919, announced on 26 January the establishment in Petrograd of an alliance of futurism and politics under the banner of Komfut (KOMmunizm-FUTurizm),[48] but the subsequent issue announced that permission to register such a collective had been refused.[49]

An event of more substance occurred in Petrograd on 7 February 1919, when the Museums Committee proposed the establishment of a Museum of Artistic Culture to examine contemporary cultural questions and their current investigation. A declaration called upon painters and artists to 'liberate art from the dead historical pedantry of the past'.[50] In the words of Grishchenko: 'The Museum of Artistic Culture must suit the artist and not the archaeologist.'[51] Its dedication was more to the shaping of the future than to the housing of the past: 'Our strength,' wrote the Petrograd Kollegia

under David Shterenberg, 'lies in our love for the future. Our task is to realize it.'[52]

Four days later a further Museums Conference was held in the Winter Palace (renamed the Palace of Arts) in Petrograd to discuss in detail the work and aims of the Museum of Artistic Culture. Material factors were given priority for study, divided into surface, *faktura*, density and weight. Secondly came Colour, divided into saturation, strength, relation to light, purity and transparency. Third came Space, comprising volume, depth and dimension. Fourth came Time (movement), its spatial expression and its links with colour and material. Fifth came Form 'as the result of the mutual interaction of material, colour and space', and as composition. Sixth came Technics, concerning painting, mosaic, relief, and other processes. Acquisitions were planned[53] and exhibitions projected, including a memorial exhibition of Rozanova's work, non-objective and suprematist painting, the colour-dynamos of A. Grishchenko and the 'tectonic primitivism' of A. V. Shevchenko.[54] Simultaneously, the Petrograd branch of IZO was to undertake an elaborate publishing venture with the books *Cézanne*, *Cubism*, *Picasso*, *Braque*, *Le Fauconnier*, *Futurism and its Representatives*, *Orphism*, *Suprematism*, *Non-Objective Creation*, *Boccioni the Futurist*, *On Faktura* (by Markov), *Cubism* (by Apollinaire),[55] a volume on anatomy, and new editions of Alberti, Palladio and Vitruvius.[56]

On 3 April 1919 a colossal exhibition was opened in seventeen rooms of the former Winter Palace. The exhibition continued until 29 June. It was immense and comprehensive, although Rodchenko, Tatlin and Malevich were not represented. Two hundred and ninety-nine exhibitors displayed 1826 works.[57] Almost all of the Petrograd groups were represented including painters formerly associated with the World of Art, the Union of Youth and even the Wanderers. Individual exhibitors included Altman, Baranoff-Rossiné, Mansurov, Mayakovsky, Puni, Stepanova and Shterenberg (see Plate 148).

Smaller exhibitions illustrating particular tendencies followed. Altman had declared in 1918 that proletarian art signified collective art. In May 1919 a collective group exhibited at the building of the former Stroganov College in Moscow. This, the first Society of Young Artists (Obmokhu) exhibition, presented works anonymously. Proceeds and expenses were divided. The collective largely comprised students from the Free Studios in Moscow, although Yakulov apparently contributed to the first of the exhibitions.[58]

It was in 1919 too that the proposed exhibition Non-Objective Creation and Suprematism was realized in Moscow, as the Tenth State Exhibition. Organized by IZO in Moscow, it was presumably guided into existence at least in part by Tatlin. This exhibition was exclusive, authoritative and concentrated. Two hundred and twenty works by only nine exhibitors were assembled into a strong and coherent exhibition in which the development of non-objective art from suprematism could be examined at first hand. The exhibitors were V. S. Agarykh (a pseudonym of Varvara Stepanova), Alexander Vesnin, N. M. Davydova, Ivan Klyun, Malevich, M. I. Menkov, Popova, Rodchenko, and the late Olga Rozanova. The exhibitors each had a debt to Malevich, however opposed to his position he or she might have become by 1919. Malevich showed a *White on White* painting and Rodchenko a *Black on Black*

148

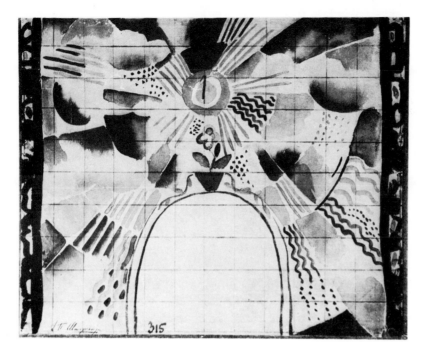

148. David
Shterenberg: *The
Sun of Freedom*,
1918. Ink and
watercolour on
paper. Museum of
the Great October
Socialist Revolution,
Leningrad.

painting. Each of the nine published a manifesto in the catalogue. The optimism of
Malevich ('I have broken the blue shade of colour boundaries and come out into
white. Behind me comrade pilots swim in the whiteness')[59] contrasted starkly with the
negative and literal tone of Rodchenko ('As a basis for my work I put nothing').[60]
Rodchenko declared that 'the crushing of all "isms" in painting was for me the
beginning of my resurrection. With the funeral bells of colour painting, the last "ism"
was accompanied to its grave, the lingering last hopes of love are destroyed and I
leave the house of dead truths.'[61]

By later 1919 the investigation of pictorial and material construction had moved
substantially out of the privacy of the artist's studio. Rodchenko, Tatlin and others
began to evolve works to which a social dimension was integral. Exhibitions of
anonymous collective works were taking place in street decorations, in cafés and in
theatres; public works pointed to a new collective identity.[62] In order to extend its
social dimension, construction increasingly deserted painting for activities less redo-
lent of aesthetic predilection and self-expression for a communal, public and political
expression.

The Revolution was followed by the Civil War and from autumn 1919 by the War
of Intervention. The White Guard under Yudenich marched on Petrograd. Further
north the British were in Archangel. Denikin was in the Ukraine and Kolchak in
Siberia. Politically the Soviet territories were isolated from Western Europe and from
much of the Ukraine. The cultural effect of this was to encourage further the develop-
ment of attitudes independent of Western Europe, and to affirm the sense of a distinct
social identity.

149

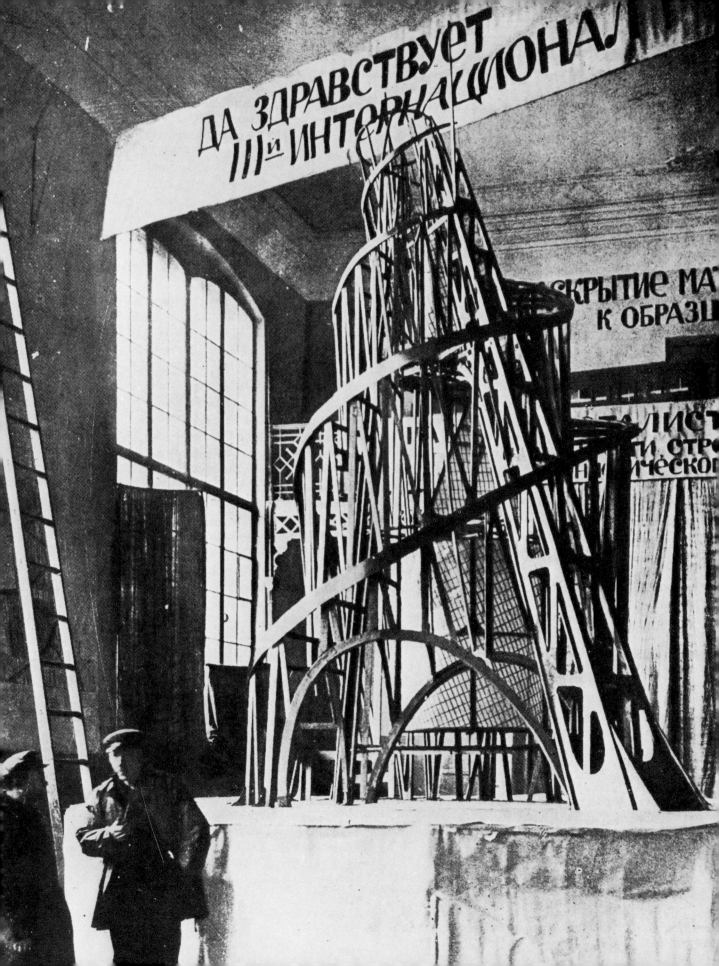

8 THE MONUMENT TO THE THIRD INTERNATIONAL

WITH the evolution, display and publication of Tatlin's Monument to the Third International (Plate 151) the history of constructivism entered a new phase. Tatlin's project, designed as a government building, was widely influential for all its apparent impracticability. It represented a vital extension of construction into the public sphere, exemplifying the wedding of constructivism and social commitment. As such it is a pivotal work.

Punin's pamphlet *The Monument to the Third International* (Plate 150) began by declaring: 'In 1919 the Department of Artistic Work of the People's Commissariat for Enlightenment commissioned Vladimir Tatlin, the artist, to work out plans for a monument to the Third International. A collective workshop was set up comprising the artists Vladimir Tatlin, I. A. Meyerzon, M. P. Vingradov and T. M. Shapiro. They developed the project in detail and built a model of it.'[1] The monument was envisaged as far exceeding in height the Eiffel Tower in Paris.

The model was exhibited on 8 November 1920 (Plate 149) in Petrograd and in Moscow during December at the time of the Eighth Soviet Congress there. According to T. M. Shapiro it was constructed, without any previous model, from only two drawings.[2] Tatlin's change of outlook since exhibiting before the Revolution, at 0.10 and The Store, was immediately apparent in the scale, materials and social content of the monument. It rapidly became widely influential, providing a focus of attention for theoreticians and those consciously seeking to develop a social commitment in their practical projects. It soon became known as Tatlin's Tower.

The monument appeared to lean (Plate 152), dramatically emphasizing its energetic qualities: the spiral thread seemed to heave forward off its base upwards and forwards, the screw thread of a tunnelling device screwing into the air as it emerged from the earth. In fact all of its forms lay vertically above the area prescribed by its groundplan so that nothing actually projected beyond that implied circle. The illusion was strengthened by the pyramidal form (B in the diagrammatic elevation of the work published by Punin): the static form of the pyramid was modified, by the device of making one of its sides vertical, into a thrusting and dynamic image which suggested instability whilst remaining well within equilibrium.

151

149. Vladimir Tatlin: Model of the Monument to the Third International on view, 1920. Tatlin stands with pipe in the foreground. At left a large elevation drawing is displayed on the wall.

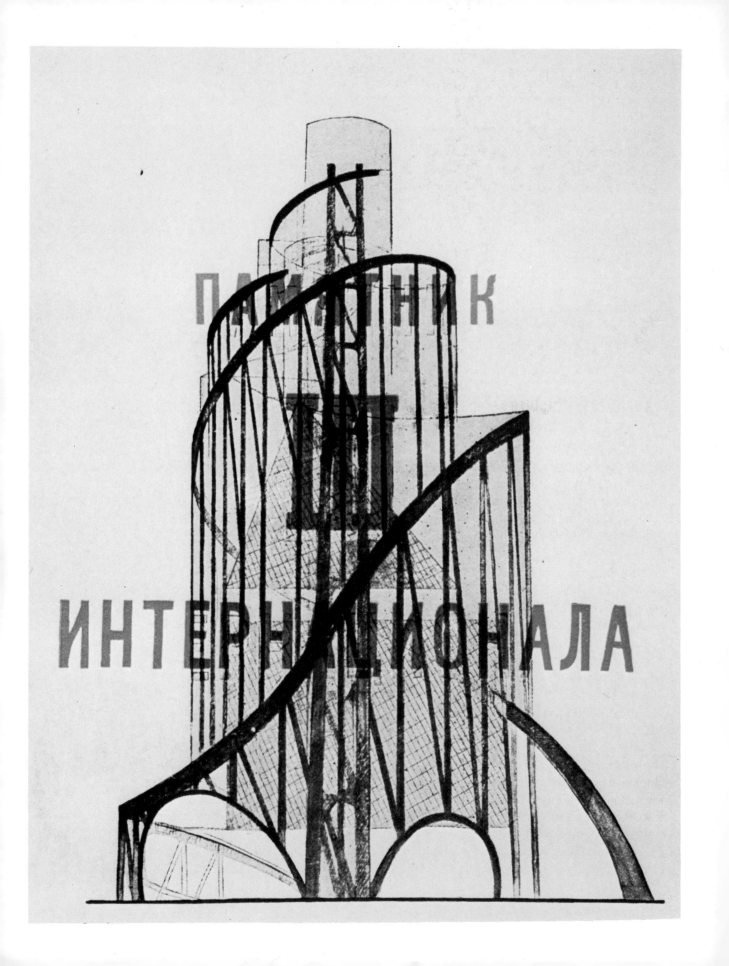

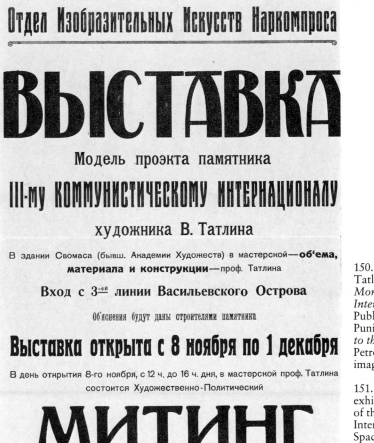

The diagrams (Plates 150, 152) illustrate that the pyramidal form echoed that of the overall, spiral-clad form. Both recede dramatically from a horizontal and substantial base to a small focal point; both make maximum use of the fact that a diminution of this kind emphasizes the effect of scale in a building. This provided a unifying formal theme in the monument. As the pyramid was designed to rotate it also provided a precise and regular reminder of the coincidence of microcosm and macrocosm, in which the part is distinct from the whole yet directly related to it.

The spirals which engirdle the halls have in themselves little lean. They twist around a vertical axis visible in the diagram published by Punin and along which the driving mechanism was to be installed. Extending a line from the ground through the outermost edges of the spirals (b_1, b_2, and the next, not b_3, on the diagram—Plate 152) shows that they remain comfortably within the perimeter of the base. A massive sloping strut, at the right in the diagram, provided rigidity for the spirals, counteracting their spring-like tendency to compress. This feature of the monument distinguishes it from an engineer's construction, for spirals are employed as a formal rather than a structural device. The flexibility of a metal spring is suggested yet not employed. The vertical and diagonal struts prop up the spirals in order to counteract this effect and

invite comparison with the rigid closed-in spiral of a screw-thread. Tatlin's determination to reveal the inner workings of his building has led to a compromise in which the spiral's flexibility is denied, whilst the rigidity of his structure is integrated and expressed as minimally as possible. The diagonal strut acts as a buttress running from top to bottom of the main structure, from its outermost edge to its central vertical axis. In so doing it connects with each of the spirals twice and with each of the halls once. The diagonal struts between the spirals are further buttresses. Access to each of the great halls was to be available via the massive diagonal strut, the most direct route, the easiest to construct and the single line upon which the complex movements of the halls were in contact, at a tangent, with the static structure. Access from one hall to the next was via this diagonal column.

Having established this emphatic leaning strut for both structural and expressive purposes, Tatlin subsequently allowed it to influence the course of the spirals themselves and their smaller supporting struts.[3] The two identical spirals begin from points on the circumference of a circle marking the outer limits of the building at ground level. As they are concentric, they converge upon a point vertically above the centre of the circular perimeter of the plan. Each of the spirals is truncated so that this geometrical resolution is prevented. Each of the spirals meets the great buttress twice but stops short on its second encounter. The smaller struts are then continued above the spirals. This is the only actual imbalance within the building and it remains safely within the perimeter of the plan. Tatlin at the top section of his tower inserted a new form, an almost cylindrical truncated cone.

The near-cylinder, were it not fixed within the framework of girders and struts from which it emerges with such naturalness, would be poised at its most precarious point of balance—on one of its circular edges with its uppermost point all but vertically above its lowest point. The upper part of this section is the only feature of the monument to project beyond its overall conical shape. This has the effect of transmitting the appearance of an acute inclination from the spiral strut to the supported structures of the spirals and to integrate these two strongly contrasting elements in the overall form of the tower. In more practical terms this extension of the overhang, which occurs most clearly at the furthest point of the spirals from their spinal support, permits the circular opening at the top of the tower (b_3 to a_1) to be elevated and removed sufficiently from the main body of the tower for it to be visible from the ground. Punin explained the reason for this in his pamphlet: it 'includes a telegraph office as well as a large screen situated at the axis of a spherical projection to receive projected images'.[4]

Tatlin's Tower was closer in appearance to an apparatus than to a building or a monument, in its combination of skeletal framework and moving parts. It is perhaps not irrelevant that St Petersburg by the time of the Revolution was a centre for astronomical study, and the Hermitage contains a collection of Renaissance navigational and astronomical devices. The monument resembles a telescope or a mechanism for measuring the heavens. It seems as much related to the sky as to the earth as it screws out of one and into the other. In this respect it is instructive to note that the spirals enter the ground in the elevation diagrams and the base under the model in the

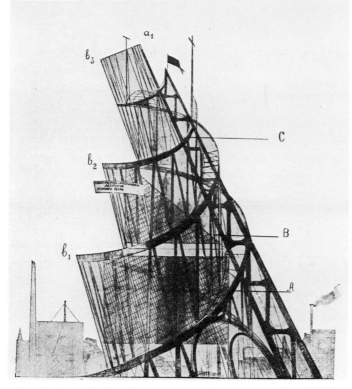

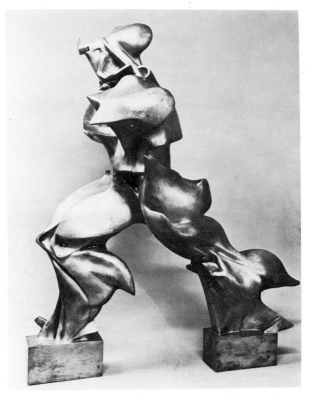

152. Vladimir Tatlin: *Elevation of the Monument to the Third International*, 1919–20. Published in Punin's book of 1920.

153. Umberto Boccioni: *Unique Forms of Continuity in Space*, 1913. Bronze, height 111.2 cm. Museum of Modern Art, New York.

photographs, without interruption, implying that the monument continues below the surface of its visible base. As the spirals are logically able to extend forever outwards and downwards the monument is envisaged emerging from the earth itself, an ascending form moving forwards and upwards. On a colossal scale it is a spiral relief upon a horizontal base: it has no façades. This apparent spiralling upward and forwards would be enforced by optical impressions for an observer moving round and through the structure, and emphasized by the recession abruptly expressed in the diminution of the curves of the spiral towards the apex of the tower. Furthermore, the circular movements of the halls within, contrasting with the stationary spirals, set up a mobile relationship. This relative movement would resemble a vast screw turning, moving upwards and forwards out of the earth and into the air.

For all its lack of façades and its thoroughly three-dimensional coherence, Tatlin's Tower has a front, sides and back. They correspond less to the architectural concepts of main and subsidiary façades than to the sense of a front and a back associated with a figure. The main diagonal support acts in relation to the spirals as does a spinal column to ribs. The communications facilities intended for this support strengthen the comparison. If the main diagonal may be interpreted as a spine, the body to which it is linked is engaged in dynamic forward-thrusting movement. Consistent with this impression is an analogy between the two great arches which lead off from the spine and striding legs recalling the ancient sculptural tradition of the striding figure revived by Rodin and more recently by Umberto Boccioni (Plate 153).[5] In interpreting the lean of the tower, it is reasonable to suggest that it signifies a forward stride. In the political

155

arena of 1919–20, to imply such a forceful forward stride was to imply, too, confidence in the progress of communism.

Three features characterize Tatlin's use of the spiral in his monument: firstly, they appear to lean, although they converge vertically above the central axis of the monument; secondly, Tatlin employs a double spiral; and thirdly, the spirals are not cylindrical but conical. To employ two concentric conical spirals is as rare in structures of an architectural scale as the single cylindrical spiral is common.

Historically the double-spiral has particular connotations. One of its most ancient forms is the Caduceus associated with Hermes or Mercury. Intertwined spirals depict unity arising from opposing forces; the snakes of the Caduceus represent this opposition and unity (Plate 154). This opposition has at times been associated with the apparent movements of the sun and moon.[6] The formal theme of intertwined spirals and their steady resolution is basic to Tatlin's Tower, where it is analogous to a process of evolution through dialectical conflict. Tatlin's monument is concerned with *becoming* rather than *being*. All its forms and functions progress towards resolution.

Whilst Tatlin showed no tendency towards academic figuration in sculpture, it is notable that in one of the few works by Rodin in which the figure is given a minor role to play in relation to an architectural element, the theme of the monument should be labour. It would be natural for a Russian after 1917 planning a monument on a revolutionary theme to turn to France for inspiration. Given Rodin's popularity in Russia and the fact that he had executed a maquette for a monument to labour in 1893–4 (Plate 156), his work would provide a natural source of reference. That this monument so plays down the importance of individual figures against the architectural spiral makes comparison with Tatlin's Tower inevitable. Rodin may simply have concluded, as Punin was to do, that figure sculptures are less appropriate for a monument to labour than are more architectural forms. Leonardo, in his studies of multi-spiral stairwells, investigated variations on rectangular and circular plans, but it is not possible to find in his notebooks references to conical spirals, either single or double. In such a form the spiral exists usually as an external staircase around a ziggurat or tower. In all of these instances the spiral ascends around a solid core and is single not double. The ziggurat at Samarra near Mosul in Iraq (Plate 155) is perhaps the closest of such forms to Tatlin's Monument to the Third International.[7]

A conical spiral aspires to a single point beyond which it cannot pass; by contrast, a cylindrical spiral is infinitely extendable and does not approach a final point. Consequently, the conical spiral is a form more complete in itself. This extension towards a goal was imbued with a spiritual significance by both Wassily Kandinsky and Mikolajaus Čiurlionis. Čiurlionis depicted his visionary mountain with two ascending and spiralling roads symbolizing spiritual endeavour and elevation above earthly concerns (Plate 157).[8]

It seems unlikely that at this point work upon materials led to the evolution of the double spiral form. Steel would be the only material which might hold up the vast monument—although for reasons of structural mechanics alone this must remain in doubt. Work with materials in the manner used by Tatlin before the monument project involved the exploration of the qualities of different materials and their

156

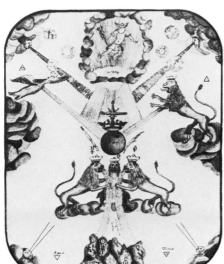

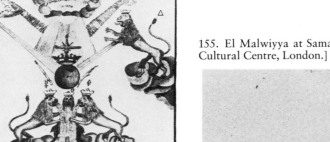

154. *The Generation of Metals*, from an eighteenth-century manuscript. St Andrews University, Scotland. Mercury holds the Caduceus (top centre); also visible are the symbols for Earth, Air, Fire and Water.

155. El Malwiyya at Samarra near Mosul, Iraq, *c.* 847–61. [Photograph The Iraqi Cultural Centre, London.]

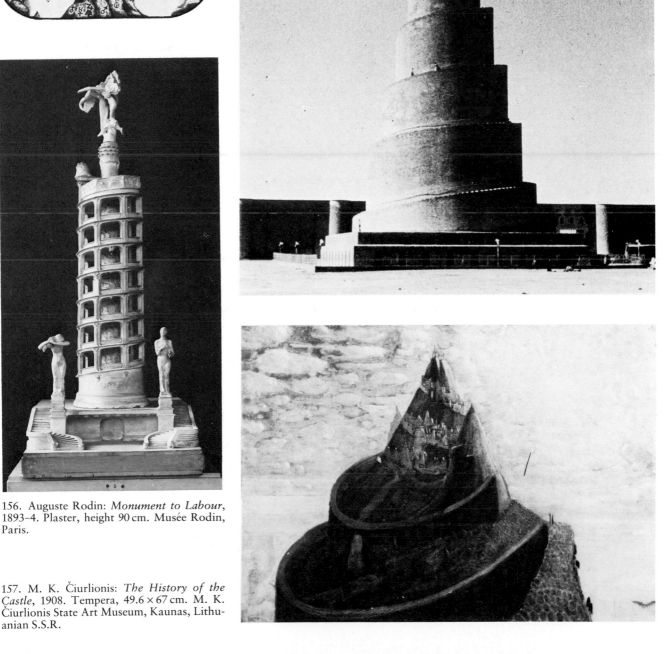

156. Auguste Rodin: *Monument to Labour*, 1893–4. Plaster, height 90 cm. Musée Rodin, Paris.

157. M. K. Čiurlionis: *The History of the Castle*, 1908. Tempera, 49.6 × 67 cm. M. K. Čiurlionis State Art Museum, Kaunas, Lithuanian S.S.R.

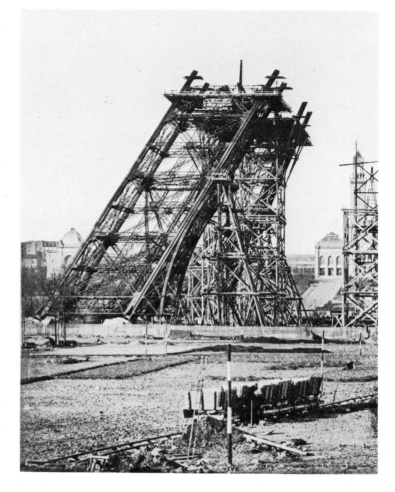

158. Gustave Eiffel: First leg of the Eiffel Tower under construction, Paris, 1888.

159. (facing page) Vladimir Tatlin: Model of the Monument to the Third International, 1919–20. [Photograph Alfred J. Barr Archive, Museum of Modern Art, New York.]

interactions. Work directly with the materials does not presuppose the evolution of geometric forms, nor is it an engineer's approach to materials. In working on his model Tatlin used wood. It is only necessary to compare the side elevation of the tower (Plate 152) with a photograph of one of the legs of the Eiffel Tower under construction (Plate 158) to appreciate the extent to which Tatlin's design is not that of an engineer, as Eiffel's metal structure had been.

Tatlin's spirals were not the most efficient structure to reach the intended height. The expensiveness and complexity of Tatlin's structure indicate that it was far from being purely functional in terms of mechanical efficiency, economy of means or usefulness as a building. Yet as an expression of aspiring force and cohesion it was impressively efficient. The ascending spirals play a crucial role in this but it is an expressive and symbolic role and not a functional role, having more in common with the mystical mountain of Čiurlionis' painting than with the robust practicality of a spiral staircase. Tatlin's great raised spirals unite with the leaning pier to symbolize progress upward and forward.

158

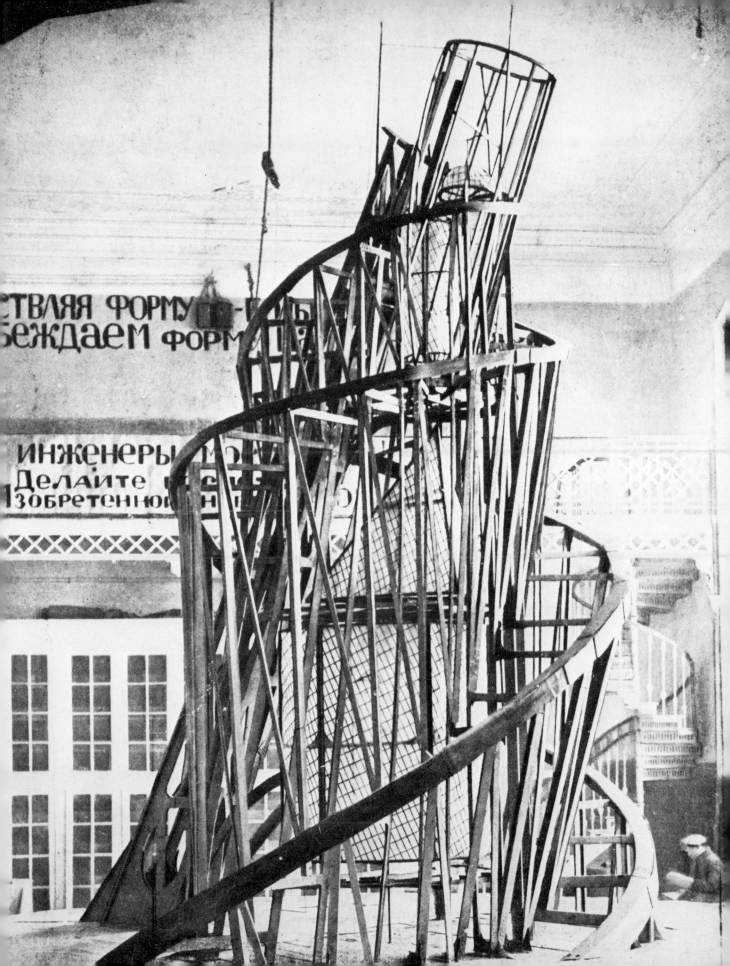

The decreasing radius of each spiral rapidly lessens the interior space available as the monument ascends, so that the interior halls decrease rapidly in size (Plate 159). In so doing they provide a perfect parallel of the evolution of decision-making and power which emerges from the broad earth to the largest assembly hall, and thence upwards to bodies both smaller and higher in authority and altitude. The purification of collective will is a theme of Tatlin's monument and the spirals are crucial to its expression: the function of Tatlin's Tower is to be a monument but, in addition, it is to function as a social alembic. The theme of spiritual aspiration is anchored in practical decisions and a political view of human evolution. In a sense the tower is more a social mechanism than a symbol, for it includes, physically, the processes by which social decisions and conflicts would be resolved. Here the spirals reflect the process of dialectical argument and its continuing resolution and purification. The monument was, after all, to house the decision-making processes of communist government. The tower concerns itself with movement in a particular way, for in place of a static, complete structure it embodies a process. As a monument it does not commemorate an event of the past but reveals the continuing evolution of the present. The monument, itself part of this evolution, was to provide a focal point of this process of becoming. A dialectical view of history as a process of evolution has replaced the contemplation of events, isolated in time and space. History is envisaged as the story of human evolution, a process of growth, an advance towards self-knowledge: 'From the point of view of the human actors,' wrote Hegel, 'history is a union of irony and tragedy; from the point of view of the whole it is a cyclic or spiral advance.'[9]

Close as this may seem to Tatlin's starting point, his material, non-aesthetic investigations had brought him also to a standpoint from which he was able to approach social organization as ultimately a material process. From this point of view Tatlin was uniquely suited to the commission for the Monument to the Third International. In the solution that he devised lies evidence of a new role for creative activity.

With the coming of the October Revolution, constructivists argued the essential identity of their own material investigation of creative work with the broad development of the political and social revolution. That the Communist Party did not necessarily accept this special relationship is evident from arguments put forward in *Pravda*, *Lef* and other periodicals of the 1920s. Whether or not this link was a real one, the case for its existence was vigorously argued.

Tatlin had radically adjusted his own standpoint, moving from construction defined by material characteristics, to a more diagrammatical construction related to the process of government and its role within the social body. In providing a social dimension to his process of construction, Tatlin evolved a pioneering and a vigorously new work, distinctly communist in its commitment.

If the ascending spirals of Tatlin's Tower exemplified and contained the processes of resolving conflicts and decisions, so too did its dynamic lean indicate a will to action. Here was a social alembic: the evolution of human history was to be determined here, and corporate will condensed, purified and transformed into the energy of action. With its committees in session the tower would have comprised the nerve centre of intended world government.

160

The function of Tatlin's two spirals was to provide a structure which corresponded to the process of communist government. The banner suspended from the tower, and visible in the elevation published by Punin (Plate 152), reads 'The Soviet of Workers' and Peasants' Deputies of the World'. As the revolutions of the spirals diminish with height, the rooms suspended within them grow smaller. According to Punin the sequence of these rooms from bottom to top was (1) a cube, given over to legislative work and large meetings as, for example, the International, (2) a pyramid, for executive administrative committees, and lastly (3) a cylindrical room given over to the dissemination of decisions and information by printing presses, propaganda offices, a telegraph office, projection equipment for the proposed large screen and a radio station.[10]

Difficulty arises over the various forms of the uppermost section. Punin does not mention the hemispherical room clearly visible both in the side elevation illustrated in his pamphlet and in the models, but not indicated in the rear elevation published by him. In the version known from the photographs the sequence of rooms from bottom to top is cube, pyramid (right-angled), cylinder (circular in cross section) and hemisphere. All are elementary geometrical solids yet there is no clear relationship between them. Beyond the fact that for practicality's sake (although this is not a predominant factor in the construction) each of the rooms has a horizontal floor, there is little to indicate a reason for beginning the sequence of rooms with a cube at the bottom passing, via pyramid and cylinder, to a hemisphere.

Revealing comparisons may be permitted by considering the sequence of forms of cube, pyramid, cylinder and hemisphere outside of the context of architecture. It has been suggested that the formal structure of the main diagonal strut connecting the spirals is comparable to that of the spine of the human body in relation to the enclosing and protective forms of the skeleton, and of the rib cage in particular. This suggestion of a figurative element in Tatlin's Tower tempts comparisons more with sculptural than with architectural precedents. Punin objected that figurative monuments 'cultivate the heroism of the individual', for their forms were 'too specific in the midst of the ten-mile ranks of the proletariat'. What was needed, according to Punin, was a monument which reached 'beyond the representation of man as an individual'.[11] Punin had even rejected the use of a generalized, typical figure in monumental sculpture as incapable of expressing the vitality and variety of the masses who are 'richer, livelier, more complex and more organic'.[12]

Tatlin's Tower, even if it does contain figurative elements, cannot be described as specific, yet there is more than a metaphorical resemblance, for Tatlin's Tower employs a spine, legs, rib cage and vital organs that move: Tatlin's construction is more than a visual representation, for it functions, both mechanically and socially. The sense in which the organs of Tatlin's Tower could be said to be alive was in their social functioning. If the tower contains references to the human form, it is upon the communal and not the individual level: the figure he presents is not heroic or typical but the collective and social body of man—a hyperhuman, the human form of the collective identity. It was more than a symbolic object. Tatlin's Tower provided an image of the social macrocosm.

Reference to works by Tatlin's admirer and colleague Rodchenko adds support to this analysis. Rodchenko's kiosk designs of 1919–20 (Plate 160) were for information and propaganda points; their function is comparable with Tatlin's project in this respect. For the most part they were for much smaller constructions—though not always, for Rodchenko's own design for the offices of the Soviet of Workers' and Peasants' Deputies (Plate 161), dated 1920, suggests an enormous scale.

Rodchenko is close to Tatlin in designing projects which appear to be highly impractical. Unless these works are dismissed as personal fantasies, their evident coherence must be assessed on a different level. Part of the aim of those investigating construction after the Revolution was to devise forms in keeping with new concepts of the role of cultural and creative activity within society. The political revolution demanded, if the constructivist view of materialist creative work were to be brought into step with it, an examination of artistic creativity which went beyond individual stylistic questions to broader cultural problems. To re-establish the image of the human being within this investigation meant to abandon the depiction of the individual in order to depict a social identity. Projects by Rodchenko, and Tatlin's Monument to the Third International, attempt this. These apparently impractical structures occupy unexplored territory; non-objective art and the study of material construction have become social rather than personal, collective rather than individual. Tatlin's monu-

160. Alexander Rodchenko: *Project for a Street Kiosk (Biziaks)*, 1919. It incorporates display screen, projectors, clock, etc.

161. Alexander Rodchenko: *Sovdep project. Elevation*, 1920. Ink on paper, 26 × 21 cm, inscribed 'section' and 'hall'. Tretyakov Gallery, Moscow.

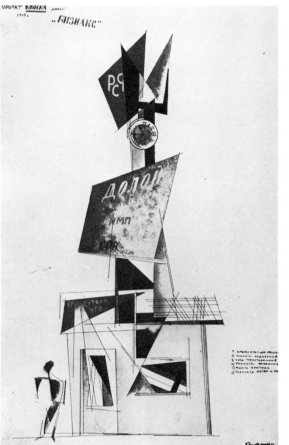

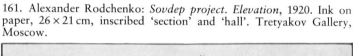

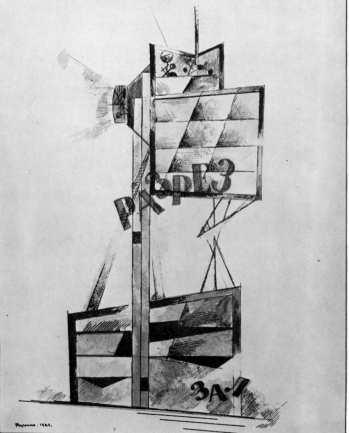

162. Attributed to Martin van Heemskerck: *Pharos*, c. 1570. Pen and wash on paper, 19.4 × 25.6 cm. Musées Royaux des Beaux-Arts de Belgique, Brussels (Collection de Grez).

163. Martin van Heemskerck: *The Colossus of Rhodes*, 1570. Engraving. Courtauld Institute of Art, London (Witt Collection).

ment surpassed Rodchenko's studies in its integral inclusion of government organizations. Tatlin's project shares with Rodchenko's designs a declamatory quality, but Tatlin's was intended to function as a complex social organism. Its resemblance to human form was not superficial; indeed it has no superficial resemblance to human form. Its relation to the human figure was linked to its social function. Its scale was necessarily enormous. Tatlin would have provided one of the Wonders of the Modern World. It is not surprising that the project readily recalled and challenged the monumental Wonders of the Ancient World, in particular the pyramids,[13] the Colossus of Rhodes and the Pharos lighthouse (Plate 162). Both Tatlin's Tower and the pyramids were intended as gigantic monuments, neither properly sculpture or architecture, but a fusion of the two.

The pyramids, celebrated for centuries amongst the Seven Wonders of the Ancient World, shared with two other Wonders the characteristic of monumentality. The statue of Zeus and the Colossus of Rhodes were both enormous sculptures on an architectural scale. The Colossus stood astride the harbour mouth at Rhodes at such a height that ships could sail beneath (Plate 163). The combination of engineering skill and sculptural monumentality distinguished the Colossus as a work whose possibilities and problems were closest to Tatlin's own. The Colossus with its maritime function could be expected to attract Tatlin's particular interest in view of his naval experience. Moreover, as his gigantic monument was designed for Petrograd, recognition of its maritime prowess was appropriate. According to T. M. Shapiro, who assisted Tatlin in the construction of the model of the tower, its two enormous arches were intended to straddle the River Neva in Petrograd.[14] This strengthens the case for its interpretation as a special kind of striding figure. Comparison with Kustodiev's painting the *Bolshevik* (Plate 164) underlines the political message inherent in this.

The chambers suspended within Tatlin's Tower were intended to move. Punin's pamphlet states that 'the singular nature of the mechanism allowed the rooms to move at different speeds. The lowest room, a cube, moves around its axis once per year . . .

163

164. Boris Kustodiev: *The Bolshevik*, 1920. Oil on canvas, 101 × 141 cm. Tretyakov Gallery, Moscow.

The next room is pyramidal and revolves around its axis once per month ... the highest room is cylindrical and revolves once a day.'[15] The smooth revolutions of the enormous halls were to mark off time as regularly as a clock, capable of indicating the hour, day, month and year by the positions of its inner forms in relation to the skeletal framework supporting and encasing them. Rodchenko's kiosks, which date from 1920 and were executed with a knowledge of Tatlin's project, each incorporate a clock of the more familiar form. However, Tatlin's project differs from Rodchenko's designs by virtue of the organic integration of its interior forms, functions and movements into its supporting framework. Whereas Rodchenko's towers would conceal their mechanisms, Tatlin intricately related the movements of his halls to both the movements of heavenly bodies and to social developments.

In considering the tower as a figure it was suggested that it comprised an image of the social macrocosm within which the individual human being was the microcosm. In relating the work of the Soviet of Workers' and Peasants' Deputies to the movements of the planets, Tatlin attributed to these political and organizational bodies

a regular rhythm, exemplified by the speed of the various halls' revolutions about the axis: this is to suggest a harmony of rhythm between the processes of human social development and the movements of heavenly bodies. Tatlin here approaches astrology.

The interpretation of Tatlin's monument as a figure signifying the social human form, and the interpretation of the monument as a clock, or as a device which regulates the organizational activities of men and relates them to celestial rhythms, are not irreconcilable interpretations. The Zodiacal Man (Plate 165) of alchemical and medical history related the passage of the sun through the twelve zodiacal constellations to parts of the human body. That the signs of the zodiac could be marked out on Tatlin's Tower to be traversed by both solar rhythms and movements within, makes of Zodiacal Man an instructive comparison with Tatlin's Tower, for whilst Zodiacal Man relates the stars to the anatomy of the individual human being, Tatlin's Tower, seen as an image of collective man, relates celestial rhythms to the anatomy of the social body.

This suggests an astrological interpretation of history, whereas Hegel and Marx saw an evolutionary process in history. In the paintings of Čiurlionis the zodiac was much in evidence, with gods observing the activities of men. Tatlin rejected such explicit references to mysticism, but he may have shared with Čiurlionis a preoccupation with the movement of the stars. On the formal level alone it is possible to see in the representation of time employed in astrological and alchemical diagrams a hierarchy of shapes comparable to that employed by Tatlin (Plate 166). Here are found, working upwards, the rectangle which is solid and heavy, the triangle with its connotation of aspiration from the earthbound heavenwards, and the circle whose shape is complete, perfect and celestial. Time necessarily played a significant role in alchemical theories being closely linked to celestial movements.

For a consideration of time and movement in Tatlin's project it is fruitful to consider the theory of history proposed by the poet Velimir Khlebnikov. Khlebnikov's works in the poetic field touched upon Tatlin's work with materials at several points and this has been discussed in connexion with Tatlin's reliefs. Khlebnikov's verbal investigations led him to a consideration of the evolution of verbal roots in which he considered the basic verbal material lay.

Khlebnikov's concerns with history and with language were closely related, for in words lay a key to the past. Khlebnikov defined his attitude as:

> To find, without breaking the circle of roots, the philosopher's stone for transforming all slavic words into one another—this is my first attitude toward the word. This self-contained word is beyond daily life and everyday uses. Having observed that roots are only spectres which conceal the strings of the alphabet, to find the unity of world languages in general, constructed units of the alphabet—this is my second attitude toward the word. The road to the world of trans-sense language.[16]

Although Khlebnikov published and collaborated with the Russian futurists, he adopted the Russian word *budetlyanin* rather than *futurist*. For Khlebnikov the *budetlyanin*, or future-dweller, was involved in an investigation of a future in which

165. Jollat: *Zodiacal Man*,
1533. Woodcut.

166. *Man, Alchemy and the
Cosmos*, from J. Manget,
Bibliotheca Chemica Curiosa,
Geneva, 1702.

167. (facing page) Naum
Gabo: *Standing Wave*, 1920.
Metal rod with electric motor,
height 58.5 cm. Tate Gallery,
London.

the aggressive automobiles of Marinetti's manifesto had no place. The study of time,
which he called *budetlyanstvo*, he defined as 'the study of the influence of the future
on the past'.[17] Khlebnikov considered time to be a spatial phenomenon, permitting an
investigation of its rhythms and structure across history. The key to these rhythms in
history he sought in the study of numbers, and the intervals between major events of
world history. Khlebnikov's mathematical theories of history had been published in
the manifesto *A Slap in the Face of Public Taste* as early as December 1912.

Tatlin's Tower comprises a kind of clock in which the deliberations and actions of
the world of men are related to and regulated by the rhythms of the sun, the moon
and the earth. These movements are those of the daily revolution of the earth about
its own axis with the consequent apparent movement of the sun, the period of the
phases of the moon, and the movement of the earth around the sun, and hence its
passage through the constellations of the zodiac. Whilst Tatlin's Tower does not
incorporate planetary movements it begins to resemble an orrery as much as a clock.
This implies a view of history in which rhythm and number determine events.

In Russia, Pyotr Uspensky, a vigorous and popular writer on mystical interpreta-
tions of the universe, seized upon the fact that scientific research increasingly under-
mined the apparent solidity of the daily world; and he forged from these elements a
volume that, as suggested earlier, exerted persuasive power upon Tatlin's generation,
the book *Tertium Organum: Key to the Laws of the Universe*.[18]

166

There is an immediate resemblance evident between Uspensky's descriptions of the nature of time and those of Khlebnikov:

'Things are connected, not by time, but by an inner connection, an inner correlation, and time cannot separate those things which are inwardly near, following one from another. Certain other properties of these things force us to think of them as being separated by the ocean of time. But we know that this ocean does not exist *in reality* and we begin to understand how and why the events of one millenium can directly influence the events of another *millenium*.[19]

Uspensky describes time as spatial and flexible like a piece of paper: 'If on one corner is written the year 1812, and on the fourth 1912, those corners can touch each other. If on one corner the year is written in ink and the ink has not yet dried, then the figures may imprint themselves on the other corner.'[20]

Uspensky's view of humanity is of a creature extending in time as well as space yet visible to our untrained perceptions at only that cross-section called 'now':

Thus all those great characters who tower like giants in the history of mankind, like Buddha-Siddartha and Jesus in the realm of the spiritual, and Alexander the Macedonian and Napoleon the Great, in the realm of physical conquests, were but reflexed images of human types which had existed ten thousand years before, in the preceding decimillenium, reproduced by the mysterious powers controlling the destinies of our world.[21]

In March 1913 in the journal of the Union of Youth, M. V. Matyushin had brought together a discussion of Uspensky's *Tertium Organum* and the recently published text *Du cubisme* by the French cubist painters Albert Gleizes and Jean Metzinger. As Tatlin was associated with the Union of Youth at this moment he had access to Uspensky's ideas through Matyushin's article even without reading *Tertium Organum* itself.[22] In Matyushin's article Uspensky's theories were linked with those of cubism, for Uspensky insisted that the way to learn to see in the fourth dimension was to develop the mental practice of imagining objects from all viewpoints simultaneously, a process which, as it happened, could be illustrated with negligible difficulty from French cubist painting. For a constructor of material objects, such as Tatlin, to envisage extensions in time as a feature of his work would involve movement and development.[23] The extent to which Tatlin's Tower complies with such a concept of a developing work is striking. It is revealed by a comparison with Gabo's contemporary kinetic sculpture *Standing Wave* (Plate 167), a wire (vertical at rest) which is vibrated by means of a motor concealed in the base of the work. The form assumed by the wire as it flexes and vibrates makes visible a virtual volume related as much to the movement as to the wire. Whilst it cannot be denied that vibration which produces the form relies upon extension in time, it nevertheless has no evolution or development in time, and is merely an exercise in vibration. Seen from Uspensky's position its extension in time is in any case inevitable. The fact that the sculpture may be switched on and off merely indicates the irregularity of its organization in time. To attempt to restrict the form of the sculpture to those periods of vibration and to disclaim its form when the wire is static is an exercise in labelling. By contrast, movement in Tatlin's

168. El Lissitzky: *Tatlin working on the Monument to the Third International*, 1922. Collage and drawing. Collection Eric Estorick, London.

Tower was concerned with continuity and not the shape of movement. In linking the movements of his halls to those of the sun, moon and earth, Tatlin related them to smooth and apparently endless movements. Around them he wrapped the ascending spirals of argument. Within them he placed the actual conflicts and decision-making which constitute historical evolution relating them to astronomical movements of infinite extension in time. No cessation of movement is imagined, for Tatlin links his monument on the one hand to the ceaseless movement of the heavens, and on the other to the ceaseless movement of human history.

The extent to which this is an astrological link remains unclear, for Tatlin was capable of borrowing from astrology those concepts appropriate to his monument's functions to construct a kind of cosmological model; there was no specific suggestion in Tatlin's work of foretelling the future, as to a degree there was in Khlebnikov's.

It is possible to find within the covers of the *Tertium Organum* of Uspensky a hint of that utopian vision of mankind's progress which appears to have been a central feature in Tatlin's Tower. In a passage of the *Tertium Organum* which the author may have regretted when fleeing the Revolution, Uspensky quotes from *Cosmic Consciousness* by a Dr Bucke concerning a revolution that is not only spiritual but also social:

> The immediate future of our race is indescribably hopeful. There are at present impending over us three revolutions ... (1) the material, economic and social revolution which will depend upon and result from the establishment of aerial navigation, (2) the economic and social revolution which will abolish individual ownership and rid the earth at once of two immense evils—riches and poverty, and (3) the psychical revolution.[24]

The internationalism of communism is what the monument was intended to celebrate. Its form was dedicated to the unity of mankind whose oppositions, it was suggested, are resolved by and whose energies are chanelled into the evolution of mankind as a whole through a dialectic process. Its hanging sign refers to the earth as 'the terrestrial sphere', emphasizing that unity puts mankind into a cosmological framework, harmonizing the social and the celestial. Tatlin's Tower does not include a sphere, for it was intended to stand upon a sphere, that of the earth whose astronomical relationships to the sun and moon it reflected in its own internal movements. The planet earth itself is the first great hall of the sequence, the least organized, the source of those conflicts which the higher halls of the tower resolve and purify into concerted actions.[25] Just as the futurist poet Khlebnikov compared his linguistic constructions to a search for the philosopher's stone which would reveal the links between the languages of men, so Tatlin's Tower represents a social alembic for the resolution of opposites and the transmutation of base social material by a purifying and social philosopher's stone.[26]

In El Lissitzky's photomontage of Tatlin working on the Monument to the Third International (Plate 168), Tatlin is associated with the compasses. By his feet are mathematical symbols amongst which are a spiral and the symbol for infinity. In alchemical diagrams the compasses are associated with Chronos (or Saturn), the

169

personification of time (Plate 169). His image is associated with the hourglass. Both of these symbols appear in alchemical diagrams and in, for example, Dürer's *Melencolia I* (Plate 170), a work dominated by a figure in brooding contemplation of time, geometry and number.[27] The magic square behind Dürer's angel testifies to the alchemist's fascination with numbers. Khlebnikov's preoccupation with numbers was comparably alchemical: 'The secret irrational ties between objects are not the pain of muteness for us any more, but the joy of first namegiving. On the border of the Fourth Dimension the dimension of our times—one can speak only in the language of Khlebnikov.'[28]

In 1914 Khlebnikov had published *Battles 1915-1917: A New Teaching about War*,[29] in which he applied his numerical theory of history to contemporary events. According to Khlebnikov the number *365* underlies human history and *28* is linked with personal destiny. It is significant in connexion with Tatlin's Tower that *365* is the number of days in the year and may be related to the largest and lowest of Tatlin's halls. Similarly *28* is the number of days in a lunar month, and corresponds to the twenty-eight day period of revolution around its axis of the pyramidal hall in Tatlin's Tower.

In his structure, Tatlin was concerned with the periods of revolution of the halls and not with the means required to make them move. The critic Nikolai Punin had admitted in his pamphlet that details of the building had still to be defined. Amongst those details was the considerable matter of the mechanism necessary to turn the vast halls about their axes. Tatlin's halls remain formal devices conceived on the abstract level of the geometer and not on the practical level of the mechanical engineer. Tatlin was not designing as an engineer: he would have needed engineers to reconcile the formal requirements of his tower with mechanical feasibility. None of these difficulties arose in 1920 when the model was exhibited, for it was executed in wood and on a sufficiently small scale for questions of stress and weight-bearing to have been effectively postponed. His priority was the arrangement of significant movements and only after these necessities are established do questions arise concerning the mechanical difficulties involved. The engineer's priority would not be the fact that halls rotate but how they rotate; on this crucial aspect of Tatlin's Tower his elevations and his model remain totally uninformative. All that Punin's pamphlet offers is the assertion that 'the singular nature of the mechanism allowed the rooms to move at different speeds'.[30] Given that no known work executed by Tatlin before the tower employed machinery, it is to be suspected that his lack of involvement with machinery continued into the designs for the tower. This is not at all to say that, had it been executed, its machinery would not have comprised an important and an impressive element within the whole; but it is to say that Tatlin did not begin with his machinery and build around its most efficient deployment. It was the idea and not the mechanistic realities which were his prime concern: as engineering, the tower is utopian. It is significant that when the model was exhibited in Moscow it was operated by a small boy concealed in the base to turn a crank handle.[31]

Nevertheless, and in spite of this, the image it presented was of a building so lacking in traditional architectural devices as to evoke parallels with factories and industrial

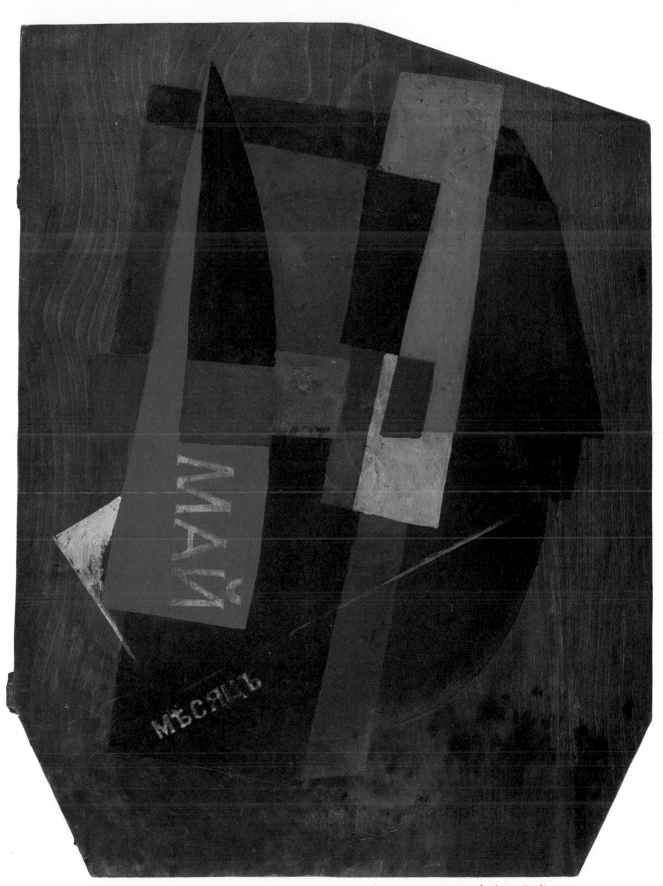

III. Vladimir Tatlin: *Composition*, 1916–17. Oil on wood, 52 × 39 cm. Nationalgalerie, Berlin.

structures. The exposed struts and girders directly evoked the appearance of engineering structures without their severely material functions. If Tatlin's Tower is to be considered as a machine, the question of its purpose or function arises at once.

There is a degree of irony in the fact that Tatlin's work was soon described as 'machine art' both in Konstantin Umansky's book on Russian art published in 1920,[32] and in the sign displayed at the Berlin Dada exhibition in June 1920 by George Grosz and John Heartfield, which declared, 'Art is Dead, Long live the new machine-art of Tatlin.' The German mechanistic view of Tatlin in 1920 was perpetuated by Raoul Haussmann's photomontage *Tatlin at Home*, now in the Moderne Museet in Stockholm.

A comparison of Tatlin's Tower with devices that are primarily mechanical emphasizes his omission of the apparatus of movement which is assumed to operate through unseen devices. In, for example, Sir William Herschel's great reflecting telescope (Plate 171), discussed here as a functional mechanism for the purpose of comparison and not as a suggested influence on Tatlin, the apparatus for revolving the platform on which the structure stands and the pulleys for raising his enormous telescope are explicitly revealed as an integral part of the mechanism. Similarly,

169. *An Emblem of the Philosopher's Stone*, French seventeenth-century engraving. Chronos (Time) with scythe and dividers surmounts the diagram; the sun (representing gold) and moon (silver) flank the emblem.

170. Albrecht Dürer: *Melencolia I*, 1514. Engraving 23.9 × 16.8 cm.

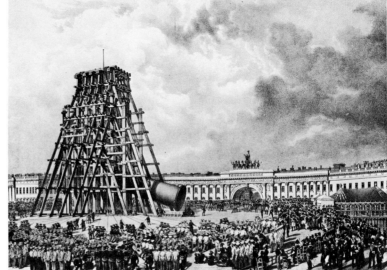

171. Sir William Herschel: Reflecting telescope, 1788.

172. Bichebois and Bayot: *The Erecting of the Alexander Column in St Petersburg*, from Auguste de Montferrand, *Plans et details du monument cousacré à la memiore de l'Empereur Alexandre*, Paris, 1836. Lithograph. National Museum of Finland, Helsinki.

Herschel's construction is defined by the function of raising, lowering and revolving the telescope in order to survey differing segments of the night sky; it is necessarily therefore a structural framework within which the crucial function is incorporated in the telescopic cylinder. The supporting skeleton is as it is, solely in order to support this cylinder and permit it to move. In Tatlin's Tower the relationship of the inner halls to the framework of struts which surrounds them is, on the mechanical level, entirely obscure, as is the method of supporting the enormous rooms within the structure of the spirals. Whilst Tatlin's Tower does relate its rotating rooms to its outer framework, it is not on the mechanical level that this occurs. This is further revealed by comparing Tatlin's Tower to the structure devised to erect the Alexander Column in the Palace Square before the Winter Palace in St Petersburg in the 1830s (Plate 172). There is no evidence to link this structure, surrounding the erection of an earlier colossal monument in the city for which Tatlin's monument was intended, with Tatlin's own, but it does provide a striking visual parallel and a comparison permitting Tatlin's Tower to be assessed as an engineering mechanism. Again the structure has a clear mechanical function which is the essence of the relationship of the outer skeletal framework to the cylindrical core. In this it is similar to the example of Herschel's telescope although the scale of the operation is altogether larger, and the sheer weight of the column finds its expression in the density of the wooden struts needed to support it during erection. There is a direct interplay between the weight of the inner element, the column, and the outer supporting framework. In Tatlin's Tower this remains unclear, and even allowing for its proposed execution in metal, which might make its supports less obvious than their wooden counterparts, no hint is given of how the inner halls could be related mechanically to the outer framework of the tower.

It would appear that, whilst Tatlin's Tower would involve engineering, it is not primarily an engineering structure. When working on the tower Tatlin was operating

173

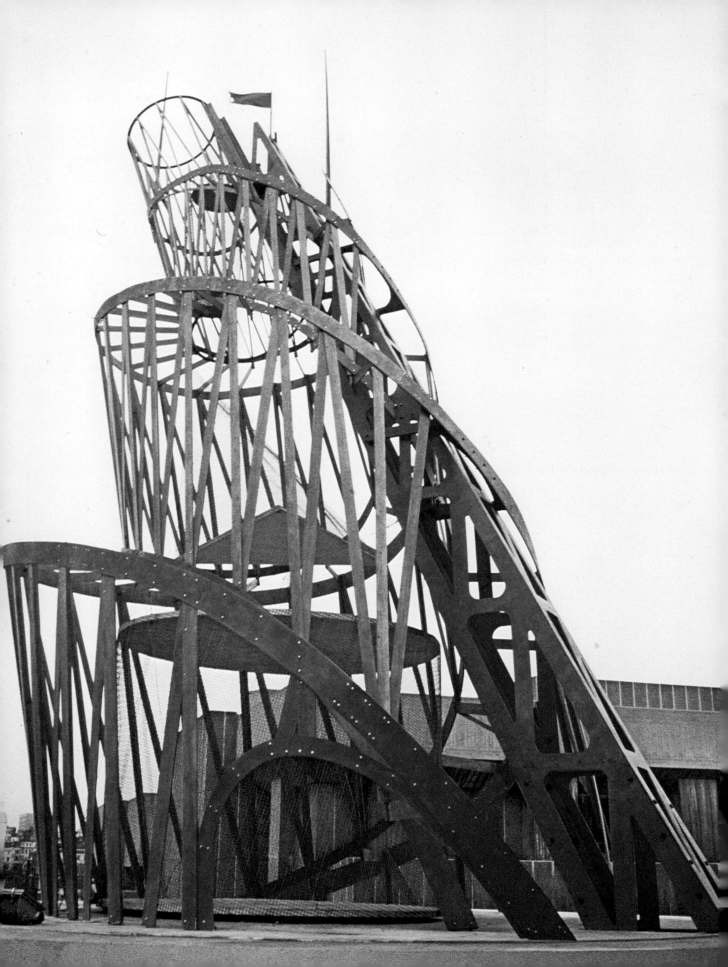

in a new field of creative activity. His own work had evolved from the personal and aesthetic world of his paintings to the stage of material investigations in his reliefs. Now his work had further evolved with the integration of a social element into his tower. If this involved engineering problems then Tatlin would employ engineers during the realization of his project. He worked as a creative person and not as a man fulfilling predetermined functional requirements by the appropriate disposition of materials. His position in this respect was perhaps the opposite of that of Gustave Eiffel whose own tower of thirty years earlier had resulted from an engineer of brilliance approaching a cultural activity by constructing a monument to the modern age. Eiffel's engineering considerations related to the structural possibilities of his material and its configuration in space. Its mechanical function was to reach a height of 300 metres and be stable. In doing so it supported little other than itself and the pressure of the wind. Tatlin, in wishing his tower to go higher than Eiffel's tower, was approaching the problem with more optimism than experience. His approach was not at all that of the engineer.

Eiffel's brilliance was to have defined his forms by strict references to mechanical stresses and to the nature of his materials. Unlike Tatlin's Tower, Eiffel's is symmetrical around its central axis. Its severity in these features is modified only by the application of minimal decorative devices and by the inclusion of restaurants and other facilities for visitors, facilities in themselves irrelevant to the structure of the tower, which is otherwise permitted to express dynamic thrust and poise by virtue of forms demanded by the engineering principles of the 1880s. The symmetry of Eiffel's tower lacks the forward thrust of Tatlin's Tower, yet it sits more lightly upon the ground and does not appear to emerge from it. On the occasion of the modifications of the Eiffel Tower for the Exposition Universelle of 1900, Eiffel published a book of engineer's drawings describing every strut of his tower and containing photographs of various stages of its construction.[33] The leaning legs in the early stages of construction, before the great arches were completed, have the forward thrust of Tatlin's Tower but with a far more incisive sense of the precise use of materials to control stresses and to constrain immense forces.

Eiffel's tower even incorporated kinetic features to which those of Tatlin's Tower were comparable: there were for example its two systems of lifts, one of which moved diagonally along the complex curve of the leg of the tower running on tracks, cables and pulleys. Eiffel described in his book how the tower was illuminated for special festivities by many gas-jets in glass domes, or submerged in the brilliant red glow of a hundred Bengal candles (Plate 173).

There is no reason to suppose that Tatlin's plans to rival the Eiffel Tower, indeed to outstrip it, in height and signficance, date from his time in Paris, for the known works executed upon his return to Russia were his reliefs. The idea may have its roots, however, in this experience, for Eiffel's design, like that of Tatlin is full of spirals and struts; it has sloping arches and stretches vertiginously above surrounding masonry buildings.

At the time of Tatlin's visit to Paris, Eiffel's tower was still a vigorous image of modernity.[34] As such it attracted Robert Delaunay as a theme for many paintings.

175

IV. Reconstruction of Tatlin's Monument to the Third International, made by Christopher Cross, Jeremy Dixon, Sven Rindl, Peter Watson and Christopher Woodward, 1971, for the exhibition Art in Revolution, London.

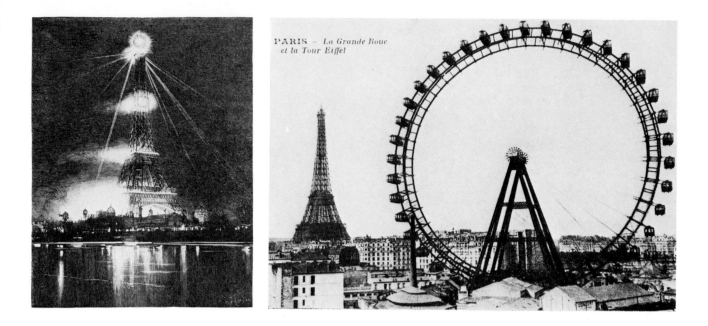

PARIS – La Grande Roue
et la Tour Eiffel

Tatlin and Delaunay had interests and acquaintances in common and it is possible that Delaunay's views of the Eiffel Tower had a long-lasting impact upon Tatlin.

It was in 1913 that Delaunay exhibited his painting the *Cardiff Team* (*Third State*) (Plate 74) at the Salon des Indépendants in Paris. As this exhibition was held in the spring it is just possible that Tatlin may have seen Delaunay's large oil there. It stands over six feet high and is painted in brilliant colours. It is the most complex and vital of the whole series. As well as the Eiffel Tower, Delaunay depicted the Great Wheel constructed for the 1900 Exposition Universelle (Plate 174). Here was an example of regular mechanical movement on an enormous scale which might be expected to have impressed Tatlin's mind either through Delaunay's paintings or from the experience of the Wheel itself (see also Plate 175). Delaunay also depicted in the *Cardiff Team* Blériot in flight, an advertisement for the Astra aeroplane construction company and leaping sportsmen. The Astra advertisement recalls the third kind of painting by Delaunay which Tatlin may have encountered, paintings with cosmic themes in which light issues from the sun and the moon as discs or curves of colour, balancing strong solar rhythms against intricate and more delicate lunar rhythms. Delaunay's enthusiasm for cosmic themes and celestial interactions, as well as for the Eiffel Tower, are equally themes in Tatlin's Tower. As Tatlin worked with Yakulov in 1917 in the Café Pittoresque and as Yakulov had visited Delaunay, even as late as 1917 it is possible that the disks, wheels and towers of Delaunay's painting may have been the subject of discussion in Russia.[35]

Cosmological theories and the definition or description of Utopia are not incompatible. Tatlin united a cosmological with a utopian image of order and progress in his tower, identifying the organization of the social identity of humanity with the endless and effortless regularity of celestial movements.

Amongst utopian writers respected in communist circles was the Dominican monk Tomasso Campanella (1568–1639), who was admired by Lenin and whose ideas prefigured communism. His interests, like those of Tatlin, spanned the earthly and

176

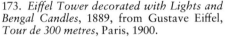

173. *Eiffel Tower decorated with Lights and Bengal Candles*, 1889, from Gustave Eiffel, *Tour de 300 metres*, Paris, 1900.

174. Eiffel Tower and Great Wheel, Paris, *c.* 1900. [Photograph Editions Nugeron, Paris.]

175. Alexander Rodchenko: Cover for V. Mayakovsky, *Paris* (Parizh), Moscow, 1925. The Eiffel Tower and Great Wheel are both visible.

social on the one hand, and the astronomical and cosmological on the other. He was a contemporary of Bacon and of Galileo, of whom he published a defence, *Apologia pro Galileo*, in 1622. The text, whose image of Utopia commended Campanella to communist readers, was his *City of the Sun* published at Frankfurt in 1623,[36] for in the City of the Sun individual ownership is prohibited amongst its citizens: 'All things are common with them, and their dispensation is by the authority of the magistrates. Arts and honours and pleasures are common and are held in such a manner that no-one can appropriate anything to himself.'[37]

Campanella's city is rich in cosmological and astronomical allusions: 'It is divided into seven rings or huge circles named from the seven planets',[38] and at its centre as the crowning glory of the city stands a temple whose cosmological inscriptions call to mind both Khlebnikov and Tatlin.

On top of the hill is a rather spacious plain and in the midst of this there rises a temple built with wondrous art ... The temple is built in the form of a circle; it is not girt with walls, but stands upon thick columns, beautifully grouped. A very large dome, built with great care in the centre or pole, contains another small vault as if it were rising out of it and in this is a spiracle which is right over the altar ... Nothing is seen over the altar but a large globe, upon which the heavenly bodies are painted and another globe upon which there is a representation of the earth. Furthermore, in the vault of the dome there can be discerned representations of all the stars of heaven ... with their proper names and power to influence terrestrial things marked.[39]

Elsewhere 'in the halls and wings of the rings [of the City] there are solar timepieces and bells and hands by which the hours and seasons are marked off'.[40]

Whilst parts of Campanella's text can be read as a description, not of the Temple of the City of the Sun, but of Tatlin's Monument to the Third International, and although he is known to have been admired by Lenin and read in Russia, there is no factual evidence to indicate that Tatlin was familiar with Campanella's *City of the Sun*. What this comparison does suggest is that Tatlin's Tower may have been a consciously utopian project and not merely an impractical project.

What distinguishes fantasy from utopian speculation is the degree to which it incorporates and exemplifies a system that is organized and controlled to perfection and is given a social and political expression. In the light of this both Campanella's *City of the Sun* and Tatlin's monument are utopian constructions. Furthermore, a utopian construction may be just beyond the rim of feasibility in order to act as a model to be emulated and referred to: it clarifies aims and relations in an ideal social order, and does not actively participate in the less perfect present, except as a spur to action and a model of organization.

The rocket and flight pioneer K. E. Tsiolkovsky, whom Tatlin is known to have admired, provided a description of a Utopia, the publication of which was contemporary with Tatlin's Tower. Tsiolkovsky, in bringing together cosmological order and social organization, is as close to Campanella as he is to Tatlin. Furthermore, Tsiolkovsky was aware of recent developments in physics, and his Utopia lay in a future closer to Tatlin's grasp. Tsiolkovsky's Utopia was described in his novel *Beyond the Planet Earth*, first published in complete form in 1920.[41] Tatlin's monument was displayed in November and December of that year.

In *Beyond the Planet Earth*, Tsiolkovsky describes an imaginary encounter between the great scientific thinkers, who mysteriously convene from different centuries and different countries to converse in the remote castle of a Russian called Ivanov, who expresses Tsiolkovsky's views. They are a thoroughly international assembly and comprise Laplace, Newton, Helmholtz, Franklin, Galileo and Ivanov. The tower of the castle in which they converse is reminiscent of that of Campanella and that of Tatlin: 'At the top of the castle was a spacious glassed-in hall . . . the transparent dome would sparkle with the light of the planets and countless stars.'[42] From this remote observatory they plan a flight into space. The castle itself, although not in the least urban, is a marvel of scientific ingenuity: 'At night the castle with its myriad electric lights glowed from afar with the beauty of a heavenly constellation.'[43] It was lit by electricity from a turbine operated by a waterfall, and its suppliers were delivered by dirigibles. In due course the scientists build a rocket, launch it from a giant gun and establish themselves in orbit around the earth. Their rocket was propelled by blast-tubes which spiral round it and gradually widen towards the outlet aperture whilst inside the rocket is a cylindrical common room.[44]

Once established in space Newton, Galileo and their colleagues began to organize a utopian world floating in space, entirely man-made, logical and orderly: 'The layout of dwelling houses here will be astonishingly simple and standardized . . . The houses will be as standardized as the clothes; they will be built for millions of people.'[45] These

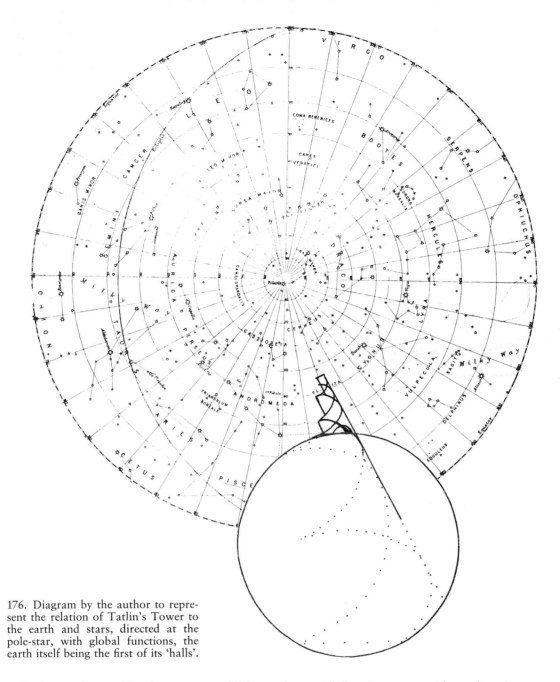

176. Diagram by the author to represent the relation of Tatlin's Tower to the earth and stars, directed at the pole-star, with global functions, the earth itself being the first of its 'halls'.

colonies are housed in glass rooms which revolve weightless in space, with gardens in them. Tsiolkovsky's description of the construction of these dwellings is close in details to Tatlin's Tower: the building elements consisted of 'thin cylindrical plates of a special strong and resilient glass, with a square wire netting welded onto the side. There were also spherical parts, ready-made metal attachments and very thin sheets of pure metal.'[46] Within this space-bound utopia order reigns supreme; all machinery functions smoothly and all social difficulties are resolved. The year is 2017, the hundredth anniversary of the Revolution in Russia.

By comparison, Tatlin's model is ponderously bound to the earth, yet in this it may

be said to go further than Tsiolkovsky's model Utopia, for in Tatlin's model the lowest hall may be seen as the terrestrial sphere (Plate 176), and it is this which provides Tatlin with his vehicle in time and space. From this viewpoint the imperative development is not of propulsive power but of social organization. The International which Tatlin's monument celebrates embodies an aspiration towards the unity of mankind sharing the sphere of the earth.

There is no doubt that Tatlin's monument became a *cause célèbre*. It was not only illustrated in Punin's pamphlet of 1920 but almost at once advanced as an international influence through the agency of such publications as Konstantin Umansky's *Neue Kunst in Russland 1914–1919*, the periodicals *Veshch* and *Broom*, and a book by the Hungarian Kassák.[47]

If Tatlin's Tower is impractical, it is because the design is utopian: yet if it is utopian, it provides a model in physical terms which verges upon feasibility, and a model too of social organization. Both the communist movement in Russia after the October Revolution and Tatlin in his proposed Monument to the Third International were concerned to realize utopian goals in the organization and growth of the social organism. The material realization of Utopia had become a theoretical possibility and requirement. Tatlin reflects that. After his tower in 1920, there is no further separation possible from the point of view of constructivism. Tatlin's Tower was a crucial work in forging this link. Difficulties concerning its practicality and interpretation did not cloud the clarity of this achievement amongst Tatlin's contemporaries.

Punin's pamphlet concludes:

The realization of this form means the embodiment of dynamic force with an unprecedented grandeur, comparable to the pyramids' embodiment of static force. We emphasize that only the fulfilment of the power of the many-millioned proletarian consciousness could hurl into the world the idea of this monument and this form. It must be built by the muscles of that power, for we have before us the idea, the living and classical expression in a pure and creative form of the international alliance of the workers of the world.[48]

Tatlin's Tower was almost certain to have been an impractical proposition, as problematic and expensive to erect as it was adventurous in its conception. It indicated an imaginative grasp at possibilities which, in physical terms, remained just out of reach. But if it was utopian, it was proposed at a time when Utopia was apparently receiving material and social foundations.

9 CONSTRUCTIVISM

On 1 January 1919 Tatlin had been appointed head of the Free Studios in Moscow. This meant that to a considerable extent art tuition in Moscow was under his authority. In addition, he became an instructor at the Petrograd Free State Studios where he organized the Studio for Volume, Material and Construction in what had formerly been the Imperial Academy of Arts.[1] Amongst Tatlin's assistants there were Bruni, Altman, Shapiro and Meyerzon; the last two assisted on the Monument to the Third International. 'The Revolution,' declared Tatlin, 'is strengthening the impulse towards invention. That is why a golden age of art will follow the revolution, a time when the mutual relation of the individual of initiative and the collective is clearly distinguished. The individual with initiative is the condenser of the energy of the collective.'[2]

Nikolai Punin, a spokesman for Tatlin in 1919, had already mentioned the projected monument in an article on 9 March. The tower summed up Tatlin's work for the campaign for monumental propaganda. In his tower, Tatlin had made a contribution that was widely publicized, was influential, and extended into the public and specifically communist domain the concern with construction that had developed from his pre-war studies. The tower as a construction had much in common with those earlier pioneering explorations, but it moved beyond them by virtue of its incorporation of a social aspect in which the world-wide aspirations of communism were allied to Khlebnikov's theory of human activity developing in harmony with the movement of the sun, the stars and the earth through space and through time. Punin recognized this link and there can be little doubt that only a thorough study of Khlebnikov permitted the evolution of Tatlin's Tower. The relative incoherence of towers projected in its wake by Rodchenko, Yakulov (Plate 177) and others is a testament to the fact that Tatlin worked with a maximum economy of elements with no superfluous element permitted. 'I ask what is the difference,' wrote Punin, 'between the Third International and Tatlin's reliefs of Khlebnikov's *Martian Trumpet*. To me there is none.'[3] The internationalism of communist endeavour was integral to Tatlin's project; Punin recognized in this a link with Khlebnikov and with Tatlin's reliefs.

Khlebnikov's influence had continued to grow during the years of war and revolution. His theories of the structure of time, in particular in relation to war, found a considerable response in, for example, the collage book assembled in 1916 by Olga

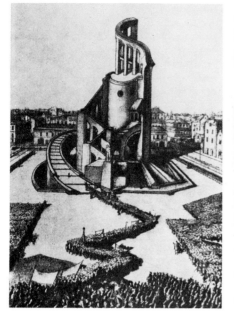

177. G. Yakulov and V. Shchuko: *Monument to the Twenty-Six Baku Commissars*, 1923. Drawing. Whereabouts unknown.

178. Olga Rozanova: Illustration to A. Kruchenykh, *Universal War*, Petrograd, January 1916. Paper and fabric collage on paper, 21 × 29 cm. Collection George Costakis, Athens. [Illustration © George Costakis 1981.]

Rozanova and Alexei Kruchenykh, *Universal War* (Plate 178). Rozanova died in November 1918. Kruchenykh with Zdanevich and other poets continued their activities after 1918 from Tiflis (Tblisi) in Georgia. *Zaum*, trans-sense poetry, was varied in its products but vital to Khlebnikov, and to various painters. Malevich published a *zaum* poem in 1919.[4] The pre-war reliefs of Tatlin had been closely associated with Khlebnikov's poetry and his importance for Tatlin did not cease with the Monument to the Third International.

On 13 April 1919 Khlebnikov declared in *Artists of the World* that 'the Alphabet, for most nations, is a brief dictionary of the spatial world, very close, painters, to your art and to your brushes'. He explained the spatial, and colouristic, significance of particular consonants and their combinations. For Khlebnikov verbal construction was closely allied to material construction in space. 'V,' wrote Khlebnikov, 'is one circle round another, in all languages, *Kh* is the impact of one point on another, *Z* is the flash of light on a hard surface, *Zh* is movement from a dark place, *Ch* is a bowl or containing shape, *Sh* the flux of several surfaces together, *P* a bridge between two points'; the list continues. With such a key, construction in materials could well have a verbal origin, particularly as Khlebnikov compiled *Artists of the World* at Tatlin's request.[5]

During 1919 Khlebnikov headed south upon a characteristic perigrination in the direction of Astrakhan. He moved to Kharkov where he was caught up in the Civil War, being arrested in turn by both White and Red Russian armies. He became ill with typhus.

In May 1920 Tatlin transferred from the art section of Lunacharsky's Moscow Ministry Narkompros to its Petrograd branch, although he remained on the organizing Kollegia of both departments.[6] In Petrograd his tower evolved throughout most of 1920, until its display in Petrograd in Tatlin's studio from 8 November until 19

182

December 1920 and its subsequent removal to Moscow for exhibition at Union House (Dom Soyuzov) at the Eighth All-Russian Congress of Soviets. Bruni, who was again sharing accommodation with Tatlin in 1920, was much excited by the monument.

During this period Khlebnikov's long poem *Ladomir* was published in Kharkov, and his dramatic poem *Death's Error* was staged at Rostov-on-Don. His wandering continued eastwards and south, from the Black Sea to Baku on the Caspian where he worked on government propaganda and began to assemble his long poem *Zangezi*. The Caspian, the war and his feeling for Arabic poetry, mathematics and astronomy took him on into Persia in 1920 where he slept in the streets and ate from the beaches. He grew increasingly frail and took little care of his physical needs.

Khlebnikov's studies of language led to a search for its roots and the transformations endured by words and their roots from one language to another. The idea of a universal language was as germane to Khlebnikov's thinking as was the Tower of Babel to the inherent internationalism of Tatlin's Tower. Both Tatlin and Khlebnikov were thinking globally, of a united planet earth caught up in astral rhythms. Khlebnikov's *Ladomir* described an enormous sculptural monument at the summit of Mont Blanc signifying the unity of mankind. The world of the Future was called *Lyudostan* (Peopleland) and its rivers sang of unity:

> Where the Volga says *I*,
> The Yangtse-kiang murmurs *lo*
> The Mississippi says *ve*
> Old Man Danube murmurs *all*
> And the waters of the Ganges say *the world*[7]

In 1921 Persia fascinated Khlebnikov. The possibility of a Soviet Persia inspired poems that dwelt upon Persian themes and gave an added force to that Southern Asian element in his own background. The Persian prophets Qurrat-el-Ayn and Zarathustra appeared in his poems. If buildings in Persia and neighbouring Iraq revealed a striking resemblance to Tatlin's Tower, such an enthusiasm was equally strong in Khlebnikov's poetry in 1920–1.[8] Uzbekistan had its own fascination for Tatlin's generation. Popova's paintings in the *Shakhi-Zinda* series evoked Samarkand in their titles and Arabic mathematics in their geometrical structure. Yakulov in the war had recuperated at Tashkent. The ancient cities of the silk route, Tashkent, Bukhara, Samarkand, with their cultures of Asia on the brink of the Arabic south had fascinated Kuznetsov and many other painters, providing a flavour distinct from any that Europe could offer. In a period of cultural isolation from the West, its fascination grew.

By 1921 Khlebnikov was suffering from chronic malnutrition, yet refused full medical treatment and returned to Moscow. His vision of the future announced in the *Trumpet of the Martians* manifesto still echoed in Moscow and Petrograd. As he wandered and grew ill, the vitality of his poetry provided an odd contrast with his physical condition. His visions, like Tatlin's Tower, were difficult to realize. 'We live in the silence of thunder,' announced Viktor Shklovsky in January 1921; 'In this powerful air the iron spiral has been borne of a monument twice the scale of St Isaac's Cathedral ... In the century of great lifting cranes, beautiful as the wisest Martian,

iron has every right to be furious and to remind mankind that our age, known in vain since the time of Ovid as the iron age, has no art of iron."[9] Tatlin, however, was always a pioneer, a discoverer of new lands, a pointer to new worlds. His vision was for the future and his influence was widespread, and the gulf of practicality that existed between his projects, insights, and discoveries and the context within which he worked is a measure of the independence and visionary quality of his work. The Revolution, which had given him so much authority in the realm of creativity and had made so many demands by 1921, had begun to reorganize in its first major readjustment the structure of Soviet creative activity. IZO, the art section of Lunacharsky's ministry, led by Tatlin in Moscow, was replaced in 1921, and demands were made that Tatlin's workshop should be closed. The closure of IZO meant a return for Tatlin to Petrograd where in November he was made a professor of sculpture. In Moscow the organizational activities of IZO were supplanted by those of the Institute of Artistic Culture.

By 1921 an initial period of innovation and creative ferment had become consolidated into a body of theory and work. Within this period Tatlin's example was of widespread influence and importance. He had acquired followers and admirers even before the Revolution, but, however broad his influence and however communal his projects, Tatlin remained an inventive and creative man of ascetic individuality. His conflict with suprematism had provided numerous painters with a critique of its achievements and a dichotomy of standpoints with reference to which they were able to mount an investigation of material construction in painting. Vesnin, Exter, Rodchenko, Popova and Stepanova had all taken this road, and if it was not that of Tatlin, it was a direction explored by frequent reference to his position. He remained pioneer and visionary: it was left to others to colonize and chart precisely areas of creative activity that Tatlin had vigorously opened up.

For Rodchenko the exploration of pictorial construction continued, increasingly negative and analytical, through 1920, culminating in its decisive abandonment in 1921. *Faktura*, as the recognition of the materiality of paint spread by various means across surfaces, had been a guiding priority in paintings of 1920, still in association with geometrical form. In this Rodchenko had remained distinct from Tatlin's approach to pictorial construction, for Rodchenko emphasized elements of geometrical form, as independent of scale or personality in his paintings as in a geometer's diagram. This was maintained by the use of ruler, compasses, scientific drawing instruments and, later, the camera. Where Tatlin had used ready-made elements of great irregularity and had organized them by reference to an underlying geometrical structure, Rodchenko made the geometrical elements themselves the basis of his constructions, working thereby with common intellectual property and eschewing idiosyncratic and unique properties. This carried Rodchenko beyond self-expression and personal style but still left him painting.

A *Composition* by Rodchenko from 1920 (Plate 179) reveals his concern for both a planetary theme and a structure occupied by letters. It shows Rodchenko responding to Tatlin and, perhaps via Tatlin, to Khlebnikov. In addition, by constructing his painting from the letters *RSFSR*, Rodchenko gave his work a social implication.

184

Altman too was to work with letter forms at this period. In his panel *Work* (Trud) of 1921 (Plate 180), *faktura* and the board-ground of the painting are much in evidence. *Faktura* and material are essential and recognized. The enormous Cyrillic *R* indicates Russia (Rossiya). Khlebnikov in his poem *Ladomir*[10] in 1920 had used letters as protagonists in a conflict involving *G* (Germany), *R* (Russia) and *L* (Ladomir). On the whole, however, Rodchenko worked with circles and straight lines evenly drawn producing contradictory picture space by means of repeated elementary units. Work with lettering, with cosmic and politically committed themes was taken up later by Lissitzky in, for example, the *Story of Two Squares* published in 1922.

When Rodchenko extended his unit constructions into three dimensions in 1920, he produced in effect a rigorous critique of painting's claim to be a special class of object, for here all trace of illusionism is jettisoned for a self-explicit, impersonal, geometrical structure, in which symmetry, *faktura* and material construct an object that needs no artist to make it, no training or expertise; that is devoid of narrative; and that has no rarity value, for its structure is ultimately intellectual and beyond the restraints of any particular scale and material that embody it, and can therefore be reproduced. The variety of these works reveals how far Rodchenko's process of construction was an investigation, an experiment repeatable at other times by other hands. Rodchenko

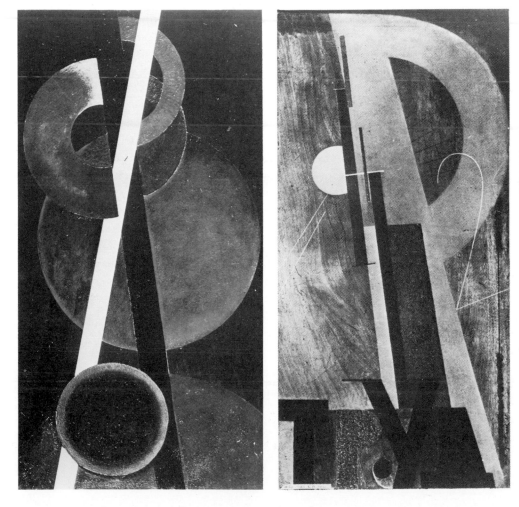

179. Alexander Rodchenko: *Composition*, 1920. Oil on board, 70 × 35 cm. Private collection, Moscow. The forms incorporate the Cyrillic letters *RSFSR*.

180. Natan Altman: *Work*, 1921. Oil on board. Tretyakov Gallery, Moscow. The Cyrillic letters for *trud* (work) provide forms for the painting.

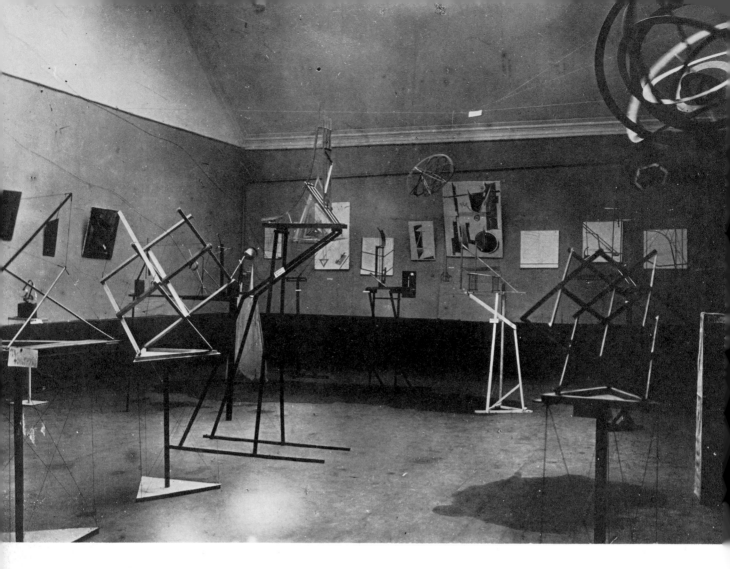

was on the threshold of painting and eager to move beyond it. In this Tatlin had provided guidance, yet Rodchenko's critique remained a largely negative and matter-of-fact critique of art. Rodchenko's works are extreme, new objects, common material, on the outer verge of art. When Rodchenko subsequently exhibited with his pupils at the Obmokhu group exhibition in May 1921 in Moscow (Plate 181), his approach and that of Tatlin were distinct, but the influence of both was reflected in the objects exhibited. Rodchenko's ultimately scaleless constructions derived from concentric geometrical figures, the circle, square, ellipse, hexagon and triangle hung from the ceiling. They were executed in wood but ultimately the construction was independent of that material, for the construction would not suffer by execution in other materials, by other hands at another time. To this degree Rodchenko had reached beyond self-expression and the preciousness of the art-object to a construction that was common property, did not demand originality of execution, and was not limited to particular materials. Nor did these works have a top or bottom to them. They were kinetic, for they moved in currents of air, revealing their construction in the light; yet their construction did not itself evolve or change, for it was beyond

186

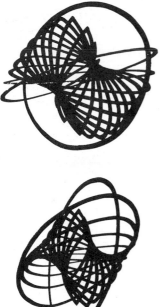

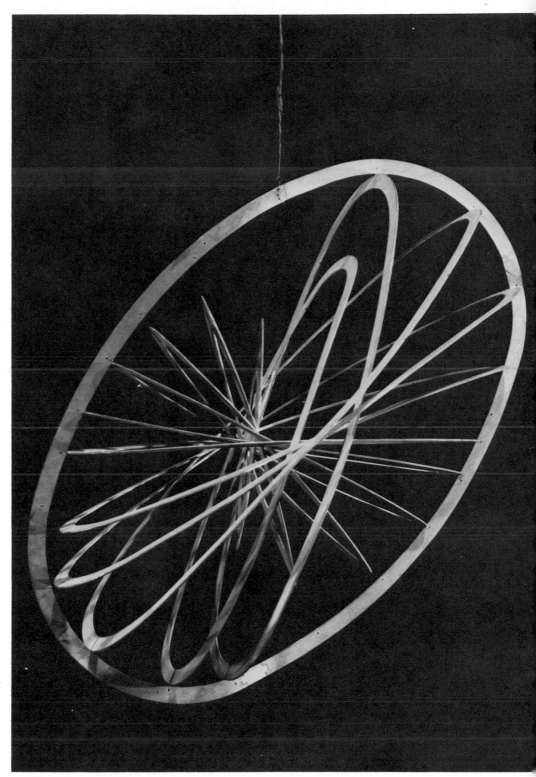

182. Reconstruction of Rod-
chenko's *Oval Hanging Con-
struction No. 12, c.* 1920, made
by John Milner and Stephen
Taylor, 1972. Photographs
show visual effect of movement
of the construction.

181. (facing page) The Obmo-
khu exhibition, Moscow, May
1921. [Photograph Alexander
Rodchenko Archive, Mos-
cow.]

183. Alexander Rodchenko:
*Oval Hanging Construction
No. 12, c.* 1920. Painted ply-
wood and wire, 83.5 × 58.8 ×
43.3 cm. Collection George
Costakis, Athens. [Illustration
© George Costakis 1981.]

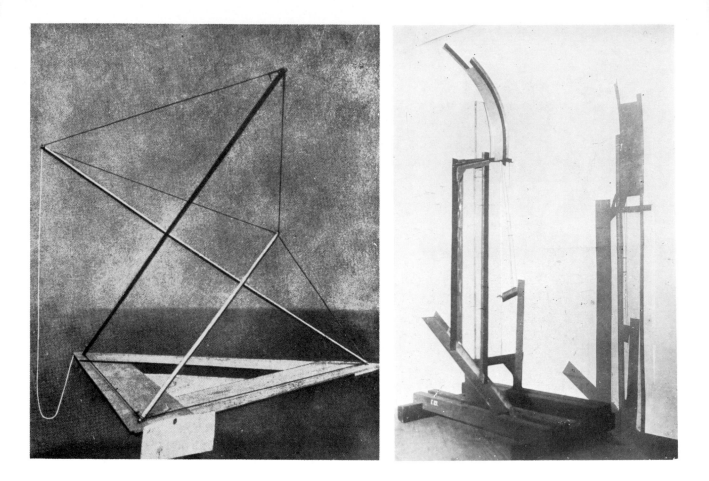

specific viewpoints whether in time or space. Only the tower amongst Tatlin's works had approached this kind of geometric construction and its double spiral may be reflected in the double-spiral surfaces suggested by the ribs of Rodchenko's elliptical mobile (Plates 182–3).

Rodchenko did not work in isolation, and his development during 1920 may be seen as a progression towards communal work. Rodchenko was active in both of the important institutes established in 1920 in Moscow, the Institute of Artistic Culture (Inkhuk)[11] and the Higher Artistic and Technical Studios (Vkhutemas)[12]. Both of these organizations were to play a vital role in the evolution of cultural theory and practice.

When Inkhuk was first organized in Moscow in May 1920[13] its first president was Wassily Kandinsky, whose essay 'Concerning the Great Utopia'[14] dates from this time. The aim of the Institute was to act as a centre for the discussion and formulation of theoretical concepts, many of which were in turn investigated in practice within the studios of the Vkhutemas. Rodchenko was amongst those who vigorously opposed Kandinsky's programme at Inkhuk and sought to implement different ideals after Kandinsky's departure from Russia for the Bauhaus at Weimar. Rodchenko, Osip Brik and the theorist Boris Arvatov formed a leading committee within Inkhuk.[15] As well as organizing theoretical study, Inkhuk devised group projects and arranged exhibitions. Nikolai Tarabukin, the critic and theorist, became the secretary.[16]

It was within Inkhuk that the examination of construction, central to Rodchenko's

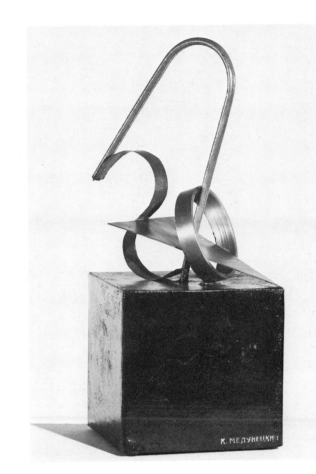

184. V. Ioganson: *Flexible Construction*, 1921. Wood and wire. Whereabouts unknown. Photograph published in Laszlo Moholy-Nagy, *The New Vision*, London (Faber and Faber), 1939.

185. Georgiy Stenberg: *Construction of Spatial Apparatus No. 11*, 1920. Iron, wood and glass, $81.2 \times 27.5 \times 41.1$ cm, signed 'G.ST'. Whereabouts unknown.

186. Konstantin Medunetsky: *Construction No. 557*, 1920. Tin, brass and iron, height 45 cm, signed on base. Yale University Art Gallery, New Haven, Connecticut (Gift of Collection Société Anonyme).

work, began to be taken up by sympathetic followers adopting the name 'Constructivists'. Their programme was discussed during 1920 at a plenary meeting of Inkhuk where a group was established under the title of the First Workers' Group of Constructivists. Rodchenko was an active participant. Alexei Gan, theoretician, was also in the group, together with V. Ioganson (Plate 184), Konstantin Medunetsky (Plate 186), Varvara Stepanova, Vladimir Stenberg and Georgiy Stenberg (Plate 185). Of these members the Stenberg brothers and Medunetsky assured the closest links between the collective exhibitors of Obmokhu, who had first shown anonymously in 1919, and the new constructivist group.[17]

The year 1920 saw a proliferation of groups with common members. Rodchenko in 1920 was active at Inkhuk, with the First Workers' Group of Constructivists, teaching at Vkhutemas and close to Obmokhu; he also continued to exhibit with Zhivskulptarkh, the collective group investigating the relation of painting, sculpture and architecture.[18] Other group activities were to follow so that the period beginning in 1920 may be seen as indicating Rodchenko's close involvement with collective activities, both theoretical and practical. As a result the achievements of his own processes of construction were communicated directly to others; the impersonal aspect of his work can be seen as a positive and spreading force from this moment, in exhibitions and theoretical discussions and in specific works.

The Vkhutemas in Moscow was initiated on 29 November 1920 from the First and

Second Free State Studios, and it provided courses in painting, sculpture, architecture, graphics, textiles, woodwork and metalwork.[19] It also had a foundation course which from 1920 to 1923 was under the direction of Rodchenko.[20] The overall director was Favorsky. Although constructivist processes by no means dominated the Vkhutemas, they provided a forceful element within the conflict of different theoretical and group interests active there.

Amongst the first texts produced to support the foundation course were *Colour Construction* by Vesnin and Popova, *Spatial Construction* by the architects Doku-chaev, Ladovsky and Krinsky, *Graphic Construction*, to which Rodchenko contributed, and *Volume Construction* by A. Lavinsky. The relationship between Rodchenko's constructed objects and his teaching was a close one. By 1920 Rodchenko had relinquished his residual links with suprematism, which was still in evidence in Moscow but now increasingly focussed its activities in Vitebsk.[21] By the time Malevich held a retrospective exhibition in Moscow in 1920 Rodchenko's concept of painting was incompatible with that of Malevich. Malevich, in his essay to accompany *Suprematism—34 Drawings* published in late 1920 at Vitebsk, could still describe painting as a window onto life: 'What in fact is a canvas? What do we see represented on it? Analysing the canvas we see, primarily, a window through which we discover life.'[22] Rodchenko's painting can have made little sense in such terms. Indeed, the mystical aspect which suprematism increasingly wore was the antithesis of Rodchenko's clear-minded and methodical inquiry.

If group activities flourished and became more complex in 1920, so too were other levels of public presentation of the latest developments much in evidence. Exhibitions included one in Moscow that comprised twenty-two participants and 351 works by a cross-section of members of Zhivskulptarkh and Inkhuk. Here works by Kandinsky could be seen with works by Rodchenko.[23]

Construction also invaded the theatre. The director Meyerhold in particular was an admirer of Tatlin and had worked with him before the Revolution. 'We have only to talk to the latest followers of Picasso and Tatlin to know at once that we are dealing with kindred spirits. We are building, just as they are building.'[24] Verhaeren's *Les Aubes* (*Zori*) (Plate 187) opened at Meyerhold's theatre with sets by V. V. Dmitriev. On stage, painted cubes, close to the pictorial experiments of Miturich, contrasted with a colossal construction of diverse materials which was movable and adjusted during the performance. 'What the modern spectator wants,' declared Meyerhold, 'is the placard, the juxtaposition of the surfaces and shapes of tangible materials.'[25] These Dmitriev provided with cables and slotting sheets of metal that showed an evident debt to Tatlin's example. The day following the opening of *Les Aubes* in Moscow, Tatlin opened his Petrograd studio to display his model of the Monument to the Third International.

By 1921 Rodchenko and Tatlin provided alternative avenues for the investigation of construction: Tatlin remained a pioneer of invention, discovering new areas of investigation, whilst Rodchenko, more negative and critical in his outlook, progressed step by step through an increasingly rigorous rejection of the conventions of painting. Through their teaching, works and ideas, Tatlin and Rodchenko gathered a growing

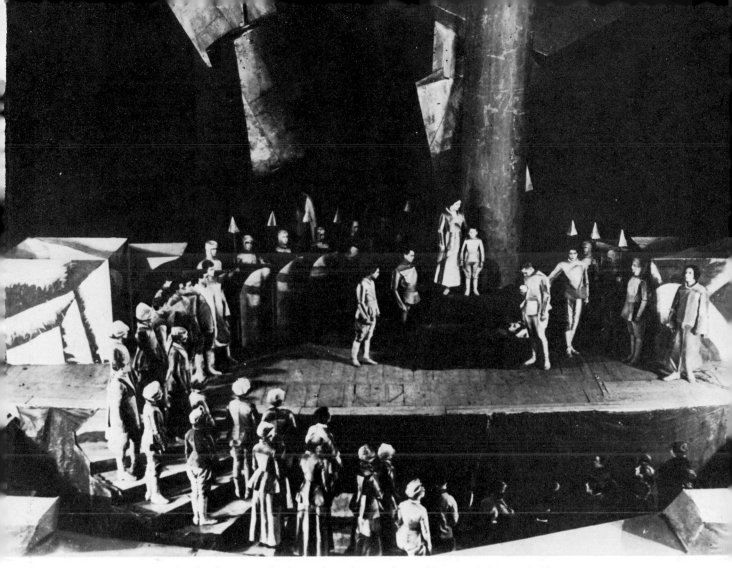

187. V. Dmitriev: Stage set for the play *Les Aubes* by Emile Verhaeren, directed by Vsevolod Meyerhold, Moscow, 1920.

number of adherents to the cause of construction. The First Workers' Constructivist Group constituted the beginning of an expansion which reached a high point and culmination in 1921.

The First Workers' Constructivist Group brought together Rodchenko, Stepanova, the theorist Alexei Gan and the converts Konstantin Medunetsky and Vladimir and Georgiy Stenberg. In January 1921 these last three exhibited together in Moscow as 'constructivists', a title which they adopted for their exhibition and its catalogue.[26] They exhibited three kinds of work, colour-constructions, projects for spatial constructions and spatial constructions.[27] In addition certain of Medunetsky's works were distinguished as colour-constructions from materials (Cat. Nos. 13–15). The metals used in the spatial constructions were iron, copper and steel in various combinations. The separate study of construction in colour and in space was a characteristic of the Vkhutemas foundation course.

A text published by the constructivists Medunetsky and the Stenberg brothers in

their catalogue in January 1921 described aesthetes and artists as 'the great seducers of the human race'. 'Constructivism' they declared 'the highest springboard for a leap into universal culture'.[28] They described the factory as the place where 'real life' is fashioned, yet did not attempt to describe the relation of their own constructions to factory products, despite describing constructivism as 'the shortest route into the factory'.[29]

The impersonal quality of Rodchenko's 1920 constructions and the public dimension of Tatlin's work in 1919–20 initiated a radical re-examination of the social role of the creative person. Both men had begun to tackle the reconciliation of creative activity with an awareness of a larger social identity. Self-expression no longer had a place in their work. The anonymous exhibitions organized by Obmokhu and the emergence of other collective groups showed the increasing spread of such attitudes.

Constructions by the Stenberg brothers lacked the austerity and economy characteristic of Rodchenko and Tatlin. They reflected the spread of particular attitudes of which they were not themselves formulators. The danger inherent in this development was the evolution of a mannered constructivist style. The constant reassessment of

188. Shapiro: *Selection of Materials*, 1921. Glass, iron and wood, including part of an easel. Photographed in Tatlin's studio, Leningrad. [Photograph A. B. Nakov, Paris.]

189. Cover for the catalogue of the exhibition $5 \times 5 = 25$, 1921. The catalogues contained original drawings by the exhibitors who also hand-painted the catalogue covers.

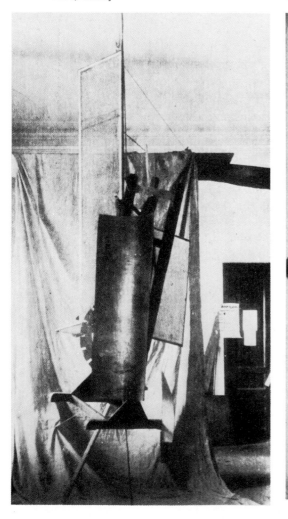

the process of construction could decay, particularly amongst followers, into the emulation of its forms. This, in effect, points to the links between the process of construction and its context, for as the context evolves so necessarily must the outward means and forms of construction. To restate or re-use such forms was to abandon a crucial element of the process and to produce work without that social extension which was integral and not superficial to the evolution of construction for Rodchenko and for Tatlin. For Rodchenko, construction was a process independent of specific materials. The rhetoric of Medunetsky and the Stenberg brothers[30] was at odds with the reductive approach of Rodchenko. Increasingly this involved the identification of creative activity with utilitarian work, a subject upon which Osip Brik had expounded in 1918. 'Construction,' proclaimed Rodchenko in February 1921, 'is the contemporary attempt to organize the utilitarian deployment of materials. Constructive life is the art of the future. It is time for art to flow into the organization of life.'[31]

At the Moscow Inkhuk on 18 March 1921, a group was established to define 'construction' in material and social terms. This, the Group for Objective Analysis, gathered around Rodchenko.[32] Members included Vesnin, Stepanova, Gan, Ioganson, Medunetsky and the Stenberg brothers. Members of the Group for Objective Analysis were well represented two months later in the third exhibition of Obmokhu, at which Rodchenko, Ioganson, the Stenberg brothers and Medunetsky all exhibited constructions. The exhibition comprised a survey of the impact of Rodchenko and of Tatlin. Although Tatlin had remained independent of Obmokhu, his own followers were similarly involved in material constructions, especially Bruni and Shapiro (Plate 188).

Material construction led to the perimeter of art. Pictorial construction, as was clear to Tatlin and subsequently to Rodchenko, led ultimately to the abandonment of painting as a special kind of construction. The contrasting approaches that Tatlin and Malevich had pioneered resulted in analytical paintings of great severity by Rodchenko, Popova, Exter, Vesnin and Stepanova. In 1921 the reductive analysis of painting took them beyond painting altogether. In September 1921 in Moscow they each contributed five works to the exhibition $5 \times 5 = 25$; and an original drawing by each participant was inserted into every catalogue (Plate 189). $5 \times 5 = 25$ led to the abandonment of painting and construction beyond the canvas, as Tatlin's precedent had suggested. Rodchenko's catalogue drawings were minimal yet comparable in symmetry with his recent wooden unit-constructions. His paintings abrogated the unity of the individual work. *Last Painting* comprised three canvases each painted with one of the primary colours, red, yellow, blue.

The 1921 exhibitions of Obmokhu and $5 \times 5 = 25$ revealed the spread and the vigour of construction evolving during the period of Tatlin's Tower and the year after its display. Construction, due largely to Tatlin's pioneering work, had become a widespread force with many adherents. Its social implications, first grasped in Tatlin's Tower, had led to a rigorous study of construction in painting: that in turn led beyond painting, beyond style and self-expression, and perhaps beyond art. This was the position that Tatlin and Miturich encountered when visiting the Moscow Inkhuk in December 1921 where Rodchenko and his sympathizers had established their authority. Rodchenko's reductive studies had led in the exhibitions of 1921 to a critical

point where painting as a special activity was rejected and where art in its private guise was condemned. Already in 1919, Osip Brik had called for the abandonment of painting. 'The bootmaker,' wrote Brik, 'makes boots; the table-maker makes tables. But what does the artist make? He does not make anything; he *creates* in a way that is obscure and shady.'[33] In 1921 Brik was a central figure of Inkhuk in Moscow. In a statement issued on 24 November 1921, he announced the renunciation of art as an activity separate from socially orientated work. Rodchenko and twenty-four others followed Brik's lead, an assembly of theorists and practitioners endeavouring to seek creative work beyond art. The social dimension, explicit in Tatlin's Tower and in Rodchenko's constructions, now became a primary consideration. Their announcement marked a new phase in the history of construction. '1921: I completely stopped painting,' wrote Rodchenko; 'I evolved the slogan *Representation is finished: it is time to construct*. I went into production.'[34] He declared with Brik in November 1921 the 'pointlessness of easel painting' and proposed 'the absoluteness of production art, and of constructivism as its sole form of expression.'[35] Production art (*proizvodstvennoe iskusstvo*) was the name adopted for the new phase of creative activity where construction was to be fully integrated into social development, where creativity and work were identified.

What Tatlin encountered in Moscow at Inkhuk in December 1921 was a committed, tenacious and explicit attitude to creative work. As construction moved towards work in diverse fields, it brought with it a radical critique of material and social considerations. In the face of the mounting criticism of the wealth of activities broadly derived from Russian futurism, even Lunacharsky was taken to task for supporting them. 'Let a commission composed of workers examine the real fees of our nonchalant poets and painters to find out with whom they really deal,'[36] demanded a letter to *Pravda* in September 1921. The tower earned its share of unsympathetic criticism too: 'Perhaps it is extraordinarily interesting and the work of a talented man, but it is more than that; like a cubo-futurist still life it is unwarranted and, terrible to say it, unnecessary.'[37]

This sense of the 'necessity' of the constructed object was, in 1921, a subject of concern and study for admirers as well as critics of Tatlin's example. The aesthetically oriented programme that Kandinsky had endeavoured to introduce at Inkhuk in 1920, by the next year had been superceded by the study of construction under the guidance of Rodchenko and his colleagues. With their new commitment to production, Rodchenko, Gan and others defined their aims at Inkhuk as 'the establishment of ties with all productive principles and centres of the whole Soviet mechanism; bringing into being and formulating communist forms of existence'.[38]

In the studios of Vkhutemas these principles found practical expression. To quote Rodchenko: 'I was head of the metal workshop at the Vkhutemas, and in charge of projects. Out of the same department which once made mounts for icons, lamps and other church plate, there began to emerge constructors producing electrical devices, metal objects of daily use and metal furniture.'[39]

The collusion of Inkhuk theorists, amongst them Osip Brik, with the constructivists around Rodchenko and Tatlin provided a base for the reconciliation of theory and

practice, of material construction and ideology. From 1921 theorists played a vital interpretative role elucidating the social dimension of constructivist work both for its practitioners and in public debate. Alexei Gan was one theorist-interpreter. 'Death to Art,' declared Gan in his book *Constructivism* in 1922; 'art is inextricably connected with theology, metaphysics and mysticism.' His slogans demanded a transition 'from art as a speculative activity to socially thought-out creative work'.[40] Even when contact with Western Europe became possible again in 1921, construction remained linked to communism and was a cultural development that could not be exported from its social context. 'In the West,' wrote Gan, 'constructivism fraternizes with art ... Our constructivism has established clear aims: to find the communist expression of materialist construction.'[41] Inkhuk the same year announced the preparation of a book, *From Depiction to Construction*, designed to clarify the ideological bases of the productivist attitude. Tatlin was amongst the contributors listed, along with Exter, Rodchenko, Vesnin, Arvatov, Brik and Kushner. Tatlin the pioneer constructor found himself in a new context by 1921 and with new tasks ahead. Production art was a growing force, although the Petrograd Museum of Artistic Culture permitted a broader view of contemporary activities where Tatlin's vision, with that of Khlebnikov, continued to flourish with extraordinary originality. Tatlin's relative independence was stressed by the publication in 1921 of Nikolai Punin's assessment of Tatlin's achievement, *Vladimir Tatlin: Against Cubism*.[42]

The book was dedicated in February 1921 to the students of the Free State Studio in Petrograd. Punin approached Tatlin obliquely, carefully avoiding a biographical or even chronological approach. Instead, Punin began with a critique of French painting, describing its devotion to taste, beauty and pleasure as a cul-de-sac, hemmed-in and prevented from further development by its devotion to the individual and an ineradicable fascination with illusion and depiction throughout post-Impressionism and cubism. It was this fascination that Punin deplored in works by Cézanne, Picasso, Gleizes and Metzinger which he otherwise recognized as pioneering and significant. 'It is thanks to the French School,' declared Punin, 'that art is identified with the romantic, individual and symbolic.'[43] He discerned a resultant decline in professionalism and regretted that even cubist *faktura* had become a game of nuances and suggestions. Russian art with its feeling for materials, derived ultimately from icons where colour was identified with pigment, seemed to Punin to offer enormous possibilities of development beyond cubism. Tatlin's abandonment of stylistic priorities in favour of the investigation of surface and materials seemed to Punin to avoid the errors of cubism. In Tatlin, ephemeral, personal and expressive qualities were replaced by material considerations, in the making not of illusions but of objects. 'Pigment for Cézanne,' wrote Punin, 'was no more than colour which he always controlled through chromatic relationships';[44] whereas for Tatlin, following Russian traditions, colour was an attribute of the material of a pigment, of paint, and, as Punin pointed out, 'colour, understood as material, inevitably leads to work on materials in general'.[45] The depiction of light was rejected, for 'it was necessary to forget everything other than the surface',[46] and this was flat only through convention. Tatlin, as Punin explained, was a cultural pioneer in whose relief lay the roots of a new attitude to the

material world, no longer depicted, but directly manipulated: 'The working of a surface by means of paints, that is the real aim of painting.'[47] It led to Tatlin's painterly constructions, and 'it became necessary to seek an exit not only from the canvas but from the whole tradition of European art'. Creativity was to become communal and useful: 'Art is starting to become the presentiment and reflection of life—it is life itself.'[48]

The demands of the Moscow production art group were not necessarily those of Tatlin, but they recognized his achievements. Tatlin did respond to production art but independently. His organizational activities remained important as did his understanding of the concepts elucidated by Khlebnikov. Production art identified creativity and work more directly and rigidly than would have arisen naturally out of Tatlin's own researches. Nevertheless, his response was vigorous. Boris Arvatov reported at Inkhuk in 1922 'that Tatlin, the painter and master of corner reliefs, made an offer to the engineers of a machine industry trust to teach the pupils of the factory as well as the workers how to process material. The engineers failed to grasp the essence of his offer and advised Comrade Tatlin to go to the technical office and teach draughtsmen how to trace fine lines.'[49]

In December 1921 Tatlin had travelled from Petrograd to Moscow together with Miturich to discuss with Rodchenko, Brik and the members of the Moscow Inkhuk their aims and principles. He returned to Petrograd to establish an equivalent body in the form of a new kind of museum, the Museum of Artistic Culture (Muzey Khudozhestvennoy Kultury), dedicated to the investigation of contemporary creative activity. Tatlin established there the first museum of modern art, housing the achievements not of the past, but of the present.

In establishing the Petrograd Museum of Artistic Culture at 9 Issak Square in 1922, Tatlin sought to provide an institute for the study of contemporary creative processes. The idea had first been raised in 1917, and it was a considerable achievement that five years later the programme began to be realized. Plans existed for eighteen similar museums throughout Soviet territory. Their function was in contrast to historically based traditional museums, for their emphasis lay upon the developments of contemporary creative activity. The breadth of Tatlin's policy is indicated by his collaboration with Malevich and Matyushin at the Museum of Artistic Culture.

In his capacity as head of the museum, Tatlin was a positive and active influence in the creative life of Petrograd. As president of the Union of New Tendencies in Art,[50] he organized a retrospective exhibition to open on 10 June 1922 as a survey of recent tendencies. Malevich showed suprematist works and gave two lectures, 'A New Proof in Art' and 'Art, Factory and Church'. Amongst Tatlin's own exhibits was a monochrome pink painting. Amongst the other exhibitors were Dymshits-Tolstaya, N. F. Lapshin, V. V. Lebedev, S. D. Lebedeva and N. A. Tyrsa.[51] Tatlin's survey of creative activity in Petrograd indicated an outlook far broader than that of the Moscow production art advocates: the museum, said Tatlin 'had the aim of mobilizing all the artistic strengths of Petrograd working in the region of new art in painting, theatre, music, sculpture and matters of construction'.[52]

The poet Khlebnikov had issued an *Edict of the Presidents of the Globe* on 30

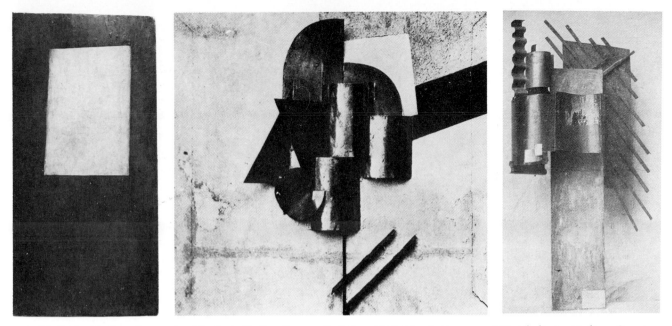

190. Vladimir Tatlin: Surface for *Zangezi*, 1923. Oil on wood, 115 × 55 cm. Galerie Gmurzynska, Cologne.

191. Vladimir Tatlin: *Counter-Relief*, *c.* 1919. Metal, plaster, etc. Whereabouts unknown. Illustrated in *Das Kunstblatt*, November 1922, No. 11, p. 496, in a review by Paul Westheim of the Erste Russische Kunstaustellung, Van Diemen Gallery, Berlin.

192. Vladimir Tatlin: *Counter-Relief*, *c.* 1919. Wood and metal. Whereabouts unknown. Exhibited Erste Russische Kunstaustellung.

January 1922, signed Velimir I, in which he attempted to transpose his calculations of historical waves from earth-years to those of Jupiter, Saturn and Uranus. Both Khlebnikov and Tatlin were now criticized by Lunacharsky, who was eager that Tatlin's Tower should never be built. Khlebnikov, who had been living at the Vkhutemas in Moscow, was a sick man. His sister had married the painter Pyotr Miturich, and Khlebnikov travelled to Novgorod hoping to recuperate in their company. He died at the village of Santalovo on 28 June 1922. Miturich was present and drew Khlebnikov on his death bed. When Khlebnikov was buried Miturich inscribed his coffin 'The President of the Globe'.

Miturich, who worked with Tatlin at the Petrograd Museum of Artistic Culture, communicated to Tatlin the news of the death of the poet who had been so close to both of them. 'When we found out about the death of Khlebnikov,' replied Tatlin, 'we hung in an exhibition surfaces which projected into space and by their force and size overwhelmed everything else exhibited ... There were up to ten notices. On them was written his dates and *Khlebnikov is dead*.'[53] Mayakovsky wrote his obituary, calling Khlebnikov the 'Columbus of new lands of poetry, which now we populate and cultivate'.[54]

An elaborate homage to Khlebnikov took place the following year, on 9 May 1923, when Tatlin arranged a performance of the dramatic poem *Zangezi* at the Petrograd Museum of Artistic Culture. Tatlin played the central part in this complex and difficult poem. There could be no clearer indication of Tatlin's respect for the poetry and the man. The readings were performed in the midst of a large corner construction, and an exhibition of Tatlin's reliefs was held simultaneously as a homage to Khlebnikov; the link between their work was made explicit. 'Parallel with his word constructions,' wrote Tatlin, 'I decided to make a material construction. This method

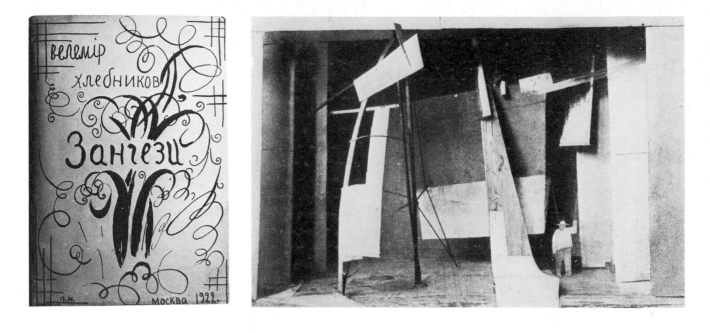

made it possible to fuse the work of two people into a unity.' Tatlin sought to embody Khlebnikov's poetry in material constructions (Plate 190): 'To emphasize the nature of these sounds I use surfaces of different materials treated in different ways.'[55] The previous year Tatlin had exhibited reliefs at the First Russian Exhibition at the Van Diemen Gallery in Berlin (Plates 191–2). Whilst it is impossible to be specific about sources in Khlebnikov, it is likely that these and other reliefs owed to Khlebnikov as much as Tatlin's Tower had done.

Khlebnikov's *Zangezi*, compiled from material written since 1920, had been published in 1922 (Plate 193). The poem is built up from a series of 'sails', sections written at various times. It employs a variety of trans-sense or *zaum* languages which Khlebnikov listed as '(1) birdsong, (2) the language of the gods, (3) the astral language, (4) *zaum* language—the surface of thought, (5) the decay of the word, (6) noise writing, (7) mad language'.[56]

Parts of the poem were referred to as 'surfaces' (*ploskosti*), each with a distinct theme. Surface 4 encompassed numerical and historical theories, whilst Surface 6 introduced the linguistic (and national) protagonists, the letters *R*, *L*, *K*, *P* and *G*; a war of the alphabet ensued in Surface 7. Surface 20 contrasted sorrow and laughter, and Tatlin's arrangement for this is known from a photograph (Plate 194). Khlebnikov's ornithological studies made the birdsong sections of *Zangezi* particularly arresting. 'Peet pet tvichan. Peet pet tvichan. Peet pet tvichan,' echoes one bird, whilst his swallow calls, 'Tseeveet Tseeveet'.[57]

The relation of Tatlin's work to that of Khlebnikov was complex and close. The critic Punin had stressed the link, and Tatlin was considered the Khlebnikov of painting. In his tribute to the poet he planned a construction that was a counter-relief. One of the maquettes for *Zangezi* contained various materials intersecting and held in position by wires. To develop the counter-relief on a scale large enough to incorporate performers was an ambitious undertaking and may reflect features of Tatlin's Tower. A maquette for *Zangezi* comprises three main conjunctions of materials. At the rear

198

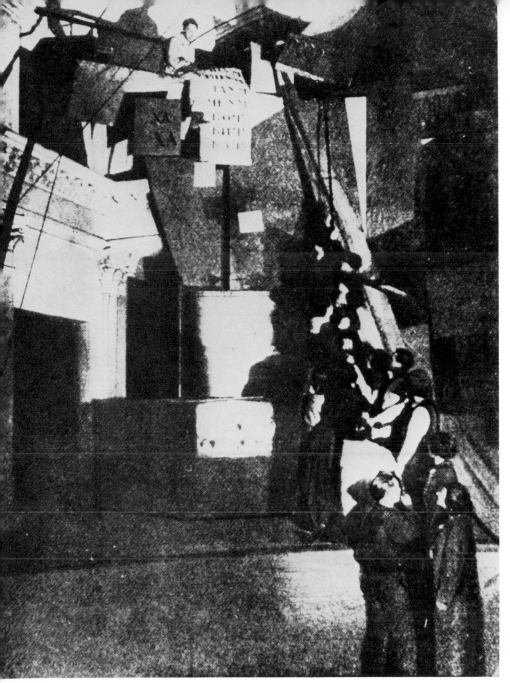

193. Pyotr Miturich: Cover illustration for V. Khlebnikov, *Zangezi*, Moscow, 1922. 24.1 × 15.2 cm. Institute of Modern Russian Culture, Blue Lagoon, Texas.

194. Vladimir Tatlin: Maquette for *Zangezi*, 1923. Wood, wire, etc. Whereabouts unknown. This maquette represents Laughter (left) and Sorrow (right), and corresponds to Surface 20 of Khlebnikov's poem.

195. Performance of *Zangezi* at the Museum of Artistic Culture, Petrograd, 9 May 1923. This photograph represents Surface 9 of the dramatic poem. Tatlin is reading the text 'Moum, Boum, Laum, Cheum, Bim Bam Bom'. To the side of this sheet of board hangs a board inscribed 'Ha-Ha'.

and top of the construction a sloping horizontal support recalls similar devices employed in earlier corner reliefs (Plate 108), in particular as a plane appears to hang from it towards the centre of the assemblage. Other surfaces to left and right of this are linked to the crossing strut or wire. A photograph of the performance (Plate 195) reveals a modified construction but does show the crossing strut or rod positioned across a corner of a hall in the Museum of Artistic Culture.[58] The corner space itself relates closely to Tatlin's corner reliefs.

Just as Tatlin's Monument to the Third International revealed a response to Khleb-

nikov, here, in a work of 1923, Tatlin has again employed techniques evolved eight years previously, and in connexion with a specific poem by Khlebnikov. Khlebnikov's *Zangezi* incorporated the material sounds of language at the expense of references to meaning. It is possible that a link or a parallel was visible here with Tatlin's attitude to the elements of his relief-constructions, in which material was not dominated or made subservient to usage, or to a predetermined structure that carried meanings. Tatlin constructed with the material elements themselves; Khlebnikov in a sense did the same. In the poetry of one and the reliefs of the other, construction with materials was a common factor.

A drawing by Tatlin of the character Laughter (Plate 196) in *Zangezi* shows a linear construction around and through the figure, comparable to aspects of the assemblage at the left of Tatlin's maquette. The circular curved element which in the maquette appears to be of wire, in the drawing is indicated at the figure's waist height. In both cases this curve is attached to a vertical element at the right and to a curved 'profile' at the left. The upper part of this assemblage in the maquette is connected to a strut which extends to the left and downwards from the horizontal, as does the line passing through Laughter's head in Tatlin's drawing. In the drawing a linear construction is related to the figure, providing an independent profile in which correspondences are established with the figure. That this drawing connects the assemblage at the left of

196. Vladimir Tatlin: *Laughter*, design for *Zangezi*, 1923. Inscribed 'Zangezi', 'Laughter' and 'Laboratory of the Museum of Artistic Culture'.

197. Vladimir Tatlin: *Sorrow*, design for *Zangezi*, 1923. Inscribed from Surface 20 of the poem: 'I shall take any board as princess sadness'.

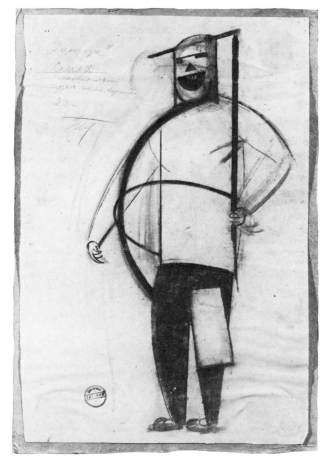

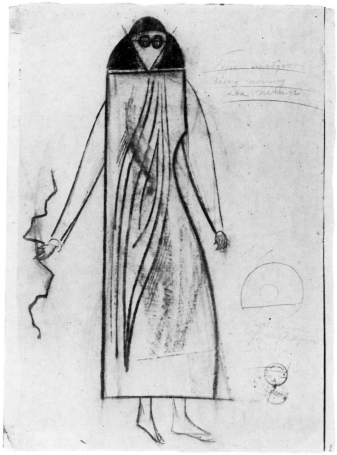

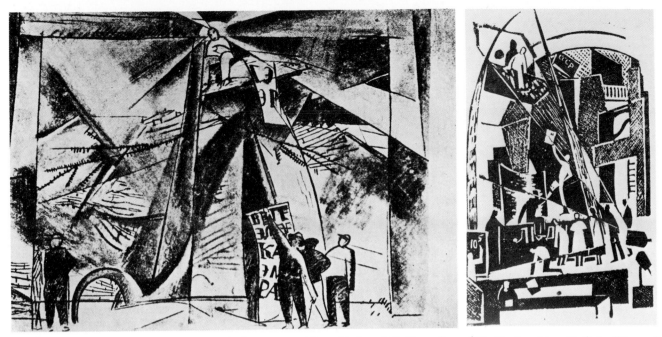

198. Vladimir Tatlin: *Drawing*, 1923. Inscribed at top *G* and *R*, and below *G, L, K*, etc. For Surface 7 of *Zangezi*.

199. N. Lapshin: *Tatlin's 'Zangezi' production, Surface 4*, 1923. Woodcut. '10⁵' refers to Khlebnikov's time theories.

Tatlin's maquette (Plate 194) with the figure of Laughter is placed beyond doubt by features of the final presentation visible in a photograph of the construction with performers (Plate 195).[59] The construction has been modified and much simplified in comparison with Tatlin's maquette. Nevertheless, the almost vertically sloping diagonal visible to the right of centre in Tatlin's maquette is visible behind and above the group of performers. To the far left of the photograph a taut, bow-like form is seen projecting upwards to the height of the strut which crosses the corner of the hall. This is recognizably what remains of the assemblage at the left of the maquette. There seems little left to associate this with the figure of Laughter, until the rectangular notice hung beneath the reader in the performance is inspected. The cyrillic letters *XA XA* (*Kha-Kha*) are indicative of laughter, the equivalent of 'Ha-Ha!' in English. Laughter still stalks Tatlin's construction, and it was laughter which had first introduced Khlebnikov's approach to words, in his celebrated poem 'Incantation by Laughter' published in 1910. Lastly, the linear construction overlaying Tatlin's drawing of Laughter identifies the vertical line with the back of the figure, or at least with the vertical element of the human frame. There may be some support for this for the assumption of a relation to the figure or head in Tatlin's reliefs. A further correspondence exists in one of the corner reliefs (Plate 110) in which an acutely bent-back line closely corresponds to that of Laughter (Plate 196) drawn eight years later. This corner relief may correspond to the verbal innovations of Khlebnikov, perhaps to the root of the word *smekh*, laughter, and a relation between this relief and a figure. In Tatlin's *Zangezi* construction of 1923 this was the case, and Tatlin exhibited 'material constructions' to coincide with the performance.[60] Sorrow (Plate 197) is also identifiable in Tatlin's maquette (Plate 194 right of centre), and his drawing is inscribed with a line from Khlebnikov's poem *Zangezi*.

200. Vladimir Tatlin: Pattern for suit and coat designed not to constrict movement, 1923–4. Published in the periodical *Red Panorama*, No. 23, 1924.

201. Vladimir Tatlin wearing the suit he designed for Leningrad Clothes (Leningradodezhda), 1923–4.

202. Vladimir Tatlin wearing the coat he designed for Leningrad Clothes, 1923–4. Linings were detachable with flannel lining for autumn and sheepskin for winter.

203. Vladimir Tatlin: *Everyday wear, woman's suit*, 1923–4. 56.8 × 77 cm. Bakhrushin Theatre Museum, Moscow.

At the right of Tatlin's *Zangezi* maquette are features which again relate to Khlebnikov's writing. A drawing for the production (Plate 198) shows the main distribution of the elements reversed and modified. The bow-like curved structure is here right of centre and the leaning rectilinear assemblage is to the left of centre. The rudder-like structure retains its lean and the rhythm of its slow concave curve. In the drawing, however, it is associated with an arch, an association inevitably linked in turn with Tatlin's use of this motif in his Monument to the Third International. Through its arch a series of forms in stair-like progression suggest movement in space and time. Uniting these two structures, one of which recalls Khlebnikov's verbal constructions, and the other of which refers, through Tatlin's Tower, to Khlebnikov's mathematical investigation of time and of the rhythms of history, uniting, in other words, two constructions of figures, two views of man, sits the poet. A more succinct presentation of Tatlin's regard for Khlebnikov could scarcely be evolved, embracing in one construction the two main investigations which comprised Khlebnikov's work, to both of which Tatlin provided a response.

Tatlin described *Zangezi* as 'the peak of Khlebnikov's production', for, 'in it his work with language and with the study of the laws of time have fused together in the newest form'.[61] Tatlin pointed to construction as the link between himself and Khlebnikov: 'the word is a building unit, material, a unit of organized space.' Khlebnikov, said Tatlin, regarded words as 'plastic material'. Tatlin described his production of *Zangezi* in terms that confirm the visual evidence: 'Parallel with his word constructions, I decided to make a material construction.' Tatlin described the 'two green *kha*' which are the *Kha-Kha* (Ha-Ha) of Laughter, part of the Song of the Astral Language in the poem. Tatlin did not point out that his presentation of *Zangezi* summarized his own response to Khlebnikov's achievement.

Tatlin, in devising a material construction for the display and performance of a poem, was applying the process of construction to specific external demands. Tatlin incorporated visual lettering as well as declamation. He also used a projector to throw light upon particular events and areas in the construction (Plate 199). 'To guide the attention of the spectator,' wrote Tatlin, 'the eye of the projector leaps from one place to another, creating order and consistency. The projector is also necessary to emphasize the properties of the material.'[62]

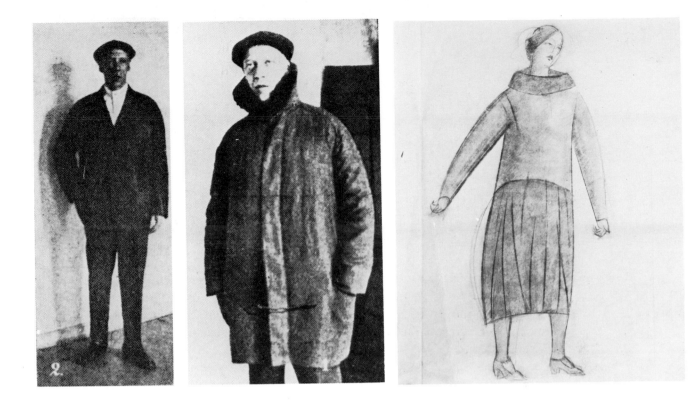

Nikolai Punin lectured on Khlebnikov's theories of time to supplement Tatlin's performance and exhibition. Punin commented on Tatlin's production that 'the problem was an extremely difficult one, for *Zangezi* is not a play but a poem, and it is necessary to stage it, that is, to devise, or more accurately, to find action in it'.[63] According to one critic the performance failed to do this so that 'the spectacle was dead. More precisely, there was no spectacle.'[64] The critic, Sergei Yutnevich, expressed more admiration for Tatlin than for Punin, but ultimately regretted the 'chamber-theatre' quality of the production: 'Some sort of extra-gigantic megaphone should be used to proclaim the harm of experimental chamber-theatre under whatever sauce it is presented.'[65]

Whatever Tatlin's achievement in terms of theatre, his extension of relief-construction to interpret the words and ideas of Velimir Khlebnikov represented an application of his process of construction to the commemoration of a relationship between two creative men of indisputable originality: 'If Tatlin loved one of his contemporaries with an inexhaustible and unreserved love, it can only have been Khlebnikov. Mayakovsky remained for him a kind, magnanimous, brilliant friend, but Khlebnikov was his passion. Only *his* poems did Tatlin preserve in his memory. Only of *him* did Tatlin speak with reverence. He considered it his greatest good fortune to have met him.'[66]

Designs for *Zangezi* were amongst Tatlin's exhibits at the huge exhibition Paintings by Petrograd Artists of All Tendencies, 1919–1923, which showed 1621 works by 263 artists. Amongst Tatlin's designs was Cat. No. 1511, *Iverni-vyverni*, a machine for *Zangezi*. He exhibited many designs for *Zangezi* (1444–1503), costume designs (1505) and construction notes (1506–7), as well as drawings for the model of the Tower (1507–8) and prototypes for clothing (Plates 200–3). Khlebnikov was further com-

memorated in 1923 when the new magazine *Lef* published his poem *Ladomir* and recollections of Khlebnikov by Petrovsky. His sister and brother-in-law, Vera and Pyotr Miturich, brought out an edition of his *Verses* in 1923.

The exhibition Paintings by Petrograd Artists of All Tendencies was an inclusive survey and various groups were represented, including the World of Art, the suprematist group Unovis, the Organization for Proletarian Culture (Proletkult) and the Group for New Tendencies in Art. Tatlin's Petrograd-based colleagues featured substantially, including Lev Bruni, V. Dmitriev, S. I. Dymshits-Tolstaya, S. K. Isakov, N. F. Lapshin, Pyotr Miturich and Ya. A. Shapiro.[67]

That Tatlin exhibited drawings for prototype clothing was an indication that he was responsive to the production-art stance taken up by Brik, Rodchenko and their circle at Inkhuk in Moscow. Tatlin produced designs characterized by their lack of stylistic qualities (Plates 201–3). Style had been systematically deleted from his painting and three-dimensional non-utilitarian works, and it was not re-introduced when Tatlin turned to the design of useful objects. He was not slow to follow the lead of Rodchenko, Popova and others in the development of construction within this sphere. This was not applied art: it was the application of the principles of material construction to useful ends, although occasionally painted imagery was employed (Plate 204). Its critique of creativity prevailed, and the investigation was carried out in the light of what had been learned of construction: it was not specific to particular areas of design. Tatlin designed not only clothes but a stove, a tea service, textiles and diverse other

204. Vladimir Tatlin: *Young Fisherman*, c. 1919. Ink and wash on paper, mounted on oval paper, widest diameter 32.5 cm. Collection George Costakis, Athens. [Illustration © George Costakis 1981.] Possibly a design for a plate.

205. Alexander Rodchenko wearing the work-suit he designed and standing in front of folded constructions (see Plate 183), c. 1922, photographed by Mikhail Kaufman. Photograph collection George Costakis, Athens. [Illustration © George Costakis 1981.]

206. Vladimir Tatlin: Stove, 1923–4. One of five stoves designed for economy of fuel, incorporating airing cupboard and hot and warm ovens.

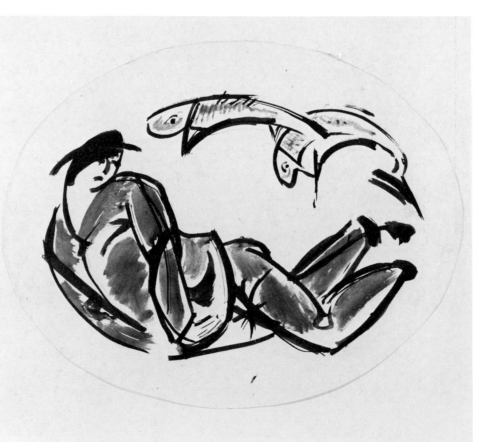

204

projects. The suit for everyday wear was modelled by Tatlin for an article published in 1924 (Plates 200–1);[68] it also illustrated an overcoat and a stove by Tatlin. The overcoat (Plate 202) was similarly styleless and eschewed elegance in favour of a study of material qualities. It had several different detachable linings.

Tatlin had become involved in textile design in 1923 in collaboration with the Shveiprom factory. His development of construction into objects useful to the new society was as thorough as that of Rodchenko (Plate 205), Popova and Stepanova; like them, Tatlin approached each project with the development of construction as a prime consideration, on both the material and the social level. His design for a cheap, efficient stove (Plate 206)[69] reveals how diverse were the activities that this led to. Tatlin's material approach to creativity might function in any sphere, for it had been creativity itself that lay at the core of his investigation. Five models were made of the stove. By working on construction to utilitarian ends Tatlin was integrally involved in the whole object. His designs were necessarily the opposite of applied art, for no art as such was here applied; there was no trace of decoration. Tatlin was in effect re-inventing the coat, stove and suit. Here was a radical role for the constructivist within the factory. These designs contained no rhetoric of style or self-expression. The social dimension of Tatlin's designs existed but was integral to his objects: they were useful products for a communal and supposedly classless society. Tatlin was constructing discreetly and without art's aloofness from daily life. His designs grew from an intimate study of materials and their handling. Rodchenko and Popova, a

little like Malevich, applied forms from their paintings to the surfaces of bowls and dishes. In 1923 such a pictorial use of surfaces was inconceivable to Tatlin; it suggested a decorative purpose at odds with the integral nature of construction.[70]

The achievements of the Moscow Inkhuk group on the one hand and of Tatlin on the other were well recognized by the theorist Nikolai Tarabukin, secretary of the Moscow Inkhuk and an associate of Rodchenko and Brik. In his book *From the Easel to the Machine*[71] published in 1923, he charted the rise of the new cultural attitudes. Tatlin's pioneering abandonment of illusionism was recognized as seminal. In addition, the Obmokhu group, Popova and Miturich all received praise from Tarabukin. Committed, like his colleagues, to utilitarian production, Tarabukin was impatient with those who merely emulated technical construction or remained active solely as painters. The art of the future, according to Tarabukin, would enlighten society as a whole and not merely the individual.

Tarabukin saw in Tatlin a creative man who surpassed the achievements of Picasso. A cubist relief by Picasso was ultimately pictorial and personal, whilst an assemblage of materials by Tatlin was 'a theoretical problem solved with materials'. 'In this work, the artist does not begin from the techniques of the artisan, but from the coordination of two fundamental elements of an object—its destination and its form.' 'In production,' wrote Tarabukin, 'constructivism is merely a means of attaining utilitarian ends.'[72]

Utilitarian production demanded a willingness not only to abandon self-expression—Tatlin after all had evolved this way—but to work in collaboration, forsaking a commitment to the object produced by the individual as certainly as he forsook the individual object. In utilitarian production, reproduction was necessary and the individuality of both creator and object was consequently undermined. Tatlin's Monument to the Third International and his production of *Zangezi* had both been group projects under Tatlin's leadership. His designs for ceramics, stoves and clothes were an extension of this position. At the enormous exhibition Paintings by Petrograd Artists of All Tendencies, Tatlin's contributions were presented as 'the collective work of the central group of the Union of New Tendencies in Art headed by V. E. Tatlin'. All were stamped 'Tatlin's Studio'. The slogan of the group was 'Towards the new object through the discovery of material'.[73] Tatlin worked on textiles at the Shveiprom factory, intended his clothes and stove for mass production, and in addition endeavoured to set up a creative laboratory at the Novyy Lessner factory in Petrograd.[74] He was a practical man and his involvement was thorough. He responded to the principle of utilitarian production but was no mere illustrator of its theories. For Tatlin, practice preceded theory. In his *Order of the Day No. 1 for the Culture of Materials Group* issued in 1923, he carefully provided for the exclusion of those who 'present empty phrases not confirmed by craftsmanship'.[75]

By 1925 circumstances had altered radically. Constructivism began to diversify, and subsequently its parts became more specialized. Inkhuk and the Museum of Artistic Culture, both of which had functioned as lenses concentrating the development of creative theory and work, were reorganized. In October 1924 Tatlin was appointed head of the Department of Material Culture at a reorganized Leningrad Inkhuk. Less

207. V. & G. Stenberg and Kazimir Medunetsky: Set for the play *The Storm* by Ostrovsky, 1924. Directed by Alexander Tairov at the Kamerny Theatre, Moscow.

208. Alexandra Exter: Sets and costumes for film *Aelita*, 1924. Directed by Protozanov. [Photograph National Film Archive, London.] Revolution on Mars.

than a year later, in August 1925, he was sent to the Ukraine to the Kiev Art Institute where his theatrical experience was of primary importance as head of the institute's theatre, film and photographic section, Teakinofoto. Tatlin remained at this post until 1927, an affirmation of the theatre's continuing importance to him. Designs by Tatlin were used at the Gorky Theatre in Leningrad during 1925 for Jules Romains' play *Cromedeyre-le-Vieil*.

All of the constructivists were involved in the theatre. The period 1923–5 with its commitment to production greatly encouraged this. The public and communal nature of their evolution made them an appropriate vehicle for constructivist utilitarian experiment. Tatlin's influence had been evident in Dmitriev's designs for *Les Aubes* in 1920. After 1921, the year of the experimental exhibitions of Obmokhu and $5 \times 5 = 25$, the impact of Tatlin's example was increasingly evident. At Obmokhu's exhibition of May 1921 the Stenberg brothers and Konstantin Medunetsky emerged as followers more of Tatlin's methods than Rodchenko's. By 1925 the Stenberg brothers and Medunetsky were celebrated theatrical designers exploring construction on stage (Plate 207). All of the exhibitors at $5 \times 5 = 25$, Rodchenko, Stepanova, Exter (Plate 208), Vesnin and Popova, developed theatrical projects during 1923–5. Tatlin's production of *Zangezi* in 1923 confirmed the independence of his approach. It would be an error to consider Tatlin's involvement in the theatre and film institute at Kiev as a retreat from his primary activities, for the theatre provided an essential aspect of his creative work.

Utilitarian construction with its well-developed ideological commitment could not be understood outside of its Russian and Soviet context. Tatlin had pioneered the integration of a social dimension into his projects and it is not surprising that a version of his Monument to the Third International (Plate 209) provided a focal point of the Soviet section of the International Exhibition held in Paris in 1925. The model was exhibited at the Grand Palais amidst posters and paintings (Plate 211). In the Soviet

207

Pavilion, designed by Konstantin Melnikov as a complex kiosk with diagonal symmetry and dynamic trumpet-like projections (Plate 210), the extension of constructivism into production was displayed in books, textiles and furniture and in designs and maquettes for theatrical productions. Rodchenko, much in evidence as contributor and organizer, made a deliberate point of contrasting his cheap but ingenius rural reading room with the lavish and stylish elegance of much that dominated the more commercial pavilions of the 1925 Paris Exhibition.

In the Octagonal room of the Grand Palais Tatlin's model tower asserted the international aims of communism. It was exhibited in conjunction with the project it inspired from Yakulov, his medievalizing and masonry translation of Tatlin's Tower, the Monument to the Twenty-Six Baku Commissars (Plate 177). Alongside were kiosk designs by Medunetsky, Kostin and Shterenberg. Tatlin's revised model, standing some four metres high, was given a prime site, illustrated in the official catalogue and awarded a gold medal.

Meanwhile in Moscow in 1925 Tatlin was exhibiting in quite a different context amongst Leningrad draughtsmen, some of whom had followed his experiments closely. The contributors of drawings included Bruni, Miturich, V. Lebedev, N. Kupreyanov, P. Lvov and N. Tyrsa.

During 1926–7 Tatlin remained at Kiev with little involvement in activities further north. Even theatrical exhibitions omitted his works. He exhibited, however, in the Ukraine in 1927 at the All-Ukrainian Jubilee Exhibition. This colossal exhibition seen at Kharkov from 8 November 1927 to 5 February 1928 subsequently toured the Ukrainian towns and cities of Kiev, Odessa, Dnepropetrovsk, Lugansk, Donetsk,

208

Makeyevka and Mariupol. Tatlin contributed only to the first display where 1680 works by 223 exhibitors were shown.[76]

A week before the opening of this exhibition, Tatlin was represented at a major retrospective survey in Leningrad. The tenth anniversary of the Revolution led to broad surveys of a decade's achievement in every sphere. Despite its title, the Exhibition of the Newest Tendencies in Art, a retrospective flavour was much in evidence. Early paintings by Tatlin, his *Sailor*, *Seated Nude* and *Bouquet*, were hung amongst cubist works by Udaltsova (*Restaurant*, ca. 1915), Falk and others. By contrast the Russian Museum, which had recently taken over from the Museum of Artistic Culture in Leningrad, exhibited Tatlin's relief on six wires (Plate 116), in a modified state, during 1927. Of others represented at the exhibition of 1927, some had emigrated: even Larionov and Goncharova were mentioned in a review as were David Burlyuk, Kandinsky, Puni and Chagall, none of whom had remained in Russia, and works by Guro and Olga Rozanova were exhibited posthumously. Pyotr Miturich and Lev Bruni exhibited, as did Udaltsova's husband Drevin.[77] When the periodical *The Press and Revolution* surveyed recent achievements in the theatre, painting, sculpture and architecture, Tatlin's counter-reliefs were recognized as important works alongside the 'spatial paintings' of Bruni and Miturich.[78] Such surveys served to reveal the conflict of many groups and to call into question the achievements of each. Furthermore, constructivism, having moved out of painting, was not able to maintain a challenging position within the pictorial field.

On returning from Kiev, Tatlin entered the Moscow Higher Technical Institute (Vkhutein), the recently reformed and reorganized Vkhutemas. At Vkhutein Tatlin

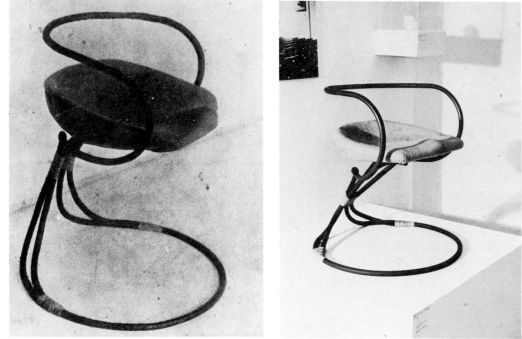

212. Vladimir Tatlin and Rogozhin: Bentwood chair with moulded seat, *c*. 1927. Beechwood, developed in Tatlin's studio at Vkhutemas Woodwork Department. The bentwood provides spring and the seat can tip to left or right.

213. Reconstruction in metal and rubber of Tatlin's chair of *c*. 1927, made by Enterprise Metal Co., London, 1971. In a case in the background a milk jug by Tatlin (Plate 215).

214. Display at Paris–Moscow Exhibition, Moscow, 1981, showing metal reconstruction of the chair of *c*. 1927 with small milk jugs reconstructed from Tatlin's designs by Sotnikov. Models of chairs and lamp after Rodchenko, as is the wood construction beside the chair.

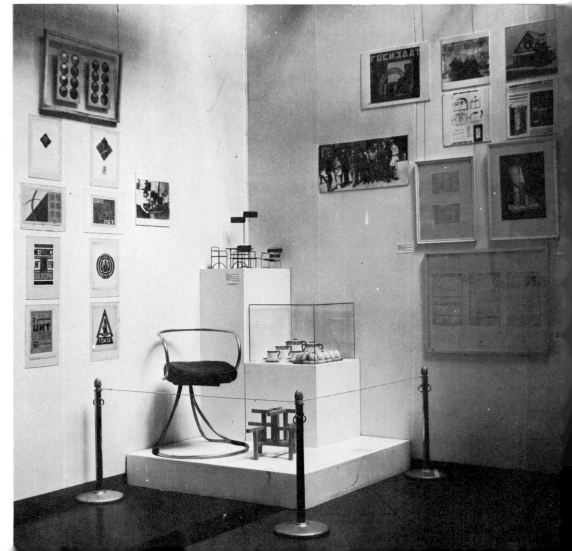

215. Vladimir Tatlin: Milk jug, 1930. Designed in Tatlin's studio at the Vkhutein, Moscow. Base stamped: 'Culture of Materials'.

216. Vladimir Tatlin: *Nude*, 1927. Pencil on paper, 31.8 × 22.4 cm, dated 26 January 1927. Collection George Costakis, Athens. [Illustration © George Costakis 1981.]

became head of the metal and woodwork sections and, in due course, of the ceramics section too. Tatlin's earlier experiences in teaching and his familiarity with collective work were compatible with and extended by his new post.

It became impossible to distinguish where Tatlin's contribution ended and that of his colleagues and pupils began. Stylistic features were never a factor of Tatlin's inventive and original projects, and no unified style emerged. The chair (*c.* 1927—Plates 212-14) and the milk jug (1930—Plates 213-15), both evolved at Vkhutein under Tatlin, reveal this. Each is unprecedented, succinct and complete at its simplest form with a sense that the material is integral to the structure. These elements in the milk jug are integrated to a degree familiar in Tatlin's other works, but it eluded Rodchenko, Popova and Malevich in their ceramic works. Its base is stamped 'The Culture of Materials'. The chair, which has been associated with the name Rogozhin,[79] displays economy and originality. Made of wood in Tatlin's studio at Vkhutein, it made use of splicing and tieing, techniques familiar to the sailor. Its bentwood construction gave it spring, and made it light and comfortable. These designs evolved from the exploration of material qualities in the light of utilitarian functions, and not the imposition of preconceived forms upon the material. The relation that emerged was organic.[80]

As Tatlin's involvement with Khlebnikov had shown, he found no contradiction between the culture of materials and an intimate awareness of literary developments. Furthermore his work became increasingly observational (Plate 216) and depictive once more. In 1929 he approached the irrational stories of Daniil Kharms whose book *Firstly and Secondly*[81] Tatlin illustrated in 1929 (Plates 217-26). Here he functioned fully as illustrator, deferential to the stories' imagery and no longer seeking a material equivalent, as Khlebnikov had provoked him to do some six years previously. Tatlin's sailing experiences proved useful in a second book illustrated by him in 1929: this was

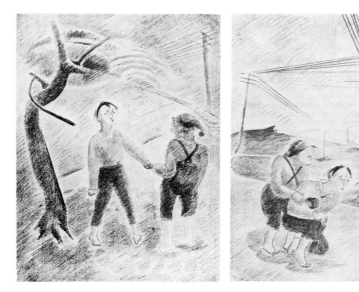

217–26. Vladimir Tatlin: Illustrations to Daniil Kharms, *Firstly and Secondly*, Moscow, 1929.

On the Sailing Ship[82] by S. Sergel (Plates 1, 227–32). The illustrations were representational and figurative; their content was autobiographical although Tatlin published them under the pseudonym Lot. His theatrical costume designs had demanded a revival of figurative work and this was reflected in the book illustrations of 1929. They have a refinement and sparseness comparable to drawings by Miturich, Tyrsa, Bruni and Lvov. Four designs of 1915–18 for Wagner's *Flying Dutchman* had been exhibited in Moscow in 1928 in an exhibition of State acquisitions, and in 1929 a *Helmsman* was shown together with *Nude* of 1913 in the Exhibition of Contemporary Soviet Art held at the Grand Central Palace, New York.[83]

The 1920s were a time of diverse developments in Tatlin's work; he resisted specialization and narrow categories of creative activity, although painting once again began to attract his attention as did figurative and representational theatre design.

213

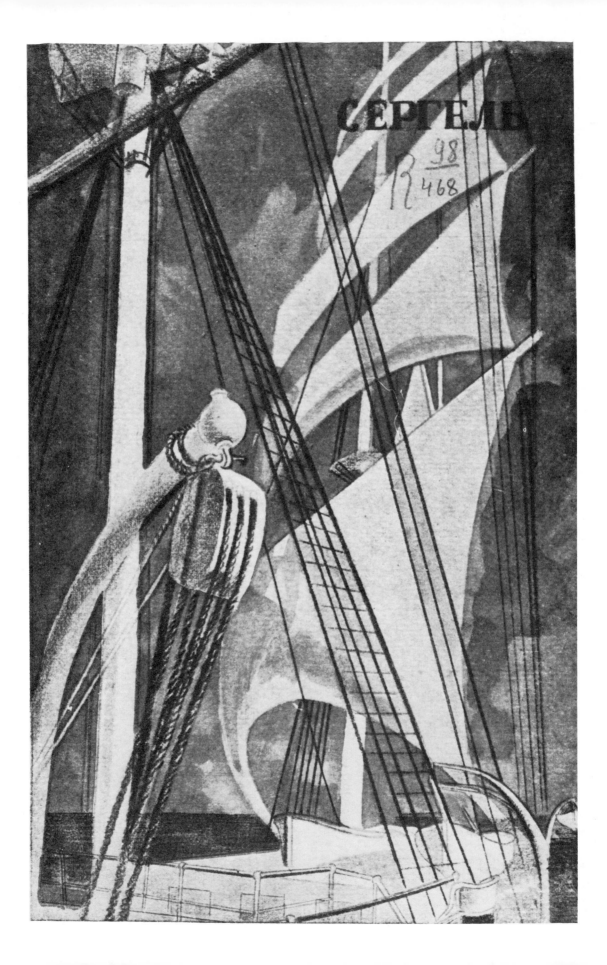

СЕРГЕЛЬ

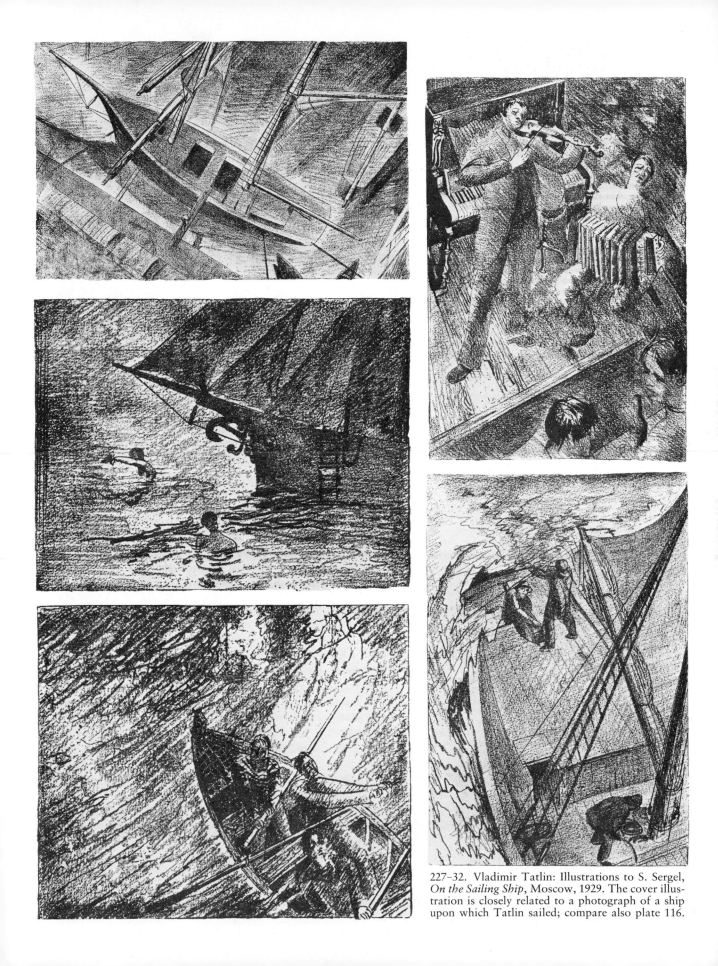

227–32. Vladimir Tatlin: Illustrations to S. Sergel, *On the Sailing Ship*, Moscow, 1929. The cover illustration is closely related to a photograph of a ship upon which Tatlin sailed; compare also plate 116.

10 ICARUS

TATLIN's projects had shown the greatest diversity. He had explored the perimeter of art and under special circumstances had endeavoured to take creativity beyond art altogether. His investigative mind led him into many areas of study, amongst which painting was only a part of an all-embracing whole. For the constructivists and for Tatlin in particular, an important precedent existed in the work of Leonardo da Vinci, as much inventor and constructor as painter, for whom there was no contradiction in the simultaneous study of painting and the design of machinery. Tatlin's project for a flying machine (Plates 233, 235–6), between 1929 and 1932, recalls both Leonardo's example and Khlebnikov's preoccupation with birds. Tatlin the sailor had watched tireless gulls follow his ship for days scarcely moving their wings. *Letatlin*, his glider, was a response to that memory. The verbal punning of its name recalls the neologisms of Khlebnikov: *letat*, to fly, plus *Tatlin* gives *Letatlin*. Furthermore in Khlebnikov's numerical theory of history, the period of 365 years, or its multiples, divides the dates of great men in comparable fields of endeavour.[1] Tatlin was born in 1885 and Leonardo died in 1519, so that the period of time which elapsed between their lives was 366 years, perhaps close enough to Khlebnikov's 'historical wave' of 365 years for the parallel to have intrigued Tatlin.

Khlebnikov's collected works were published from 1928, and this may have re-awakened Tatlin's excitement at Khlebnikov's writing, images and theories.[2] Tatlin, teaching the culture of materials at the Moscow Vkhutein, was familiar with the flexible properties of bentwood, as the chair made under his supervision there testified. These facets were united in the glider *Letatlin*, which Tatlin evolved as head of a small group of researchers at the Experimental Scientific Research Laboratory housed in the beautiful and extensive Novodevichy Monastery in Moscow, its gilded domes rising above high enclosing walls. Tatlin's group was made up of the Vkhutein students A. S. Sotnikov and Yu. V. Pavilionov and an advisory panel of M. A. Geyntse, A. V. Losev, A. E. Zelinsky and A. B. Shchepitsyn. They studied the handling of materials according to principles of organic construction. 'My machine,' observed Tatlin, 'is built on the principle of life, of organic forms. Through the observation of these forms I concluded that the most aesthetic forms are the most economical. Creative work is giving form to material.' In particular Tatlin and his group studied insect flight and the flight of birds reared at the laboratory in the monastery.

217

233. Tatlin and colleagues attempting to launch *Letatlin*, *c*. 1932. Published in the periodical *Ogonek*, No. 17, 15 August 1933.

234. Alexander Rodchenko: Study for a cover of *Lef* magazine, 1923. Collage, inscribed 'ZGARAAMBRA' and 'LFF'. [Photograph Arts Council of Great Britain.]

235-6. (facing page) Vladimir Tatlin: *Letatlin*, 1929–32. Wood, cork, duralumin, silk cord, steel cable, whale-bone, leather fittings. Zhukovsky Central State Museum of Aviation and Cosmonautics, Moscow.

Flight had been a recurrent theme of Russian futurist poetry and painting. The poet Kamensky was a pilot and had assembled reliefs on the theme of flight. Malevich had painted an *Aviator* in 1914[3] and had commented in his essay *On New Systems in Art* in 1919 that 'we may compare the aeroplane with a bird which develops into many kinds of iron birds and dragonflies'.[4] A collage which Rodchenko prepared for *Lef* magazine (Plate 234) about 1923 features an airship moored in its hangar. Along the length of the hangar Rodchenko inscribed 'ZGARAAMBRA' from the first line of Kamensky's poem 'Juggler', published in the first issue of *Lef* in 1923.[5] The same issue carried the article on Khlebnikov describing Tatlin and Khlebnikov collaborating on a performance: 'We changed its name to *Cast-iron Wings*. The text was shortened a little. We kept Khlebnikov's numbers and Tatlin's fan blades, the cast-iron wings.'[6]

This suggests a flight theme in reliefs by Tatlin. If the linguistic and historical researches of Khlebnikov, the son of an ornithologist,[7] who himself had a deep interest in birds, were reflected in Tatlin's constructions, it would not be surprising to discover the study of birds reflected there also. As Tatlin's investigations were not linked to particular forms, he was not committed to mechanistic or specifically urban forms any more than Rodchenko had been.[8] In the flight of birds he found a complex manifestation of construction.

Letatlin was a flying machine in the tradition of experiments by Leonardo da Vinci and, recently, by Lilienthal (Plate 238).[9] By 1932 mechanized air travel did not rely upon human effort or gliding. Tatlin's glider was a machine independent of the geometrical forms of modern engines.[10] His approach was not the engineer's disposition of materials into a predetermined form, but the exploration of material qualities and their articulation with minimal interference. His aim, as a constructor, was neither to depict bird-flight in the manner of the artist nor to build aeroplanes in the manner of the engineer. Working with a surgeon and a pilot[11] he evolved an equivalent for the gliding mechanism of the bird. His construction included the mechanical

218

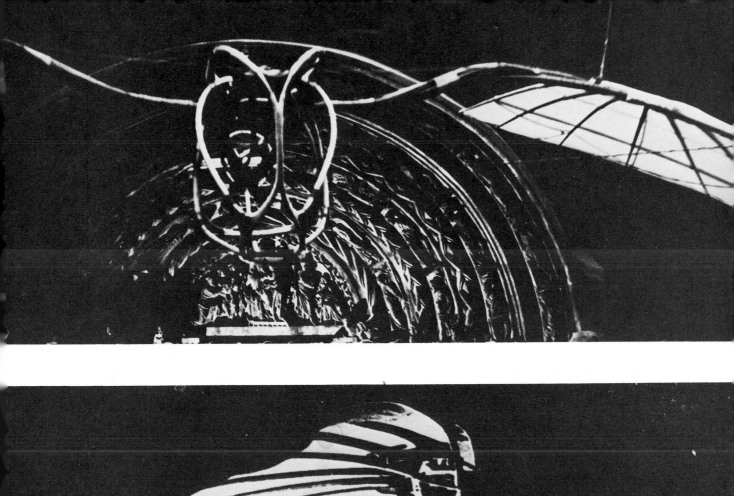

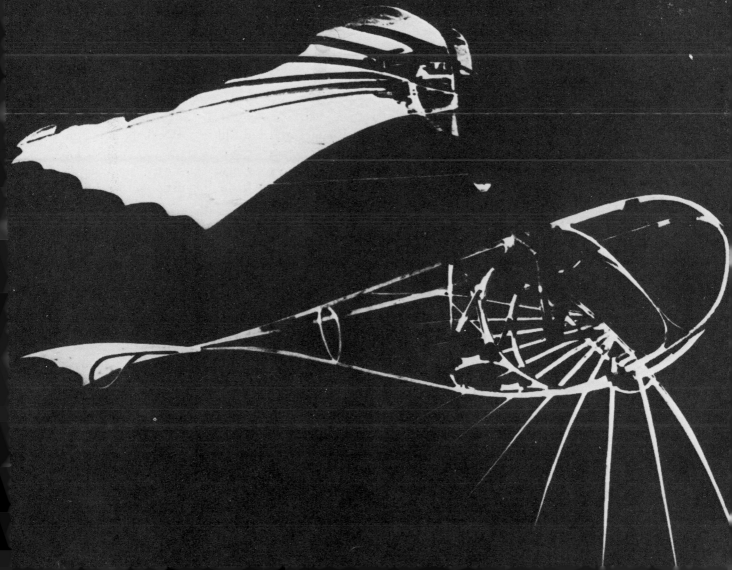

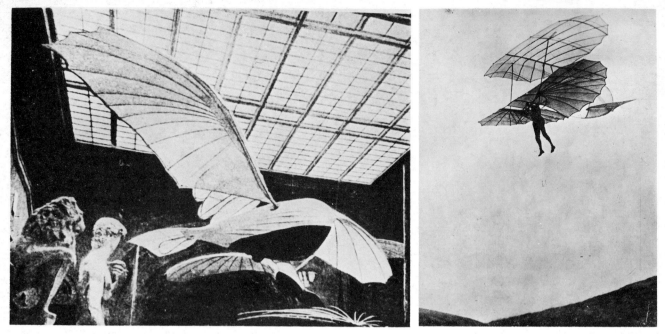

237. *Letatlin* on display in the Pushkin Museum, Moscow, 1932. Published in the periodical *Brigade of Artists*, No. 6, 1932.

238. Otto Lilienthal in flight, 1896. [Photograph BBC Hulton Picture Library, London.]

structure of the human being (Plates 239–40). Tatlin extended the figure, adjusting the levers and rhythms of the body to the movements of gliding flight. The technology of Tatlin's glider derived from organic construction and the search for its equivalent in particular materials.

Tatlin's construction mediates between the natural forces of wind and living organisms. 'I want to give back to man the feeling of flight,' wrote Tatlin. 'We have been robbed of this by the mechanical flight of the aeroplane. We cannot feel the movement of our body in the air.'[12] Tatlin described his glider as 'an everyday object for the Soviet masses, an ordinary item of use'.[13] Whether or not his machine flew, Tatlin's hope was never realized.

To interpret Tatlin's removal to the Novodevichy Monastery as a retreat or as the sign of an inward withdrawal to an impracticable and isolated world would be to construe his circumstances mistakenly. As the head of a small investigative team, comparable with that which devised his model Monument to the Third International, he was not alone there. When *Letatlin* in its various versions was exhibited in 1932, it aroused considerable interest. Furthermore, Tatlin was officially honoured on 17 January 1931, during his work on the glider, as a 'valued exponent of the arts'. The moment was one of recognition and not of obscurity, of communal work and not of isolation. Nor was the huge monastery a remote or obscure site. It is fairly central in Moscow and in its extensive graveyard lie buried many celebrated figures of Moscow's past, a tradition continued in post-revolutionary years. In 1930 after the suicide of Mayakovsky, his body was borne there in honour on a tank-like catafalk (Plate 242) designed by Tatlin in collaboration with his group of Vkhutein students.

Tatlin's work continued to diversify. The relation of creativity to work, and of the creative person's role in society was a theme vigorously studied by constructivists and

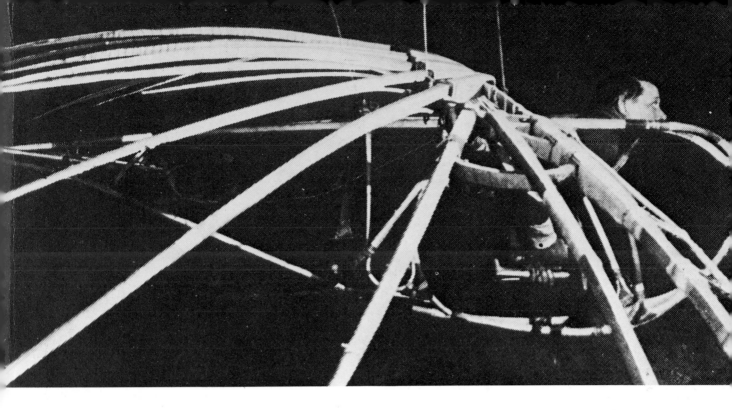

239. Vladimir Tatlin: *Letatlin* with Tatlin in the piloting position, *c.* 1932. [Photograph Angelica Rudenstine.]

240. Vladimir Tatlin: *Diagram of Pilot's Position in Letatlin, c.* 1932. [Photograph Angelica Rudenstine.]

241. (below) Vladimir Tatlin: Wing strut for *Letatlin*, 1929–32. Willow and cork, length 240 cm. Collection George Costakis, Athens. [Illustration © George Costakis 1981, photograph by Robert E. Mates.]

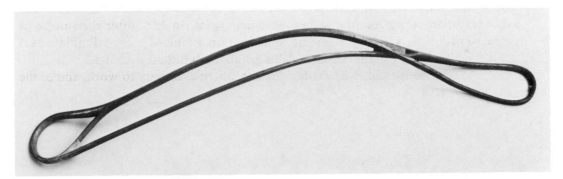

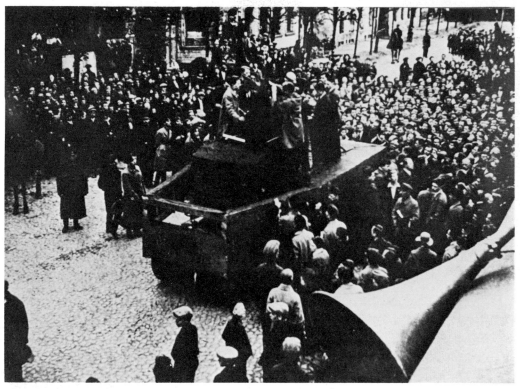

242. Vladimir Tatlin: Catafalk for Mayakovsky's funeral, 1930. Painted red. [Photograph Mayakovsky Museum, Moscow.]

not solely an attitude imposed by external authority. Circumstances were not entirely unsympathetic. Between 1928 and 1933 Khlebnikov's collected works were being published, in 1929 Malevich was given a retrospective exhibition at the Tretyakov Gallery in Moscow, and in 1931 Tatlin was awarded honours in recognition of his creative achievements. In 1932 Tatlin was given a one-man exhibition at the Museum of Decorative Arts, the Pushkin Museum, in Moscow. On the other hand a government degree of 1932 announced the dissolution of all independent art groups. From this time forward the Union of Artists became all-embracing, and in 1932 Tatlin joined its Moscow branch. One of Tatlin's pupils, D. Danin, has left a description of Tatlin at about this time.

> A huge white face and huge white hands. His pallor was not white but blue from the cold. It was hard for him to keep warm in the world about him. His sweater expressed his lack of warmth. It was of big home-made colourless woollen knitting which characterizes and depersonalizes everything old, poor and ill. Or military. Not decorative, simply a warm sweater, ever-lasting, never taken off, one and the same in autumn, winter and spring. And summer too, it seems. Over the sweater was worn one of two dark jackets—blue or black. This costume was the only one; it was unchanged. In winter a fur coat was added—not expensive, but of good red fur. In any other life V. E. Tatlin could even have looked noble.[14]

222

243-4. Vladimir Tatlin: *Letatlin*, 1929-32. [Photograph David Browne.]

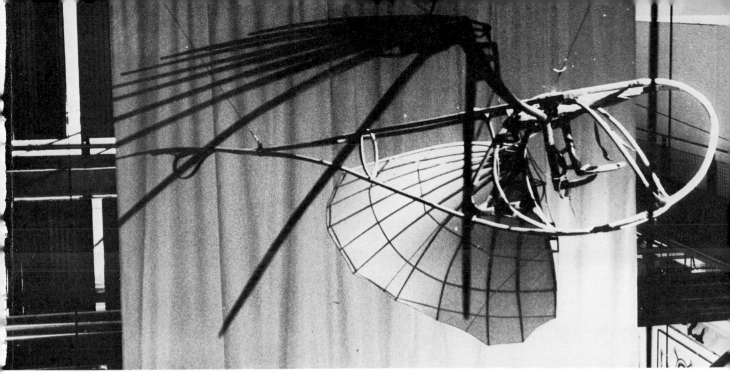

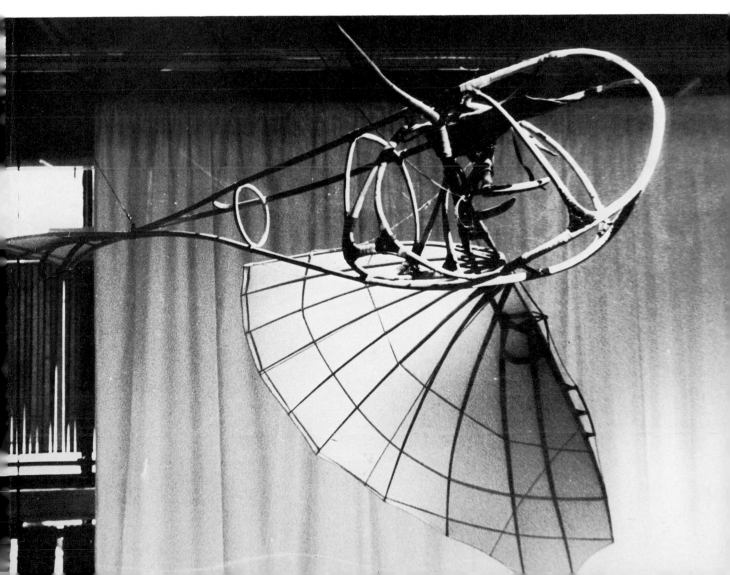

Tatlin used his one-man exhibition to display his *Letatlin* studies. Three models with studies and fragments (Plate 241) were exhibited in addition to photographs of his Monument to the Third International and other constructions.[15] A brochure, published to accompany the exhibition, included two articles, one by Tatlin, 'Art into Technics', and one by K. Artseulov, a former wartime pilot involved in the evolution of *Letatlin*. 'Thousands of Muscovites,' wrote Danin, 'especially children, walked into the Museum of Fine Arts to look at the Tatlin bird, flying out of the past from the time of Icarus, and out of the future from an unknown time.'[16]

Tatlin's ideas were discussed on the evening of 5 April 1932 at the Writers' Club in Moscow.[17] Tatlin delivered a statement and reports were published in the press. Tatlin described his work on the 'air-bicycle' (*vozdushnyy velosiped*), his study of bird flight and his dissection of storks, ducks, swallows and sparrows. The evening was a boisterous event, for Tatlin hoped to see *Letatlin* in common use and envisaged flying schools for children of eight years of age. The press responded. Kornely Zelinsky, in the newspaper *Evening Moscow* the next day, described Tatlin's laboratory at the Novodevichy Monastery: 'A few steps on to the open balustrade of the tower, then you draw back a heavy iron bolt and enter a high, vaulted bell-room, tranformed now into a medieval laboratory. High up, shrouded in the twilight of the monastery, hangs in rope a great white bird without a head, resembling Lilienthal's glider.'[18] Within this tower the reporter found Tatlin engaged in his search for a technology that placed man harmoniously at one with natural materials. Tatlin left no doubt that he rejected a mechanistic approach to materials, the defiance of the air that comprised the motorized aeroplane which in Russia as elsewhere was evolving fast.

Letatlin (Plates 243–4) has no superfluous features, for each joint, each section is part of the whole, yet complete in itself. 'Art,' said Tatlin, 'is going out into technology.' Tatlin had the integrity and ingenuity to take such a step; the reductive and investigative qualities of his work made it possible. Much modern technological development was repetitive and accumulative in detail, tending to adapt and evolve earlier constructions to new ends and to force material into predetermined, preconceived distributions. Such an attitude had long been rejected by Tatlin, and his glider was a whole and integral invention. Tatlin was able to claim with justification that art was moving out into technology, for a real contribution was being made.

Tatlin was confident that *Letatlin* would fly and be commonly available: 'In the spring, we are going out with tents and we are going to start testing it on the slopes.'[19] To the reporter Tatlin's rejection of the machine seemed short-sighted; he described *Letatlin* as 'technological Khlebnikovism'.[20]

Letatlin was a construction in the line of Tatlin's material investigations which led into uncharted areas. The ideas of Khlebnikov did much to determine directions, but the construction itself was integral and complete in its own terms. Tatlin had played a role that was distinct from that of Rodchenko or, for example, the Stenberg brothers. He remained concerned with the social extension of constructivism. Constructivism was not a style, although attempts were often made to understand it as such, nor was it mechanistic. Construction, under the guidance of Tatlin, was continuing to evolve

224

with unfettered originality. His standpoint, held with confidence and authority, was dedicated neither solely to art nor solely to technology: a new means of creative work was still evolving.

Constructivism, misunderstood as a style, was called by Tatlin 'constructivism in inverted commas':

> It did not explore the organic relation between materials and their handling. Only in the resolution of the conflict provided by these relationships is the vital and essential form born. It is not surprising that 'constructivists' became decorators or turned to graphic work. Work in this area, including the furniture and objects of life, is just beginning. The birth of new institutions of culture and life where the mass of workers will live, think and reveal their gifts, will call for more than superficial decoration and will demand above all objects that are appropriate to the dialectics of the new existence.[21]

As did earlier constructions, Tatlin's glider raised questions on the broadest cultural level. It was again exhibited at the Russian Museum in Leningrad in 1932 together with two reliefs and a ceramic work, the Tsarevich plate, designed by Tatlin from an early drawing for the play *Tsar Maximilian*, and executed by V. Chekhonin for the Leningrad Lomonosov porcelain factory. These works formed Tatlin's contribution to the last colossal retrospective survey exhibition of the series which characterized the post revolutionary years. The Jubilee Exhibition of 15 Years' Work by Artists of the RSFSR opened in the Russian Museum in Leningrad on 15 November 1932 and showed 2824 works by 357 artists. Nikolai Punin was amongst the contributors to the catalogue. As this all-embracing display illustrated many tendencies, the contribution of Tatlin and his colleagues was numerically small. Amongst the contributors were Altman, Bruni and Miturich, as well as Malevich, Drevin and Suetin.[22] A Leningrad bias was evident, and none of the Moscow constructivists were represented.

The colossal exhibitions of the early Soviet period were initiated to provide a cultural cross-section at a critical historical moment; they were catalytic in their effect, identifying particular attitudes to the cultural demands of the Revolution by making evident the whole spectrum of achievement. The first large surveys were assertions of what was available as raw material for a new culture.

By 1932 the huge survey exhibition was a distinctly retrospective look at what had been achieved. The early revolutionary years were now history, and constructivism had become a discreet contributor to specialized fields. Its spread and its dissolution were aspects of a single process. Constructivist specialists were engaged in films, in graphic design, in theatrical design and in architecture. There can be no doubt of the importance of constructivism to the film directors Sergei Eisenstein and Dziga Vertov, or to the architects Moizei Ginzburg and Ivan Leonidov, but each of these men was a professional specialist, expert in his own field.

For Tatlin, constructivism was beyond such specialization; it was an investigation of creativity itself. Up to 1932 Tatlin undertook a cultural investigation of unremitting vigour following its implications into a wide variety of activities ranging from painting to the design of stoves and gliders. After 1932 Tatlin's studies focussed upon design

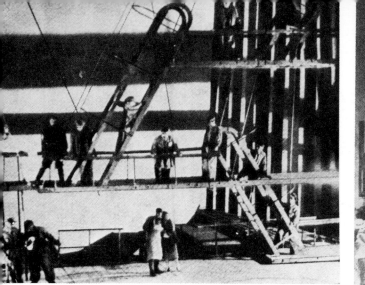
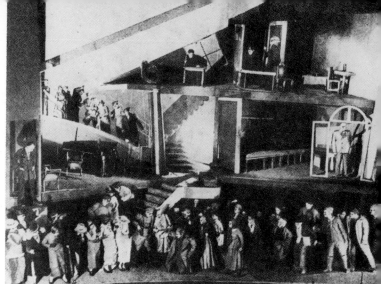

for the theatre. In addition he returned to easel painting. To see this development as a relaxation from the demands of construction is inevitable. But two points demand consideration. Tatlin's construction had evolved increasingly along communal and public lines, and the theatre provided a natural context for the continuation of such cooperative work. Since the staging of *Les Aubes* by Verhaeren at Meyerhold's theatre, Tatlin, a committed theatre designer from the start of his creative career, had watched other constructivists become increasingly attracted to the theatre.[23] Altman and Bruni as well as Popova, Exter, Vesnin, Stepanova and Rodchenko all undertook major constructivist projects in the theatre. Although Tatlin's projects were less easy to categorize, his staging of *Zangezi*, after Khlebnikov's death, still represented a contribution to the field of theatrical work. At Kiev in the mid-1920s he had been head of a department specializing in theatre as well as film and photography. Constructivists had never lost touch with the theatre. Prolific theatre designers of the late 1920s and early 1930s were early admirers of Tatlin's work. Konstantin Medunetsky and Vladimir and Georgiy Stenberg continued to construct on stage. Well represented in theatrical projects at the 1925 Paris Exhibition, they became specialists in this area, working mostly for Tairov's Kamerny Theatre in Moscow.

During 1934–5 Tatlin once again began to construct for the stage with designs for the Moscow Art Theatre's production of *The Comic Actor of the 17th Century* by Ostrovsky. Designs by the Stenberg brothers and also by Ryndin for the Kamerny Theatre in 1931 provide a background against which to view Tatlin's sets of a few years later. The Stenbergs' sets for *Line of Fire* (Plate 245) by Nikitin was a skeletal arrangement of ramps, steps and platforms ultimately heir to the innovations of Stepanova, Popova and Vesnin almost ten years earlier. Just enough detailed clues are provided to suggest the walkways and decks of a ship. The action of the play occurs on all of these levels. No doubt is left in the spectator's mind that he is witnessing a theatrical event: the suspension of disbelief is discouraged.

By contrast, Ryndin's set for *Sonata Pathétique* (Plate 246) is more complex and credible. Using the full stage height, Ryndin explicitly indicates a house with its front removed to reveal five rooms and a staircase open to the audience and containing the action of the play. Each room has a distinct shape and atmosphere. Despite the

226

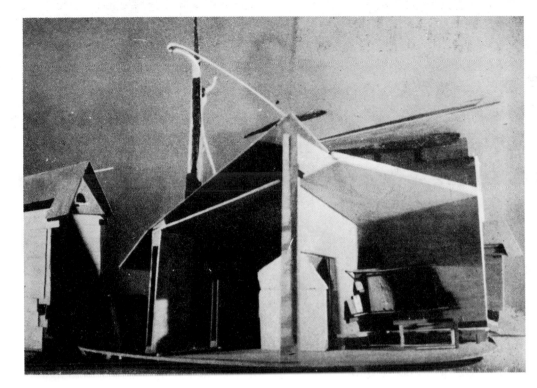

245. (facing page left) V. & G. Stenberg: Set for the play *The Line of Fire* by Nikitin, 1931. Directed by Alexander Tairov at the Kamerny Theatre, Moscow.

246. (facing page right) Vadim Ryndin: Set for the play *Sonata Pathétique*, 1931. Directed by Alexander Tairov at the Kamerny Theatre, Moscow.

247-8. Vladimir Tatlin: Maquettes for set of the play *The Comic Actor of the 17th Century* by Ostrovsky, 1935, at Moscow Art Theatre II.

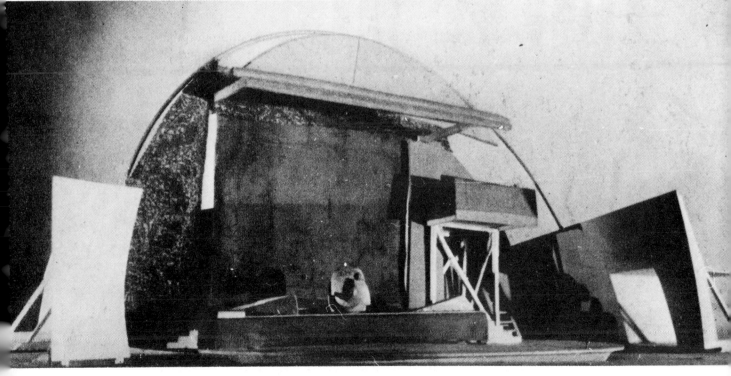

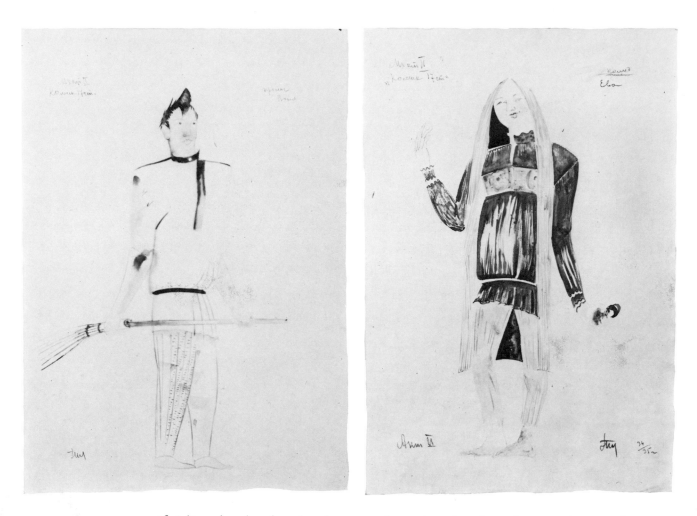

artificiality of such a frontless house, major concessions have been made towards an illusion of actual rooms.

Tatlin's maquettes for *The Comic Actor of the 17th Century* (Plates 247–8) are surprisingly comparable to Ryndin's: the audience is confronted with rooms and buildings, however intricate the construction of detailed parts of the set. Only the meticulous care taken over the conjunction of planes recalls the *Zangezi* maquettes, and only the constructed podium is comparable with recent designs by the Stenberg brothers.

The narrative or representational content of these sets appears to accept a degree of illusion removing attention from the handling of materials. This set reveals an acceptance of the illusions and narrative richness of the theatre. On the one hand, it is clear to Tatlin's audience that a scenic construction stands before them which can barely induce the image of an actual house, yet compared with the Stenberg's set or recent schematic stagings of Mayakovsky's plays *The Bedbug* and *The Bath-House* at Meyerhold's theatre, Tatlin's set is explicitly domestic. In the costumes (Plates 249–51) the latent theatrical power of Tatlin's early theatrical designs begins to re-emerge. Later stage designs confirm this commitment to a full-bodied illusionism at the

228

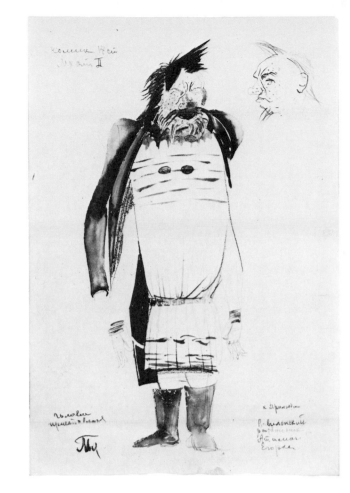

249. Vladimir Tatlin: *Man*, costume design for *The Comic Actor of the 17th Century*, 1934–5. Pencil and watercolour, signed, inscribed 'MKhATII. Comic. of 17c.' Whereabouts unknown.

250. Vladimir Tatlin: *Eve*, costume design for *The Comic Actor of the 17th Century*, 1934–5. Pencil and watercolour, signed and dated, inscribed 'Comic. of 17c.' Whereabouts unknown.

251. Vladimir Tatlin: *Male Character*, costume design for *The Comic Actor of the 17th Century*, 1934–5. Pencil and watercolour, signed and dated, inscribed 'Comic. of 17c.' Whereabouts unknown.

252. (below) Vladimir Tatlin: Set for the play *Let us not Surrender* by Semenov, 1935. Directed by Alexander Tairov at the Kamerny Theatre, Moscow.

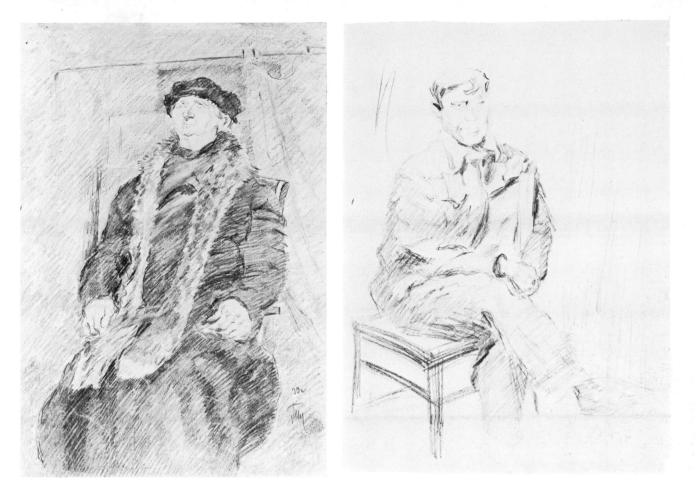

254. Vladimir Tatlin: *Portrait of a Man*, 1939. Pencil on paper, 46.5 × 30.9 cm, signed and dated '39 Tatlin'. Collection George Costakis, Athens. [Illustration © George Costakis 1981.]

255. Vladimir Tatlin: *Portrait of A. V. Shchiptsyn*, *c.* 1940? Pencil on paper, 44 × 32.3 cm. Collection George Costakis, Athens. [Illustration © George Costakis 1981.]

service of narrative. He designed for numerous directors, including Tairov in 1935 (Plate 252), where his marine experiences lent verisimilitude to a construction of ship's rails and cabins. The ship's decks rise up the stage and rooms are open to the audience.

By 1935 Tatlin was thoroughly involved in depiction, both in painting and in the theatre. Many of the contacts and colleagues with whom he had worked in the early post-revolutionary years were no longer accessible. Larionov, David Burlyuk, Exter and Puni had all emigrated. Yakulov was dead, and Tatlin's closest links with the literary innovators of the early revolutionary years, Khlebnikov and Mayakovsky, were also dead. Almost twenty years of exhausting commitment had passed since the Revolution.

Tatlin by 1935 (Plate 253) was still a prolific worker, but in place of that rigorous search for fundamentals characteristic of most of his career, he was content to collaborate upon productions without startling innovations, content to employ his talents as a visual artist in traditional forms. In theatrical design he aimed at characterization, attempting, for example, in *The Comic Actor of the 17th Century* to emphasize the bigotry and niggardliness of those particular features drawn out by the playwright. In painting, Tatlin turned again to oil and canvas for the depiction of

231

253. Vladimir Tatlin, 1934, photographed by M. Nappelbaum. Museum of Modern Art, Oxford.

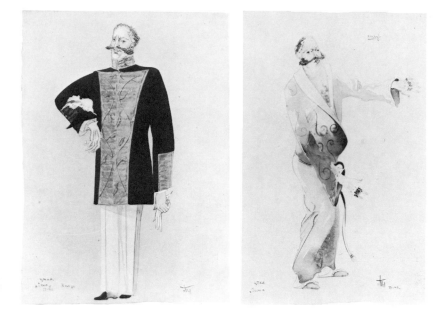

256–65. Vladimir Tatlin: Costume designs for the play *Business* by A. Sukhovo-Kobylin, 1939–40. Performed at the Central Soviet Army Theatre, Moscow.

objects and figures bathed in light. After twenty years he returned to an art that was private, individual and representational, turning to it with enthusiasm and determination, as the number of paintings from the 1930s and 1940s indicate. For the most part they were handled vigorously and with a sense of the material of paint, yet their primary aim was the description of the play of light upon the objects before him. A number of figurative works (Plates 254–5) testify to a literalness of vision and an absence of assumed style, characteristics that had maintained Tatlin's integrity and originality through his most abstruse experimental phase. At fifty Tatlin was reconsidering his aims.

Commissions followed both for the painter and for the set designer. In 1938 at the All Union Agricultural Exhibition Tatlin designed installations for a pavilion of cattle-breeding. Theatrical commissions continued. For the Soviet Army Theatre in 1939–40 Tatlin designed sets and costumes for *Business* (Delo) by Sukhovo-Kobylin

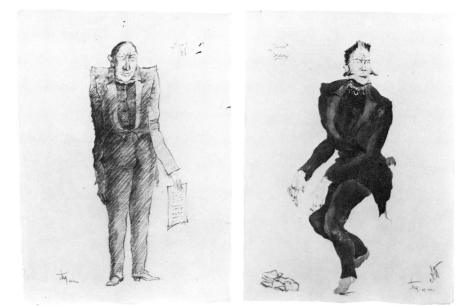

232

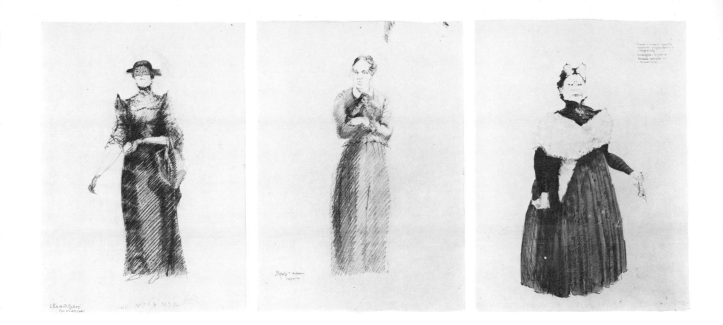

using a dry and literal style for the sets and a contrasting grotesque style for the costumes (Plates 256–65). Tatlin also made maquettes, and the play was staged in 1941. For the play *Spring 1921* in 1939–40 Tatlin included a self-portrait drawing in his designs (Plate 267): this dry, slightly awkward drawing depicts an ageing sailor with lined face, a vulnerable man and a stark contrast to the firm lines of Tatlin's early sailor self-portrait painting, for now the line too is faltering and delicate compared with the fierce decisiveness of the earlier work.

When Khlebnikov's unpublished works were assembled into a book by Khardzhiev in 1940, he turned to Tatlin for a memorial drawing of Khlebnikov (Plate 269), who had died eighteen years previously. The drawing is a gentle depiction of Khlebnikov as a solitary poet seated on a park bench in winter and writing on scraps of paper. The King of Time, stripped of the bizarre and visionary images of the poems, is revealed as a slight man susceptible to the cold of the winter. Tatlin too was vulnerable,

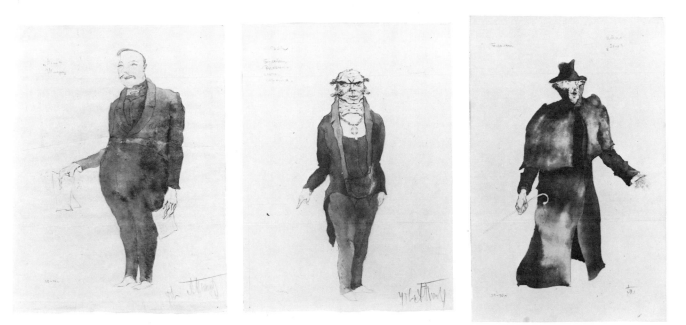

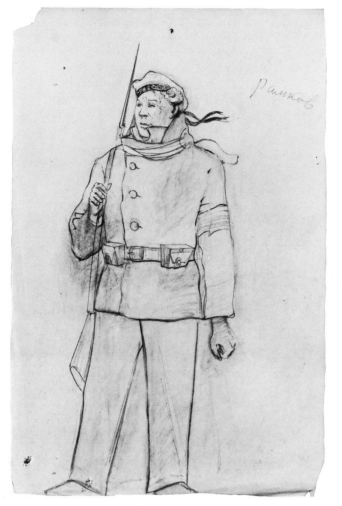

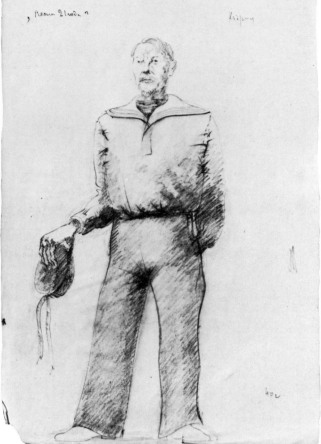

266. Vladimir Tatlin: *Sailor*, costume design for the play *Spring 21* by Stein, 1939-40. Whereabouts unknown. Performed at the Lensovet Theatre, Moscow.

267. Vladimir Tatlin: *Kudrin (Self-Portrait)*, costume design for *Spring 21*, 1939-40. Pencil on paper, 46.5 × 30.5 cm, inscribed 'Spring 21'. Whereabouts unknown.

and the coming of war brought personal disaster with the death at the front of his only son in 1943. He moved the following year into a collective house for artists on Maslovka Street in Moscow.

Until 1952, the year before his death, Tatlin worked vigorously on theatrical productions, designing costumes, sets and maquettes.[24] Towards the end of his life, during 1951-3, his work on gliders received increasing recognition and Tatlin worked at the Moscow Centre for Research into Gliders (Dosaaf), giving lectures and reporting on his pre-war experiments. He died on 31 May 1953. An urn with his ashes was taken to the cemetery of the monastery where he had studied the flight of cranes.[25]

Tatlin was an extraordinary man. He sought to define creative work in material terms. He engaged his energies in the broadest range of activities without loss of integrity. He sought a common ground of creativity and his work proceeded through phases so distinct and so complete that for him repetition was impossible.

A photograph taken in the 1940s (frontispiece) shows Vladimir Tatlin, a face of

234

268. Vladimir Tatlin, 1940s. Photograph collection George Costakis, Athens. [Illustration © George Costakis 1981.]

269. Vladimir Tatlin: *Portrait of Velimir Khlebnikov drawn from memory*, frontispiece to Velimir Khlebnikov, *Unpublished Works*, Moscow, 1940.

great sadness and intense concentration, plucking the strings of a Ukrainian stringed instrument similar to the *bandura*. 'His voiceless singing,' recalled Danin,

> cast a spell on everyone. He cast the spell by his strange musicality—its ancient natural folk quality together with a secret irony. Delicately he would make fun both of his own seriousness of execution, and of the exaggerated seriousness of his listeners. He accompanied himself on the gently sounding instrument that he called not a *bandura* but a *domra*. It was made by him—he hollowed out its body from solid wood.[26]

He made the instrument as he made his tools and workbench. Tatlin was both practical man and dreamer, the lyricist of construction. He tuned the material world to discover what means could make it resound. No taste or style or system detracted from that search. No facile intriguing solution or familiar device was permitted. The completeness and newness of his works were discovered and not devised. Tatlin's discoveries provoked new journeys. He discerned new seas of creativity.

235

NOTES TO THE TEXT

NAMES AND TRANSLITERATION

Where Russian names have an established form in the Roman alphabet this has usually been employed; *Diaghilev* is an example. But it should be remembered that spellings may vary in bibliographic references according to the language in which a text is written.

Certain Russian cities have changed their names. St Petersburg became Petrograd in 1914, and after the death of Lenin in 1924, it was renamed Leningrad. Each is used in turn in the book as appropriate to the period under discussion.

In transliterating Russian words no indication has been made of the two 'silent' Russian letters, the hard sign and the soft sign.

Russian institutions have sometimes become known by the Russian abbreviated forms of their full titles. The following have been used in this book:

Inkhuk	Institute of Artistic Culture, Moscow
IZO Narkompros	Arts Department of Commissariat of Enlightenment
LGALI	Leningrad State Archive of Literature and Art
Obmokhu	Society of Young Artists
Opoyaz	Society for the Study of Poetic Language
Svomas	Free Studios (Free State Studios)
TsGALI	Central State Archive of Literature and Art, Moscow
Vkhutein	Higher Artistic and Technical Institute
Vkhutemas	Higher Artistic and Technical Studios
Zhivskulptarkh	Group for Study of Interrelation of Painting, Sculpture and Architecture

ABBREVIATIONS USED IN NOTES TO THE TEXT

Abramova, 1966	A. Abramova, 'Tatlin k 80-iyu so dnya rozhdeniya' (Tatlin, to Mark the 80th Anniversary of his Birth), *Dekorativnoe iskusstvo*, No. 2, 1966, pp. 5–8.
Andersen, 1968	Troels Andersen, *Vladimir Tatlin*, Stockholm (Moderna Museet, exhibition catalogue), 1968.
Andersen, 1979	Troels Andersen (ed.), *Art et poésie russe, 1900–1930*, Paris, 1979.
Barooshian, 1974	V. M. Barooshian, *Russian Cubo-Futurism*, The Hague, 1974.
Bowlt, 1976	J. E. Bowlt, *Russian Art of the Avant-Garde*, New York, 1976.
Braun, 1979	E. Braun, *The Theatre of Meyerhold*, London, 1979.
Brown, 1973	E. J. Brown, *Mayakovsky: A Poet in the Revolution*, Princeton, 1973.
Compton, 1978	Susan P. Compton, *The World Backwards*, London, 1978.
Danin, 1979	D. Danin, 'Uletavl', *Druzhba narodov*, No. 2, 1979, pp. 220–36.
Gordon, 1974	D. E. Gordon, *Art Exhibitions, 1900–1916*, Munich, 1974.
Gray, 1962	Camilla Gray, *The Great Experiment*, London, 1962.

236

Khardzhiev, 1940	Nikolai Khardzhiev, 'Mayakovsky i zhivopis' (Mayakovsky and Painting) in *Mayakovsky: Materialy i issledstvo*, Moscow, 1940, pp. 337–400.
Khardzhiev, 1976	Nikolai Khardzhiev, K. Malevich and M. Matyushin, *K istorii russkogo avangarda* (Towards a History of the Russian Avant-Garde), Stockholm, 1976.
Khazanova, 1970	V. Khazanova, *Sovetskaya arkhitektura pervykh let Obtyabrya* (Soviet Architecture in the First Years after October), Moscow, 1970.
Khlebnikov, 1968	V. V. Khlebnikov, *Sobranie sochineniy* (Collected Works), ed. Tynyanov and Stepanov, Leningrad, 1928–33; re-edited and annotated in 5 vols. by V. Markov, Munich, 1968–72.
Khlebnikov, 1976	*Velimir Khlebnikov: Snake Train*, ed. Gary Kern, Ann Arbor, 1976.
Lobanov, 1930	V. M. Lobanov, *Khudozhestvennie gruppirovki za poslednie 25 let*, Moscow, 1930.
Malevich, 1967	K. S. Malevich, *Essays on Art, 1915–1933*, ed. Troels Andersen, 3 vols., London, 1967–9.
Malevich, 1975	K. S. Malevich, *Écrits*, ed. A. B. Nakov, Paris, 1975.
Marcadé, 1972	Jean-Claude and Valentine Marcadé, 'Des lumières du soleil aux lumières du théâtre: Georges Yakulov', *Cahiers du monde russe et soviétique*, No. 13, 1972, pp. 5–23.
Markov, 1967	V. Markov, *Manifesty i programmy russkikh futuristov*, Munich, 1967.
Markov, 1969	V. Markov, *Russian Futurism: A History*, Los Angeles, 1969.
Marshall, 1965	Herbert Marshall, *Mayakovsky*, London, 1965.
Punin, 1920	Nikolai Punin, *Pamyatnik III Internatsionala*, Petrograd (Izdanie Otdela Izobrazitelnykh Isskusstv N.K.P.), 1920.
Rakitin, 1970	Vassily Rakitin, *Lev Aleksandrovich Bruni*, Moscow, 1970.
Rodchenko, 1979	*Alexander Rodchenko*, Oxford (Museum of Modern Art, exhibition catalogue), 1979.
Shklovsky, 1970	V. Shklovsky, *A Sentimental Journey: Memoirs, 1917–1922*, trans. R. Sheldon, Ithaca, 1970.
Shklovsky, 1972	V. Shklovsky, *O Mayakovskom*, Moscow, 1940; ed. and trans. as *Mayakovsky and his Circle* by Lily Feiler, New York, 1972.
Rowell, 1978	Margit Rowell, 'Vladimir Tatlin: Form/Factura', *October*, No. 7, fall 1978, pp. 83–108.
Sillart, 1913	Sillart, 'Vystavka futuristskoy skulptory Bochchioni' (Exhibition of the Futurist Sculpture of Boccioni), *Apollon*, No. 7, 1913, pp. 61–3.
Uspensky, 1930	Pyotr D. Uspensky (Peter Ouspensky), *Tertium Organum*, trans. Nicholas Bessaraboff and Claude Bragdon, London, 1930. First published Moscow, 1911.
Volkov-Lannit, 1968	L. F. Volkov-Lannit, *Aleksandr Rodchenko Draws. Designs. Discusses.* Moscow, 1968.
Vystavki, 1965	*Vystavki sovetskogo izobrazitelnogo iskusstva* (Soviet Fine Art Exhibitions), compiled by V. G. Azarkovich et al., Moscow (Sovetskiy Khudozhnik), 1965.
Woroszylski, 1972	Wiktor Woroszylski, *Life of Mayakovsky*, London, 1972.
Zhadova, 1977	L. A. Zhadova, *V. E. Tatlin*, Moscow (Sovetskiy Khudozhnik, exhibition catalogue), 1977.

NOTES TO CHAPTER 1

1. See Zhadova, 1977, p. 60.
2. Ibid., p. 2.
3. Ibid., p. 1. Tatlin was born in Moscow but moved to Kharkov with his family when he was only two. See Rowell, 1978, p. 83, n. 2.
4. Zhadova, 1977, p. 1; Danin, 1979, p. 221.
5. 'Speaking slowly he would describe his wonder at that time beneath an unfamiliar sky to see for the first time that most beautiful and strangely secretive constellation of the Southern Cross' (Danin, 1979, p. 221).
6. Ibid., p. 222. No icon can today be traced to Tatlin's hand.
7. He once travelled on the educational sailing vessel *The Great Princess Maria Nikolaevna* (Velikaya Knyazna Maria Nikolaevna).
8. Danin, 1979, p. 222.
9. He was especially proud of his silent role in *Boris Godunov*. Tatlin admired Mussorgsky throughout his life. Discussed in Danin, 1979, p. 222.
10. Velimir Khlebnikov, 'Zaklyatie smekhom' in *Studiya*

impressionistov (Study of the Impressionists), ed. N. Kulbin, St Petersburg, 1910, p. 47.
11. Donkey's Tail exhibition, Moscow, 1912, Nos. 265–7: *Peaches* (study), *Garden* (drawing), *Street in the South* (esquisse), and *Carnations* (study), respectively. The last two were allocated Cat. No. 267.
12. Kandinsky's works were Cat. Nos. 71–4, entitled *Improvisations a–d*.
13. Other titled works were *In the Garden* (Cat. No. 344), *Market* (384), and *Small Shop* (356).
14. Drawing purchased by the State in 1928–9.
15. N. Kulbin, 'Svobodnoe iskusstvo kak osnova zhizni' (Free Art as the Basis of Life) in Markov, 1967, pp. 15ff. Originally published in the anthology *Studiya impressionistov*, St Petersburg, 1910.
16. Khlebnikov had written at the Burlyuks' home near Kherson in the summer of 1910. It was from his conception of the perfect rural world that the idea of an Hylaea group emerged. Markov, 1969, p. 36, suggests that Khlebnikov may owe some of this idea to Larionov.
17. *Sadok sudei*. The book included 'Zoo' (Zverinets) by Khlebnikov. It has been translated by Richard Sheldon in

Khlebnikov, 1976, p. 147, under the title 'Menagerie'. See Markov, 1969, pp. 8ff., 22ff.

18. *Apollon*, October 1910. See Will Grohmann, *Kandinsky*, London, 1959, p. 62.

19. Grohmann, 1959, p. 67.

20. At 73 Nevsky Prospekt.

21. Léger first exhibited in Russia on 23 January 1912 at the Knave of Diamonds exhibition. *Woman in Blue* (1912) was exhibited from 1 January 1913 in Moscow at the Modern Art (Sovremennoe Iskusstvo) exhibition. Apollinaire's opinions on Léger's paintings were included in the Knave of Diamonds publication *Sbornik statey po iskusstve* (Anthology of Statements on Art). In Paris Léger lectured at the Académie Wassilieff. Further contacts occurred in the early 1920s. See L. A. Zhadova, 'Fernan Lezhe i molodoe sovetskoe iskusstvo' (Fernand Léger and the Young Soviet Art), *Tvorchestvo*, No. 6, 1981, pp. 20–2.

22. An early Soviet survey of Shchukin's collection was P. P. Pertsev, *Shchukinskoe sobranie frantsuzskoy zhivopisi* (The Shchukin Collection of French Painting), Moscow (Museum of Modern Western Painting), 1921.

23. Kandinsky showed *Concert* (Cat. No. 64), *Compositional Study* (F. Hartmann Collection, 65), *St George (Variation 1)* (66), *Improvisation No. 20* (67), *Improvisation No. 21* (68), and *Improvisation No. 23* (69).

24. Léger showed a study for three portraits from the 1911 Salon d'Automne, a still life, an unidentified study and drawings.

25. The innovations of this production, sponsored by the Union of Youth, included the absence of footlights, and actors moving in the auditorium, techniques Meyerhold was later to develop extensively. See *Russian Modernism: Culture and the Avant-Garde, 1900–1930*, ed. George Gibian and H. W. Tjalsma, Ithaca, 1976, p. 180.

NOTES TO CHAPTER 2

1. N. Kulbin, 'Svobodnoe iskusstvo kak osnova zhizni' (Free Art as the Basis of Life) in *Studiya impressionistov*, St Petersburg, 1910; reprinted in Markov, 1967, pp. 15–22 (these quotations pp. 16, 19 respectively).

2. I am indebted to Anthony Parton's unpublished research on Larionov for information supporting these observations.

3. A. Kruchenykh and V. Khlebnikov, *Mirskontsa*, Moscow, 1912.

4. See Khardzhiev, 1940, p. 370.

5. With regard to Russian awareness of cubism in 1912, note should be made of the last work listed in Nikolai Kulbin's retrospective exhibition (1907–12) held in St Petersburg in October 1912: 'No. 84 Nature Study. Cubist sculpture in clay'. See Gordon, 1974, pp. 617–18.

6. Zhadova, 1977, p. 3.

7. See Woroszylski, 1972, p. 72.

8. Andersen, 1968, p. 12.

9. D. and N. Burlyuk et al., *Poshchechina obshchestvennomu vkusu*, Moscow (G. L. Kuzmin), 1912.

10. Markov, 1969, pp. 41 ff.

11. 'Obrazchik slovonovshestv v yazyke'.

12. 'Pereverten.' The poem is printed with an attempted translation by Gary Kern in *Khlebnikov*, 1976, p. 65.

13. Conceivably this was painted in 1912, but probably not later. In the 1912 Donkey's Tail exhibition to which both Larionov and Tatlin contributed, Larionov exhibited as No. 99 in the catalogue *Study for a Portrait of V.E.T.* This was very probably Vladimir Evgrafovich Tatlin.

14. Tatlin showed a *Sailor* (Matros) as No. 84 in the Union of Youth exhibition, St Petersburg, 17 December 1911 – 23 January 1912; and at the 1912 Donkey's Tail exhibition he showed *Self-Portrait* (256) and *Sailor* (257).

15. *Starinnaya lyubov.*

16. At the 1913 Donkey's Tail and Target exhibitions, Larionov exhibited a painting of a Venus in this pose.

17. The text is reprinted in Markov, 1967, pp. 170ff., text No. 44. Compton, 1978, reproduces illustrations by Rozanova (p. 96) and D. and V. Burlyuk (p. 106) from the third volume produced by the Union of Youth. Rozanova's drawing is as difficult to read for its imagery as the most difficult rayonnist works by Larionov. The Burlyuks' collage-like heads integrate image and background by flatter means and reveal an awareness of the edge of the format that is closer to Tatlin.

NOTES TO CHAPTER 3

1. Khlebnikov drew and painted occasionally. According to Livshits, in 1913 Khlebnikov executed a woman's portrait and another portrait 'in the style of Renoir'. See B. Livchitz, *L'Archer à un oeil et demi*, Lausanne, 1971, p. 54.

2. V. Khlebnikov, V. Mayakovsky and D. and N. Burlyuk, *Trebnik troikh*, Moscow, 1913.

3. A. Kruchenykh and V. Khlebnikov, *Slovo kak takovoe*, St Petersburg (EUY), 1913.

4. *Sadok sudei No. 2*, St Petersburg (Zhuravl), 1913.

5. Cited in Markov, 1969, p. 51.

6. In December 1911 the Second Mendelevskian Convention was held in St Petersburg dedicated to problems of time and higher dimensions. It was addressed by Professor N. A. Oumoff, whom Uspensky met in January 1912. See Uspensky, 1930, p. 125. The reputation of Einstein, Minkowski and other scientists in relation to cubism has been explored by L. D. Henderson, 'A New Facet of Cubism: "The Fourth Dimension" and "Non-Euclidean Geometry" Reinterpreted', *Art Quarterly*, winter 1971, p. 410.

7. It is possible that Larionov may have influenced Khlebnikov's thinking. Certainly the *Seasons* echo the poet's enthusiasm for uniting verbal and visual elements, his primitivism and his fascination with planetary movements and time.

8. Tatlin was remembered for his singing. Shklovsky has asserted that an old song which Tatlin used to sing as an art student at the Moscow College influenced Mayakovsky in his poem 'Man' (Chelovek). See Shklovsky, 1972, p. 94. Danin, 1979, p. 223, reprints a song he attributes to Tatlin. See also Danin, 1979, p. 222.

9. Danin, 1979, p. 223. Margit Rowell gives spring as the time of Tatlin's arrival in Berlin, moving on to Paris in early summer and visiting Picasso at his studio at 242 Boulevard de Raspail. Lipchitz may have interpreted, and could have communicated his enthusiasm for Čiurlionis as well as Picasso. The precise dates are discussed convincingly by Rowell, 1978, p. 88, n. 9.

10. From Marcadé, 1972, p. 11.

11. See Boccioni's *Technical Manifesto of Futurist Sculpture* of 1912: 'By considering bodies and the parts as *plastic zones*, any futurist sculptural composition will contain planes of wood or metal, either motionless or in mechanical motion, in creating an object; spherical fibrous forms for hair, semi-circles of glass for a vase, wire and netting for atmospheric planes, etc.' (published as a leaflet in *Poesia*, Milan, 11 April 1912; this translation is from U. Apollonio, *Futurist Manifestos*, London, 1973, p. 65). A. V. Lunacharsky, future Commissar of Enlightenment, visited Boccioni's sculpture exhibition at the Galerie de la Boëtie in Paris and reviewed it with enthusiasm for the periodical *Den* (Day), No. 210, 1913: 'Sverkhskulptor; sverkhpoet' (Supersculptor and Superpoet). This review is reprinted in *Russkaya progressivnaya khudozhestvennaya kritika vtoroy poloviny XIX—nachala XX veka* (Progressive Russian Art Criticism of the Latter Half of the Nineteenth and of the Early Twentieth Century), ed. V. V. Vanslova, Moscow, 1977: 'Hence sculpture will use simultaneously all materials, plaster and cloth, wood, iron, glass and human hair' (p. 848). Further to Lunacharsky and Italian futurism, see Markov, 1969, p. 149. *Apollon* magazine's review noted in particular the *Synthesis of Human Dynamism* and *Spiral Expansion of Muscles in Motion* (Sillart, 1913, pp. 61-3).

12. A discussion of the scroll was published by a Russian in Paris in 1913. See R. Bravsky, 'Simultanizm', *Gelios*, No. 1, November 1913, pp. 35-7.

13. According to Gray, 1962, p. 104, the Russian exhibition of folk art was held in Berlin in the autumn of 1913. Others repeat the story that money earned in Berlin with the troupe allowed Tatlin to reach Paris. In any case it would appear that Tatlin would, in all probability, have been able to see the Erste Deutsche Herbstsalon in Berlin.

14. A. Shevchenko, *Printsipy kubizma i drugikh sovremennikh techeniy v zhivopise*, Moscow, 1913.

15. V. Aksenov, Le Fauconnier and G. Apollinaire, *Bubnovy valet. Sbornik statei po iskusstvu* (Knave of Diamonds: Collection of Articles on Art), Moscow, 1913. See Gail Harrison, *Ex Libris 6*, New York, 1977, No. 2.

16. There were two translations in 1913. This was E. Nizen, *O kubizme*, St Petersburg (Zhuravl), 1913. See Compton, 1978, p. 21.

17. Laurens exhibited two works at the Salon des Indépendants in Paris in 1913.

18. According to Khardzhiev, 1976, p. 27, Juan Gris made his Russian début at the large Modern Art (Sovremennoe Iskusstvo) exhibition in Moscow on 1 January 1913 and which also included Léger's *Femme en bleu*.

19. Italian futurism, which itself borrowed cubist techniques, was increasingly respected in Russia. *Apollon* magazine carried an article on Boccioni's sculpture exhibition in September 1913 which discussed (but did not illustrate) Boccioni's *Bottle in Space* as well as *Spiral Expansion of Muscles in Motion* and *Anti-Graceful*. See Sillart, 1913, pp. 61-3.

20. A. Kruchenykh, *Pustynniki. Poema* (Hermits: A Poem), illus. N. Goncharova, Moscow (Kuzmin and Dolinsky), 1913; A. Kruchenykh, *Poluzhivoy* (Half-Alive), illus. M. Larionov, Moscow (Kuzmin and Dolinsky), 1913; A. Kruchenykh, *Pomada* (Pomade), illus. M. Larionov, Moscow (Kuzmin and Dolinsky), 1913.

21. M. Larionov, *Luchizm*, Moscow, 1913; Eli Egan-

bury, *Nataliya Goncharova, Mikhail Larionov*, Moscow (Ts. A. Myunster), 1913; *Oslinyy khvost i mishen*, Moscow (Ts. A. Myunster), 1913.

22. V. Khlebnikov, A. Kruchenykh and E. Guro, *Troe*, illus. K. Malevich, St Petersburg (Zhuravl), 1913.

23. Cited from Markov, 1969, p. 125.

24. *Novye puti slova*.

25. Markov, 1969, p. 127.

26. A. Kruchenykh and V. Khlebnikov, *Slovo kak takovoe*, St Petersburg (EUY), 1913. Discussed at length in Markov, 1969, p. 398, n. 24, and Woroszylski, 1972, p. 109.

27. G. Gibian and H. W. Tjalsma, *Russian Modernism*, Ithaca, 1976, pp. 167-8. This painting was representational. Also shown at this exhibition were Rozanova's *Dissonance*, Filonov's *Half a Picture* and Matyushin's *Red Ringing*.

28. Ibid., p. 168.

29. The text is translated in G. Daniels, *The Complete Plays of Vladimir Mayakovsky*, New York, 1968, and is discussed in Woroszylski, 1972, pp. 72-83. It was performed on two nights, 2 and 4 December 1913. *Victory over the Sun* was performed on 3 and 5 December. Kulbin, Blok, Livshits, Chukovsky, Shklovsky and Pasternak all saw the play.

30. Asked in the late 1920s which artists had most influenced his development, Tatlin replied Alexei Afanasev (his tutor at Penza), Mikhail Larionov and Pablo Picasso. See Abramova, 1966, p. 5.

NOTES TO CHAPTER 4

1. Marinetti's first Russian performance was at the Kalashnikov Exchange, St Petersburg, on 1 February 1914. He repeated the performance on 4 February. See Woroszylski, 1972, pp. 93-4, and *Russian Modernism: Culture and the Avant-Garde, 1900-1930*, ed. George Gibian and H. W. Tjalsma, Ithaca, 1976, p. 168.

2. They were included in Vadim Shershenevich, *Manifesty italyanskogo futurizma*, Moscow, 1914. See also N. Osorgin, 'Italyanskiy futurizm', *Vestnik Evropy*, No. 2, 1914, pp. 339-57. Discussed in Markov, 1969, p. 161.

3. Khardzhiev, 1976, p. 88.

4. Khardzhiev, 1976, p. 88, reports that Tatlin in spring 1914 told Malevich that he no longer considered him his tutor. Anderson, 1968, p. 12, noted that it was Malevich who wrote on 21 February 1914 informing the Union of Youth of his withdrawal of membership along with that of Tatlin.

5. Tour discussed in Woroszylski, 1972, pp. 89ff.; Brown, 1973, p. 44; Markov, 1969, p. 138; and at length in N. Khardzhiev, 'Turne kubo-futuristov, 1913-14gg.' in *Mayakovsky. Materialy i issledovaniya*, Moscow, 1940, pp. 401-27. Cities visited included Kharkov, Odessa, Simferopol, Sevastopol, Kishinev, Nikolaev, Kiev, Minsk, Kerch, Penza, Samara, Rostov, Saratov and Tiflis.

6. Described in Markov, 1969, p. 196. Other exhibitors at Exhibition No. 4 included Chekrygin (Cat. Nos. 189-206), Goncharova, Exter, Larionov (87-102), Le-Dantyu (116-25), Shevchenko (207-27, No. 226 was a study for a rayonnist composition), and Ilya Zdanevich (67-74). Kamensky, Le-Dantyu and Zdanevich comprised a substantial contribution by poets to the exhibition.

7. V. Markov, *Printsipy tvorchestva v plastike, faktura*

(Principles of Creativity in the Plastic Arts, *Faktura*), St Petersburg, 1914; reviewed in *Apollon*, No. 3, 1911.

8. Compare this with Markov's description of Khlebnikov's poetry in terms equally applicable to Tatlin's reliefs: 'Khlebnikov's rhythm, imagery and composition are based upon *sdvig*, that is, on a shift of the habitual and familiar, on the mixing of heterogeneous elements' (V. Markov, *The Longer Poems of Velimir Khlebnikov*, Berkeley, 1962, p. 31).

9. *Pervaya vystavka zhivopisnykh relefov*.

10. Zhadova, 1977, p. 4.

11. Gray, 1962, pl. 125, and Andersen, 1968, p. 89, both date the relief 1914. Andersen, without giving his source, reports that it was exhibited at Tramway V in 1915. The journal *Izobrazitelnoe iskusstvo*, 1919, which illustrated the relief, gave it to 1916. Against the background of Tatlin's development of technique, 1914–15 would appear feasible.

12. Gray, 1962, p. 319, refers to wallpaper.

13. Brochure *Vladimir Evgrafovich Tatlin, 17.XII, 1915*, published by *Novyy zhurnal dlya vsekh*, Petrograd, 1915.

NOTES TO CHAPTER 5

1. Compton, 1978, pp. 41–2, has shed light on these points. See also Markov, 1969, p. 280.

2. *Vzyal Baraban futuristov* was published by Osip Brik, Mayakovsky et al. in Petrograd.

3. 'Today all are futurists. The nation is futurist. Futurism in its death grip has *taken* Russia' (Markov, 1967, p. 159).

4. Cited in Markov, 1969, p. 294.

5. The letter *V*, not a Roman 5.

6. According to Andersen, 1968, p. 13, one of these was the plaster-based 'Glass' relief. Alexander Vesnin noted in a letter of January 1915 that Tatlin 'is now working on a screen for a plaster composition which he will show at a futurist exhibition in Petrograd' (A. G. Chinyakov, *Bratya Vesniny*, Moscow, 1970, p. 88). R. C. Williams asserts that Shchukin purchased a relief at Tramway V (*Artists in Revolution*, London, 1977, p. 156).

7. Both cited by Andersen, 1968, p. 89, the first from *Moskovskie vedmosti*, 29 March 1915, and the second from *Kievskaya mysl*, 6 May 1915. These descriptions, if accurate, suggest two lost works or possibly three, but appear to indicate a continuing interest in found objects. Concerning the exhibition The Year 1915 (God 1915), see also Markov, 1969, p. 277, and Khardzhiev, 1940, pp. 337ff.

8. He exhibited *Composition No. 7* (Cat. No. 40), *Improvisation No. 34* (41), *Painting with White Lines* (42), *Painting with a Circle* (43), *Landscape No. 175* (44), four watercolours (45–8) and two drawings (49–50).

9. K. Malevich, *Ot kubizma i futurizma k suprematizmu. Novyy zhivopisnyy realizm*, Moscow, 1916.

10. Malevich, 1967, p. 29.

11. Ibid., p. 19.

12. 'Without a number but high up in a corner just below the ceiling in the holy place, is hung a "production" without doubt by the same Malevich, representing a black square against a white background. There can be no doubt that this is an "icon"' (A. N. Benois reviewing the Last Futurist Exhibition in the periodical *Rech*, Jan-

uary 1916; reprinted in V. V. Vanslova, *Russkaya progressivnaya khudozhestvennaya kritika*, Moscow, 1977, p. 603.

13. Malevich, 1967, p. 21.

14. Gordon, 1974, p. 884.

15. Including Popova: *Portrait of a Woman (plastic drawing)* (Cat. No. 95), *Pitcher on a Table* (96), *Vase and Fruit* (97); and Udaltsova: *Shop Window Motif* (154). See Gordon, 1974, pp. 883–4.

16. According to A. B. Nakov, it was Nadezhda Udaltsova who edited this pamphlet for Tatlin (Malevich, 1975, p. 67, n. 1).

17. *Novyy zhurnal dlya vsekh*. Andersen, 1968, p. 13, mentions a work hanging in the editorial offices of this journal.

18. S. Isakov, 'K kontr-relefam Tatlina' (On the Counter-Reliefs of Tatlin) in *Novyy zhurnal dlya vsekh*, No. 12, 1915, pp. 46–50.

19. Kandinsky's *Composition VI* had comparable construction and was shown at the Erste Deutsche Herbstsalon in 1913. Any impression made there could have been confirmed at The Year 1915.

20. Rodchenko recalled seeing 'an impressive quantity' of detailed designs for costumes and sets (*Rodchenko*, 1979, p. 132). Danin, 1979, p. 233, mentions a study for *The Flying Dutchman* which features 'the silhouette of a man and a wind-filled sail against glowering skies'.

21. I am indebted to Dr John Golding for this observation.

22. These are discussed in *Apollon*, No. 12, December 1915, pp. 54ff.

23. See N. Punin, 'Risunki neskolkikh molodykh' (Drawings by Several Young Artists), *Apollon*, No. 4, 1916, pp. 1–20.

24. The interest shown by Matyushin and Malevich in theories of a fourth dimension has been discussed by Susan P. Compton, 'Malevich and the Fourth Dimension', *Studio International*, April 1974, pp. 190–5.

25. Malevich, 1967, p. 35.

26. Four years later, the Dadaist Johannes Baader was proclaimed President of the Globe at a Dada manifestation in Berlin. A flysheet signed by Baader, Hausmann, Tzara, Grosz, Janco, Arp, Huelsenbeck and others referred to the 'Dadaist Headquarters of the World Revolution'. Russian links with Dadaists were of some importance. Kandinsky provided one link, but numerous contacts were made. Ribemont-Dessaignes collaborated with Ilya Zdanevich, Apollinaire had assisted Yakulov, and in the early 1920s Grosz, who with Hausmann was particularly interested in Tatlin, visited Russia where he was accepted as a constructivist. 'The creators of the new era,' proclaimed the Dadaist Hausmann, 'the inventors of unfamiliar sounds ... were Khlebnikov and Russolo' (Raoul Hausmann, 'Introduction à une histoire du poème phonètique', *German Life and Letters*, No. 19, 1965–6; cited in the article by Glyn Pursglove, 'Velimir Khlebnikov: Futurist Darvish', *Poetry Information*, No. 17, summer 1977, pp. 69–73). See also Hans Richter, *Dada, Art and Anti-Art*, London, 1965, pp. 126–7, and B. Goriely, 'Dada en Russie', *Cahiers Dada-Surréalisme*, No. 1, 1966, p. 39.

27. Gray, 1962, p. 144, recounts that Tatlin's favourite reading comprised stories by Leskov and a constant diet of Khlebnikov. Danin, 1979, p. 225, comments that Tatlin 'carried Khlebnikov within himself with the devotion of

an evangelist'.

28. V. V. Khlebnikov, *Neizdannye proizvodenniya* (Unpublished Works), Moscow, 1940. Khardzhiev, 1976, p. 64, calls it a *mikroputevoditel* (microguide). The poem has been dated to the end of 1916.

29. V. V. Khlebnikov, *Vremya mera mira*, Petrograd, 1916.

30. *Ka* was published in April 1916 in the miscellany *Moskovskie mastera* (Moscow Masters). Ka, who has 'no obstacles in time', moves freely from XVIII dynasty Egypt to the Moslem paradise. *Ka* is discussed in Markov, 1969, p. 288, and is translated in *Khlebnikov*, 1976, pp. 139ff.

31. The text is reprinted in Khlebnikov, 1968, Vol. 3, p. 146.

32. *Truba Marsian* was written and published as a scroll in 1916. It is discussed in Markov, 1967, p. 160, and is translated in *Khlebnikov*, 1976, pp. 207ff.

33. Markov, 1967, p. 161.

34. Markov, 1969, p. 299; quoting from text in Khlebnikov, 1968, Vol. 5, p. 310.

35. It was to be produced by the firm Timan and Reyngart. Discussed in *Sovetskoe isskusstvo*, 17 September 1934; also in Zhadova, 1977, p. 46; and in E. Braun, *The Theatre of Meyerhold*, London, 1979, p. 134.

36. *Apollon*, No. 3, 1916, pp. 61–2.

37. This and the following two quotations are from Rodchenko's recollections written in 1941. Text translated in *Rodchenko*, 1979, p. 132.

38. V. Mayakovsky, 'Kaplya Degtya' from *Vzyal*, Petrograd, 1915; reprinted in Markov, 1967, pp. 158–60.

39. A. Lentulov, 'Avtobiografia' in *Sovetskiye khudozhniki*, Moscow, 1937, Vol. 1, pp. 159–62; cited by J. E. Bowlt in *The Isms of Art in Russia*, Cologne (Galerie Gmurzynska, exhibition catalogue), 1977, p. 76.

40. See Ya. Tugendkhold, 'Pismo iz Moskvy', *Apollon*, No. 3, March 1916, p. 61. Tugendkhold describes Marie Wassilieff, Lev Bruni and Dymshits-Tolstaya as 'new adepts receiving futurist laurels'. A comparable sentiment was expressed by N. Radlov in *Apollon*, No. 1, 1917, in the article 'O futurizme i mire iskusstva' (On Futurism and the World of Art): 'Do not reject Tatlin. I have seen quite naturalistic works by him, not at all badly executed.'

41. *Rodchenko*, 1979, p. 132.

42. Editorial in *Apollon*, No. 1/2, January–February 1917 (publication delayed).

43. N.R., *Apollon*, No. 9/10, November–December 1916, p. 84.

44. Listed were I. A. Aksenov, *Yelizavetintsy*, Moscow (Tsentrifuga), 1916; Nikolay Aseyev, *Oksana*, Moscow (Tsentrifuga), 1916; Vasiliy Kamensky, *Devushki bosikom*, Tiflis, 1916; V. V. Khlebnikov, *Oshibka smerti*, Moscow (Liren), 1917 (*sic*). Also listed was N. Chuzhak, *K estetike Marksizma* (Towards an Aesthetic of Marxism), Irkutsk, 1916.

45. Khlebnikov's *Trumpet of the Martians* manifesto is an example of his preoccupation with Mars. H. G. Wells' *War of the Worlds*, with its invading Martians, attracted Khlebnikov. See Markov, 1969, p. 157.

46. Two volumes of their discussions were published before the February Revolution interrupted the Opoyaz sessions: V. Shklovsky and O. Brik, *Sborniki po teorii poeticheskogo yazyka* (Studies in the Theory of Poetic Language), Petrograd, 1916, Vol. 1, and 1917, Vol. 2). Discussed in Shklovsky, 1970, p. xi.

NOTES TO CHAPTER 6

1. According to Gray, 1962, p. 196, Tatlin received the commission and engaged Rodchenko and Yakulov. Yakulov, in any case, became the chief organizer of the decorations.

2. Ivan Aleksandrovich Aksenov, *Neuvazhitelnye osnovaniya* (Invalid Foundations), Moscow, 1916, concludes with poems 'La Tour Eiffel I' and 'La Tour Eiffel II'. His book *Pikasso i okrestnosti* (Picasso and Circle) was published in 1917 with a cover by Alexandra Exter. See Markov, 1969, pp. 270–1.

3. Yakulov letter to A. V. Lunacharsky, 19 August 1918, cited in *Agitatsionno-massovoe iskusstvo* (Agitational Mass Art), Moscow, 1971, p. 128. Tairov, Mayakovsky, Ehrenburg and many other creative men and women used the Café Pittoresque.

4. N. Lakov cited in *Agitatsionno-massovoe iskusstvo*, 1971, p. 101.

5. *Rodchenko*, 1979, p. 132.

6. *Khlebnikov*, 1976, p. 174.

7. Ibid.

8. Cited by Woroszylski, 1972, p. 259, from *Iskusstvo kommuny*, No. 17, 30 March 1919.

9. Discussed in Markov, 1969, p. 303.

10. The three were *Death's Error* (Oshibka smerti), *Mrs Lenin* (Gospozha Lenin) and *13 in the Air* (13 v vozdukhe).

11. Rakitin, 1970, p. 29.

12. Cited by Woroszylski, 1972, pp. 131–2, from an article by Mayakovsky in *Nov* (Virgin Soil), December 1914.

NOTES TO CHAPTER 7

1. These dates are according to the old calendar. For new style dates introduced later in 1917, thirteen days must be added.

2. Woroszylski, 1972, pp. 174–5.

3. Old style (i.e. 6–7 November, new style). All dates new style henceforth.

4. Lobanov, 1930, p. 78. See also Marshall, 1965, p. 56.

5. Volkov-Lannit, 1968, p. 18.

6. Quoted at length in Woroszylski, 1972, p. 194.

7. Opened 9 November at the Moscow Art Salon, 11 Dmitrovka Boulevard. Lobanov, 1930, p. 74, gives the dates new style (29 November–17 December 1917) whilst *Vystavki*, 1965, p. 8, gives them old style (16 November–4 December). 314 exhibits were shown and a catalogue was published.

8. 'An inspired fool of god' was how Abram Efros remembered Tatlin at this time (A. Efros, *Profili*, Moscow, 1930, p. 290).

9. *Iskusstvo kommuny*, 1918, cited by Lobanov, 1930, p. 81. See also *Apollon*, No. 8/10, October–December 1917, p. 94.

10. See Volkov-Lannit, 1968, p. 18, and Rakitin, 1970, p. 29. G. Karginov, *Rodchenko*, London, 1979, p. 60, cites a document probably of late 1917: 'To the Federal Council of Anarchist Groups. We artists are compelled to retire from the initial group formed under the Moscow Union of Anarchist Groups, because of the intolerable conditions under which we work. V. Tatlin, A. Morgunov, A. Rodchenko'. Various writers and painters became in-

volved with the periodical *Anarkhia* (Anarchy), organ of the Moscow Federation of Anarchist Groups on Dmitrovka Street. Andersen, 1979, p. 107n, lists Tatlin, Malevich, Morgunov, Gan, Udaltsova, Rodchenko, Altman, Punin, Klyun and others. He also reports that Tatlin worked on a stove there.

11. See Lobanov, 1930, p. 83; *Vystavki*, 1965, pp. 14–15; Barooshian, 1974, p. 117n.

12. Petrograd: president: Shterenberg; Kollegia members: Altman, Vaulin, Karev, Matveev, Punin, Chekhonin, Yatmanov (*Izobrazitelnoe iskusstvo* (Fine Art), No. 1, 1919, p. 50). Moscow: president: Tatlin, Kollegia members: Dymshits-Tolstaya, Udaltsova, Noakovsky, Falk, Rozanova, Shevchenko, Korolev, Konenkov, Kandinsky (*Izobrazitelnoe iskusstvo*, No. 1, 1919, p. 52).

13. Otdel Izobrazitelnykh Iskusstv Narkomprosa RFSFR.

14. Sheldon, 1970, p. 135. Rodchenko too was given conservatorial work despite his antipathy for the art of the past: 'I looked after them with care and protected them,' he wrote, 'but I never respected them' (Alexandre Rodchenko, 'Tatlin', *Opus International*, No. 4, 1967, p. 18). Rodchenko was elected to the Moscow committee of IZO Narkompros and became a member of the purchasing committee. He organized together with Olga Rozanova the 'artistic-industrial' sub-department, and he visited schools and studios to discover their material requirements. Rodchenko was also concerned with the initiation of new collections of paintings: 'We provided all the museums in the Union with leftist works but still did not forget to acquire for the government works by Korovin, Arkhipov, Malyutin, Surikov, Vrubel and others' (Rodchenko cited by Volkov-Lannit, 1968, p. 19). According to Volkov-Lannit, Rodchenko also headed the Moscow Museum of Artistic Culture until its reorganization and transformation in 1922 (ibid.).

15. D. Shterenberg, 'Ot Redaktsil' (editorial), *Izobrazitelnoe isskusstvo*, No. 1, 1919, p. 6.

16. Ibid., p. 54. Exter established a teaching studio in Kiev in 1918 (*The Isms of Art in Russia*, Cologne (Galerie Gmurzynska, exhibition catalogue), 1977, p. 189).

17. A conference of young artists and art students held in May 1918 resolved that each student should be free to choose his instructor. This was reported in *Anarkhia* on 12 May 1918 (see Barooshian, 1974, p. 119, n. 21). The theorist Boris Arvatov recalled in 1922 that the reforms were enthusiastically received (see *Pechat i revolyutsiya*, No. 7, 1922, p. 143).

18. *Izobrazitelnoe iskusstvo*, No. 1, 1919, pp. 54ff.

19. Nikolai Punin, 'Iskusstvo i proletariat' (Art and the Proletariat), *Izobrazitelnoe iskusstvo*, No. 1, 1919, p. 24. Article dated April 1918.

20. *Izobrazitelnoe iskusstvo*, No. 1, 1919, p. 8.

21. Ibid.

22. Osip M. Brik, 'Khudozhnik i kommuna', *Izobrazitelnoe iskusstvo*, No. 1, 1919, p. 26.

23. Interest in film was accelerating. Mayakovsky, for example, made films in 1918. *Not Born for Money* (Ne dlya deneg rodivshivsya), based by Mayakovsky and David Burlyuk on Jack London's novel *Martin Eden*, was issued in 1918; designed by Burlyuk and Vladimir Yegorov; cast included Mayakovsky, Burlyuk and Kamensky (see Brown, 1973, p. 320; Jay Leyda, *Kino*, London, 1973, p. 423; and Shklovsky, 1972, pp. 98–9). In May was issued *The Young Lady and the Hooligan* (Baryshnya i khuli-

gan), scenario adapted by Mayakovsky and played by Mayakovsky (see Leyda, 1973, p. 424). Thirdly, Mayakovsky's *Fettered in Film* (Zakovannaya filmoy) in which Mayakovsky and Lilya Brik both appeared, was issued in June 1918 (see Marshall, 1965, pl. VI, and Leyda, 1973, p. 424).

24. See *Agitatsionno-massovoe iskusstvo*, 1971, p. 106.

25. See Woroszylski, 1972, p. 212.

26. See Barooshian, 1974, pp. 117, 123. In his article 'Ot Otdela Izobrazitelnykh Iskusstv Narkomprosa' (From the Fine Arts Department of Narkompros), *Petrogradskaya Pravda*, 28 November 1918, Lunacharsky made the point that preference would be given to the purchase of works by artists persecuted in the pre-revolutionary epoch, and, therefore, not represented in Russian galleries.

27. Gray, 1962, p. 230.

28. *Iskusstvo kommuny*.

29. Discussed in Brown, 1973, pp. 193–4.

30. Kazimir Malevich, 'Arkhitektura kak poshchechina obshchestvennomu vksusu' (Architecture as a Slap in the Face of Public Taste), *Iskusstvo kommuny*, No. 1, 1918. Translated in Malevich, 1967, Vol. I, pp. 60–4; also mentioned in Brown, 1973, p. 194.

31. 'Prikaz po armii iskusstva.' Discussed in Brown, 1973, p. 193.

32. Shklovsky, 1972, p. 106.

33. 'Radovatsya rano'. See Brown, 1973, p. 193.

34. 'Lozhka protivoyadiya.' Discussed in Barooshian, 1974, pp. 123–4.

35. Woroszylski, 1972, pp. 249–50.

36. Cited in Brown, 1973, p. 195.

37. Pavel Bessalko's article 'Futurism and Proletarian Culture', *Gryaduyushchee*, No. 10, 1918; cited in Woroszylski, 1972, pp. 251–2.

38. See Markov, 1969, p. 250.

39. Barooshian, 1974, p. 77.

40. *Tvorchestvo*. See Chuzhak's article 'Kakoe-zhe iskusstvo blizhe proletariatu?' (What Kind of Art is Closest to the Proletariat?), published originally in *Tvorchestvo*, but discussed afresh in *Lef*, No. 1, 1923, pp. 18–21.

41. *Internatsional iskusstva*. TsGALI, f. 665, op. 1, ed. khr. 32, list 11. Late in 1918 the International Bureau of IZO Narkompros sent a letter to German artists. This committee comprised A. V. Lunacharsky, D. Shterenberg, Nikolai Punin, Wassily Kandinsky, Sofya Dymshits-Tolstaya and Vladimir Tatlin. Their letter proposed a conference of Russian and German artists. This is discussed in the thesis by G. J. Witham, 'The First All-Russian Art Exhibition', University of Kent, 1982, pp. 33ff.

42. Construction for the engineer was much closer to the former description. 'Construction' is used here in the particular sense described. In 1918 Rodchenko was still entitling his paintings *Composition*, but this was shortly to change.

43. Zhivskulptarkh was founded in 1918 (Rakitin, 1970, p. 69) or 1919 (Bowlt, 1976, p. 43) as a collective investigative group (Kollektiv zhivopisno-skulpturno-arkhitekturnogo sinteza). Its members included Rodchenko, V. Krinsky, N. Ladovsky, A. Rukhlyadev, and A. Shevchenko. A number of collectives for the examination of cultural questions were established after the Revolution: Zhivskulptarkh was one; Obmokhu was another. Cf. Natan Altman: 'Just like anything the proletariat creates,

proletarian art will be collective', and 'only futurist art is constructed on collective bases' ('Futurizm i proletarskoe iskusstvo' (Futurism and Proletarian Art), *Iskusstvo kommuny*, No. 2, 15 December 1918, p. 3; cited in Bowlt, 1976, pp. 161-4).

44. Nikolai Punin, 'Iskusstvo i proletariat' (Art and the Proletariat), *Izobrazitelnoe iskusstvo*, No. 1, 1919, p. 10.

45. Osip M. Brik, 'Khudozhnik i kommuna' (The Artist and the Commune), *Izobrazitelnoe iskusstvo*, No. 1, 1919, p. 25.

46. Kandinsky exhibited a number of paintings of 1917. Amongst the exhibitors were A. D. Drevin, Ivan Klyun, A. A. Morgunov, A. A. Osmerkin, Anton Pevsner (his début in Moscow exhibitions), Varvara Stepanova and Nadezhda Udaltsova; see *Vystavki*, 1965, pp. 40-1.

47. Andersen, 1968, p. 13.

48. See Boris Kushner's article 'Leap to Socialism', quoted in Woroszylski, 1972, pp. 255ff.

49. *Iskusstvo kommuny*, No. 9, 2 February 1919. Discussed and quoted in Woroszylski, 1972, p. 257; Bowlt, 1976, pp. 164-6; and Richard Sherwood, 'Introduction to Lef', *Form*, No. 10, October 1969, p. 27. See also A. Efros, *Profili* (Profiles), Moscow, 1930, p. 290. Komfut, founded in January 1919, was a Petrograd body incorporating Boris Kushner as chairman, Osip Brik as the head of its school of cultural ideology, Natan Altman, Vladimir Mayakovsky and David Shterenberg. Bruni and Tatlin were sympathetic. Bruni was particularly close to Altman (see Rakitin, 1970, pp. 29, 110).

50. *Izobrazitelnoe iskusstvo*, No. 1, 1919, p. 85.

51. *Izobrazitelnoe iskusstvo*, No. 1, 1919, p. 86. Cf. Malevich, 'O muzee', *Iskusstvo kommuny*, No. 12, 23 February 1919: 'Instead of collecting all sorts of old stuff we must form laboratories of a worldwide building apparatus, and from its axes will come forth artists of living forms rather than dead representatives of objectivity' (translated as 'On the Museums' in Malevich, 1967, p. 247).

52. *Izobrazitelnoe iskusstvo*, No. 1, 1919, p. 73.

53. Initially these acquisitions comprised works by Malevich, Tatlin, Kandinsky, Rozanova, Rodchenko, Klyun, Shevchenko, Udaltsova, Morgunov, Drevin, Alexander Vesnin, Yakulov and others (ibid., pp. 73-4).

54. *Tsveto-dinamos* (Lobanov, 1930, p. 89); *tsveto-dinamist* (*Izobrazitelnoe iskusstvo*, No. 1, 1919, p. 74). The exhibition opened in Moscow in 1919 as the Twelfth State Exhibition: Colour Dynamos and Tectonic Primitivism. Alexei Grishchenko and Alexander Shevchenko published manifestos in the catalogue. Thirty-eight exhibitors displayed 182 works. See *Vystavki*, 1965, p. 45.

55. Presumably *Les Peintres cubistes*.

56. *Izobrazitelnoe iskusstvo*, No. 1, 1919, p. 67.

57. These figures are according to *Vystavki*, 1965, p. 46. Lobanov, 1930, pp. 88-9, gives them as 2826 works.

58. Obmokhu (OBshchestvo MOlodykh KHUdozhnikov). Exhibitors: N. F. Denisovsky, Yermichev, A. I. Zamoshkin, V. Komardenkov, S. Kostin, A. V. Lentulov, Konstantin Medunetsky, L. Naumov, A. Perekatov, A. Prusakov, N. Prusakov, S. Ya. Svetlov, Vladimir Stenberg, Georgiy Stenberg and Georgiy Yakulov (*Vystavki*, 1965, p. 37).

59. Gray, 1962, p. 240. Malevich, 1975, pp. 143, 216, discussed the extent to which the exhibition comprises the desertion of Malevich's suprematism by his former followers.

60. A quotation from M. Stirner. See Gray, 1962, p. 240.

61. This must have appeared a revolt against Malevich's 'ism', suprematism. See Gray in *Typographica*, No. 2, June 1965, p. 14, and Bowlt, 1976, pp. 138ff.

62. Arthur Ransome, in Moscow early in 1919, commented that 'walking about the town I found it dotted with revolutionary sculptures, some bad, some very bad, others interesting, all done in some haste and set up for the celebrations of the anniversary of the revolution last November. The painters also had been turned loose to do what they could with the hoardings and though the weather had damaged many of their pictures enough was left to show what an extraordinary carnival that had been' (Arthur Ransome, *Six Weeks in Russia in 1919*, Glasgow, 1919, p. 22).

There were also spectacular mass plays. Yuri Annenkov's *Re-enactment of the Storming of the Winter Palace* was an early example (1918). With A. R. Kugel and designs by Mstislav Dobuzhinsky and V. A. Shchuko, Annenkov staged *The Mystery Play of Liberated Toil* on May Day 1919 before an audience of 35,000 spectators. The theatre directors Vsevolod Meyerhold and Sergei Radlov also became active in this field.

NOTES TO CHAPTER 8

1. Nikolai Punin, *Pamyatnik III Internatsionala*, Petrograd (Izdanie Otdela Izobrazitelnykh Iskusstv N.K.P.), 1920, p. 4. According to Zhadova, 1977, p. 20, the model no longer exists, but was made of wood, card, wire, metal and oilpaper and stood approximately 5 metres high. The Third International was founded by the Bolsheviks in March 1919. Marx had founded the First International Workingmen's Association in London in 1864. It was dissolved in 1876. The Second International was formed in Paris in 1889, was active until the First World War and was subsequently revived. The Third International was dissolved in 1943.

2. Andersen, 1968, p. 23.

3. A. Strigalev too has pointed out that the angle of the 'spinal' strut to the vertical corresponds to that of the earth's axis to the plane of its orbit ('Proekt pamyatnika III Internatsionala' in Zhadova, 1977, p. 19).

4. Punin, 1920, p. 3.

5. Boccioni's *Muscoli in Velocità* had been discussed in *Apollon* (Sillart, 1913, p. 62).

6. See John Read, *Prelude to Chemistry*, London, 1936, pp. 106-9.

7. Mosul and Samarra both stand on the Tigris whose valley contains the ziggurats and remains of Khorsabad, Nineveh, Nimrud, Babylon and Ur. Yakulov and Khlebnikov may have established a link with Babylonian precedents for Tatlin. Mosul, close to Khorsabad, Nineveh and Nimrud, stands some fifty miles from the borders with Syria and Turkey. Tatlin visited both of these countries in 1902. The possibility of a visit to Iraq should not be overlooked. Zhadova, 1977, p. 2, lists Egypt, Asia Minor, Africa, Greece and Turkey as countries visited by Tatlin as a sailor from 1904 to 1908. When Georgiy Yakulov designed his Monument to the Twenty-Six Commissars for Baku, his monument recalled both Tatlin's Tower and that of the Malwiyya at Samarra, near Mosul, in its spiral which, like that of Samarra, was vertical. The resemblance between Yakulov's tower and

the Malwiyya is discussed in Marcadé, 1972, p. 16. Leonardo da Vinci, by contrast, was discussed by Boris Arvatov in the journal *Gorn* (Forge), No. 5, 1920, pp. 29–36.

8. This comparison is intended to illustrate the associations of a particular form and not as a specific formal source.

9. Cited by George H. Sabine in *A History of Political Theory*, London, 1951, p. 537.

10. Punin, 1920, p. 3. Several authorities describe the lowest hall as a cylinder, amongst them Danin, 1979, p. 231, who gives the sequence as cylinder, pyramid, tall cylinder, hemisphere.

11. Punin, 1920, p. 4.

12. Ibid.

13. Cf. Khlebnikov in the manifesto-scroll *The Trumpet of the Martians*, 1916: 'We, draped only in the cloak of victories, proceed to the construction of a young union with a sail around the axis of time, giving advance notice that our scale is greater than Cheops, and our task is bold, magnificent and stern' (*Khlebnikov*, 1976, p. 207). Tatlin's scale was to top the Eiffel Tower (300m) by 100m (total 400m). The cubic hall (the lowest) was to be 110m in height (see A. Strigalev, 'Proekt pamyatnika III Internatsionala' in Zhadova, 1977, pp. 16–20). According to Danin, 1979, p. 231, Tatlin considered himself, with Khlebnikov, to be 'co-president of the Globe'.

14. Andersen, 1968, p. 25. Cf. T. M. Shapiro: 'Walks along the banks of the Neva with its forest of cranes and girders were for us an inexhaustible source of inspiration. The view of moving openwork constructions against a background of swiftly flowing clouds revealed to us the poetry of metal' (in K. Simonov, 'Kakaya interesnaya lichnost' (What an Interesting Individual) in Zhadova, 1977, p. 24). Within the Baltic region the spiral tower motif could have been encountered in Copenhagen, where the Saviour's Church is distinguished by a single-spiral tower.

15. Punin, 1920, p. 3.

16. Khlebnikov, 1968, Vol. 2, p. 9; cited in Barooshian, 1974, p. 23.

17. Barooshian, 1974, pp. 36–7. Khlebnikov also acknowledged as an aim 'to effect a gradual transfer of power back to the starry sky' (*Khlebnikov*, 1976, p. 195).

18. Pyotr D. Uspensky, *Tertium Organum. Klyuch k zagadkam mira*, Moscow, 1911. Markov, 1967, p. 72, n. 2, makes the point that both cubo-futurists and ego-futurists read Uspensky.

19. Uspensky, 1930, p. 152 (Uspensky's italics).

20. Ibid., p. 56.

21. Ibid., p. 122. Tatlin's use of the spiral in this context may have some of the significance attributed to it by C. H. Hinton and cited by Uspensky, p. 70, fig. 2. Cf. Susan P. Compton, 'Malevich and the Fourth Dimension', *Studio international*, April 1974.

22. Tatlin joined the Union of Youth on 3 January 1913 and left it approximately one year later (see Andersen, 1968, p. 12). He exhibited with the Union of Youth in St Petersburg, 23 November 1913 to 23 January 1914.

23. Uspensky, 1930, p. 157, talks of visible and tangible objects being 'shadows of real things, the substance of which is contained in their function'.

24. Uspensky, 1930, p. 308.

25. The spirals emerge straight from the earth.

26. The theories of Khlebnikov and Uspensky extended beyond astronomy proper into the philosophical speculations of astrology and the related concepts of alchemy, where gold, silver and other metals were associated with the sun, moon and planets. Uspensky believed that alchemy was of continuing usefulness in scientific research. See Uspensky, 1930, p. 126.

27. Cf. John Read, *The Alchemyst in Literature and Art*, London, 1947, p. 59: 'The doctrine of melancholy … is inseparable from the Saturn mysticism which permeates alchemy … One of the elements of Saturn mysticism is measurement typified by the compasses, balance and hourglass.' It is a tantalizing coincidence that in the photographs of Tatlin displaying his model of the tower, a ladder, which is so clear a feature of Dürer's print, leans against a wall in the background of the photograph.

28. Benedikt Livshits in *Volche solntse* (The Sun of the Wolves), Moscow, 1914; cited in Markov, 1969, p. 189.

29. Velimir Khlebnikov, *Bitvy 1915–1917, Novoe uchenie o voyne*, Petrograd, 1914 (dated 1915). Discussed in Markov, 1969, p. 193.

30. Punin, 1920, p. 3.

31. Andersen, 1969, p. 25.

32. Konstantin Umansky, *Neue Kunst in Russland 1914–1919*, Potsdam and Munich, 1920.

33. Gustave Eiffel, *Tour de 300 metres*, Paris, 1900, 2 vols. Together with these minutely detailed descriptions he included an essay by himself concerning the history of building towers, from the Tower of Babel to the most recent.

34. In 1889, and still in 1900, it even had a Russian restaurant at first platform level. Whether this survived until 1913 is not known.

35. Marcadé, 1972, p. 11. Cosmic themes were also available, however, in works by Kupka and Balla, such as *Mercury Passing Before the Sun, as seen through a telescope* of 1914 (H. L. Winston Collection, Birmingham, Michigan). For Delaunay's cosmic themes see, for example, *Circular Forms: Sun, Moon* of 1913 (Stedelijk Museum, Amsterdam). In 1909 Delaunay had inscribed an oil painting of the Eiffel Tower: *Mouvement profondeur 1909 France-Russie* (see Jean Cassou, *Robert Delaunay*, Paris (Editions Berggruen), n.d.: *La Tour*, oil on canvas, 1909, 46 × 38cm).

36. *Civitas solis, idea reipublicae Platonicae*. Available in English translation in F. R. White, *Famous Utopias of the Renaissance*, Chicago, 1946.

37. Ibid., p. 166.

38. Ibid., p. 158.

39. Ibid., p. 160.

40. Ibid., p. 175.

41. K. E. Tsiolkovsky, *Vne Zemli*, published by the Kaluga Society for Natural History and Local Studies, 1920. Translated by K. Syers as *Beyond the Planet Earth*, London, 1960. Tsiolkovsky began the novel in 1896. Part of it was published in 1918 in the popular journal *Priroda i lyudi* (Nature and Man). Comparable themes characterize Evgeny Zamyatin's novel *We*, written in 1920, which is set in a future utopian society whose central area is called the Cube. The novel also features $\sqrt{-1}$. Rodchenko executed designs for a dramatic version in the later 1920s.

42. Tsiolkovsky, 1960, p. 17.

43. Ibid., p. 43.

44. Ibid., p. 46.

45. Ibid., p. 90. Malevich's *Planits* involve a comparable concept.

244

46. Ibid. These are comparable with the halls in Tatlin's Tower.

47. L. Kassák and L. Moholy-Nagy, *Uj Müvészek Könyve*, Vienna, 1922.

48. Punin, 1920, p. 6. Khlebnikov's view of man in the universe is of fishes caught in a net of stars: 'Stars are a net, we are the fishes/Gods phantoms in the deep' (*Gody, lyudi i narody*, written 1916–17, published 1924). Khlebnikov's global view of humanity was appropriate not only to the astrological timbre of his theories but equally to the internationalism of communism that sought a world revolution. In his poem *Ladomir* (Goodworld), in itself a utopian work, Khlebnikov envisaged a world harmony. Khlebnikov's future world-state was to be called *Lyudostan* (Peopleland) and its harmony was to be symbolized by a colossal sculpture surmounting Mont Blanc (see Khlebnikov, 1968, p. 149). Cf. A. Strigalev, 'Proekt pamyatnika III Internatsionala' in Zhadova 1977, p. 19: 'Tatlin expresses the global significance of this project by the measurements, forms and movements of his architectural masses, relating the Monument to the Third International to our whole planet.' Strigalev points out that the height is one hundredth part of the earth's meridian.

NOTES TO CHAPTER 9

1. See Gray, 1962, p. 259, and Andersen, 1968, p. 13. The Free State Studios were called Svomas, a contraction of the Russian for Free Studios: SVObodnie MASterskie. *Masterskaya Obema, Materiala i Konstruktsii* (Studio for Volume, Material and Construction).

2. TsGALI, f. 665, op. 1, ed. khr. 32, list 11. Several quotations from this typescript are used in Abramova, 1966, pp. 5-7. The whole text of this statement is printed in French translation in Andersen, 1979, pp. 127–8. Point 7, part 2, asserts that 'there is no error in Khlebnikov's example' (p. 128).

3. N. Punin in *Iskusstvo kommuny*, No. 17, 30 March 1919; cited in Woroszylski, 1972, p. 259.

4. K. Malevich, 'O poezii', *Izobrazitelnoe iskusstvo*, No. 1, 1919.

5. *Khudozhniki mira*. Discussed in Danin, 1979, p. 225.

6. A notice dated 25 July 1919 from the Moscow Free Studios refers to a course for school workers and lists amongst the tutors for the course Tatlin, Malevich, Babichev and Yakulov. Discussed in D. Sarabyanov, *Babichev*, Moscow, 1974, p. 71.

7. V. Markov, *Longer Poems of Velimir Khlebnikov*, Berkeley, 1962, p. 149.

8. 'Truba Gul-Mulla' (The Trumpet of Gul-Mulla) was an unfinished poem of 1921 recounting Khlebnikov's Persian trip. See also his poem 'Vidite persy . . .' (See, Persians . . .) in Vélimir Khlebnikov, *Choix de poèmes*, ed. Luda Schnitzer, Honfleur and Paris, 1967, p. 199. Arabic mathematics and astronomy penetrated Uzbekistan thoroughly and its culture inspired Popova in 1916 as well as Khlebnikov. The Shakhi Zinda, the Shrine of the Living God, is a complex of religious buildings at Samarkand. Lev Bruni and Petrov-Vodkin both painted at Samarkand in later years.

9. Viktor Shklovsky in *Zhizn iskusstva* (Life of Art), No. 650/2, 5–9 January 1921.

10. *Ladomir* was written by 22 May 1920 and published

13 July 1920. See Khlebnikov, 1968, Vol. 1, p. 188.

11. Inkhuk is an abbreviation for INstitut KHUdozhestvennoy Kultury (Institute of Artistic Culture).

12. Vkhutemas is an abbreviation for Vyshie KHUdozhestvennye i TEkhnicheskie MASterskie (Higher Artistic and Technical Studios).

13. Khazanova, 1970, p. 204 (who cites TsGALI, f. 941, op. 1, d. 75, list 7).

14. V. Kandinsky, 'O velikoy utopii', published in *Khudozhestvennaya zhizn* (Artistic Life), 1920, No. 3. See Khazanova, 1970, p. 204. Kandinsky sought 'an analysis of the means of art' seen in relation to the psychology (*psikhita*) of man. A 'psycho-physiological' laboratory was proposed within Inkhuk.

15. According to I. Matsa, 'O konstruktivizme', *Iskusstvo*, No. 8, 1971, p. 46, Osip Brik was elected president of Inkhuk on 23 March 1922.

16. Khazanova, 1970, p. 204. Also active within Inkhuk were Varvara Stepanova, the sculptors A. Babichev and Bryusova, Anton Lavinsky, the architect Nikolai Ladovsky as well as Lyubov Popova, Alexander Vesnin, Gustav Klutsis, V. Ioganson, V. Krinsky and others. Alexei Gan and the Stenberg brothers were to play a part in Inkhuk (see Khazanova, 1970, p. 204). Subsidiary groups of Inkhuk were subsequently established in Petrograd under the presidency of Tatlin, and in Vitebsk under the presidency of Malevich. Khazanova, 1970, pp. 25–6, gives March 1921 as the date of the Workers' Group of Constructivists (Rabochaya Gruppa Konstruktivistov).

17. K. N. Afanasev and V. Ye. Khazanova, *Iz istorii sovetskoy arkhitektury 1917-1925*, Moscow, 1963. For exhibitions see *Vystavki*, 1945, p. 59.

18. Kestutis Paul Zygas in his Cornell University Ph.D. thesis 'The Sources of Constructivist Architecture', 1978, has clarified the sequence of Obmokhu exhibitions and has traced the development of the Zhivskulptarkh collective into the Group for Objective Analysis (pp. 37ff.).

19. With ceramics these last three formed the Faculty of Industrial Production (Matsa, 1933, p. 45).

20. Zhadova, 1977, p. 43, n. 15. Subsequent heads of the foundation course were K. Istomin (1923-6) and R. Toot (1926-30). Rodchenko continued to teach at the Vkhutemas until 1930 (ibid., p. 35), becoming most closely associated with the woodwork and metalwork departments.

21. During 1920-2 a subsection of the Vitebsk studio of suprematists was set up under IZO at Smolensk and run by the Poles Strzeminski and Kobro.

22. Kazimir Malevich, *Suprematizm-34 Risunka*, Vitebsk, 1920. English translation in Malevich, 1968, pp. 123, 251.

23. The Nineteenth Exhibition of the All-Russian Central Exhibition Bureau (XIX Vystavka Vserossiyskogo Tsentralnogo Vystavochnogo Byura Otdela IZO Narkomprosa), Moscow, 1920. Exhibitors also included V. F. Krinsky and A. V. Shevchenko.

24. Vsevolod Meyerhold, *On the Staging of Verhaeren's 'Les Aubes'*, translated in E. Braun, *Meyerhold on Theatre*, London, 1969, pp. 171–3, from *Vestnik Teatra*, 1920, Nos. 72–3, pp. 8–10. Mayakovsky wrote an open letter to Lunacharsky in 1920 in support of the staging of *Les Aubes* and arguing in favour of the achievements of Tatlin and Picasso (V. V. Mayakovsky, *Polnye sobrannye sochineniya*, in 13 vols., Moscow, 1950-61, Vol. 12, p. 17).

25. E. Braun, *Meyerhold on Theatre*, London, 1969,

p.173. Tatlin may have assisted Dmitriev.

26. See A. B. Nakov, *2 Stenberg 2*, London and Paris, 1975, p. 65.

27. The Russian phrases are *Tsveto-konstruktsiya proekt prostranstvenno-konstrukivtnogo sooruzheniya* and *Konstruktsiya prostranstvennogo sooruzheniya*. 'Spacial construction' is not quite a literal translation. Nakov, 1975, p. 35, uses 'spacial apparatus'.

28. Ibid., p. 66, where the complete text is translated.

29. Ibid.

30. 'Constructivism will lead humanity to master the maximum of cultural values with the minimum of energy', slogan from the catalogue *Konstruktivisty: K. K. Medunetsky, V. A. Stenberg, G. A. Stenberg*, Moscow, 1921; reprinted and translated in Nakov, 1975, pp. 65–6.

31. Cited in Khazanova, 1970, p. 19.

32. Rabochaya gruppa obektivnogo analiza Inkhuka. Ioganson's lecture 'On Construction' attempted a definition of 'technical construction'. See D. Sarabyanov, *A. V. Babichev*, Moscow, 1974, appendix, and A. Babichev, 'O konstruktsii i kompositsii' (On Construction and Composition), *Dekorativnoe iskusstvo*, No. 3, 1967, pp. 16–17.

33. Osip Brik, 'Khudozhnik i kommuna' (The Artist and the Commune), *Izobrazitelnoe iskusstvo*, No. 1, 1919, p. 25.

34. Volkov-Lannit, 1968, p. 35.

35. Lobanov, 1930, p. 101.

36. See Woroszylski, 1972, pp. 274, 280, and Marshall, 1965, p. 58.

37. A. A. Sidorov reviewing Punin's pamphlet on Tatlin's Tower in *Pechat i revolyutsiya* (The Press and Revolution), No. 2, August–September 1921, pp. 217–18.

38. K. N. Afanasev, *Iz istorii sovetskoy arkhitektury 1917–1925* (From the History of Soviet Architecture, 1917–1925), Moscow, 1963.

39. Volkov-Lannit, 1968, p. 35.

40. A. Gan, *Konstruktivism*, Tver, 1922, p. 18.

41. Ibid., p. 70.

42. Nikolai Punin, *Vladimir Tatlin. Protiv kubizma*, Petrograd (Gosizdat), 1921. An unsympathetic review by N. Stefanovich appeared in *Pechat i revolyutsiya*, No. 12, 1922, p. 258.

43. Punin, 1921, p. 7.

44. Ibid. p. 11.

45. Ibid., p. 12.

46. Ibid.

47. Ibid., p. 14.

48. Ibid., p. 22.

49. Cited in G. Karginov, *Rodchenko*, London, 1979, p. 119, from *Vestnik iskusstv*, 1922, No. 5. Tatlin, in conjunction with the Petrograd Proletkult, worked also for the N. Lessner factory. This was reported by Arvatov in *Pechat i revolyutsiya*, No. 7, 1922, p. 146, and again in the same periodical, No. 7, 1927, p. 168. Tatlin informed Arvatov at Inkhuk in 1922 that, as his counter-reliefs were not useful, he would make no more of them (Protocol No. 7 of the teaching council of Inkhuk; cited by Abramova, 1966, p. 6).

50. Obedinenie novykh techeniy v iskusstve.

51. In addition *Vystavki*, 1965, p. 97, lists Andreev, Bodnek, Ya. M. Guminer, Denisov, V. I. Kozlinsky, Mashurov, S. V. Priselkov, A. I. Taran, Yutkevich and A. Yakolev.

52. LGALI, f. 4340, op. 1, ed. khr. 19; cited in Zhadova,

1977, p. 7. Malevich headed the formal section, Filonov the section for communal ideology, Matyushin the section for organization, Terentev the philological section and Tatlin the section for the culture of materials. Malevich appealed for Western European works and periodicals. See C. Malevitch, 'La Musée de la Culture Artistique de Petrograd' in *Malévitch*, Paris (Centre Georges Pompidou, Musée National d'Art Moderne), 1978, pp. 30ff.

53. TsGALI, f. 527, op. 1, ed. khr. 338; cited in Zhadova, 1977, p. 7.

54. Woroszylski, 1972, p. 294.

55. V. Tatlin, 'On Zangezi', is translated in Andersen, 1968, p. 69.

56. *Zangezi* in Khlebnikov, 1968, Vol. 2, Part 1, p. 387, n. 118.

57. Ibid., p. 319.

58. See Sergei Yutnevich, 'Sukharnaya stolitsa', *Lef*, No. 2, April–May 1923, pp. 181–2. Tatlin's maquette is for Surface 20 (Ploskost XX) of *Zangezi*. The figure *20* is discernible upper right in the photograph. The theme of this section of the poem is *Gore i Smekh* (Sorrow and Laughter): Laughter is at the left of the maquette and Sorrow at the right. The text is available in Khlebnikov, 1968, Vol. 2, pp. 317ff. The construction was not placed centrally on a stage as the maquette might appear to suggest.

59. *Zangezi* was performed by Tatlin together with untrained performers who were students from the Academy of Art, the University and the Mining Institute. An illustration shows part of the performance: the text which overhangs the balcony comprises a series of variations on Russian verbal roots mostly associated with *um* (mind). Visible, reading from the top, are MOUM, BOUM, LAUM, CHEUM, BOM BIM BAM. This part of *Zangezi* is published and in part translated in *Khlebnikov*, 1976, pp. 75ff. Mayakovsky claimed that Khlebnikov in his poetic experiments had created an entire periodic table of the word. See also Zhadova, 1977, pp. 43–5.

60. Vladimir Tatlin, 'O Zangezi', *Zhizn iskusstva*, No. 18, 8 May 1923, p. 15. Khlebnikov made elaborate notes concerning the spatial and colouristic equivalents of letters and verbal roots. There can be little doubt that in *Zangezi* Tatlin employed this system at least in part. It is likely that it also finds reflection in Tatlin's reliefs. According to Khlebnikov *M* is dark blue, *L* is ivory or white, *G* (hard) is yellow, *B* is deep red, *Z* is gold, *K* is sky-blue, *N* is soft red and *P* is black with a suggestion of red (see Khlebnikov, 1968, Vol. 5, p. 269, and *Khlebnikov*, 1976, p. 260). In 1919 in *Khudozhniki mira* (Artists of the World), Khlebnikov attributed specific spatial qualities to verbal roots and to individual letters. Commentaries were provided for most letters and Tatlin, in 'O Zangezi', refers to these concepts. 'The Alphabet,' wrote Khlebnikov, 'for all nations, is a brief dictionary of the spatial world, and very close, artists, also, to the art of your brushes' (V. V. Khlebnikov, *Khudozhniki mira*, 13 April 1919; reprinted in Khlebnikov, 1968, Vol. 3, pp. 216–19).

61. Andersen, 1968, p. 69. In fact, this plate relates to Surface 8 in Khlebnikov's poem, 'The War of the Alphabet', in which *G* and *R* (*Ge* and *Er*) are protagonists. The names of these letters are visible overhanging the balcony in Tatlin's drawing.

62. Ibid.

63. Nikolai Punin in *Zhizn iskusstva*, No. 20, 1923; cited

in *Lef*, No. 2, April–May 1923, p. 181.

64. Sergei Yutnevich, 'Sukharnaya stolitsa', *Lef*, No. 2, April–May 1923, p. 181. Yutnevich takes Punin to task for what he considers the pretentious tone of his article in *Zhizn iskusstva*.

65. *Lef*, No. 2, April–May 1923, p. 182.

66. Danin, 1979, p. 225, who recalls that Tatlin's favourite part of *Zangezi* described thought-clouds that fly through time. According to Danin, no one read Khlebnikov as simply or as convincingly as Tatlin (p. 227).

67. A full list is given in *Vystavki*, 1965, pp. 117–19. Amongst other exhibitors were M. V. Dobuzhinsky, S. M. Dudin, B. M. Kustodiev, V. V. Lebedev, M. Lebedeva, P. A. Mansurov, V. M. Matyushin, D. I. Mitrokhin, K. S. Petrov-Vodkin, N. A. Tyrsa and P. N. Filonov. Punin's review of the exhibition discussed Tatlin at some length and asserted that 'the influence of the Russian icon on Tatlin is infinitely greater than that of Cézanne or Picasso could be' (N. Punin, 'Obzor novykh techeniy v iskusstve Petersburga', *Russkoe iskusstvo*, No. 1, 1923; reprinted in French translation in Andersen, 1979, pp. 185ff. This quotation p. 187. Dymshits-Tolstaya is discussed on p. 190 and Bruni on p. 191).

68. 'Novyy byt' (New Way of Life) in *Krasnaya panorama* (Red Panorama), No. 23, 1924, p. 17, and reproduced in Andersen, 1968, p. 73. Cf. E. Kronman: 'At the end of the epoch of war communism, Tatlin worked on clothes, and at the start of the N.E.P. entered the Shveiprom factory etc., worked on furniture and so on' ('Ukhod v tekhniku', *Brigada khudozhnikov*, No. 6, 1932, pp. 19–23).

69. During 1924 Tatlin's stoves were discussed in the newspaper *Leningrad pravda*: 'In the battle for a way of life, in that cultural battle bequeathed to us by comrade Lenin, the works of Tatlin and the young collective grouped around him, are playing a great role' (quoted by Abramova, 1966).

70. Cf. Boris Arvatov in *Iskusstvo i klassy* (Art and the Classes), Moscow and Petrograd, 1923: 'the constructivists have revealed the basic and even the only aim of art to be the creative manipulation of real materials' (p. 39) and 'constructivism is not a form but a method' (p. 85).

71. N. Tarabukin, *Ot molberta k mashine*, Moscow, 1923.

72. Nikolai Taraboukine, *Le Dernier Tableau*, ed. and trans. A. B. Nakov and M. Petris, Paris, 1972, pp. 49–50.

73. Zhadova, 1977, p. 8.

74. In 1923 the Museum of Artistic Culture was reorganized into the State Institute of Artistic Culture (Ginkhuk: Gosudarstvennyy institut khudozhestvennoy Kultury). Tatlin's clothes and stove were produced at Ginkhuk. Tatlin submitted coat designs to *Leningradodezhda* (Leningrad Clothes) and had them approved. The press discussed them in April 1924. See Zhadova, 1977, pp. 7–9, and Gray, 1962, p. 259.

75. Andersen, 1968, p. 14.

76. The All-Ukrainian Jubilee Exhibition marking the tenth anniversary of the October Revolution. *Vystavki*, 1965, pp. 236–7, gives a list of exhibitors. During 1927 Tatlin also designed a book cover for the Ukrainian anthology of texts *Vstrecha na Perekrestnoy Stantsii*. *Zustrich na perekhresniy stantsii* (Meeting at the Crossing Station), edited by Mihail Semenko and announced in *Novyy Lef*, No. 3, 1927, p. 48.

77. Other exhibitors included Konchalovsky, Le-Dantyu,

Mashkov, Osmerkin, Rozhdestvensky, Shevchenko and Shkolnik.

78. See Fedorov-Davydov, 'Skulptura' (Sculpture), *Pechat i revolyutsiya* No. 7, October–November 1927, p. 184.

79. According to A. Abramova in *Dekorativnoe iskusstvo*, No. 4, 1964, p. 10, it was executed by Rogozhin under Tatlin's instructions.

80. In recent years the chair has been executed in bent steel in an attempt to force a comparison with the tubular steel chairs of Breuer, Mies van der Rohe and others, although competition of this kind could hardly be compatible with the nature of Tatlin's culture of materials. Furthermore, the recent steel variants illustrate more readily than Tatlin's own works the myth of his preoccupation with machinery. Gray described the chair as steel (Gray, 1971, p. 290) and a steel reconstruction (1976) by V. G. Solopov and V. Ya. Pavlov was exhibited in Moscow in 1977. Tatlin's study of materials led to the study of natural forms. In the late 1920s Tatlin's student A. Sotnikov evolved a set of crockery for a children's nursery from such studies. Tatlin himself designed a reed basket containing ten non-spill drinking vessels. See Abramova, 1966, p. 7.

81. D. Kharms, *Vo-pervykh i vo-vtorikh*, Leningrad, 1929.

82. S. Sergel, *Na parusnom sudne*, Moscow (Molodaya Gvardiya), 1929. It is possible that Tatlin was the author of poems signed 'Lot' published in *The Donkey's Tail and Target* in 1913.

83. USSR Arts and Crafts Exhibition (exhibition-bazaar) opened 1 February 1929 in Grand Central Palace, New York, travelling subsequently to Philadelphia, Boston and Detroit.

NOTES TO CHAPTER 10

1. Rodin, for example, was born 365 years after Michelangelo.

2. Khlebnikov, 1968. The works were first published in Leningrad between 1928 and 1933. Tatlin's glider was evolved during these years.

3. Oil, 114 × 65 cm., now in the Russian Museum, Leningrad. See Malevich, 1967, Vol 1, p. 11.

4. Kazimir Malevich, *O novykh sistemakh v iskusstve*, Vitebsk, 1919. Translated in Malevich, 1967, Vol. 1, p. 87. This view is essentially a mechanistic one and at odds with Tatlin in certain respects. Tatlin developed his own engineless machine from a study of young cranes in flight. His preoccupations led him to study organic construction, not in order to overcome nature but to be in harmony with its evolution. Cf. Khlebnikov 'The young bogatyr stood on the shore of the nocturnal sea and listened to the voices of the flying cranes, to the avalanche of victory in their voices, and he read the flying book, the nocturnal pages of nocturnal clouds' (*Khlebnikov*, 1976, p. 185).

5. In fact Rodchenko mis-spells Kamensky's first line which should read 'Zgara-amba'; see V. Kamensky, 'Zhongler', *Lef*, No. 1, 1923, pp. 45–7 (not No. 3 as the collage might suggest).

6. D. Petrovsky, 'Vospominaniya o Velimire Khlebnikove' (Recollections of Velimir Khlebnikov), *Lef*, No. 1, 1923, pp. 143–71. This quotation, p. 152.

7. In Astrakhan. See Markov, 1969, p. 11. Flight without

a motorized aeroplane is a recurrent theme in Khlebnikov's writings. His *Propositions* speak of ploughing the clouds (*Khlebnikov*, 1976, p. 232), and his time-travelling heroes are often winged: 'He [Ka] had to depart. Flapping his wings, dressed in gray, he vanished. Twilight flickered at his feet as if he were a leaping monk, my proud and beautiful vagabond' (p. 169). Tatlin too recalled being fascinated, whilst still a seaman, with the effortless but organic flight of sea birds following the ship: 'They would fly for three days without tiring. When a storm came and the wind rolled up into great balls, these remarkable birds continued to fly and not grow tired: they were better designed than our aeroplanes. Birds are of a flexible construction, whilst aeroplanes are rigid. Their wings are soft and living, whilst those of the aeroplanes are dead and rigid' (Zhadova, p. 60). Tatlin referred to *Letatlin* as 'a very light bird' and the flying of it as 'swimming in the air' (p. 61). He envisaged schools having *Letatlin* flying lessons for children (p. 61). The wings and fuselage were covered in parachute silk. Total weight was 32 kilo. A model of *Letatlin* is preserved in the N. Ye. Zhukovsky Central State Museum of Aviation and Space Flight, and is made of wood, cork, duralumin, silk cord, steel cable, whalebone and leather straps.

8. See Vladimir Tatlin, 'Iskusstvo v tekhniku' (Art into Technology) in the catalogue of Tatlin's 1933 retrospective exhibition *Vystavka rabot zasluzhennogo deyatelya iskusstv V. Ye. Tatlina*, Moscow and Leningrad, 1933; translated in Andersen, 1968, pp. 75–6. See also Tatlin on, 'constructivism-in-inverted commas', in I. Matsa, 'O konstruktivizme', *Iskusstvo*, No. 8, 1971, pp. 46ff.

9. Danin, 1979, p. 288, recalled seeing Tatlin with a book in Russian or German, illustrating Lilienthal's study of soaring birds.

10. As, in its own way, Tatlin's Tower had been. Tatlin appears to have consulted studies by Tsiolkovsky of organic flight. See Andersen, 1968, p. 9. Compare this with Tsiolkovsky's novel *Beyond the Earth* in which the inhabitants of enormous space dwellings, where only the slightest gravity is maintained, fly from chamber to chamber: 'The fliers had small wings on the sides of their bodies, rather like fishes' fins which they operated by means of their legs to obtain a steady motion through the air.' Tsiolkovsky was widely recognized in 1932. Note also, however, that Miturich was constructing flying models in 1916–17 (N. Rozanova, *Pyotr Miturich*, Moscow, 1973, p. 6).

11. See Tatlin, 'Art into Technology' (Andersen, 1968, p. 76): 'I have consulted comrades M. A. Geyntse, surgeon, and A. V. Losev, pilot instructor.' According to Ye. Kronman in the article 'Out into Technology, Tatlin and Letatlin', *Brigada Khudozhnikov*, 1932, No. 6, pp. 19–23, Tatlin and his assistants 'dissected birds and bred young cranes' to study them.

12. Tatlin interviewed by K. Zelinsky (*Letatlin* in *Vechernaya Moskva*, 6 April 1932, p. 2; translated in Andersen, 1968, pp. 77–80).

13. Tatlin, 'Art into Technology', 1933; translated in Andersen, 1968, p. 76; cf. Khlebnikov's proposition: 'Let sailing through the air be one leg of mankind and let spark-speech be the other' (*Khlebnikov*, 1976, p. 191).

14. Danin, 1979, p. 224. In a poem by Valery Bryusov, which mentions Tatlin and his Tower, it is Mayakovsky who is compared to Leonardo da Vinci. V. Pertsov gives the text in *Sovremenniki* (Contemporaries), Moscow,

1980, Vol. 2, p. 408.

15. Gray, 1962, p. 259, refers to Tatlin working on a model entitled *Industrialisation* during 1931–3. This is perhaps closely related to, or even identical with the photographs of the Monument to the Third International exhibited as Cat. No. 10.

16. Danin, 1979, p. 228.

17. Rakhtanov recalls the metting (Zhadova, 1977, pp. 59ff). Danin, 1979, p. 228, saw *Letatlin* at the Writers' Club, its great wings spread out over Boris Pasternak and his audience.

18. *Vechernaya Moskva*. Translated in Andersen, 1968, pp. 77ff.

19. Ibid., p. 79.

20. When Tatlin abandoned work on *Letatlin* and left the Novodevichy Monastery in 1937 a symbolic funeral was arranged with a small procession through the streets of Moscow. Tatlin, living on Maslovka Street with Volodya, his son, and a housekeeper who was a former nun, in two rooms, was unable to house the glider. Danin and a friend took it by bicycle from the monastery where Tatlin, Sotnikov and Zelinsky handed it over. Friends housed it beneath their ceiling. Discussed in Danin, 1979, pp. 229–30.

21. Zhadova, 1977, p. 26. Later projects concerning this 'way of life' included a mobile studio for artists and a project for the City of Air (Gorod Vozdukha), a city in the midst of nature based upon the *izba* or cottage modernized and reorganized, a peaceful spacious city with facilities for hunting, fishing and sport. See Abramova, 1966, p. 7.

22. *Vystavki*, 1965, pp. 411–12, gives the full list.

23. Tatlin and Meyerhold had quarrelled over the set for Sologub's *Navi chary* in 1917. They did not come together again until 1931 and then only briefly. Recounted in Danin, 1979, p. 233.

24. Amongst these productions were the following: *Deep Reconnaissance* by A. A. Kron directed by M. N. Kedrov at Gorky Moscow Art Theatre (1943); *The Little Blue Handkerchief* by V. P. Kataev; *The Distant Land* by E. L. Shvarts at the Central State Children's Theatre (1944); *Captain Kostrov* by A. M. Fayko at the Moscow Drama Theatre (1946); *Twelve Months* by S. Ya. Marshak (1946); *For Those at Sea* by A. A. Surov (1947); *The Offence* by A. A. Surov (1948); *Enough Simplicity for Every Wiseman* by A. N. Ostrovsky (1948); *Somewhere in Siberia* by I. I. Iroshnikova (1949); *The Magic Box* by P. G. Malyarevsky (1949); *Bowl of Joy* by N. G. Vinnikov (1950); *Envoy of Peace* by S. P. Antonov (1951); *The Truth About Father* by M. Kalinovsky and L. Berezin (1951); *The Battle for Gryukvald* by I. L. Selvinsky (1952).

25. The architect Rudnev spoke at his funeral. Tatlin's possessions were preserved by his friend the sculptress Sarra Lebedeva (these were subsequently presented to TsGALI), and by Lev Vladimirovich Rudnev (these were subsequently presented to the Architectural Museum); the Theatre Museum received his musical instruments (Abramova, 1966, pp. 5–7). A bronze portrait of Tatlin (1943–4) by Lebedeva is illustrated in A. Kamensky, *Vernisazhi* (Vernisages), Moscow, 1974, pl 39. In 1968 an evening in memory of Tatlin was held at the Central House of Architects in Moscow. A. Strigalev gave a paper there. See V. V. Kirillov, *Put poiska i eksperimenta*, Moscow, 1974, p. 139.

26. Danin, 1979, p. 223.

INDEX

249

251